DARA BIRNBAUM
THE DARK MATTER OF MEDIA LIGHT

Edited by Karen Kelly, Barbara Schröder, and Giel Vandecaveye

S.M.A.K.—Stedelijk Museum voor Actuele Kunst Ghent
Museu de Arte Contemporânea de Serralves Porto
DelMonico Books•Prestel Munich Berlin London New York

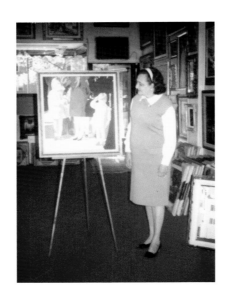

For my Mother
Who chose to frame my earliest works . . .
And who taught me to see from a different perspective.
Dara Birnbaum

It is nothing short of amazing that it is only now that the initiative has been taken to organize a comprehensive retrospective exhibition of the work of American artist Dara Birnbaum. The catalyst behind the exhibition as well as this book was Birnbaum's visit to the S.M.A.K.—Stedelijk Museum voor Actuele Kunst—in early 2005. She traveled to Ghent to discuss a new presentation of the decisive work *Tiananmen Square: Break-In Transmission* (1990), which is part of the Museum's collection. During the visit, the idea of assembling a retrospective arose. Five years later, the exhibition was a reality. Titled "The Dark Matter of Media Light," the show is the first to give holistic insight into the essential oeuvre of this visionary artist.

Birnbaum's art is radical, committed, political, and consistent over a period of almost four decades. The work is unequaled in its structural and critical approach to the media, and television in particular. In the 1970s, surrounded by Postminimalist artists and confronted with the machismo of body artists, Birnbaum focused in on that which imposes itself most on the everyday reality and psyches of United States residents: the ideologically manipulated image generator known as television. Her approach encompasses both a formal image analysis and a razor-sharp dissection of the latent codes of the images generated by the entertainment industry. She enters such images, manipulates them, slowing down and repeating sequences, thereby pointing out their weaknesses. By lucidly assembling sound and visuals, the artist forces the spectator to abandon a lethargic way of looking.

What initially took place on a single TV screen evolved in later works into encompassing multiscreen video installations. The expansion of the work into architectural space has developed in tandem with the image structures she builds. This results in environments where the spectators' movements unconsciously determine the work, making them accessories to Birnbaum's

spatialized reflection on the fragmented and shallow mass media, the industrially produced image. Exposed are the myths that images are innocent, truthful, and credible; clichés and stereotypes quietly smother, by way of a specific and effective image manipulation. Birnbaum has focused much of her energy on challenging available technology and using it in unexpected ways, even when there were no cheap video cameras or accessible digital-editing programs. Viewing images requires guidance and steering; via art and music, Birnbaum steers viewers through a different route, away from that intended, thus lifting superficial images out of their cultural vacuum and enriching them historically and culturally.

One need not interpret Birnbaum's oeuvre as a warning; better to see it as a micro revolution challenging us to consider the impact of images on the individual in our postindustrial society. In a world where such things as interactive television, Facebook, and YouTube are the deceitful agents of personal agency and freedom, Birnbaum's work becomes more topical and more important by the day. In a media landscape where, more than ever before, event and catastrophe supersede information and reasoned analysis, her layered body of work offers us a manual for fathoming the ideological underpinnings of commercial image machines.

I want to express my respect and gratitude to Dara Birnbaum for her critical vision and continuous engagement. Further words of thanks to the Marian Goodman Gallery, the entire team at the S.M.A.K. and the colleagues at Serralves. I hope that the exhibition and this publication will help to spread the seminal work of Dara Birnbaum to a wider and future public.

Philippe Van Cauteren
Artistic Director
S.M.A.K.—Stedelijk Museum voor Actuele Kunst, Ghent

For Dara, here and now

I have always been surprised at not having encountered Dara Birnbaum's art more often. Her exhibitions have been too few and far between. It is perplexing that the occasions to appreciate her work are so scarce, when she is widely acknowledged to be one of the most lucid and perspicacious analysts of the role of audiovisual mass media. At times, I have come across one of her works in a museum collection show, but more often than not I found one only in a rare catalogue, in a review of an exhibition that today is deemed historically important, and in the comments of other artists with whom she has collaborated, such as Dan Graham, a friend and keen connoisseur. Thus my awareness of her production has grown along with a sense of urgency to promote both its visibility and a better understanding of it.

Therefore it is for me extraordinary to have been able to associate the Museu de Arte Contemporânea de Serralves with a retrospective show of Dara Birnbaum's oeuvre and this publication, both of which the S.M.A.K. has taken the initiative to produce at long last. Presenting such work, together with valuable reflections on its nature, clearly fulfills the mission of a contemporary art museum in a globalized society that is more and more tamed by a *sic transit gloria mundi* mindset that links fame to consumerism: that of unearthing the most critical works of our time and fostering discourse around them.

There are innumerable issues worthy of reflection in Birnbaum's oeuvre; while some have been explored in previous shows, this exhibition and publication provide fodder for fresh approaches. This is an oeuvre widely known to have contributed to the contemporary discourse on the relationship between art and television, specifically to an evaluation of the modes of perceiving and assessing political events and historical moments as they are conveyed via the manipulative conventions of television and the mass media in general. Likewise, Birnbaum is widely and rightly recognized for her critical analysis of the representation of women in the context of a mass media that offers "wonder women" and other fictive models

that are equally alienating and damaging. Her groundbreaking formal deconstruction of tele-invasive languages is also consistently acknowledged. Appropriating television's own techniques of editing, pasting, and repeating, she exposes the consequences of the media's manipulations and conformism.

This exhibition, along with the texts contained in this book, raises new questions regarding Birnbaum's oeuvre and the multiple universes it encompasses and refers to. Together they certainly present an occasion to rethink the extraordinary architectural and sculptural nature of her work, one of the most original crossings of the immateriality of the video image and its objectivization in the exhibition space. They also offer a new opportunity to reevaluate the rigor and the keenness with which Birnbaum considers sound in her pieces, freeing it from its condition as hostage of the images it may accompany. It is an occasion to rethink the fluctuating relation between the vernacular of popular culture and the syntax of "high" culture, whose antithetical and contradictory elements her work has never ceased to examine.

For these reasons, I would like to express my profound gratitude to Dara Birnbaum, for her work, as well as for her courage and for the patience, persistence, and generosity from which this project grew. Recognition is also extended to the authors of the essays in the catalogue, as well as its editors, the private and institutional collectors who kindly loaned their works, the sponsors of the show (especially EDP, the exclusive sponsor of the exhibition in Serralves), and those who helped us at Marian Goodman Gallery, as well as to all the collaborators inside and outside the two coproducing museums who made both the exhibition and the publication possible.

João Fernandes
Director
Museu de Arte Contemporânea de Serralves, Porto

The preparation of this comprehensive publication has involved, as Dara Birnbaum puts it, "unearthing an archive." Quite literally this meant, among other things, digging through a vast number of handwritten pages and typescripts, notebooks, drawings and preparatory sketches, videocassettes, DVDs, and other ephemera that record the creative outpouring of a rigorous artistic practice. The process both reaffirmed recognized themes in Birnbaum's oeuvre and exposed previously unobserved motifs and junctures that echo throughout. Containing items as varied as early sketches for the San Francisco architectural firm Lawrence Halprin & Associates (which manifest a lifelong consideration of the mechanics of civic space), small and intimate self-portraits in pencil and ink copied from Polaroids, contact sheets containing sundry collections of stills from television and film (some, photographs from her own television screen; others, Hollywood film stills, found on a Los Angeles street), and troves of photocopied theoretical texts and critical essays, the artist's archive divulges her ongoing efforts to find new avenues into domains of both the individual and the collective, in order to "insert something that's about a contemporary position, that has political overtones or interferences."

By the mid-1970s, early in Birnbaum's artistic development, it was television that had become, according to Manfredo Tafuri, the real architecture of the time: the average American was watching a full seven hours and twenty minutes a day of television; as the artist herself has stressed, it was vital to consider the structural aspects of television "because that was the contemporary language of the U.S." By isolating television's imagery from its context and breaking its flow, she could get at its essence, refusing to submit to its one-way address. But, as American art historian Johanna Burton questions in her essay in this volume, how does an artist seemingly so engaged with contemporary media and technology "maintain speed . . . in the face of one of the fastest consuming and commodifying processes of the twentieth century"? Burton concludes that Birnbaum's dissection of mass media's vernacular could not be limited to a single strategy of appropriating, reediting, and re-presentation. Instead, she repeatedly seeks "new methods of disruption . . . [and refuses] to give up the game."

The storyboards and notes filling the artist's filing cabinets and drawers reveal this tenaciousness: in carefully editing, layering, repeating, and recomposing many types of imagery—appropriated but also self-produced—Birnbaum takes the individual to task in the reception of media and the great myths that it transmits. A close look at her archive in relation to her work provides a glimpse into how this artist finds, according to Burton, "access to [her] own

images and how they navigate the question of the 'I' from within several concentric sets of cultural terms." In order to navigate this question of the "I," Birnbaum has never been afraid to enter territories of the Other. Rather than buying into the euphoria surrounding video at the time, or the idea of video as an alternative to television, Birnbaum "entered the opponent's field directly," argues Sigrid Adorf, showing her works in commercial settings and making an artwork commissioned by Rémy Martin in the guise of a television advertisement. Describing how she had already begun her strategic game in a series of video studies made in the mid-to-late 1970s, Adorf, who has extensively researched the use of video by women artists, suggests that Birnbaum entered the nascent field of video art just as bluntly, challenging the especially gendered biases of the period. "My very early tapes seem affected by a perception of psychological space, as portrayed in Acconci, but from a female perspective. I had observed that with Acconci's work the woman was basically used, entrapped, seduced," Birnbaum notes. "It did interest me that [his] seductions were directed out toward an anonymous viewer, who in fact could almost always be assumed as female. That's probably why, as a woman, I went for a position of self-inquiry." Her self-inquiry departs from that of many of her peers: by exploring the manipulations of the body by the camera in her early single-channel tapes, Adorf argues, Birnbaum "draws attention to the intimate relationship *with* the image and thematizes that relationship itself, before turning around and offering herself *as* an image for the encounter with the viewers' own groping, attentive gestures."

Among the most evocative preoccupations found in these early tapes, which have haunted the thirty-five years of Birnbaum's practice, are the mirror and its allegorical counterpart, the shadow. In her works, the mirror, rather than producing a coherent doubling, disorients and confuses, and visibility can be found in the darkness of the shadow. Like Pliny, who recounted the story of a woman capturing her dying lover's image by tracing his shadow, she sees that place of negative projection and repression as a paradoxical site of expression, creativity, and empowerment. The shadow is both the site of loss and invention. In her essay, curator and writer Marianne Brouwer embarks on a journey into this "dark matter," mapping its range beyond language, where personal trauma and horror reside, and discovering there the recurring theme of "Woman in search of herself." As Brouwer argues, Birnbaum takes a political path through the domain of hysteria, claiming that "emancipation starts with the beginnings, however inarticulate, of a new and different narration, which must be forced from within language itself, because language is owned by those who inflicted the unspeakable pain on the subject." Her ensuing question of where that subject positions itself in society is key for Birnbaum.

Though the materials in this artist's archive bring to light some of the private aspects of an oeuvre that has often been seen as more engaged with the public sphere, it is, again, the confrontation of the two that interests her. Photographs documenting several early installations show the usually domesticated television screen turned out the window toward the street. Initially studying and working in environmental architecture, the artist often leaves white-cube gallery spaces in search of more public realms. Art historian Steven Jacobs, arguing that Birnbaum's aim to create a discursive environment for media extends into three dimensions, traces her production of "a variety of situations in which the virtual space of the media is thrown back into the real private and public spaces of the city." Media artist Marina Gržinić further situates Birnbaum's work as an evaluation of how the medium of video interprets and reprograms political space as capital. She describes Birnbaum as emphatically activist in her determination that we, as media consumers, must first apprehend and then tackle the underlying capitalist mechanisms of the mass media: "Birnbaum's installations [articulate] what can be defined as a specific logic . . . [that] is connected to dramatic shifts in the way we perceive space and time, information, history, and last but not least politics in public space."

The viewers of Birnbaum's installations—sometimes literally targeted by elaborate mechanics—are provoked to ask questions regarding their own accountability as spectators. Passive viewership, such as that typical of entertainment, is no longer an option. Many renderings in Birnbaum's archive establish how meticulously she considers the multiple perspectives of her beholders. Their bodies, their paths and movements, are within the frame of her installations and are directly inscribed into the imagery. In presenting contemporary media culture in ways that awaken us to the repercussions of our own submissive consumption, the works show us that there must be an individual response to counter oppressive forces and to give, as the artist puts it, "back to the body its elemental disposition, its capacity for expression."

Birnbaum attempts to locate potentiality in the "liminal in-between" of dualities, where, theorist Michael Newman insists, "transformation may be stalled or enabled." While acknowledging that for her "transitions are subject to repetition and failure," he proposes that they also hold promise. He finds both destruction and possibility in her repeated attempts to "explode" the image. German author, music journalist, and cultural critic Diedrich Diederichsen deepens this understanding by emphasizing the audio aspects of Birnbaum's work and analyzes how her visual elements work in tandem with her sound. Her "formal" techniques of appropriation, repetition, and fast-paced editing attempt to divest the popular of its oppressive operations

while simultaneously offering possibilities for pleasure and empowerment. As we can witness in two conversations with longtime colleague and friend Hans Ulrich Obrist, which span twenty-five years, Birnbaum's engagement is based in an optimistic belief in critique. Moreover, she does not ask us to sacrifice playfulness, joy, and sentiment as we look and listen in the dark matter of media light.

* * *

Given the enduring vitality and influence of her thirty-five year deconstructive investigation of mass media, the full-scale evaluation of Birnbaum's work in the retrospective exhibition "The Dark Matter of Media Light" and in this accompanying catalogue is long overdue. Her generosity in admitting us into her archive—a process described by the artist as "bringing to light the shadow side and the repressed side of myself"—was our privilege. We are pleased that she agreed to reproduce not only a selection of her writings but also some of the more personal materials we encountered in the archive—some of these, reproduced on the translucent pages of this book, she considers gifts to the reader.

We wish to thank all of this book's contributors, each of whom has seemed to delight in and to be fascinated by Dara's oeuvre and practice as much as we have. In close collaboration with the artist, Rebecca Cleman and Lori Zippay, who have for many years distributed Dara's work through Electronic Arts Intermix (EAI), crafted a series of detailed entries on more than forty of her works both famed and little known, turning what was initially conceived as an exhibition catalogue into a format closer to a catalogue raisonné that will doubtless trigger much more writing in the years to come.

A book of this scale would not have been possible without the generosity and input of many. We would like to thank the S.M.A.K. and the Serralves Museum for initiating this project and bringing it to fruition. Maria Ramos of the Serralves Museum, in particular, offered inexhaustible energy and professionalism in her management of this book. We are sincerely grateful to Domenick Ammirati for lending his sharp and judicious eye in the editing of the texts, to Jeremy Sigler for additional editorial support, and to Aniko Erdosi for her help with our research. Koen Bruneel conceived a design that smartly reflects Birnbaum's refined sensibilities. We would also like to extend our gratitude to Richard Gallin, Sam Frank, and Karina Daskalov from Marian Goodman Gallery for their support.

Karen Kelly, Barbara Schröder, and Giel Vandecaveye

CONVERSATION

HANS ULRICH OBRIST–DARA BIRNBAUM

FROM THE SERIES "PORTRAITS OF ARTISTS"
CONCEIVED BY MUSEUM IN PROGRESS AND PETER KOGLER
SEPTEMBER 1995

HANS ULRICH OBRIST (HUO): To begin, it would be nice to talk a bit about your time in Berkeley.

DARA BIRNBAUM (DB): My time in Berkeley . . . I feel like I grew up in Berkeley, figuratively speaking. I moved there about 1970. Before that, I had gone to college in Pittsburgh, after which I had gone back to New York, where I was from. But I was looking for a place that was different, and I think a lot of people went to Berkeley thinking it was that *somewhere else*. It was the mecca of alternatives at that time. The university was still very, very active. Most of the people around me had participated in the Free Speech Movement in 1965. There was a kind of revolution in the street at the time. Streets were sometimes lined with the National Guard. The shopkeepers on Telegraph Avenue would put up boards because everyone was throwing rocks during demonstrations. Abbie Hoffman and other people certainly considered Berkeley as a major site of political activism.

HUO: What about you? Were you involved in direct activism, in terms of Vietnam but also in terms of feminism?

DB: Well, it's like what Sergey Eisenstein said, when one makes revolution you don't call it revolution—you're simply in the act of doing it. In my youth, my brother and I were active politically, when we lived in New York. I guess we took what could be called, in retrospect, a very leftist, liberal position. When I came to Berkeley, I thought I was going to find solutions that perhaps were not possible to find elsewhere. The city drew strange people and had gotten the nickname "Berserkley." It was of course a locus for the antiwar movement. I was marching against Vietnam from early on, and by the time I made it to Berkeley, I had an FBI file. Lawrence Halprin's architectural firm discovered the file around 1971 or 1972, when I was working with them on a project for the city of Everett, Washington.

HUO: A text you've published, "Finding Anyplace in Cyberspace" (1995), is dedicated to Abbie Hoffman, with a long Hoffman citation. Did you read him at this time?

DB: I got to breathe him, not read him. I saw him for the last time years later at the National Student Convention, in 1988, one year before his death. I was making a video (which eventually became part of the work *Transmission Tower: Sentinel* [1992] for Documenta 9), of Allen Ginsberg reciting his poem "Hum Bom!" It was very interesting because it was the first time in twenty-two years that students came together nationally. They didn't want any cameras or to allow any press in. I was teaching at Princeton University, and I was feeling really depressed, like nothing could happen in the United States from the position of youth activism. One of my students said, "Don't get so down. It's not there on the surface, but it's underneath. In a few months, we're going to have a National Student Convention with campus representatives from all over America." That student got me into the convention. I was the only one given permission to film it. Hoffman and Ginsberg were there as elder statesmen, speaking from a position of twenty years later. They said to each other and to the students how they were opposite. But of course opposites attract.

HUO: But despite this convention, you've been frustrated by the level of activism in the U.S. in recent years.

DB: People have protested, but the media has largely censored or ignored such protests, and newspeople basically report from a government-condoned pool. The media largely turned away from many of the smaller demonstrations that were orchestrated throughout the United States against the Gulf War. Perhaps some weren't even that small. But you had the feeling that any opposition movement was fragmented. Sometimes the media claims to be assuming the role of "eyewitness," letting the viewer believe that they are *there*, at the site of a news story, when in fact they bring you very controlled images.

HUO: It leads back to the Vietnam War.

DB: It was the same time as Woodstock. In the film, one of the

These and following images in this interview: Stills from "Portraits of Artists," conceived by Museum in Progress and Peter Kogler, 1995.

performers looks out and says, "Hey, we've got almost a half million of you motherfuckers out there. You know, we're not alone." The point is, if you could be seen, you were not alone, and this was true also for the antiwar movement. The object of the time was to be seen. By the eighties, I think that the object of the time was to disappear, that not to be seen was a much more activist position, like being a hacker or creating computer viruses. And this is the reason I cited Abbie Hoffman in the article I wrote on cyberspace—to call him maybe the first hacker. Hoffman looked for the weakness in the system. He formed the Yippie movement. There was Chicago '68 in the United States and May '68 in Paris. Look at the differences. In Chicago, the perspective of Hoffman and the Yippies was that we have a system in place—television—and it has the pretense to be everywhere; you had to get on television to get your message heard. How do you get on? You make the best street theater possible. If you are the most dramatic, you get the most television time and space. In France, the position was opposite. It was to look at the system and to say the system is not functioning properly. We'll never participate until we reestablish what the system is. So the purpose of the student-worker coalition was actually to tear the system down, to the point of stopping the Cannes Film Festival in 1968. One can't speak from a structure that does not have integrity. Whereas with Hoffman, the philosophy was more kind of "grab what you can."

HUO: In "Finding Anyplace in Cyberspace" you talk about the *membrane*, about the inside/outside with regard to cyberspace.

DB: This essay was connected to "Anyplace," an architectural symposium that discussed how this new territory of cyberspace was being systematized in part through architecture. In fact, if you refer to public space, you can take a look at the Greek idea of *polis*, or a physically gathered public. I would say that idea is absent in cyberspace. Although it *seems* that everyone can enter into it—can gather—there is in fact a dispersal, which I find to be

contradictory. As a "media artist," I'm in a strange position, because now, after fifteen years, I have to discover what media means and what space it occupies all over again.

HUO: In the text you talk about disruption, inconsistency, and unpredictability with regard to the hacker. Is this related to visual terrorism?

DB: I don't know if I am capable of visual terrorism. The works I've been doing lately—such as *Hostage* (1994)—touch on that, but they are probably more anti-terrorist.

HUO: The piece with the targets.

DB: And also being targeted. The work focuses on events surrounding the kidnapping and killing in 1977 of Hanns-Martin Schleyer, who was abducted by the Red Army Faction in its attempt to get several members of the Baader Meinhof out of jail. It's an interactive piece, with multiple channels, and a tension becomes evident when you, as a viewer who engages with it, realize that you are also held hostage. You can cut across the main field of vision, break the beam of transmission, and change the main representation. Then, when you're outside the main viewing area, looking obliquely at the displays and looking into the space the installation occupies, you can see that perhaps another viewer has already been targeted. He/she is not always aware of being hit by the laser beam, though he/she may become aware of it because of the effect it has on the motion of the representation: it freezes the images of one channel. The question becomes, "Are you the observer of your culture, or are you active within it?" I am always asking myself that. Another example is in the *Damnation of Faust Trilogy* (1983–87). In the first part, two young women, they're seductive—that's a big no-no sometimes. "Why are you using seductive images of women so much?" So when I bring them back in part three, *Charming Landscape* (1987), I ask them to look at themselves. The second half of part three is a timeline of documentary footage and appropriated imagery, basically

from the time period of their own lives. They were born in 1968 and 1969.

I always remember one scene from the civil rights movement, a demonstration in the South where for the first time someone black tried to sit down at a lunch counter and tried to order like a white person. He was viciously attacked. When you appropriate these images, take them out of their original narrative flow and out of the original documentation, and re-represent them, I think you more strongly feel the boundary between the person who documented that action and your position, inactive, as a viewer. In that scene, the cameraman seems to me to be standing just on the boundary between looking into a scene where a man was being viciously beaten and being involved in the activity itself. I am trying, in a very guttural way, to get this feeling aroused in the viewer. If you took one step forward, you would be in that action, and you would have to put yourself into either a victimized role or into a hostile role.

HUO: I had the impression when *Hostage* was installed at Paula Cooper Gallery that the viewer was positioned as both victim and aggressor—like targeting and being targeted at the same time.

DB: Exactly. If you take a step backward, you're an observer; if you take a step forward, you are within the action. The works for me don't bring an answer; I've never known how to do that. They always bring a question. I think that's OK, because if you have a good question, it's really the first answer.

HUO: Can we talk more about the membrane?

DB: I don't know what the membrane is made of anymore. It's an intriguing issue: what substance is it, how porous, how transitory is it, what speed does it take to get through it. There is a wonderful science-fiction book by Stanislaw Lem, *The Invincible*. In it, a planet is discovered on which only machines exist. There are two types, very small units and very large units. The large units represent a kind of clunky industrialization. The small units are similar to computer parts. They don't think for themselves but can come together and form a larger unit, and when they're all acting in unison, this unit succeeds. It succeeds over the giant machines, the colossus. It's like how, if you go into a wave, you have to be like a particle in it, since you're not a part of it. And if the oscillation in that particle is different, you can be expelled from the system—you can feel yourself being pushed out. If you're in tune with that system's oscillation, you're engulfed within it. This needs to be a constant reminder with regard to our relationship with media.

HUO: Appropriation, which you've alluded to with regard to your *Faust* trilogy, is a key element in your early video works like *Technology/Transformation: Wonder Woman* (1978–79) and *Pop-Pop Video: Kojak/Wang* (1980)—and the practice involved pirating television and mass media much more than fine art. Did you have a dialogue with other artists in the seventies working with appropriation?

DB: I don't feel that I had that much of a dialogue, but early on I did get involved with a group of peer artists in New York. My boyfriend and another close friend would come home late at night from working together, and we would discuss what was going on in the arts. They realized that I had a lot to say. At first I helped this friend with his work; then we worked together. And the group he was part of was showing mostly in alternative spaces, like the Kitchen. "Alternative" also meant finding a loft here, a space there—anything that worked. It's something I still believe in. I am on the board of directors for Creative Time, an organization that finds a new space each time we work with an artist, in relation to the needs of the piece. Maybe this is also the same kind of thing with Museum in Progress? What spaces do they choose to occupy? Do you use the spaces of media with the holes that are left in it? For example, to reoccupy *Der Standard* [a Vienna-based Austrian national newspaper] is Brechtian, in a way—the idea that you use the holes in a medium (radio, television, newspaper) if you can.

HUO: It's akin to the way you might install a piece in a barbershop.

DB: It wasn't a barbershop; it was a very posh hair salon in SoHo, very fashionable. But I like the word barbershop; it's very nineteenth-century America. You just went and got your hair cut there. You didn't try to be in style, you just tried to be trim. In a salon, they try to be a little exotic.

Anyway, now you can't get away from monitors in stores. But I think SoHo H-Hair, where *Technology/Transformation* was installed, was the first store in New York to have a TV monitor. The shop had three large color photographic prints mounted on a front wall, adjacent to and directly visible to the left in the storefront window. These were next to—forming the background for—the placement of the monitor, which swiveled. (It could turn in for the patrons of the store or out toward the passersby.) The photographs were of a man's hands, with big scissors, trying to cut off the hair of a woman. You had the feeling that he was pursuing her, sort of a reverse of the myth of Samson. It was good to have the photos there, in addition to the monitor, as it strengthened the idea of the portrayal and reversal of mythology. The sound went out to the street. At that time, they had one videotape. Can you guess what it was? The Italian version of *Woodstock*!

I asked the owner if I could show my work in the window. She said, "Well, what is your work about?" I never know how to say what my work is, exactly, so I just said, "It's about Wonder Woman." She said, "Oh, that's great! I love Wonder Woman." She agreed to put it on for a few weeks. People stopped to look. Passersby became stoppersby. You can put TV on anywhere and people will stop.

HUO: This piece in turn leads to *Rio Videowall* (1989), which you made as a commission for a shopping mall in Atlanta.

DB: We consume a lot in America, and the dynamic of passersby on the street in New York looking in a shopwindow is not really that different from the dynamics of a plaza, as with the Rio complex. Monitors act like an attract loop to get people to a location to shop. The thing about *Rio Videowall* is that, instead of the viewer focusing on Wonder Woman's body, a "keyhole" is cut in the shape of your *own* body through images of the natural landscape that had occupied the site before the mall was built. There are two cameras that pick up your outline as you enter this public, dynamic space.

HUO: The work is in permanent transformation?

DB: For me, it had to change in order to be permanent. However, maybe what Ackerman & Company originally wanted was a beautiful, repeat-loop, video water fountain.

Conceiving it, I thought, "How do you use images in video works, in public space, that don't become old? What kind of flux can they have?" I decided to use three types of imagery, each one representing a different historical aspect of video that would merge and form a kind of montage and would always be stimulating and different. When you came into the shopping center, from either of two distinct points, your body's image was made into a silhouette. You became like a black hole. This went up on the video wall. Filling that black hole, beamed down from a satellite, was a feed from CNN, which is headquartered in Atlanta. You had no control over the imagery coming through your own body.

HUO: So it was the news of the day that caused the body, and the piece, to be continually renewed.

DB: And it was your body that was opening up a space within the background imagery, which was of the original landscape that had been there before the plaza was built. It had been destroyed to make way for the Rio complex, and a new landscape—completely artificial—and the building were introduced. Thus, as you enter the shopping arena, you break open the memory of the old, and the keyhole your body forms is used to transmit the memory of the new.

HUO: It creates a dynamic standstill.

DB: Another interesting thing here is that both the developer and the architect said that they wanted to change the philosophy toward shopping malls in America and make their project different. First, they would eliminate the "anchor store." There is always an anchor, the big-name store, the attractor that other stores would feed off. Here they said the anchor will be some kind of public artwork. I have a wonderful videotape that in my old age I want to look at and laugh. They recorded the final round of meetings between the arts organizations, the advisors, the developer, and the architect. The architect and the developer said, "What can we do to attract people? We want to attract the new gentry." I didn't know what "new gentry" meant; I assumed it was some kind of Yuppie, upscale young people. "How do we attract them?" they asked. *They were looking for a buzzword*. The word they came up with, finally, was *electronic*. Something electronic would bring the new gentry in. The developer said, "Yes, once in England I saw something which went into the minds of young people and pulled things out." Ackerman & Company went to a media arts organization, in Atlanta, for advice—to ask what they should do. They put out a call for an international competition for video art. I was so afraid of what they would get that I decided that I had to compete.

I think sometimes it's crazy that I do video and media-related work, because it's just as it was when I worked in architecture: I was actually against building. I think with video I am against a proliferation of electronic imagery. I don't have a compulsive love of electronics.

HUO: Haven't things changed a lot in recent years, in that categories have blurred? Before it was either cinema or photography or video or painting. Now the whole question is just of images and what happens between them—the *entr'images*, or as Camille Bryen says: "n'être qui entre." Can you talk about your first work, which was very much about the *entr'images*? I'm talking about the photographs you took from television as a sequence in 1977 [*Lesson Plans (To Keep the Revolution Alive)*].

DB: Actually I did some work before the one you're referring to that I would like to rescue. One of the earliest works was called *Mirroring*, which was influenced by Jacques Lacan's writings. I think it's a good piece, though I haven't seen it in many years. When I made it, in 1975, we had the open-reel system in video. You can't hold video up to the light to see it like you can with film. I think working with video is more like playing chess. I felt video was like this: I had to be seven moves ahead and seven moves behind. And I could never see any one move at a time, nor see an image directly; I only saw it in my mind. This was a great excitement for me.

The work from 1977, *Lesson Plans (To Keep the Revolution Alive)*, was static, taken photographically off TV, because in 1977 you did not have Betamax or VHS; you just had imagery coming at you. How do you capture these images? Which are the most important? What is their C-major chord? Oh, it's the reverse-angle shot—very structuralist. In prime time in the late seventies, when most people looked at TV in America, what did they see? They saw crime drama. And what is crime drama? It's a lot of reverse-angle shots to create tension with regard to the person you are supposed to identify with. So I took typical reverse-angle shots and put a selection of them up on the gallery walls, with text panels of the dialogue beneath them. When you stopped the action and read what was being said, for me, it was even worse than I would have imagined. Two policemen in a car look out through the windshield, then they look at one another. They are looking at a black man. Well, even today, he must be the perpetrator. "You think this is our guy?" "Yeah, that's our turkey. I want him so bad I can almost taste him." That was American TV! Everything was stereotyped, especially the roles assigned to women. And you see a similar critique in all my early pieces, like *Wonder Woman*. A woman transforms into a primitive race; she's portrayed as asexual; she changes her image from average secretary into Wonder Woman. And as an Amazon she goes out to save mankind.

HUO: After your first two exhibitions, you went into single-channel video work with *Wonder Woman* and *Pop-Pop Video*. You changed the speed of what you appropriated: you accelerated, you slowed down.

DB: At the beginning, I never changed the speed of the footage. I took exactly what was there.

HUO: I see. So it was only repetition?

DB: Because it's taken out of the narrative flow, you look and you think the speed is wrong. Like in *(A)Drift of Politics*, my first video installation, from 1978, there are two women. That was all about "two shots," where the characters appear in the same frame. In the original program, *Laverne & Shirley*, you see two women working on a Coca-Cola bottling assembly line. At the end of the day, they take off their rubber gloves and put them over the Coke bottles. (Now with AIDS, unfortunately, there is a need for everything to have this rubber membrane.) They leave the plant and go out into the world together. This was the end of the so-called nuclear family in America. Where is the father? Where is the mother? We adolescent Americans are alone now. They're women, but girlish women, forming their own nuclear family.

Making this kind of work, I thought it was really important not to change the speed and not to change the medium. You don't speak from another voice; you speak from that voice. I took only the two shots from *Laverne & Shirley* and butt-edited them. Then I made subtitles, because I took the audio and I put it in a separate room. I thought, "Let the audio be like a radio play, and in this first room put only imagery." But you could read in the subtitles what they were saying in the frame. The words went by so fast that you couldn't believe all the two women were saying.

HUO: So all this thematic content became visible through shifts of context?

DB: Absolutely, and not through shifting the medium. I related myself to a peer group dealing early on with media images like Jack Goldstein, Robert Longo, Cindy Sherman, Sherrie Levine. But these artists were always translating the medium, and I wanted to use the medium on itself.

In Amsterdam in 1985, there was an exhibition, a kind of multipart exhibition-symposium. The organizers gave me a compliment and said they named it in part after what I was doing. They called it "Talking Back to the Media." And I think this was what I wanted to do—I wanted to arrest the image without translating it. I thought, "How do you put video on to video? Television on television?" People said that I became a pirateer: "Oh, she's the one who pirates the images." In the seventies, I had this ferocious image—I was a singular, woman pirate. I got my photo around a lot. "Yeah, she's the pirateer of images." Now I tease people and say, "In the seventies, she *appropriated* images. In the eighties, she *stole* images. Now, in the nineties, she *samples* images." It goes like that as the generations change.

HUO: You made a book with regard to Situationism, which brings us back to questions of appropriation. Gilles Deleuze differentiates between creative theft and betrayal.

DB: But creative theft was absolved by the Situationists. The book I did, in which I used anonymous street posters from the May '68 uprisings, is dedicated to the people who made them. It's something I really respect, their approach to the original, which was seen as a multiple and owned by everyone. Their images were plastered on walls in public space, as in Paris, and they said, "You can take these images. You can take these words. There is no copyright."

I'm actually in a dilemma. To make my work, I took images that I felt belonged to me but that technically didn't, like Wonder Woman. In 1977 the average American family watched seven hours and twenty minutes of TV a day. So I said, "It's my landscape. I can paint my landscape; I can take from it." In effect, I was saying, "No, you cannot send these images only one way at me. You cannot make my landscape into that image of a woman."

Now comes the ironic thing: what happens when the images are put back out there? I put them on cable TV opposite the "real" Wonder Woman. I put them into an avant-garde film festival and made them like a barroom B movie. They were shown in the storefront of H-Hair. But what happens years later is a nightmare, in a way. Then I felt like I owned these images. And that's the strangeness of art-making for me.

HUO: It's like a boomerang?

DB: Exactly. The Situationists created images, as with the posters, that were sent out to affect mass numbers of people, and they didn't attempt to own those images. No one signed them. Whereas I've become an owner, in some ways, of Wonder Woman. And now I constantly have to ask myself, "What images am I making? What am I making that is consumed? How saleable does it become? What's its marketplace?" You know, there's an image highway, not only an information highway. And the image highway is, in part, the galleries and the system of selling images. And for us—meaning a peer group of, for example, Bill Viola, Gary Hill, Mary Lucier—it's different now again. But I would say that at the very beginning we got

into video because we thought of it as a multiple, as it doesn't carry the aura of a painting.

HUO: Lucy Lippard once said that the goal of feminism is to change the character of art and directly attack the infrastructures of the art world. Did you too have at the beginning this idea of attacking the infrastructures of the art world?

DB: I don't think I made my work so much to undermine the art world directly. I had such a lack of belief in that structure that it didn't matter to me.

My belief—and I want this still to be true—was in the message. So I don't know how McLuhan I am, but I just knew something had to be said regarding mass-media imagery. And perhaps I did, very idealistically, see art as one of the few activist positions that could be held in society. Then, the more I learned, the more I saw what was controlled.

HUO: You always saw video as a vehicle?

DB: Maybe I saw art as the vehicle.

HUO: With regard to your early works, you have often cited Raymond Williams as an influence. What was the importance of his texts to you?

DB: I think Dan Graham was the one who gave me a Raymond Williams book and said, "Well, you can read this, I'll lend it to you." That was my first encounter with Williams's texts, a structural look at British television. In England there existed the remnants of the nuclear family. TV was programmed keeping this in mind, formatted for people at home, especially housewives. So that was a beginning.

HUO: Besides museums, art galleries, and other locations where you have contextualized or shown your work—the hair salon, the shopping mall—you've also made interventions directly into television. What does this mean? Maybe it would be interesting to talk about your recent MTV project.

DB: I've done two projects for MTV. One was what they called an "Art Break." For that, MTV came to me. In 1987 they took six artists from the United States—but I was the only video artist—and they said, "Do whatever you want." Everyone was so hot to look at the new graphics, digital processing, or, at that time especially, Claymation. And they had really the most grotesque representations of women, as they still do, in my opinion. Maybe of men also. So they said, "You've got thirty seconds, and you have no budget." And I said, "Artists working with video never have a budget." They said, "No, we mean that you can go wherever you want. We're paying your bills." For an artist that's a very privileged position.

So thirty seconds; what do you say? I had friends . . . I remember a stern warning coming from Benjamin Buchloh. "What are you going to do for MTV, entering into that supermarket of imagery?" And I said I'd rather enter, risk, and perhaps fail—I'd rather learn from it than not enter it.

I decided to use a very early cartoon by Max Fleischer, Coco the Clown, from his *Out of the Inkwell* series (1919–29). Coco came out of the inkwell and got into fights with the guy who animated him—Fleischer—to take the pen away from him and say, "You're not going to animate me anymore; I'm animating myself." I guess I was sympathetic to Coco, growing up. And now, as a woman in America, I thought, "Fuck your images of women on MTV. This is really getting ugly. I'll animate myself."

I took the original Fleischer cartoon and cut it up a lot into very quick sequences. In this quick mini-narrative you see Fleischer drawing Coco. Then Coco looks up and there's a machine drawing a woman for him—he has to have a woman; I don't blame him! He looks up and gets excited looking at the image of the woman. But the machine has an erase-arm, and it erases her, and he gets very upset.

For a fraction of my piece, I decided to go back to the kind of animation that originally in America was really strong, cel animation. Like I said, everyone was looking for the newest digital effect—people would be sitting there wasting a fortune trying to make MTV videos that looked like scratched film. They would make beautiful images in camera, and then they'd get someone in post-production to put in the scratches for $1,000 an hour. So I thought, "I'm using cel animation. We're redrawing Fleischer using his own devices." I found someone who did illustrations for his studio in the forties. In my piece, the kiss that the woman blows to Coco becomes an MTV logo. It lands on his crotch; he falls out of the frame. And at the end you see a woman animator trying to make a new image, with Fleischer already in her video palette. Already history has become just a piece of digital information.

HUO: What was the second MTV project?

DB: The Whitney Museum of American Art, the American Center in Paris, and the Public Art Fund in New York came to me and said that I was one of seven people they picked to work with video imagery, and that they would be able to give me some money to create a piece that would be shown on MTV. This project was called TRANSVOICES, and my piece was called *Transgressions*. Now the year was 1992. You have a five-year difference between these two commissioned works. A further difference was that I got twice as much time, sixty seconds instead of thirty seconds, and far less than half as much money. It was very funny. In 1987 there was no limit to the budget—MTV went anywhere they wanted to go. By 1992 I was offered what was really, as an artist using this kind of medium, almost no money.

The spots were created to be part of a dialogue between the U.S. and France, so they were also shown on Canal Plus, in France. The subject was, "Where are you now, in 1992?" For the United States, it was a celebration of the five-hundredth anniversary of Christopher Columbus's discovery of America, and in France you had the beginnings of the formation of the European Union. The E.U. didn't get together in 1992, and if you're a little wise, you know that it's perverse to say that Christopher Columbus discovered America.

My piece *Transgressions* shows mappings of the growth of the United States and France, with everything in transition. And you know from Paul Virilio, as I do (because I know we both read his books) that today we deal with boundaries that

are much less visible. Later this idea became part of *Four Gates for St. Pölten*, a work I was commissioned to make for the new capital of Lower Austria, which is scheduled to open on May 31, 1996. And I thought, "I'm going to find St. Pölten all the way back, historically." I even found it on the old Roman road; it was there that early on. I want to make a work that will allow someone to travel through the previous spaces and times of that now "new" government complex to see the constant fluidity of what we have called and made as boundaries.

HUO: Maybe as a last point it would be interesting if you talked a little bit about your *Tiananmen Square: Break-In Transmission* (1990) and *Transmission Tower: Sentinel*, to which you alluded earlier.

DB: *Tiananmen Square: Break-In Transmission* came after *Rio Videowall*. In *Rio*, we have this television box as one of twenty-five units. Thus you could symbolically relate the box to a pixel as well as a TV: microcosm and macrocosm. The television image now breaks through its "frame." Previously the image was contained within an individual box, an individuated frame; now the image was being pushed out into a multiframe matrix, stretching past its previous boundaries.

For *Tiananmen Square*, it was almost the opposite. I made very small boxes, a landscape of imagery formed by LCD monitors, which present an image that you can see only frontally, and if you go to the side, it ghosts out. That's the mechanics of it. At first you see the small monitors as if they were lights hanging from the ceiling, as if information is coming down at you—it's not putting video work on a pedestal. I think I had the impulse to hang it like this because the feeling was already, as it was with *Transmission Tower*, that the information is coming from out there. At first museums and institutions chose to contextualize video by building a platform for it, a base for a sculptural event. You turn the monitor on, you see the image. But here it was coming like lights—I thought they had to be small and similar to utility lights. At a distance you only see light. Only when you come closer do you see image. Given this necessary proximity of the viewer, he/she has to travel through that space to see many small images.

There is, from my point of view, no "eyewitness news." A slogan from Channel 7 in New York, ABC, one of the biggest networks in the United States, goes "We bring you Eyewitness News." No, you bring to me, obviously, a mediated portion of news. So here you would more appropriately say ABC's version of the news of Tiananmen Square. They own that news; you have to buy it from them. If you go and say, "I really want to do this work and re-represent the news," they say, "Oh, who will you make it for? Will you make it for the State of New York? Then we will

charge you one rate per minute. Will you make it for the whole of the United States? Oh, you also want to go to Europe? Which countries?" You even have a rate now for the cosmos, for the universe. The networks already know where this is all going. I think the most important thing for me in my work has been to uncover the mechanism of television, to question it, and then to look at this larger mechanism developing—the communication, the networking. Television has projected itself into space already. In the United States there's some good science fiction about what happens when it goes out there. *Wonder Woman*, you know, will eventually reach someone on a distant planet who will see the show in a different time and space than our own. So I think with the work *Tiananmen Square*, it was to say, "You've made an awfully large image of this event for me on TV." I have to deal with that size, and with the fact that there's really no unity in that image.

HUO: So in *Tiananmen Square: Break-In Transmission*, you show different views of the events?

DB: Different views, from a "garagey" song composed by the students, "The Wound of History," to the exact moment—which for me was a very important moment in the history of television—when CNN and CBS were taken off the air, when they were told, "You will cease to exist in this way." The Chinese government shut down satellite transmissions, knowing that they would eventually crack down on the students. The major networks knew that any minute these demonstrations would go violent. That's what everyone was waiting for, the rupture. Dan Rather is there. They have the image of him, headphones on, a big satellite dish in the background. What he's hearing in his headphones is, "They just broke off transmission of CNN." And he's hearing from their field reporters, "We're getting the first images of violence, of the police cracking down on people." At CNN's headquarters when I show you that imagery, re-represent it, you see that in the newsroom, when the government comes in to stop the broadcast, the news team tries to push the government representatives back out; they're trying physically to say, "No, what are you doing? You can't stop us!" At CBS, Rather makes it a diplomatic moment. He stalls. He says to the government as they come in, "I'm sorry, I don't understand. Oh, you need to shut us down." What he's doing is buying time. He bought one-sixteenth of a second or so, just enough time to get out the first images of violence, to audiences worldwide. That's my interest—to look at historic moments and how they affect us. I think I want to leave behind a kind of totem. I want to leave behind pieces of the history of this crazy, industrialized telecommunications system that affects all of us. Maybe it's the telecommunications that are making the envelope-like membrane we were talking about earlier.

HUO: I thought *Tiananmen Square* is also like a *parcours*, but a *parcours* where there isn't any given path. It's a *parcours* where every viewer finds her or his own path.

DB: That is true. Each viewer can find the images he or she wishes to look at. But dominating the small images—the loops—there is a large monitor in the background, and there is a surveillance switcher. The surveillance switcher is going around the room, taking grabs from these small images and randomly putting them up on the large monitor. So if you're viewing an image, that image may be taken by the surveillance switcher. It can be taken away from you and all of a sudden put on to the large monitor, as TV. The work is about control. When are you in control of your own representation, or when is it out of your control? Do you have the ability to control it?

Even going back to 1979, *Kiss the Girls: Make Them Cry* shows women presenting themselves—they're plugged into a grid structure, a tic-tac-toe board. I very purposely used these images of women and emphasized their stereotypes, so as to look at those clichés: a blonde, a brunette, a young girl, a redhead. Each woman makes a different gesture that you see clearly because I've dislocated it and repeated it; you can see how they're fighting to find an identity that gets beyond the stereotype. How do you introduce yourself to an audience of millions? What becomes your identity? Does it lie in the smallest nuance of gesture? And now we are entering into the World Wide Web. If Nam June Paik would say, "Ah, video, very good, no gravity," now you have no identity. You make your identity, right? "Well, I think I'll be Laura today! This is great, I can live out my fantasies in a good way." But already, the first case of a man stalking a woman on the internet appeared in the news a few months ago. Can you make a legal judgment on that? "Stop him, he's stalking me"? Can you rape in that system? I guess maybe there's been evolving crisis of identity in this highly technocratic society. And I knew this from the very beginning, from *Wonder Woman*, where there was a very technocratic view of a woman. You either heroicize her or you underrate her as a secretary. And what place did you ever create for me? Where am I between the two? The burst of light said that I'm a secretary, I'm a Wonder Woman, I'm a secretary, I'm a Wonder Woman, and there's nothing in-between. And the in-between is the reality we need to live in.

This interview as published here was edited directly from the original English-language transcript. It has previously been published in German, in *Dara Birnbaum* (Vienna: Kunsthalle Wien, 1995), pp. 44–64; this German version was retranslated into English and published as "Dara Birnbaum: An Interview by Hans Ulrich Obrist," in *Art Recollection, Artists' Interviews and Statements in the Nineties*, ed. Gabriele Detterer (Florence, Italy: Danilo Montanari & Exit & Zona Archives Editori, 1997), pp. 34–46.

TELEPHONE CONVERSATION

HANS ULRICH OBRIST—DARA BIRNBAUM

VIENNA, APRIL 22, 2008

HANS ULRICH OBRIST (HUO): Our work together has evolved ever since we met fifteen years ago. Coincidentally, that was in Belgium, so it's amazing we're doing this interview in Ghent exactly thirteen years after the first interview we did in 1995. At that time, we were working on *Robert Walser, Translated* (1994/2005) and now it's this book project, *Formulas for Now*. Could you talk a little bit about your project for *Formula, Formula One/F1* (2008).

DARA BIRNBAUM (DB): I think whenever you've approached me, Hans Ulrich, whether for books or exhibitions, your projects have always been thematic, and they are not the places I would normally go to for my work. The themes are almost always a surprise for me, and I always get a double reaction to being asked to contribute to a theme that you've "formulated." When you proposed "Do It!" (E-Flux/Revolver, 2005), I finally realized that, though we've known each other for a long time, there is a bit of an age gap, and that "do it" for you is something different from "do it" for me. My direct reference is Jerry Rubin, not Nike. So I felt like sometimes I had to stop you and say, "OK, you can relate it to Nike and anything else you want." It's another way of saying "do it," and it is good because it gets my speed up. But I'm a child who grew up with Jerry Rubin and Abbie Hoffman saying "Do it"—be a child of Amerika.

What I like is that you always fight for me, supporting whatever I want to do. You allow me whatever statement, reaction, and creation that I want to make. With *Formula*, I have had the same reactions—OK, what do you mean you want me to react to this term *formula*, and why is it so important to bring it up now? I think you make me fight but in a good way, and so I am always ready to turn another corner with you. I decided that I'm going to take the first formula that comes to mind, Formula 1, which is race-car driving, and I thought of how we had talked about speed. What is Formula 1? What does it mean?

Why does speed become so important? There's of course the analogy to the cultures, as well. I took up Formula 1 race car driving at a specific, politically right time, when North

Korea had opened up to being a country that would have that race, which I thought was very odd. In 2008 North Korea announced that they would host their own Formula 1 Grand Prix. As you know, I'm always interested in trying to insert something that's about a contemporary position, one that usually has political overtones or inferences.

HUO: It ties in with another project we worked on together, Media_City Seoul [2000 Seoul Biennial]. This exhibition I curated responded to the incredible ubiquity of moving-image work in Asia. Not only did we place little screens in elevators but also these very large-scale screens in public spaces, which are almost like those at a drive-in cinema. We basically infiltrated the environment with a multitude of video clips, and for that you developed a special project that was related to the North Korean-South Korean issue.

DB: I seem to be stuck on North Korea. Maybe it's because I'm so irritated by what my government voices against these enemies that have been placed in the "Axis of Evil."

There were at least three parts to that biennial, I remember. The first part was the curating you did outside the museum, on the large electronic billboards on the buildings in downtown Seoul. The second part was curated by Barbara London and Jeremy Miller inside the Seoul Museum of Art. And the third part, I believe, was by the Korean curator Byoung-Hak Ryu, who asked artists to place works in the subway system. Exhibitions have used electronic billboards elsewhere; in Times Square, the Spectacolor board has been going for about twenty years. But even coming from a city like New York, I was amazed that you got to use forty downtown electronic billboards. I remember standing with Jeff Preiss and being able to look at works by different artists on about five of the billboards simultaneously.

The moment that you approached me was a time when there seemed to be a political opening between North and South Korea. A few families from North Korea had actually been allowed to visit the south. And my hope has always been that a kind of truce can be declared rather than the kind of politics

Photograph shot directly off television screen by Birnbaum, c. 1977.

that Bush has displayed in the last several years. So I wanted to celebrate that moment, which seemed more open to negotiations. I took the flag of South Korea, which is made of trigrams, and the yin-yang symbol against a background of white purity, and I playfully used motion graphics, spinning the trigrams around as if you were throwing them to form a hexagram of the *I Ching*. Each one of the formed hexagrams points the way to peace or unity. In the end, the two eyes of the yin and yang become the flags of North and South Korea and cross each other, even for a moment sit on top of each other.

What I enjoyed is that you, Hans Ulrich, created a way of commissioning an artist. . . . There wasn't a lot of money, but it was enough to help to create the work. And I was so grateful to be able to be in this position with one of my works, outside of the museum in open public space. I remember there was a storm, and the electricity went out in the museum, and that, as an installation artist who basically does video installation, I was so glad not to be in the museum—though I did later learn from the director of the museum that my piece had to come down.

HUO: But it was there for some time.

DB: At least a couple of works were pulled down. One of them, as you would know, was made by a South Korean woman, Song Il-gon, who had made a work about an aborted fetus in a bathroom based on a real news story. When I saw that one, it really moved me. And I remember thinking that it wouldn't have made it up in New York on the Spectacolor board; I was amazed it got through in South Korea. I remember showing the work I made, *taegukki no. 1, taegukki no. 2* (2000), to Kaspar König, and he was very interested in it, but he said, "Don't you think it will be somewhat controversial?" At that point, I hadn't gotten any feedback—that's OK; that happens a lot with media work, which is usually shown from a distance. I said, "I haven't heard anything." But then I heard later, when I was in France, that the work had to be taken down. I don't consider that bad at all. It is just the reaction that occurred.

HUO: But Seoul was not the first time you took your work into contexts other than the gallery—think about your *New Music Shorts* (1981), and the very early moment when you went into television. And *Technology/Transformation: Wonder Woman* (1978–79), as we discussed in our 1995 interview, was not originally shown in a gallery but instead in a shop, so this idea of going into circuits beyond the gallery is something present even in your early work.

DB: At the time of *Wonder Woman*, I didn't care about galleries. When I entered into the gallery world, in fact, I felt that they were a little conservative (and I may still feel the same). I had the luxury of being able to insert things in different ways and in different contexts. I think that is partly because of the youthful spirit at that time, around 1975. There was a basic mistrust of the galleries, and also many galleries weren't taking on younger artists in New York City. Also, the way they were dealing with media was a little conservative. Not that they weren't showing very good work, like Bruce Nauman, but the thrill for people like myself, Jenny Holzer, and Barbara Kruger, at the time, was to escape not only the commercial galleries but even the alternative galleries. They very quickly got boring because they lacked the dynamics that we wanted to see brought to the works and statements in a more public sphere.

HUO: I'd like to speak about the very beginning, by which I mean your first exhibition. I was rereading the wonderful catalogue from Le Consortium, the early catalogue of your work from Europe [*Dara Birnbaum, Succès du bedac* no. 10, 1986]. It started with *(A)Drift of Politics: Two Women Are Active in a Space*, which is a 1978 work. Your first exhibition took place a year before that at Artists Space in New York—showing *Lesson Plans (To Keep the Revolution Alive)* (1977)—and you used not video but photos taken from television programs.

DB: Actually, Artists Space didn't want to give me a show after they reviewed my work. But a woman they did want to show, Suzanne Kuffler, whom I'd been working with, wanted me to exhibit with her. So it was really through Suzanne's demand

that I got my first show at Artists Space. I didn't know what that show would be, but I had been reading a lot of semiotics for cinema, and Dan Graham had introduced me to *Screen* magazine. I could not understand why a magazine like *Screen*, from England, would be analyzing film language from the United States' past, especially film noir. My feeling was the approach was wrong. What really needed to be talked about was the language of television, because that was the contemporary language of the U.S. and many other technologically advanced countries. The Nielsen ratings at that time, in the mid-1970s, said that the average American was watching television seven hours and twenty minutes a day. That's what I felt I had to go after.

HUO: What is interesting is that already there you are making a political work. What else was your inspiration, your oxygen, at that time?

DB: The truth is, I came from architecture, in particular environmental design. I worked in San Francisco with Lawrence Halprin & Associates.

HUO: What year was this?

DB: I started to live in Berkeley and San Francisco in 1970 and immediately went to work for Lawrence Halprin, but it was for less than two years, around 1971–72. We felt that we were the first environmental-design firm in the United States. And what that meant to me—I was very young at the time—was that we looked at the work we were commissioned to do not only as architecture, and we didn't want to introduce any kind of monumentality; instead, we tried to see into a town or city as a community and spatial environment. We would immediately try to involve the public, those people from the community who were going to be affected by our design. I was very glad that sometimes our conclusion was in fact to try to deter people from building rather than to build. And at the same time I was reading the Italian architect, historian, and critic Manfredo Tafuri, who stated that he felt television was the real architecture of the time. And that hit me very hard. In the workshops I was doing with Lawrence, there was a lot of video being used, mainly for documentation. Later this material was mostly vaulted, almost buried. And I asked Larry why, instead of vaulting it, couldn't we use it to converse with the public. But we didn't. This was my first real encounter with video being employed as a documentary tool, where I could observe firsthand the importance of its use within the workshops we led, as well as to record our activities with the communities, those for whom we were designing. I thought this kind of recording was vital and that we should use and engage the footage more and keep it active.

HUO: Last year [2007] I went to see Lawrence and Anna Halprin at their house and did a long interview with them. They remember your time there very well. The Halprins have been an extraordinary inspiration for generations of artists: they were significant for Yvonne Rainer, Simone Forti, and Bruce Nauman, and for you, all in different ways. Obviously with Rainer and Forti it had to do with dance. I think with you it probably had more to do with this link to the city. To what extent were they mentors for you? What did you learn from them?

DB: I had started architecture at a very young age. Sixteen—that was the youngest age for anyone ever admitted into the architecture program at Carnegie Mellon. When I graduated, the dean shook my hand and said, "Never again." I was very, very idealistic; I didn't really know until I graduated that I was the only woman in my class. Over the summers, I had been assisting in designing huge high-rises in New York, getting some experience. I was also completely fascinated, just to be honest, with the glass-curtain walls that had been developing out of Skidmore, Owings, & Merrill, and with a kind of flatness that could be achieved through the technical details of these kinds of buildings with mirror-glass facades. I also did work on the World Trade Center. That came back to me as I watched them collapse.

In my early architectural experience, I got very disillusioned—I was looking for something to believe in. I got a book out of a library by Lawrence Halprin, whom I wasn't familiar with. It was a book that was very much related to the pedestrian in the city. He took into account small details, the things that make a city livable, such as the covers of the gas mains and other details that have meaning to someone who's walking through the city. I was still only about twenty-one, and it was a positive change for me to look at things that way, because I had gone through a school of architecture that was much more about making singular, monumental design. I looked up Halprin, and I realized that firm was going toward something that was eventually to be considered "environmental design." I realized that this was what I was interested in, so I tried to get a job there. I wanted to be in their West Coast office, and I remember during my interview saying things like, "I am very interested in what you do, and even if I don't get the job, I want to clean up the San Francisco Bay. I would do it with my own hands."

What I had in common with Halprin was the attention to those small moments, details, movements that make and describe a space. The approach is related to the idea that a space is not only formulated by an interiorized position but from a position of the street. Being *of* the street was actually a very political position at that time. Any leftist political position, or radicalism, was shown through action in the street. One of my jobs was, for example, for Everett,

Washington, a city outside Seattle. I would go up there—I was twenty-two then—and form a workshop group. I was allowed to pick whomever I wanted to represent the community. That meant that I would maybe choose someone from the junior college but also someone who was a politician—people who had lived in that city and knew that space intimately. We would have workshops that would explore what the city was and how one moved through it. We would do it by air, by sea, and by foot. In a way, it was like what Anna Halprin was doing and discovering at that same time in her work in dance. It was the vibrancy of the movement in the city. So we were both exploring the pacing, the feeling, the different ways that one could approach traversing urban space.

HUO: This experience was obviously important, but I wonder what your other inspirations were at that time? To what extent were the Russians of the early twentieth-century avant-garde, in integrating propaganda into their practice, important for you? And what about the New York art world of previous generations? What were some of your other "toolboxes"?

DB: There are separate toolboxes. Because, on the one hand with Lawrence Halprin, it was fulfilling to feel that my idealistic view could be a view of reality. And as I said, instead of building, we sometimes chose to advise our clients not to build. The range of planning was not to make an immediate mark on an area and use that as a landmark but to have plans that read into the future. So immediate impact was balanced by the future impact of a five-year, twenty-five-year, hundred-year plan.

As for the art that appealed to me, I was growing up with Pop art in New York City. That was what did affect me, and maybe in a sense that was where I took that turn to objects from and/or generated for popular culture. The first show that I remember seeing in New York, when I was still a kid, begging my mother and going with a friend, was my introduction to Roy Lichtenstein, Andy Warhol, and even Jules Olitski. It was the era of the Brillo boxes and Campbell's soup cans by Warhol. It was the era of Lichtenstein's redoing Monet's haystacks.

I didn't get really involved in the arts until I came back from Italy, though, in about 1975. It was through that strange fact of being in Florence, a very small city where somehow something was happening, and I was there at the right moment. My time there exposed me to Vito Acconci, Dennis Oppenheim, Dan Graham, and many other people. By fate or accident, I found the Centro Diffusione Grafica there, run by Maria Gloria Bicocchi. Maria Gloria was one of the first people who got interested in video and would tell artists, while they were there, "Why don't you try to make a videotape?" That was the first air of the medium that I

breathed. The works that everyone made were later written about by David Ross. Eventually the gallery changed its name to Art Tapes 22. But all this very early tape work was being done there by Acconci, Joan Jonas, and perhaps even by Dick Landry. This was incredible to see. When I went back to New York, someone lent me a Portapak, and I just started. I was very naive and very open, and that can be a good thing.

HUO: You've said in a previous conversation with Nicolás Guagnini in *Cabinet* magazine that there were two distinctive developments for you with regard to video. There was the camera body-monitor movement with Nauman and Acconci, and then there was this other area of development, the alternative forms of approach to broadcast television.

DB: I used to call this the double root of video art. It wasn't only coming from a root in the arts, like Land art and Body art, but also from a second root that should be equally paid attention to and made use of, and that was television. That also extended to what would become cable television, which a lot of people from my own generation would use. So you would get, for example, documentaries like those by Jon Alpert. I think that my generation tried to bring together both aspects of video: art and television.

HUO: So it's almost both/and instead of either/or.

One fundamental dialogue you've had, one that has lasted ever since you two met, is your conversation with Dan Graham. I was wondering when it started and if you could talk a little bit about it.

DB: Again, it is a little strange. It's like, how did I first show at Artists Space? There is no direct line. As I mentioned, Dan had been one of the artists coming through the gallery Centro Diffusione Grafica. I met many artists there because it was a place I hung out at. I was so interested in what they were doing; I had so much energy, and I think that gave them energy. I don't think I would have met them in New York as easily. Dan Graham came through, and he was, I believe, taken to Maria Gloria's country house. We never met in Florence, but when the people I knew came back from her country home, they said, "This is an artist you would really like—he is as serious as you are." He didn't want to eat and have big dinners. He just wanted to work. People thought the two of us would get along. That's all I knew of him, though I had seen one of his early pieces at the San Francisco Art Institute's gallery, and I recognized the name. We met later when I came back to New York, in 1976, when I joined a group of younger artists who were getting work out basically through alternative spaces. The group had two or three older members, and one of them was Dan. We still did not talk much at that point.

Photograph shot directly off television screen by Birnbaum, c. 1977.

Another member of the group was Lee Lozano. Dan and Lee had been very close, and at the time she was in the middle of making an artwork, which I totally did not understand; I did not come from that background. What I did know was that she was a very bright woman who refused to speak to me. It was like nothing I had ever encountered in my life. Every time I would speak, she would turn to speak to a man, and this hurt me immensely. Finally I went over to her and said, "I'd like to know why you're not speaking to me." She did speak then, and she said, "I am doing a work, and I don't speak to women." I said, "Well, you just did." There were things I did not understand at all.

Dan was slightly removed, but it was that group that brought us together for the first time. We were in a show together in Scott Billingsley's loft. (Lee Lozano was living with Scott.) I was very excited about that show. It was the first real piece I had ever done.

HUO: Can you tell me about this piece?

DB: It was called *Back Piece* (1975) and consisted of two juxtaposed sets of slides. One set of slides was simply of the loft we were exhibiting in, before the works had been installed in it. With the empty architecture of the loft, and at right angles to it, were slides of my hand putting down still pictures of the past, of where I had been the year before—I had just come back from living in Europe, remember. Together they formed a kind of collage, bringing the past into the present. And the piece had an audio track that dealt with personality types, from Carl Jung. Within the space, you can see the space's recent past replaced by the more distant past, in the sense of a distant memory. I can now relate this to another work, like the *Rio Videowall* (1989), where there is a memory of a space that reemerges as an electronic memory. I don't think it is that different. Or there is the work based on Arnold Schoenberg's opera *Erwartung* [*Erwartung/Expectancy* was first produced as an outdoor projection in 1995], in which I took Schoenberg's drawing for the stage set and had it reappear through digital means.

I've recently been going through my archives, and it's actually been painful to look at the past. Some of the things in there I purposely put into drawers that I never opened again. But it is very good to see some of the later works in a similar light to that first one, which I never talk about to anyone. *Attack Piece* (1975), also an early work, was salvaged by Electronic Arts Intermix, who asked me, "Is there anything you did that we can preserve? We have a grant for preservation, and we're looking for the earliest works by artists like yourself." And these works I kept very, very private, but I allowed EAI to take them out and get the work off those open reels and save it, and other early single-channel works, such as *Control Piece* (1975), *Mirroring* (1975), and *Pivot: Turning Around Suppositions* (1976), among others. While they were doing the preservation, they looked at *Attack Piece* and said, "My God, this has to be shown." Now it's been bought for the permanent collection of the Museum of Contemporary Art in Barcelona [MACBA] and also by Pamela and Richard Kramlich, for their private collection. Recently they bequeathed the work to be jointly owned by the San Francisco Museum of Modern Art and Tate Modern, through the New Art Trust. So I am quite amazed by the strength that these early works have.

HUO: It's so interesting to see retrospective and memory as a dynamic process and not a nostalgic or static process. In your work of the late 1970s—for example, *Kiss the Girls: Make Them Cry* (1979)—there's this idea of using appropriated images from game shows and other popular television shows. What's changed enormously since we did our first interview in 1995 is that now, in 2008, many, many young artists are working in what's almost an orgy of appropriation, but you were using this sort of method years earlier. I wondered where it started and how it happened. There were artists in the 1970s who were working with appropriation in many different ways: appropriation of found images, of television. I was wondering if you could tell me more about the beginnings of appropriation as part of your practice.

DB: Growing up in New York, with Pop art and Warhol, I saw and assimilated a degree of appropriation early—the Campbell's soup cans, for example, as I mentioned earlier, were an important part of my initial exposure to art. But television was the landscape that my generation grew up with, and I feel that an artist can always comment on their landscape. Video started to be used as an art form in about 1965 by Nam June Paik and a few others. It was there in place for me, in light of the Portapak, in the mid-1970s when I started. My work quickly started to appropriate directly from TV. At that time, there was no direct access to television imagery as there is today. There was nothing coming through the computer either, obviously. We had no means of recording television or taking it off the air. That's why the work from the first show at Artists Space was made by shooting a camera at the TV, getting what were in essence video stills from these programs and putting these stills on the gallery walls in sequence. By the second show, "(A)Drift of Politics," I was finding people in the television industry and also the first small production houses who had tuners and therefore could get taped versions of TV shows for me. There was a place in New York called Exploring Post No. 1, owned by Ted Estabrook. He believed in my work. He had a tuner that could get these TV programs off the air and down on to tape. The other way of doing it was through CBS and NBC, but I had to make friends with people of my age on the inside who were working and willing to take the risk to get it off from their own feeds. I also thought it was extremely important not to shift media, that the medium had to be used on itself. My taking of images directly from television was the most important difference between myself and other artists of the generation I was growing up with— Jack Goldstein, Cindy Sherman, Sherrie Levine, New Image people . . .

HUO: Richard Prince . . .

DB: Yes—people who would take images that related to the space of media. That was the thing for Goldstein, and, after him, Robert Longo. Paik had called this the "anti-gravitational space of media." This is what had to be explored. And the most important thing was to take the images out of their flow or their original context and to change their syntax. I learned this through Christian Metz and film-language semiotics but chose to relate it to the language of television. The work I showed at Artists Space, which was expressed in still photography, took a very structuralist approach: for each night of the week I selected a prime-time television program, and I found that pretty much all of them were crime dramas. The most common shot I saw used was the reverse-angle-shot. So I took five exemplary programs and used a typical reverse-angle shot sequence from each. Each still image that I used was then accompanied by a matching text panel, where what

was being said at that moment is spelled out for the viewer. *Laverne & Shirley*, on the other hand, was a situation comedy, with two women having to face the world together. That paralleled what I was doing with the woman I spoke about earlier, Suzanne Kuffler. We were presenting our works together, at the Kitchen and Franklin Furnace. For sitcoms, the typical shot was the two-shot: two women in the same frame facing the audience.

HUO: That obviously leads us to pieces like *Local TV News Analysis for Cable Television* (made in collaboration with Dan Graham, 1980) for cable television but also *New Music Shorts* (1981). There you had the idea of bringing music performance and video together, even if it wasn't for commercial distribution. It was another seminal piece, much quoted now by younger artists.

DB: What I loved as a young artist in the mid- to late 1970s was that there were many great crossovers, as with music. I felt that in video then there was a complete feeling of collaboration. It was much friendlier than what is happening now, decades later. Many of my peers—artists, musicians, and performers—were already getting to be known, like Eric Bogosian, Mike Smith, Y Pants with Barbara Ess. All of them, who were performing in places like CBGB, remained relatively independent. But soon their images were *virtually* being taken away from them, and various labels were attempting to co-opt them. When Y Pants performed at the Peppermint Lounge, they couldn't even get their own images back from the Peppermint Lounge! A few of us were trying to document the scene at that time, and, having my own video camera, I felt like a real comrade with them. I would help fight, either to get their own images back to them or especially by doing recordings for them.

When it came to the form of *New Music Shorts*, I think that, by then, my generation had discovered that there were two important components of video—not only the visual image but also the audio. "White noise" was happening in music at that time—Glenn Branca, for example. Dan Graham wanted to shoot a performance that Glenn was doing at the Performing Garage, *Symphony No. 1* (1981). Dan couldn't handle it alone, so I went with him to set it up and help. It was supposed to look like a Clash video that Dan had seen. Then Glenn decided at one point that he wasn't going to do anything that was needed to assist our recording the event, so the taping got nowhere, in the sense of the original project. But I took moments that I had gotten on my own and started to edit. I was trying to show two images at once, frame within frame. But this was predigital, and through analog means the effect was nearly impossible to achieve. But for both of the *New Music Shorts* videos—one was with the group Radio Fire Fight and the other was Branca's *Symphony*

No. 1—I managed to insert secondary images into the standard frame. The two images were to tell two different aspects of the same story, give two different vantage points. *Symphony No. 1*, for example, was Glenn producing this incredible sound. At that time, no one had heard anything like it; the vibration of it went through one's body. While he was performing, outside there was a thunderstorm, which gives a similar but also an entirely different feeling. This juxtaposition for me was very strong. The tape actually generated a lot of interest. The other part of *New Music Shorts* featured a group that was less well known, Radio Fire Fight. Here I combined, within the same frame, the moments on stage with the audience looking at the same moment—the "reaction shot."

At that time, the only sizable record store that was selling a lot of independent labels was in SoHo, on Grand Street. I put "samples" of Branca, Radio Fire Fight, and other downtown groups in this window, as if they already had labels and were packaged for sale, and available, because you knew that by tomorrow they would be. I made a big promotional poster, too. Many downtown groups would actually plaster the wall below with their own posters, like graffiti. I had a lot of fun with that store. The great thing was that, occupying the corner window on the street level, you would see these groups playing, repeated over and over.

HUO: That's so exciting to hear about, because it's a practically unknown piece.

DB: Yeah, we should get that one out as well, because it documents a really important moment. You can see a real shift that occurred. I think that I am good at having my finger on the pulse of what is happening within a culture.

HUO: One could call it a habitual presentiment or an anticipation of things that later become much more prevalent.

Another pioneering aspect of your work is its relationship to installation. In 1984, with *Damnation of Faust*, you developed your work into a sort of a spatial installation, which was unusual for the time (though now, in 2008, video installation is everywhere). Already in 1984 you'd started in a nonlinear way to give video a spatial presence by combining video installation and large-scale photographic elements on the walls. Could you talk a little bit about how this vision came to you so early? I'd also like to ask you about exhibition and display features. On the one hand, your works push video into the viewing space and are the beginning of video installation, but at the same time they invent display features. Can you talk about how the idea of "spatializing" your work came to you and how you evolved through *Damnation of Faust* to many other pieces, for example, the groundbreaking *Erwartung/Expectancy* (1995/2001).

DB: Because of the televisual climate at the time, I was always thinking about the position of the viewer, whether it was in a living room or in a gallery—again, it is video's double root: art and television. When cable TV opened up, an artist had a potentially different kind of audience and time span. For instance, I was shown on *New Television*, which was supported by the public broadcast stations WNET, New York, and WGBH, Boston. So you could show work on TV, as well as through museums, galleries, and institutional spaces. In each case, the viewer is in a very different position, and thus there is a different ability for reflection in each situation. The great thing about having the moving image enter into a dynamic space is that you're dealing with flowing images in a different sense, that of patterning. That interests me a lot.

With *PM Magazine*, in 1982 at Documenta 7, I based the work on a TV program called *PM Magazine*, which was on during prime time and considered itself a new type of "news" program. What it was, though, was "entertainment news." Some of my early experimentation with installation came out of the fact that I did not know where I was going to be placed, literally, within that Documenta. I only knew I was the only "video artist" selected by Rudi Fuchs.

HUO: It was a very painting-dominated Documenta. A new spirit of painting—

DB: Absolutely! There was the "new expressionism" that reentered the discourse through Germany and Italy. I turned out to be the only "video artist" in it, beside Joan Jonas, whose work contained a monitor showing a single-channel video as a part of an installation, and General Idea, whose work included video. But that was it. I thought, "Oh my god, what am I going to do?!" I was scared, I was young, yet I had a tremendous belief in video as an artistic medium. And they refused to tell me where the piece would be situated. Well, that's tough for a media piece. What I did is design the most minimal kind of production stage set. I got a Speed-Rail system for piping and joints. And I fought for the piece to be shown out in the open, among the other artworks. I didn't want a separate dark space. I was totally against video being reduced to history film and cinematography.

HUO: You've always resisted the idea of having the video projector in the dark space, which became the golden frame of the 1990s.

DB: I can't take it. The art world feels like it's found a new situation for video, and all they've actually done is to go back to seeing video as film. I wouldn't mind that so much if they would recognize it. There is absolutely nothing new about a blown-up frame on to a projected wall. The idea for *PM Magazine* in Documenta 7 was that, no matter where they put me, I would make it work. And that's how I came to use the

matte color chroma-key blue, because at that time chroma-key blue was used for television production—in the studio. It meant that, through electronic color levels and switchers, that color blue could be replaced with any image, as on the TV news. The most familiar example, commercially, would be the weather map behind the weatherman. I thought I'd paint out my space that way in chroma-key blue at Documenta. Then I designed the work so that it fit into the Speed-Rail frame system, as if you were building a television production set, where everything could go up in a few minutes and come down in even less time. I chose industrial components, like Speed-Rail, which was lightweight but could support the monitors and the decks and everything else behind the blown-up enlargement of the mounted video still, which constituted the main "picture frame." So that way you could also put this picture—the large-scale sectioned photo enlargement and then the video images inserted within—on any wall, in almost the same way a preparator would hang a Neo-Expressionist painting. And it worked out all very, very well. The thing that made me feel best at Documenta 7 was seeing a lot of young people sit down on the floor to view the piece over and over again. They really watched this new medium, and they were not going into a spectacular and isolated space to view it. They were coming upon it the same way they would come upon the paintings that surrounded it.

HUO: And then how did your ideas about installation evolve after Documenta 7? In 1984, *Damnation of Faust*, which began as three single-channel videos, developed into more of a moving-image fresco, and then that took on another dimension. For the indoor version of *Erwartung/Expectancy*, in 2001, you used video projection on Plexiglas and also very complex sound.

DB: The *Damnation of Faust Trilogy* came about in the aftermath of *PM Magazine*. The installations, which emerged from the three single-channel video works, again referred to combining video with still photography and a "painted-out" space. As with Documenta 7, I could present my work in dialogue with painting and other, more conventional forms of art in group shows; it could be out in the open, in a way that didn't relegate it to a dark, isolated video-viewing space. *The Damnation of Faust* installation that was in the Whitney Biennial, in 1985, was the first large-scale video work that was to be presented in a main space usually occupied by painting, photography, and sculpture, out in the open with the other works. That meant a lot to me.

Compositionally, I wanted to have a freeze-frame from the video made into a mural-size picture that would serve as the ground for the video components. Dorine Mignot, the video and film curator at the Stedelijk Museum in Amsterdam, had first helped commission this installation in 1984, as part of a large group show titled "The Luminous Image." It was the first time that a major museum like the Stedelijk had shown so many media installations—twenty-two, I think. The show took the whole ground floor. When Dorine spoke to me during that exhibition, she said, "You know, I see the *Faust Trilogy* as a structure similar to a skeleton." The parts of the trilogy were, for her, like bones that were put together, the main experimental narrative that was in the work. But she saw the installation as the "marrow" of the bone.

HUO: Very nice! How would you say that this idea of the "marrow of the bone" has evolved? I've just been looking at length at *Erwartung*, which is a fascinating piece.

DB: That work exists in two forms. It was first commissioned by the Kunsthalle Wien for my retrospective in 1995–96. I am very fond of the way it was presented there. At the time, the large rear exterior wall of the museum was being used by artists selected by the Museum in Progress, such as Douglas Gordon or Christian Boltanski, so that they could hang what in essence was a large-scale painting, a mural, on that rear wall. I don't think there was one woman who presented work in that series. When I was offered the chance to make a new work commissioned by the Kunsthalle, I divided the money and made two works: an audio piece, *Bruckner: Symphony No. 5 in B-Dur* (1995) and *Erwartung*. I said to myself, "Well, if the back wall is occupied by the men's 'painting,' I want to occupy this exterior space, on the side wall, next to a pedestrian walkway." I took a sketch Schoenberg made for his opera *Erwartung*, the one I was most attracted to, which was like an oculus and also slightly like a vagina or womb. Especially since we were in Vienna, I wanted to let this man's *gesture*, his own sketch, stand as a bold statement during the day, in a digitally enlarged reproduction. It took up a major portion of that side wall.

Erwartung is a one-act opera, with only one woman in it, the main character. The libretto is by a woman, Marie Pappenheim, who was only twenty-seven at the time she wrote it. This was very rare. In both the music and the lyrics, there was the recognition of the concepts developing within Freud's circle in Vienna: the unconscious, the idea of fragmentation. The woman in the opera is in a dark forest, looking for her lost lover, who may or may not be dead. That lover is the *object* of her desire. The woman would be projected on to the Schoenberg sketch but only at night. We had a huge theatrical slide projector with PANI-slides that was placed within a built-in shelter on a platform. It was on an automatic timer, so that when dusk came the projector went on and the image of the woman occupied that stage, the Schoenberg set. So, very much like the work of mine that you included in the biennial in Seoul, *taegukki no. 1, taegukki no. 2*, it's a work of images without sound in a

public space. I also included typeset selections from the Pappenheim text within those projected frames. The text was written in 1909; here it is being re-presented one hundred years later, almost like a Hallmark card of passion. But, in fact, I thought some essential reality, or truth, lies behind some of these statements, which one might almost want to shrink from, since they are so raw. At sunset, the woman would disappear. It is similar to what happens in the opera because, as much as she is looking to bring things *to light*, into consciousness, when the light comes—the light that she has been praying for—everything dissolves, or disappears. One realizes that it's her desire, residing in her unconscious, that brings to life what she longs for, but in consciousness this can no longer exist.

A few years later, Marian Goodman saw my work at the San Francisco Museum of Modern Art ["Disrupture: Postmodern Media, Nam June Paik, Dara Birnbaum, and General Idea," 1997]. It was the first time she approached me with a proposal to show my "films" in her gallery. That was something I'd wanted for a long time, but I would never have approached her, and I didn't just want to *project* my video work against the wall of the gallery. Talking with her, when we got back to New York, I said that I had a relatively new work that I'd created for the Kunsthalle Wien for my retrospective there, and that I'd like to try to redesign it for a gallery space for an interiorized position. And I wanted to add sound to it. If she could help me with that, then I would love to present it with her. That's the way the second version of *Erwartung* was done. Marian helped by giving money for its execution, which took the Schoenberg sketch, now reproduced as a DuraClear print, and melded it to a Plexiglas screen composed in four sections. This was hung midroom, within the gallery space. The room became fully occupied with the imagery but by using only one projector—and this is a detail I love, because I still believe in an economy of means. The Plexiglas allows the light to both go through the Schoenberg drawings and also combine the image of the woman with this sketch, so that on the rear wall they can be seen together, wholly integrated, so that you cannot separate them visually. The woman resides on the Plexiglas screen as a ghost of herself. Throughout the seventeen "acts," the light is also cast off the Plexiglas surface and reflected on to the walls of the gallery space as ghostlike reflections. So you're surrounded by the imagery, and my feeling was that the viewer can become lost in a forest of images, very much the way the woman was lost in the forest in the opera itself. The music was developed with a very young DJ, Sean McBride, and he was able through a heavily compressed edit to create an "audioscape" by taking only about twenty seconds from the Schoenberg score that he felt were the essential elements of Schoenberg's music and recomposing them into a new score.

HUO: This brings us in a very interesting way to the present, because *Erwartung* was the newest piece in your most recent retrospective, which is when we did our last interview, in Vienna. Will there be new pieces in the exhibition in Belgium and Portugal?

DB: It is hard for me to talk about it for the moment. S.M.A.K. is trying to get the money together to commission something new. The work that's been on my mind is roughly based on another opera, Richard Strauss's *Woman without a Shadow—Die Frau ohne Schatten*. In this case, it's going to be abstracted, with the original functioning more as a touchstone. I still want to experiment with the qualities of light and dark in this work, with the dark being the *shadow's* essence. But I think this is hard to talk about. As with several of the single-channel videos, I will try to take the personal, and a sense of victimization and harassment, and show how this must also connect with a social consciousness. In a way, I'm hoping to work with what Strauss originally had conceived for *Woman without a Shadow*—a woman who could not project a shadow, a woman who could not extend herself—meaning by having children—and to extend this idea toward a sense of the *social*. The shadow is the side of the self that we cannot recognize. I've tried to address this feeling by collecting all the things that bury us—what you get through the internet, through the mail, all those things that come to us unwanted or unwarranted—advertisements, basically, strong and unasked-for suggestions of what I am supposed to buy in America. I'm sure it exists elsewhere—in Europe, everywhere. I've been collecting these images for about a year. I somehow want these images to deny "the woman" the ability to formulate the shadow that she needs, to achieve a fuller and complete identity. How I'm going to do it, how I'm going to edit it, I'm only figuring out right now.

HUO: One thing that I've asked you about before are unrealized projects. What projects do you have that have been too big to be realized, censored projects, regrets, forgotten projects self-censored projects? The unbuilt roads of Dara Birnbaum.

DB: *Wonder Woman* was actually part of a series I thought I might develop from among four television shows on the air in the mid-to late 1970s. In addition to *Wonder Woman*, there were *The Incredible Hulk*, *The Bionic Woman*, and *The Six Million Dollar Man*. At that time, many prime-time programs seemed to be about *transformation*. I was entranced by them. But the only work I went forward with was the prototype, *Wonder Woman*.

Then there were projects where I ran into difficulties. For example, I designed something for the Sony Corporation for their new headquarters in New York when they moved into a

midtown Philip Johnson building that had been AT&T's headquarters. I decided to try to make a work for the boardroom. The piece was to constantly update Sony's own imagery, screening their new product line but with a second set of images, which were composed of images describing the history of Sony, presented in a more experimental and "critical" way. I designed a truss that went from one wall to another that would go across and above the main corporate meeting room, where decisions were made for Sony. Let's say it's almost like a linear video wall, such as the sequential flow of images I used in *Transmission Tower: Sentinel* in Documenta 9 in 1992, where images would "fall." These Sony images would not "fall" but instead run along linear video walls and "collide" in the center of the truss through special effects I would devise. In this way, it would handle the history of the company versus its modern development. But the meetings I had with Sony kind of disturbed me. They had the idea that, as an artist and an independent video maker, I was really a diamond in the rough and that they could "polish" me and change my perspective. If I didn't cooperate in certain ways, for example, they could take that truss anyway, because *anyone* could design a truss, and on and on. This was all kind of hard business talk; I was used to some of it, actually, coming from architecture and from choosing to execute some of my video works in professional video houses. I got used to being able to "talk that talk," but I didn't want to "walk that walk." And so I walked out on the project. I don't have regrets about that.

I also ran into difficulties with a project I designed in 1992, which won a competition in Lower Austria, for a newly created government center in Sankt Pölten. I gave about three years to that work, *Four Gates*, trying to get it through according to its original concept. It would tell the history of Austria and was interactive. When the viewer came upon one of the gates, which contained a circular video screen within it, they would see the physical boundaries of the country, as mapped according to a specific historical date. Each gate reflected a different time period in Austria's history. But the presence of the viewer would also bring up an image of the military uniform that the Austrian soldiers wore at that time. For me, those army uniforms were another form of mapping, through the dress code of the army at the time they conquered territory or defended it. The Austrian administrators of the competition went with all that. The problem was that in the end, after the practical things we worked through, they did not like the way I told the history of Austria when it came to World War II, when of course the country was completely occupied by Germany. They wanted me to skip that period. I couldn't. The project was dropped, and they bought another work for the amount of money that they had already invested in *Four Gates*, the project that had actually won the competition.

One more "unbuilt project" was for the Spectacolor board, in Times Square. I was asked to do something; I was very glad to be able to do it. I got the time spot I wanted, which was December–January, the turning of the year. The year may have been 1986; I really don't remember. It was a time of changes in New York, when there was an impetus to "tidy up" Times Square. My idea was a countdown to the new year, but in decades. Every time I graphically put up the announcement of a new decade on the board—like 1986, then 1976, then 1966, all the way down to 1906—it was then superimposed with a numbered countdown: ten, nine, eight, seven . . . to zero—just the way the New Year is announced on that board and seen all over the world. Just below the Spectacolor board is the light sign that works as a running banner—and that used to be where people would read the news headlines from the *New York Times*; the announcement of the end of World War II occurred there. Of course, some of those things were invasions of different countries. I chose to display these announcements as well, which probably led to my work then being censored. The businessmen who support the sign and its advertising turned my project down. All that ended up out of it was an article in the *Village Voice*, regarding its being censored.

HUO: I also want to ask you about your archive. Gerhard Richter has his famous *Atlas*, and artists have many different sorts of archives. In Richter's case, his has become a work. You must have an extraordinary collection of images. How is your archive organized, and do you see it as a structured entity?

DB: I never choose to relate to it as a structured entity. I know that there are artists who take extraordinary care of their archives; they have an innate understanding of what their material can mean and how best to preserve it in order to hand it down or pass it on. But I think I just keep trying to be in the moment of what I'm doing. What I've discovered working with the two women helping to research and go through my archives for the book is that I've really buried things. It's like an archaeological dig. It's not been easy to pull them out. I hadn't given much thought to how they were kept. But I think the older I get, the more I realize that it is nice to allow them to have a voice in the future. We're finding an incredible image bank, both of things I made and things I collected.

You almost literally have to dust things off, and all of a sudden you recognize something. It has been very emotional for me. For example, we found one quite extraordinary small watercolor self-portrait on a tablet. It's nothing I could ever do today. I haven't painted for a long time. And to rediscover that part of myself comes with a whole mixture of emotions. It makes you find parts of yourself, some of which have been buried as well.

HUO: Great! That's a wonderful conclusion.

I have a very last question. I was recently looking at James Lipton's *Inside the Actors Studio* and all the interviews Lipton does end with his famous pivot questionnaire. So I wanted to end with a few questions from the pivot questionnaire.

What's your favorite word?

DB: No.

HUO: What's your least favorite word?

DB: Girl.

HUO: What turns you on?

DB: Animals, of all types.

HUO: What turns you off?

DB: Hypocrisy.

HUO: What sound or noise do you love?

DB: The wind.

HUO: What sound or noise do you hate?

DB: Talk without meaning, as at a casual cocktail party.

HUO: The moment we all waited for?

DB: Breath; clean breath, without pollution and without interruption, tension, or hostility.

HUO: What profession other than yours would you like to have practiced?

DB: I would have liked to have been an astronomer. Not astrology; astronomy.

HUO: Beautiful. And what profession other than yours would you not like to be?

DB: A bank teller.

HUO: And the last question. Al Pacino answered it with, "Rehearsal at three." The question is, If heaven exists, what would you like to hear God say when you arrive?

DB: Welcome!

DARA BIRNBAUM: ON THE RECEIVING END

JOHANNA BURTON

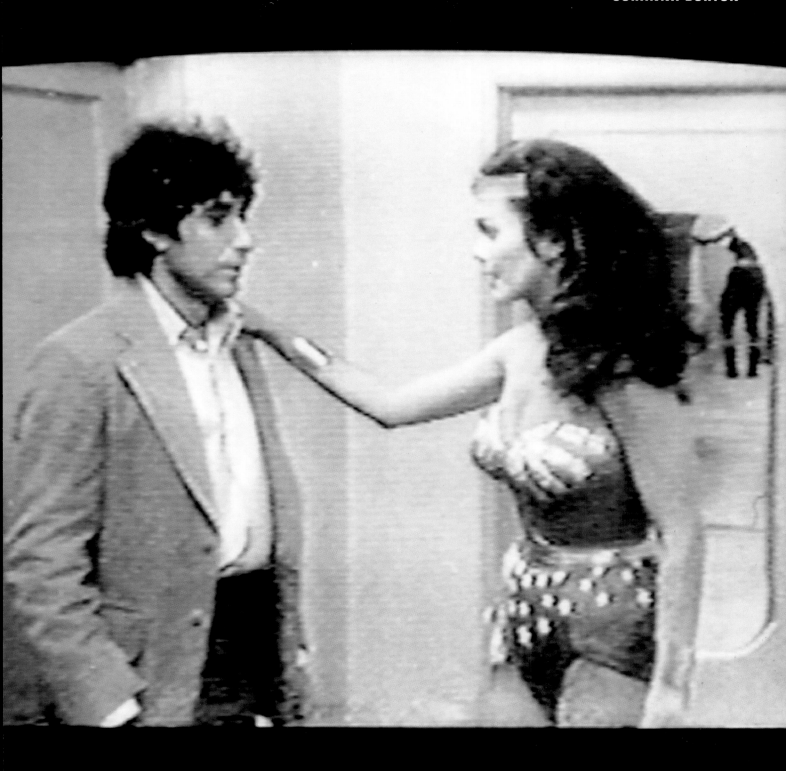

There is only one way left to escape the alienation of present-day society: to retreat ahead of it.

ROLAND BARTHES[1]

Two minor (i.e., personal) incidents, tangentially related. First: at the conclusion of a class I was teaching called "Appropriation and Its Discontents," I received a student paper that, within the scope of a broader argument, fleetingly mentioned Dara Birnbaum's now thirty-one-year-old video piece *Technology/Transformation: Wonder Woman* (1978–79). The author of the end-of-term essay described the seminal work as a feminist commentary on representations of women in the mass media. She then explained, incorrectly, that the video showed Birnbaum herself performing in the role of Wonder Woman, a popular television character from the late 1970s. Second: late-night channel surfing, a companion and I pause on a rerun of the contemporary American crime show *Law & Order* in order to contemplate a secondary character (nonetheless pivotal to the plot for being the morally depraved, highly cunning "older woman") whose face registers familiarly to us both but whose identity we initially have a hard time pinning down. The reference surfaces for us, suddenly, at the same time: "That's *Wonder Woman*! But what's her *name* again? Oh, yes, Linda Carter."

Perhaps making too much of these tandem confusions is unwise. After all, the mix-ups are straightforward enough. In the first case, a young woman too young to have *Wonder Woman* in her immediate cultural repertoire conflates an artist with an image utilized by that artist. In the second case, two viewers who came to television during *Wonder Woman*'s appearance there during the late 1970s (and the show's subsequent reruns over the next decade) cannot separate the character from the actress who once played her, nor—which is probably worse—are they able to imagine that woman *exceeding* the character she once played (which is to say, *outliving* it). Yet there is something more at stake in this neat bracket of mistakes, more anyway than the simple evidence of the workings of time marching on, leaving in its wake figments and fragments loosened from their primary contexts and thus increasingly scattered, hard to reckon. There is more at stake in this inability to *see*, or at any rate to *register*, the relationship between the then and the now: something telling about the way in which the precision of a moment and its most ubiquitous (if almost always only temporarily so) references are blunted—abstracted—as they course both forward and backward in time.

Contact sheet of photographs shot by Birmbaum directly from a recorded *Wonder Woman* television episode, 1978.

That such an array of blurriness can somehow attend what are in many ways merely the circumstantial details (because they are not exactly the content, after all) of one of Birnbaum's earliest well-known pieces has not, however, kept that piece from attaining solid iconicity. Indeed, stills from *Technology/Transformation: Wonder Woman* are called on time and again to represent Birnbaum's practice (on catalogue covers, in magazine articles), and the piece itself continues to be referred to as emblematic of a critical, deconstructive practice whose operations deeply impacted an entire generation of younger artists. To argue that it has been called upon to stand for its time (i.e., the America of the late 1970s and early 1980s, most generally, and recursive, conceptually based artworks responding to an ever-increasing spectacle culture, more particularly) wouldn't be too strong a claim. Yet, in this essay, I will argue that Birnbaum's is a practice of strategic persistence and adaptability, of which I will say more later (for now, let me borrow from Roland Barthes and characterize this as "retreating ahead"). Thus, to see *Technology/Transformation: Wonder Woman* as a time capsule, as a relic held steady and transparent in the resin of art history and/or cultural history, is to risk taking it for something we *know* and in some sense might comfortably view as *behind us*.

In September 1982, Benjamin H. D. Buchloh's influential essay "Allegorical Procedures: Appropriation and Montage in Contemporary Art" was published in *Artforum*.[2] Tracing a genealogy of the avant-garde, Buchloh begins with George Grosz and John Heartfield and moves through Marcel Duchamp, then extends his historical view to the likes of Marcel Broodthaers, Hans Haacke, Dan Graham, and Michael Asher. Buchloh's investigation closes with a discussion of a group of contemporary artists, notably all women. These artists—Jenny Holzer, Louise Lawler, Sherrie Levine, Martha Rosler, and Dara Birnbaum—are seen as carrying on a complex tradition of allegorical practice, one that closely resembles the workings of capitalism but, in redoubling its effects, undoes them. The shift from artists of the 1960s, such as Haacke, Asher, and Broodthaers, to the younger artists, including Birnbaum (a transition that Buchloh calls "paradigmatic"), hinges on the move from practices analyzing the "function of esthetic practice within the institutions of Modernism" to those paying attention to "the ideological discourses outside of that framework, which [condition] daily reality."[3] Given their reliance on the very structure they purport to undo, of course, Buchloh's take on contemporary allegorical procedures is that they are inherently fragile. Each artist's practice he describes may fall prey to a slightly different pitfall. Levine's operations, for instance, he argues, "might function ultimately in secret alliance with the static conditions of social life as they are reflected in an art practice that is concerned only with the work's commodity structure and the innovation of its product language." Rosler's practice "runs the risk of ignoring the structural specificities of the work's circulation form and distribution system, and of failing to integrate her work efficiently into the reception of current art practice, when the work's actual claim is in fact radical political awareness and change"; and Birnbaum's work "could integrate itself so successfully into the advanced technology and the linguistic perfection of governing television ideology that its original impulse of critical deconstruction could disappear in a perfect blending of a technocratic estheticization of art practice and the media's need to rejuvenate its looks and products by drawing from the esthetics of the avant-garde."[4]

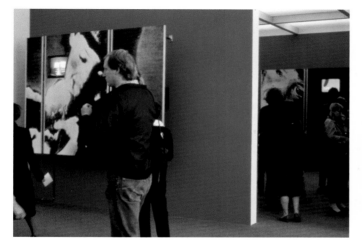

PM Magazine, 1982, installation views at Documenta 7, Kassel, 1982.

It is important to note Buchloh's argument, for it was one of the first to lay the groundwork for considering Birnbaum's practice alongside that of a number of her peers and within a longer artistic and cultural history. But there is a second reason to return to this text now: however often Buchloh's words are referenced with regard to the group of artists mentioned and the tactical methods (i.e., versions of montage) assembled there, some crucial elements of his argument have been overlooked. Primarily, in naming the shared terrain between a handful of otherwise seemingly disparate practices and seating them within a historical and tactical narrative, Buchloh constructs for them a ready-made set of predecessors and thus supposes a kind of contiguity between a number of artists operating in—and more importantly *across*—the twentieth century. Including them as the most recent participants in a kind of relay race, where the critical baton is handed from Alexander Rodchenko to Daniel Buren to Rosler, Buchloh lends a kind of coherence to the group of women whose work he admires, if with furrowed brow. Indeed, if the critic wrests from these artists' work a bit of hope in the face of what he otherwise sees as the then-contemporary "climate of desperation and cynicism,"[5] he would nonetheless seem to gesture, if not overtly so, to what he saw as their unfortunate position at the *end of the line*.[6] Heralding Birnbaum et al. for carrying on with the work of those earlier artists, Buchloh nonetheless concludes his piece by noting that this most recent "assault" on commodity culture, however effective, will likely prove temporary and that sooner or later "the general acculturation process [will find] ways to accommodate these works or their authors [will] find ways to accommodate their production to the conditions of the acculturation apparatus."[7]

That Buchloh's warning was far from unwarranted does not lessen its overarching grasp. One hears in his words the death knell for "critical" work, for work that is not merely produced to be consumed, and with this the unstated but clearly apparent sentiment that art simply will not be able to much longer outrun the reifying powers that had been gaining ground the whole of the twentieth century. His worry is "accommodation": that commodity structure will "accommodate" (and, lo, eventually profit from, by reproducing in neutered form) anything that *irritates* it or that eventually the *irritant* itself will bend, however involuntarily or unconsciously, toward the cause it was intended to rebuff. And in Birnbaum's case, in particular, the question seems

clearly stated: how does one maintain speed (which is to say critical distance) in the face of one of the fastest consuming and commodifying processes of the twentieth century, "technology" and its subsequently developed ideologies?

Buchloh's essay, in which the hopes, but also fears, for the continuation of any avant-garde were placed on an all-women group with all-male predecessors, appears in the same issue of *Artforum* as major coverage of that year's Documenta 7, an iteration of the international event more mired with controversy than usual (the curator, Rudi Fuchs, maddening the politically and socially minded by describing the enterprise in Wagnerian terms, privileging some vaguely universal sense of artistic tradition and production, refusing to mete out specificities aesthetic or ideological).[8] Fuchs named his goal for Documenta that year as providing a refuge for art, to keep it from the fray of "disrespectful misuse,"[9] which he saw so much recent (read: post-1968) art going toward. "We did everything to avoid a nervous exhibition,"[10] his catalogue essay claims, a thinly veiled statement if ever there was one.

Not incidentally, Birnbaum was included in Fuchs's Documenta, as were artists with whom she had affinities, such as Graham, Vito Acconci, Levine, Holzer, Cindy Sherman, and many others, as well as counterparts, figures taking up representation for quite different purposes: artists such as Sandro Chia, Francesco Clemente, Enzo Cucchi, and David Salle.[11] There, however, Birnbaum—the only video artist to be included in this Documenta of nearly two hundred artists—presented a definitively nervous-making piece: *PM Magazine* (1982). *PM Magazine*'s four channels of video and sound were embedded in a complex installation, with bright chroma-key blue panels bearing still images pulled from the video and reproduced as large, graphic, pixelated black-and-white bromide photo enlargements. Referring to, as Buchloh points out in "Allegorical Procedures," late Productivist work by artists like El Lissitzky (who had themselves played with new technologies and their place in spatial arrangements as modes of agitprop), the schema of the piece also flirted with less high-end references. Video footage culled from the eponymous American news entertainment show popular at the time was mined by Birnbaum for images of, among other things, a little girl licking an ice-cream cone and female ice skaters that had been so pared down as to look like nuclear-charged icons of themselves, maniacally repeating their licks and leaps. Images of a contented young woman using a computer—thrilled with the new technology from which zing rainbow bursts at every tap of its keys (this taken from an advertisement by the Wang corporation and utilized in Birnbaum's 1980 *Pop-Pop Video*: *Kojak/Wang*)—add to the repetitive and fast-paced apocalyptic vibe. The piece's sound track is a newly formulated version of "L.A. Woman," recorded collaboratively by Birnbaum and Simeon Soffer (then a student at the California Institute of the Arts, in Valencia, near Los Angeles, where Birnbaum was teaching) and sung mostly in German, the language of the exhibition's host country, mockingly referring to the return of Neo-Expressionist painting.

By late 1982, however, when Buchloh's article and the critiques of Documenta appeared in *Artforum*, Birnbaum had already turned away to some degree from "pirating" her materials from television and other mass-cultural sources. She had, from 1977 until 1982, found in the stuff of *Laverne & Shirley*, *The Hollywood Squares*, *Wonder Woman*, and *General Hospital* materials ripe

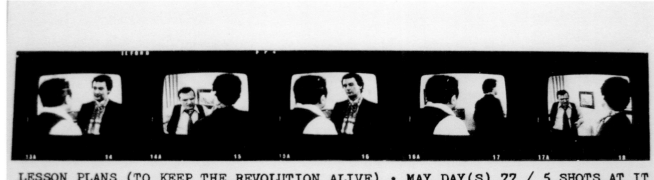

LESSON PLANS (TO KEEP THE REVOLUTION ALIVE) • MAY DAY(S) 77 / 5 SHOTS AT IT
FILM (on) forces that oppose (in order) to reunite (ON) VIDEO

Invitation card for *Lesson Plans (To Keep the Revolution Alive)*,1977, at Artists Space, New York, 1977.

for retooling and redeployment (the surfaces of TV's rapid-fire visuals made to stutter and the accompanying utterances of pithy disco tunes made embarrassingly, viscerally visible). But what had drawn her to them in the first place was her desire to take on what operated as an unrelenting, one-way address of the viewer: television was the most undiscursive medium there could be, making no room for response, rushing past without pause, created to be fully manipulative but wholly unmanipulable.[12] In figuring out ways to gain access to TV footage and then painstakingly shore up its usually invisible structures using the barest of technical means, Birnbaum forced a kind of strained dialogue, or at very least a kind of back-and-forth whereby the viewer wasn't precisely acknowledged but was nevertheless placed *within* (and thus made aware of) her own viewing experience. The fractures Birnbaum forced between images, the gaps she created in the tissue of the televisual, constituted a *space*, however odd; a literalized *reaction time*, however mechanically produced. Here stereotypes and clichés routinely presented as "natural" could be unembedded, pulled like fish from a stream and made to flop unceremoniously. In the deepest sense of the word, Birnbaum's works from the late 1970s and early 1980s can be thought of as *pedagogic*, if one understands this term in its etymological sense of being walked through something step by step. (Her work, *Lesson Plans [To Keep the Revolution Alive]* [1977], makes such a reading explicit.)

So while Buchloh and others were concerned about the reabsorption of critically appropriated material, its being brought back into the fold of a consumer culture renewed rather than revealed, Birnbaum had moved on to different methods of production for a quite particular, related but more immediate, pragmatic reason. If her painstaking gathering of television footage via friends who had access to the inner circles of the entertainment business suddenly came to a close, so did her reasons to gather it. Access to the material of television—which is to say an ability to have at one's whim its output (the means to stop, rewind, fast-forward, etc.)—became suddenly and widely available with the release of the VCR and other new, rapidly advancing, technologies. Though ownership of this device could hardly be argued to suddenly endow its owners with agency (if anything, it arguably consolidated a new level of control over them), it nonetheless rendered somewhat moot,

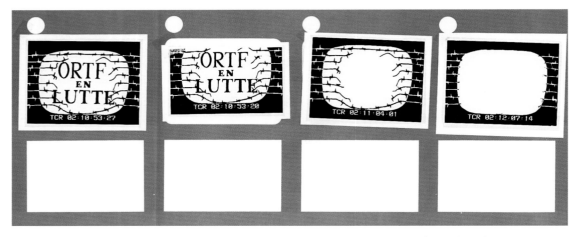

This and following page: storyboards for *Canon: Taking to the Streets, Part One: Princeton University—Take Back the Night*, 1990, showing anonymous street posters, which Birnbaum would also use in her book *Every TV Needs a Revolution*, 1992.

or at least potentially obfuscated, the kind of visual tactics Birnbaum had utilized to help her to produce "altered states" within existent images and to outplay the "rhythmical devices" of television as a whole.[13] In any case, suddenly and irreversibly, *Wonder Woman*—both television's and Birnbaum's—would never look quite the same again.

<p style="text-align:center">* * *</p>

In locating the male fetishistic enjoyment in viewing cinema, film theorist Christian Metz describes a "gap" between presence, made possible by a film's technical means, and absence, the resulting "theater of shadows."[14] It is here, Metz says, in/as the cipher of technology, that images of "woman" both appear and simultaneously disappear—put into the service of representing *something else*: transformation or desire or, perhaps more to the point, the *gap* itself, the "other" that serves as foil for firmer ground. In a different, if related, sense, Birnbaum had also been interested in the gendered implications of technically produced gaps; she once noted that in the character of Wonder Woman she was able to find a "flicker between Secretary and Superhero," conducting in *Technology/Transformation* and in other of her appropriative works a kind of search for the "in-between."[15] That images of woman are utilized as representative vessels for myriad overdetermined tropes is also hardly a new idea. But in the early 1980s, Birnbaum found in female iconography a literalized *stopgap*, and she homed in on those images that both demanded and denied identification from their viewers.

But there is more to this identification, which is rarely, if ever, acknowledged. In linking her practice, especially in the late 1970s and early 1980s, directly to television (a "medium" that Samuel Weber finds can only be defined by the phrase "constitutive heterogeneity"[16]), Birnbaum implicitly addressed not only the relationships between desire, identification, and gender but also those between desire, identification, and *class*. For those shimmering, transformative ciphers that showed up in soap operas, technology ads, and Olympic speed-skating competitions were representations not just of sexual difference but of *coarse* sexual difference. The gestures taught and learned by the participants in *The Hollywood Squares* are so clearly of a differ-

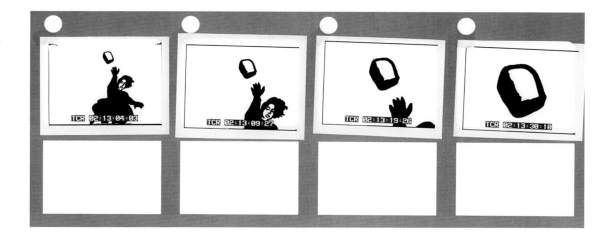

ent order, not fully governed by a reliable patina of glamour and always on the verge of devolving into bad taste, if not out-and-out kitsch.

The televisual image gave over no obvious escape from the real world but rather a rough indoctrination into its rules of engagement, even when a character was temporarily anointed with the cheap accoutrements of, for example, the special powers and flamboyant attire, of a superhero. Birnbaum's pirating of such images was not an indictment of lowbrow culture but rather an acknowledgment of its reach and a utilization of its vernacular. Indeed, Birnbaum's ambivalent relationship to television gave her an understanding of its strangely visceral hold. (The artist once likened television to a protester's brick, capable of being pried from the street and rendered an instant weapon.)[17] Television was a thing fully embedded in culture, *directing* it, reflecting it, speaking its language. Where, for the Situationists (with whom a young Birnbaum identified), a city's streets were themselves the place to pursue radical change, for Birnbaum it was ironically television that offered new avenues to be occupied and redefined by its users, despite (or because of) its usually normativizing function. Architectural in its virtual parameters, traversed by millions every day, TV could potentially be usurped, strategically redefined, occupying as it did a strange liminal space between the public and private realms.[18]

"This was the connection with *Critique of Everyday Life*," said Henri Lefebvre of his three-part opus, written between 1947 and 1981, "to create an architecture that would itself instigate the creation of new situations."[19] While Lefebvre's *Critique* is hardly an architectural manifesto, its underlying philosophical gambit is that resistance and change must be pursued in the realm of the quotidian: on the streets, in the home, while taking a break from the assembly line—that is, in the realm of society—to have any real relevance. This said, Lefebvre approaches first rural and then urban architecture as potential sites for political critique—in other words, as sociological and epistemological structures. Architecture, with its relation to discrete modes of inhabitation—and with its uncanny ability to gather memory, to be inscribed historically, to physiognomically embody the bond between individual and collective—is taken up by Lefebvre for its radical political possibility.

Drawing on the disparate uses of the term by Hegel, Marx, and Brecht, Lefebvre's formulation of "alienation" borrows from all three of those thinkers yet resolves into a slightly different conceptualization of the term. For Lefebvre, alienation was in line with, but not limited to, the Marxian concept whereby a worker is alienated from his own labor and thus from himself and humankind as a whole. Extending the analysis by insisting on its sociological dimension, Lefebvre posited alienation as part of a larger historical process whereby a kind of essential human plenitude was lost, as labor and specialized human activity were parceled out. By creating a binarizing hierarchy where there were hours to be spent working and hours to be spent self-consciously "not working"—that is, pursuing leisure activities—there resulted a third, less easily categorizable type of activities that could only be seen as supplemental, residual, boring, and "low." These were the activities of the everyday, neither paid labor nor documentable sites of "pleasure" such as entertainment or vacation: time spent bathing, doing domestic affairs, sleeping, cooking. The nearly invisible, inevitably repetitious, clearly indispensable efforts of the human animal to propel himself from workday to workday, from weekend to weekend, formed the material of the membrane that allowed for the differentiation between those counted and accountable hours but themselves garnered little attention. Inadvertently countering thinkers like Georg Lukács (who coined the term *Alltaglichkeit*—translated as "trivial life"—to designate the unceasing repetitiveness of the everyday), Lefebvre's conception of everyday life, however, posited that continually uncoiling fabric of daily activity as rife with pockets of unquantifiable space and time, these unusually positioned for potential political utilization and even possible *disalienation*. Indeed, everyday life can be seen, for Lefebvre, as the site where lost human plentitude is revealed as violently absent and, ironically, potentially regained—available for disarticulation and rearticulation in turn. That his two favorite examples of disalienation in/of daily life—Bertolt Brecht and Charlie Chaplin—are *performative* could be made much of in Birnbaum's context. For both these examples describe concisely what Lefebvre wants us to understand about the ways in which everyday life can take on meaning—and it is perhaps no accident that these are staged events, since, for Lefebvre, every move we make, every repetitive gesture of everyday life, is already scripted. We wear masks, as he puts it, all the time, and we perform according to our expected roles; we can, he suggests, perform differently, too.

My explanation of what Lefebvre would come to call his "metaphilosophy of daily life" is of course partial and therefore simplified. And, indeed, Lefebvre (a figure with complicated ties to the Situationists), with his decades-long reading across aspects of capitalist culture, is not meant here to provide some perfect key to Birnbaum's work. But in undertaking a kind of metapractice herself, she found in the syntax of television a perhaps initially counterintuitive set of terms that, when aligned with the terrain of the everyday, could be tapped for its quiet volatility and thus resist being reduced to a set of merely fetishistic lures.

To that end, Birnbaum's *Damnation of Faust Trilogy* (*Evocation* [1983]; *Will-o'-the-Wisp [A Deceitful Goal]* [1985]; *Charming Landscape* [1987]) plots, almost topologically, the question of how subjects find access to their own images and how they navigate the question of the "I" from within several concentric sets of cultural terms. Having adapted what she has called the "by-products" and unusual "folk instruments"[20] gleaned from new tech-

nologies and their industries, Birnbaum's *Faust* uses the trappings of the everyday as the site for the monumentally elegiac. That this work does not use strictly "appropriated" imagery but turns toward conventions of representation in order to create "new" images does not mean that Birnbaum was turning wholly away from previous strategies. Indeed, *Faust*, like *Technology/Transformation* or *Kiss the Girls: Make Them Cry* (1979), also pursues questions of visibility and iterability. Yet here the screen of mediation and stereotypes no longer needs to be *presented*; it is instead *implied*. Birnbaum offers viewers a kind of incongruous look into a street scene, where a series of banal interactions and exchanges between adolescents from a downtown New York neighborhood feels at once rote *and* intimate, rife with affect. If, in total, the three parts of *Faust* together give a kind of portrait, it is a portrait not only of a changing city, the changing lives of its occupants, and the changing context for cultural memory but also of the changing capacities of *viewers*.

Birnbaum mobilizes the kinds of aesthetic effects that are meant to usher in identification on the parts of viewers (like music, special effects, slow motion); but these effects are rendered highly tangible, used not as subtle framing devices but instead as densely material things. On-screen wipes and other formal tools obscure images (or become images themselves), the sound tracks overwhelm, and the narrative refuses to fully coalesce and remains dispersed. In the concluding segment, *Charming Landscape*, Georgeann and Pam, two of Birnbaum's young protagonists from the playground, reflect on their own images and their own history—assessing, that is, their own distance from who they had once been. With their playground demolished, their cultural environment changed at both the micro and macro levels, Georgeann notes matter-of-factly, "As you get older, you think back and realize this really affected me." Birnbaum's camera details the razed park; images taken from the civil rights movement and student protests in France and China are cut—never seamlessly but, rather, violently—into the account of the teenagers' local history.

Over the past three decades, Birnbaum's tactics and tools have not stopped evolving, as she takes into consideration the rapidity by which signification itself is a procedure of constant flux. She did not, in 1983, with the first part of the *Faust Trilogy*, give up forevermore the "pirated" image (which is to say images "taken" from elsewhere) but rather shifted her frame to show the ways in which *all* images partake in various modes of re-presentation. Indeed, what images are seen and *by whom* continues to be structurally and affectively considered. More recent pieces reflecting on political events, from Tiananmen Square to the Gulf War, remind us that a "break-in" can occur sometimes simultaneously on many levels (individual and collective, physical and psychic). That sexual difference continues to play a part in her work seems clear, but it is perhaps all the more important to reiterate it here. (Jacqueline Rose reminds us that

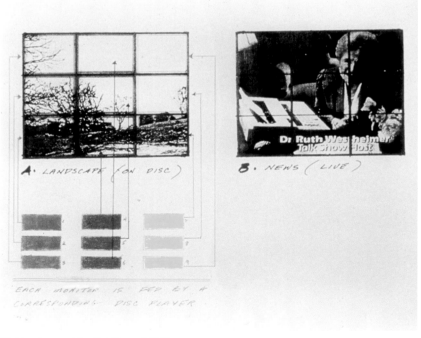

Working document for *Rio Videowall*, 1989.

47

"a feminism concerned with the question of looking can therefore . . . stress the particular and limiting opposition of male and female which *any* image seen to be flawless is serving to hold in place.")[21]

In a 1991 interview with Susan Canning, Birnbaum referred to the importance of what she had come to see as her position with regard to transmitted images in the world: "on the receiving end."[22] It's a strange phrase, one that usually implies someone getting more than their fair share of force: sexual, physical, psychological. It is a phrase implicitly aligned with passivity, but Birnbaum turns this assumption on its head. For calling attention to *how* one receives (and *with* whom—those on the receiving end are vast in number) also implies that there are *other* ways to receive, that spectatorship is available as a space for not only retooling the subject but also retooling the social.

I have suggested that Birnbaum's practice is one that functions both materially and conceptually by way of persistence and adaptability; that is to say, the artist has taken stock of the ramifications and ideologies of technology as they have assumed and changed form for the past three decades. Yet rather than simply mimic or transgress the effects or structures of technological "progress," Birnbaum proposes that, to borrow again from Barthes, we "change the object itself." If it is less *technology* per se and more the actual receivers, alongside modes of and conditions for reception, that Birnbaum explores, the artist's work can be seen as an irritant or interruption to the very modes of technology she would seem to keep up with. Indeed, Birnbaum's earliest forays into the "new technology" of the mid-1970s made evident her structural (and feminist) interest in shoring up and claiming space for the largely discounted, intractable "receiver." As early as her 1975 *Attack Piece*, Birnbaum foregrounded the metaphoric—and actual—ways in which still and moving images are sites of predatory capture. "Armed" with a 35 mm camera, Birnbaum protected her personal space by "shooting" images of the four participants whom she had asked to track her movements via Super 8 camera. Birnbaum's 1976 *Pivot: Turning Around Suppositions* likewise laid bare the kinds of dynamics that occur before and behind the lens (but which are most usually underplayed, so as not to interfere with the fantasy narrative of the story). Here, in a kind of Brechtian demonstration, Birnbaum and her male "director" Michael Lanley literally name the operations in which they participate, working to unmask conventions, to speak—rather than fulfill—their functions.

So too in Birnbaum's more recent works, such as *Erwartung/Expectancy* (1995/2001) and *Tapestry: Elegy for Donna* (2005), very different pieces that nonetheless insist on what might be called the unconscious of cultural production. In *Erwartung*, Arnold Schoenberg's score is literally fleshed out by the details of its production, by the various women who "ghost" its existence then and now, by Birnbaum's own way of finding *Die Frau* within its constructs. In *Tapestry*, Birnbaum also "stitches" together the personal and the public, by way of Yasmine, a Flemish singer and DJ. Birnbaum, turning to the lives of women—as they appear both in Schoenberg and on *Radio Donna* in Brussels—turns also to their very representation, to, that is, technological apparatuses and systems of representation. Birnbaum presents strangely touching portraits, glimpses of two figures who, despite their utter absorption by mediating narratives, produce unexpected supplements. Indeed, perhaps it is Birnbaum's own *interest* in their stories on a number of levels that shapes

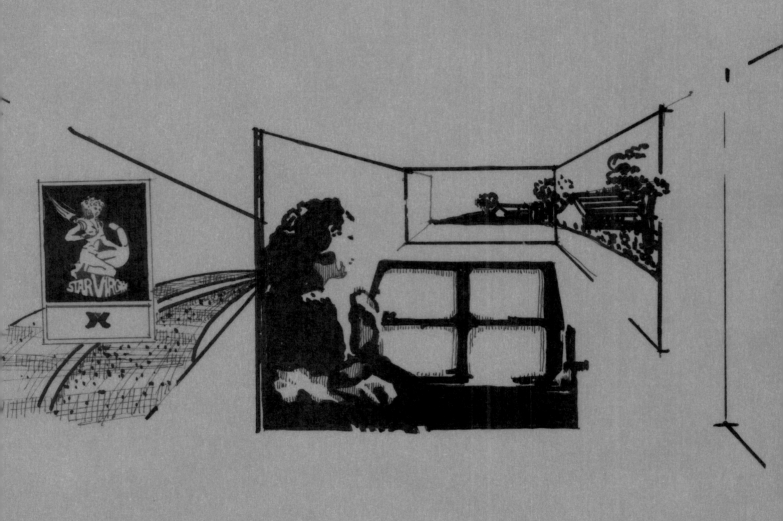

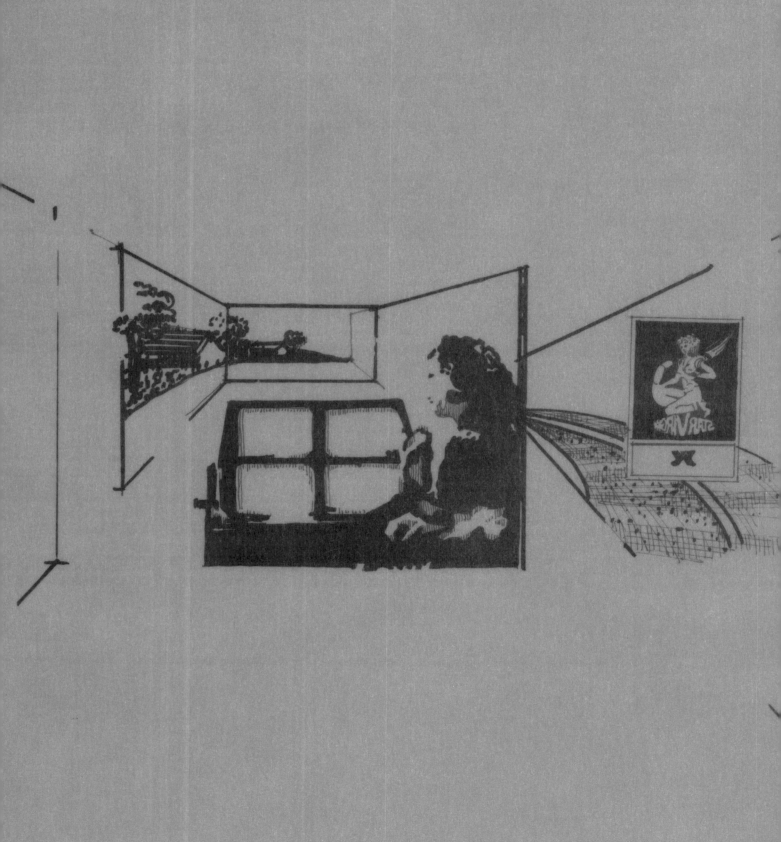

her pieces about them. Here, Birnbaum's response to two female figures enables the production of new kinds of images of them.

In 1984, Birnbaum took part in a groundbreaking (if controversial) exhibition at the New Museum of Contemporary Art in New York. Titled "Difference: On Representation and Sexuality" and curated by Kate Linker (with the museum's film and video curator, Jane Weinstock), the exhibition aimed, according to Marcia Tucker, then director of the museum, to undertake "an intellectual as well as visual exploration of how gender distorts 'reality.'"[23] Linker specifically names representation as something too often taken for granted, naturalized. The show proposed that artistic practices can overturn prevailing conventions by showing the ways in which such conventions continue and by insisting on more complicated modes of both production and reception. "Its thesis—the continuous production of sexual difference—offers possibilities for change," she writes, "for it suggests that this need not entail reproduction, but rather revision of our conventional categories of opposition."[24] (Linker's move here from "reproduction" to "re-visioning" is pointed.)

In an essay for the show's catalogue, Jacqueline Rose discusses what she calls "disturbance[s] of the visual field."[25] Such disturbances manifest at the site of the viewer who is uncertain how to place himself or herself in relation to a picture. For Rose, there is an inherent relationship between sexuality and images: images that maintain the fantasy of fixed sexual identity operate smoothly, while those that disturb that fantasy literally "trouble, break up, or rupture the visual field before our eyes."[26] Birnbaum's work had begun by quite literally troubling the visual field, by breaching any pretense of its being a holistic material or ideological surface; it progressed by continually seeking out new methods of disruption, recognizing that modes of "trouble" had to be remade at every turn. Interestingly, then, the piece called on to represent Birnbaum in the show was not one of her then-current works (addressing the present conditions of representation as effected by new technology's latest iterations) but, rather, *Technology/Transformation: Wonder Woman*, a piece that had become so utterly symbolic of such troubling operations that within the exhibition one wonders whether it could be called on to perform this task.

Birnbaum's practice implies that women (and even constructs of "woman")—like Wonder Woman, Georgeann and Pam, and Yasmine—are never fully contained by the stories told about them or by their screened images. Indeed, as I write this essay, Birnbaum has been conceiving a piece based on Richard Strauss's opera *Die Frau ohne Schatten*. Attracted to a long-ago-written story of a woman who cannot cast a shadow—who does not, in a sense, leave a trace—Birnbaum returns yet again to questions fundamental to her oeuvre: what and who can be seen, and how? Her answers direct us, always, back to the way that such images work as limit cases: bound to the contexts whose contours they help to reveal, they also point urgently to what is on the horizon, what kind of technological languages are assuming speed and to what end. If, in 1982, Birnbaum's work could be seen as signaling the impasse to which one readable strand of avant-garde practice had ceded, she has managed, nonetheless, to continue reimagining the terms of that ending—over and over again. Like a child playing battle on the beach, she patiently redraws her line in the sand, refusing to give up the game.

1 Roland Barthes, *The Pleasure of the Text*, trans. Richard Miller (New York: Hill and Wang, 1975), p. 40. The passage, truncated in my epigraph, in its entirety reads: "There is only one way left to escape the alienation of present-day society: *to retreat ahead of it*: every old language is immediately compromised, and every language becomes old once it is repeated. Now, encratic language (the language produced and spread under the protection of power) is statutorily a language of repetition; all official institutions of language are repeating machines: school, sports, advertising, popular songs, news, all continually repeat the same structure, the same meaning, often the same words: the stereotype is a political fact, the major figure of ideology."

2 Benjamin H. D. Buchloh, "Allegorical Procedures: Appropriation and Montage in Contemporary Art," *Artforum* 21, no. 1 (September 1982), pp. 43–56.

3 Ibid., p. 48. Buchloh's use of Walter Benjamin's ideas of allegorical procedure (as first set out in Benjamin's *The Origin of German Tragic Drama* [1928]) is, with the younger artists, followed up with Barthes's concept of "secondary mythification" (elaborated by Barthes in his 1957 *Mythologies*), which repeats ideological operations as a way of deconstructing them.

4 Ibid., pp. 48–50.

5 Ibid., p. 48.

6 That Buchloh's list of artists consisted entirely of women has been previously discussed, most notably at the time by Craig Owens. Here, I am interested less in why Buchloh chose not to remark on this detail in his text than in the fact that a group of women stand at the end of a genealogical line.

7 Buchloh was, of course, not the only writer asking just what the continued use value and shelf life of "allegorical" procedures might be. Owens's pivotal essays "The Allegorical Impulse: Toward a Theory of Postmodernism," *October* 12 (Spring 1980), pp. 67–86, and "The Allegorical Impulse: Toward a Theory of Postmodernism (Part 2)," *October* 13 (Summer 1980), pp. 58–80, lay fundamental tracks in this regard, considering the historical, literary, and philosophical tenets of the concept. Hal Foster, in *The Return of the Real*, enumerates the dialectical nature of the "allegorical" in art as a major question for the early 1980s. "When does montage recode, let alone redeem, the splintering of the commodity-sign, and when does it exacerbate it?" he asks. "When does appropriation double the mythical sign critically, and when does it replicate it, even reinforce it cynically? Is it ever purely the one or the other?" Here, Foster also presses into use Barthes's reassessment of his own earlier work in *Mythologies*, the text from which Buchloh drew much of his argument for "Allegorical Procedures," suggesting that Barthes's later recasting of his own terms ought to have been taken into account by Buchloh. See Foster, "The Passion of the Sign" in his *The Return of the Real* (Cambridge, MA: MIT Press, 1996), especially pp. 90–96.

8 *Artforum*'s September 1982 package on Documenta 7 includes essays by authors Annelie Pohlen, Kate Linker, Donald Kuspit, Richard Flood, and Edit deAk. Nearly all the coverage here and in other publications (including a scathing indictment by Buchloh in *October* 22 [Fall 1982] titled "Documenta 7: A Dictionary of Received Ideas") is negative.

9 Rudi Fuchs, quoted in Annelie Pohlen, "The Dignity of the Thorn," *Artforum* 21, no. 1 (September 1982), p. 60.

10 Fuchs, in his introduction to *Documenta 7*, vol. 1 (Kassel, Germany: D+V Paul Dierichs, 1982), p. xv.

11 As is evidenced in this limited sampling, Documenta 7 included a significant number of artists involved in producing critical work. It was Fuchs's framing of the exhibition, which downplayed this dimension, that rendered the show so troubling for many. Fuchs's stress was on preserving and protecting traditions of art-making by sidestepping allusions to mass media. These elements came in, nonetheless, by way of artists like Birnbaum, Levine, and Sherman whose work had a foot in both camps.

12 See Birnbaum, "Talking Back to the Media," in *Talking Back to the Media, Time Based Art* (Amsterdam: de Appel, 1985), p. 49.

13 Dara Birnbaum, *Rough Edits: Popular Image Video, Works 1977–1980*, ed. Benjamin H. D. Buchloh (Halifax: Press of the Nova Scotia College of Art and Design, 1987), p. 15.

14 Christian Metz, "The Imaginary Signifier," *Screen* 16, no. 2 (Summer 1975), p. 15. Cited in Mary Ann Doane, "Technology, Representation, and the Feminine," in *Body Politics: Women and the Discourse of Science* (New York and London: Routledge, 1990), pp. 173–74.

15 Birnbaum, interview by Hans Ulrich Obrist, in *Art Recollection, Artists' Interviews and Statements in the Nineties*, ed. Gabriele Detterer (Florence: Danilo Montanari & Exit & Zona Archives Editori, 1997), p. 46. See also this book, p. 24.

16 Samuel Weber, *Mass Mediauras: Form, Technics, Media* (Stanford, CA: Stanford University Press, 1996), p. 110.

17 Birnbaum produced a set of posters based on anonymous street posters made during the events of May 1968 in France (see the resulting book, titled *Every TV Needs a Revolution* [Ghent: Imschoot, 1992]). In an interview, Birnbaum describes her reaction to one of the '68 posters: "In the original *Mai '68* poster, *la beauté est dans la rue*, this stone, or rock, looked to me like a TV." See Birnbaum, "Media's Continuous and Discontinuous Forms," an edited transcription from a presentation and screening at the symposium "Inszenierte Imagination" (Produced Imagination) at the Kunsthochschule für Medien, Cologne, p. 187. See also this book, p. 317.

18 Birnbaum collaborated with Dan Graham in 1980 on a piece that overtly takes up the architectural siting of the television within the domestic scene, *Local TV News Analysis for Cable Television*. Other works by Birnbaum, such as her controversial project *Rio Videowall* (1989), which was built as a commission for the Rio Shopping and Entertainment Centre in Atlanta, Georgia, also address the architectural roles of the media and media vehicles.

19 Henri Lefebvre, in an interview conducted and translated in 1983 by Kristen Ross, "Henri Lefebvre on the Situationist International," in *October* 79 (Winter 1997), pp. 70–71.

20 Birnbaum, "Talking Back to the Media," p. 49.

21 Jacqueline Rose, "Sexuality in the Field of Vision," in *Difference: On Representation and Sexuality* (New York: New Museum of Contemporary Art, 1984), p. 33. Emphasis mine.

22 Birnbaum goes on to say, "In our society this is a very important position to comment from, about the transmission and receiving of these images." She is speaking specifically about images from Tiananmen Square, but I think the implications of this position are worth considering with regard to her practice overall. (Birnbaum, interview by Susan Canning, *Art Papers Magazine*, no. 6 [November/December 1991], p. 57.) See also Birnbaum's project for *October* magazine, in which she focuses on the philosophical and material implications of the "reaction" as a "necessary part of the representation: a key component of the narrative flow." (Birnbaum, "Elemental Forces, Elemental Dispositions: fire/water," *October* 90 [Fall 1999], pp. 109–35.)

23 Marcia Tucker, preface to *Difference: On Representation and Sexuality*, p. 4.

24 Kate Linker, preface to *Difference: On Representation and Sexuality*, p. 5.

25 Rose, "Sexuality in the Field of Vision," p. 31.

26 Ibid.

DARA BIRNBAUM: EXPLODING THE IMAGE

MICHAEL NEWMAN

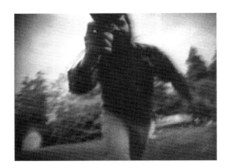

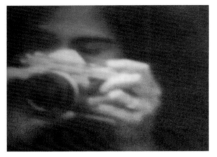

Stills from *Attack Piece,* 1975.

want to follow a thread through certain works by Dara Birnbaum, one that leads from the early installation *Attack Piece* (1975), in which media are directly related to the performance of the body, to the more recent projected-image and sound installation *Erwartung/Expectancy* (1995/2001), which is based on a libretto that uses the language of a hysteric. In between those two points, this line passes through the videos *Technology/Transformation: Wonder Woman* (1978–79), which appropriates footage from a television series, and the *Damnation of Faust Trilogy* (1983–87), in which specially shot footage is edited to transform the space and time of the image. The thread is not so different from that of Ariadne, in that Birnbaum's work, in its variety, forms something of a maze, and that what is confronted therein entangles love and violence in a way that refers to society's distribution of goods, sexualities, and power. Media in her work become not so much the physical or material bases for representations as modes of passage that explore articulations of inside and outside, as well as the liminal in-between where transformation may be stalled or enabled.

I

In *Attack Piece*, we see an interaction between an individual and a group that has a dimension of anxiety and violence while also possessing the underlying structure of a game. On a lawn outside a building, a woman—in this case Birnbaum herself—is "attacked" by one person after the other, each of whom aims to film her using a Super 8 camera.[1] Meanwhile she "defends" herself with a 35 mm still camera. The work, which was first shown in 2002, is presented with the moving and still images facing each other either on two monitors or as projections.

In *Attack Piece*, the film camera takes an aggressive role, almost that of a rapist. The aim of the game is for the person holding the film camera to close in on the woman holding the still camera. That the woman has only a still camera is described in the instructions as putting her at a disadvantage, and in addition, we read that she is to be blindfolded, although in the resulting film she appears to attempt to keep her eyes closed. But as a defense the still camera does perform two functions: first, it creates distance; second, it "freezes" the attacker. The mise-en-scène recalls Dan Graham's *Body Press* (1970–72), which installs as two silent 16 mm film projections the results of a naked man and woman each passing a film camera around their body within a mirrored cylinder. While Graham's work implies a utopian equality between the man and the woman as subjects and objects of the look, *Attack Piece*, by placing a woman in the position of "defender" and distinguishing sex from the gendered implications of the technology, since both men and women perform as "attackers,"

emphasizes the asymmetry of the situation, the imbalance of power and the inequality of access to media. Some of the resulting still photographs resemble war photography, such as the famous 1936 picture by Robert Capa of the death of a Loyalist soldier in the Spanish Civil War, which shocks because of the closeness of the representation to the violence and death that it depicts.

Attack Piece works on the intersection of psychology and technology, as movie and still camera are instruments of, respectively, aggression and defense, the wider angle and prefocus of the former facilitating movement and a more inclusive view, while the latter required its user to intuitively focus in anticipation of the aggressor's movements. Relationships of aggression and defense are mediated though technology but are not subsumed to spectacle. Instead, individual agency is involved, while the technology of the respective cameras determines possibilities. Rather than merely documenting a performance, the technological means of representation here become, as with the early videos of Vito Acconci, part of the performance itself. Furthermore, the historicity of media is folded into Birnbaum's 2002 installation of *Attack Piece*, through the use of sound: while the presentation comprises two facing digital projections, the images are accompanied by a loud sound track of the now-absent film and slide projectors. Digital media holds the memory of the analog media in which the work was originally made; this, in turn, underscores the way in which the present form of the work also stands as a representation of a previous historical moment with its critical and utopian dimensions.

The scenario of *Attack Piece* will be found again in *Technology/Transformation*, where once more a woman will fend off an attack, only there with the psychological and physical dimension of mediums inflected by the generic dimension of mass media, specifically by the representation of the superhero on television. A subsequent series of videos, *Damnation of Faust Trilogy*, which moves away from appropriation to footage shot and edited by the artist, explores the relationship between the anticipation of a life to come by young people first encountered playing in a playground and their later experiences of separation and loss, which open up a reflective, melancholy dimension of personal and political retrospection. The model of opera, alluded to in the title of *Damnation of Faust Trilogy*, will be extended in *Erwartung/ Expectancy*, which examines the conditions for the appearance of an excess associated with both feminine madness and *jouissance* (enjoyment).

Before discussing these works, however, it is useful to consider early experimental performance videos by Birnbaum that anticipate some of the later works' motifs.

Still from Dan Graham, *Body Press*, 1970–72.

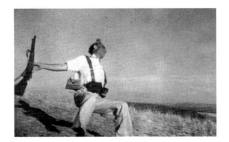

Robert Capa, *The Fallen Soldier*, 1936.

Drawings for *Attack Piece*, 1975.

Birnbaum's initial approach to video was to use it to document the performance of her own body. The apparent immediacy of video—its ability to provide a moving image contemporaneous with what it is an image of, and therefore also provide instant feedback—made it seem, in its early historical context, that video might enable a presentation of the Real of the body in "real time."[2] What Birnbaum's experimental videos document, however, is less the Real of the body as such than the realization that the presentation in moving image is always already doubled by a re-presentation. To engage with and reflect on this dimension of re-presentation, Birnbaum folded it back into the video itself. We thus find the dimensions of mirror reflection and projection staged in the videos themselves, ruining their initial immediacy and opening the dimension of allegory—of the image standing for something other than itself—that will be taken up in her videos appropriating clips from television.

Various aspects of *Technology/Transformation* are foreshadowed by Birnbaum's early series of performance experiments. In *Chaired Anxieties* (1975), she performs with a chair, first in pants (*Abandoned*), then in a skirt (*Slewed*). The videos combine the studio performance of Bruce Nauman's early videos with the forced intimacy of Vito Acconci's. The camera is low, as if it is trying to look up her skirt, and therefore aggressive, like the film camera of *Attack Piece*. She responds both defensively and aggressively. The division of these first sequences into one in which she is wearing pants and one where she is dressed in a skirt seems almost to anticipate the two aspects of the feminine that appear in *Technology/Transformation*, the secretary and the superhero, but with important differences, too. In *Slewed*, Birnbaum becomes increasingly sexual, panting and moving rhythmically and, because she is not wearing underwear, exposing her genitals to the camera. Yet it seems more like a fight than a seduction. Wonder Woman does battle, too, but her transformation is not into the exposed, openly sexual being of this video. Rather she turns into a fetish-body.

Still from *Chaired Anxieties: Slewed*, 1975.

In another early video, *Mirroring* (1975), Birnbaum performs between the camera and a mirror. Sometimes we see her face, at others her face and a reflection; in addition, her face goes into and out of focus, so that we become aware of the mediated character of her image. If video as a medium was initially welcomed for its seeming immediacy, the instantaneous production of the image drew attention to a homology to the only kind of image that is simultaneous with its referent other than a recorded moving image—namely, a mirror reflection. Artists from Acconci and Joan Jonas to Graham were quick to exploit this effect. The analogy between video and mirror prompted a famous critique of video art by critic and historian Rosalind Krauss, "Video: The Aesthetics of Narcissism." As she says of Acconci's *Centers* (1971), in which he points to the center of the video screen, it "was made by Acconci using the video monitor as a mirror."[3] Krauss extrapolates from the homology between video and mirror to the claim that narcissism is the true "medium" of video. She finds in the idea of a spiritualist medium—like the photographs that purportedly showed ectoplasm—a precedent that a psychological state, rather than a physical support, can be understood as a "medium." And she notes that most video art, whether on tape or in installation, uses the body in a circuit between camera and monitor:

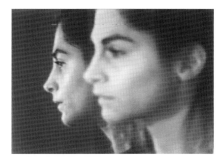

Still from *Mirroring*, 1975.

> *Unlike the other visual arts, video is capable of recording and transmitting at the same time—producing instant feedback. The body is therefore as it were centered between two machines that are the opening and closing of a parenthesis. The first of these is the camera; the second is the monitor, which reprojects the performer's image with the immediacy of a mirror.* (Krauss, p. 181)

Of course, the closure that Krauss implies is questionable, not least since it assumes that the performance is for the one performing. Clearly, for most examples of performance-related video, and certainly for Birnbaum's experiments, the performance is taking place for or as a challenge to an Other, or a "gaze" that is not to be identified with the position assumed by the artist in the work, and may be a projected Other—the position of a superego, for example—as much as the actual others who will watch the tape. While no doubt evoking

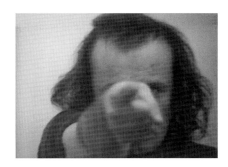

Still from Vito Acconci, *Centers*, 1971.

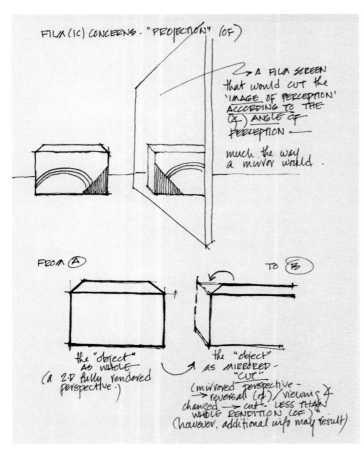

FILM(IC) CONCERNS. "PROJECTION" (OF)

→ A FILM SCREEN
that would cut the
'IMAGE OF PERCEPTION'
ACCORDING TO THE
(X-) ANGLE OF
PERCEPTION —

much the way
a mirror would.

FROM Ⓐ TO Ⓑ

the "object" the "object"
AS WHOLE AS MIRRORED-
(a 2-D fully rendered "CUT"
perspective.) (mirrored perspective -
 → reversal (of) / viewing &
 changed → cut - LESS THAN
 WHOLE RENDITION (OF)
 (however, additional info may result)

Untitled drawing from a sketchbook, c. 1975.

a narcissistic fantasy, the performance videos of the 1970s insinuate an otherness into the self-relation, and a trace of the nonpresent into the present.

It is by now a commonplace that the mass-media image functions as a mirror to reflect back to the viewer an ideal ego offering a fantasy of completion. This effect depends on the image being both the same as the ego and other than it: it's me, and it's more than me. By implying more than is reflected, the "mirror" becomes a "screen." Another early video, *Control Piece* (1975), involves an exploration of the relationship between the projection and the screen. It begins with the projection of a screen, into which the artist-performer's hand intervenes. In a second sequence, we see the projection of an image of a loft studio or gallery, into which the artist moves, so that her body itself becomes the screen for the projection. We thus have a development from the objective/subjective body in relation to the viewer as Other of *Chaired Anxieties*, through the relation of the self to the mirror image and its dissolution in an out-of-focus blur in *Mirroring*, to the body as, at once, screen for the image and stain or disruption in relation to it in *Control Piece*. The shift is from a projection of the cone of vision from the eye of the viewer, substituted for by the camera, to the subject's appearing in the projection that comes from elsewhere, yet that projection is also disrupted or interrupted. The subject has changed from presumptively occupying the place of origin to herself becoming a screen. Furthermore, the mirror has been replaced by the screen. Whereas a mirror reflects precisely what is in front of it—like its tain, its stain is invisible—the screen suggests a behind that it covers. *Technology/Transformation* will take up precisely this play between mirror and screen.

III

Technology/Transformation: Wonder Woman is a work about stalled transitions and a momentary in-between. According to notes made by Birnbaum at the time, it was to be one of four videos dealing with superheroes on prime-time TV series, the others, which were never made, being drawn from *The Incredible Hulk*, *The Six Million Dollar Man*, and *The Bionic Woman*.[4] Birnbaum saw all of them as having to do with relations between technology and biology, in a context that saw both technological advances that could be used for human betterment and the use of technology and biology in warfare. Like Theodor W. Adorno and Max Horkheimer in *Dialectic of Enlightenment* (1947), which was first published in English translation in 1972, Birnbaum's plan was to explore the entwinement of progress and regression, science and mythology, and utopia and destruction—in her case by appropriating and manipulating footage from these popular TV series.[5] In *Technology/Transformation*, the moment of potential change, emancipation, and explosive pleasure is recuperated into an image of fetishistic stasis.

The video begins with a repeated explosion that fills the screen. We then see the transformation of the female character, Diana Prince, from an ordinary woman who spins on her heels into a superhero. Birnbaum edits the video so that the spin is repeated a few times, along with its flash of white light and siren blast, as if she is stuck for a moment, until the change is completed. Then Wonder Woman is shown running through the woods, to the accompaniment of the series's theme music, again repeated several times before returning to the repeated spin, when we hear the words "Wonder Woman" sung over and over again, like a record that is skipping. The second transition occurs in a room with mirrored walls and infinite reflections. Wonder Woman cuts a doorway into the mirror, an act repeated with its excruciating sound three times, so that what would otherwise seem effortless appears full of anxiety. Then the transition from a woman in black evening clothes to Wonder Woman is performed and repeated. Thereafter she passes through the wall, meeting a man to whom she says, "We've got to stop meeting like this!"—as if to draw attention to the inversion of the "normal" relation between men and women in a fictional world where a woman can assume supernatural powers. While the man hides behind a concrete pillar, Wonder Woman fends off bullets with her bracelets. The video concludes with repeated clips of Wonder Woman running through a wasteland and spinning amid trees—although she fails to make the transition back to the "everyday" woman—until the repeating explosion from the beginning fills the screen again, accompanied by disco music, to be replaced by the words of a Wonder Woman song scrolling up a blue screen in time to the music.

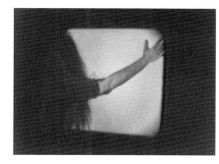

Still from *Control Piece*, 1975.

While *Technology/Transformation* works effectively without any direct knowledge of its sources, some consideration of the relation to the *Wonder Woman* TV episode will provide an additional perspective. The clips of the *Wonder Woman* TV series that Birnbaum appropriates come from episode five of the third season, entitled "Disco Devil," aired on October 20, 1978. A nerdy man in a disco is taken by a beautiful hostess to an upstairs private room, which has its walls covered in mirrors creating infinite reflections, and left alone there. In comes a man wearing a white suit—he is reminiscent of John Travolta in *Saturday Night Fever*, which opened the previous year—who appears to hypnotize the nerd by dancing. Wonder Woman then performs, in the title sequence, various feats of strength and agility and demonstrates her spinning transformation. The scene changes to that of a test for a detonator of nuclear missiles. The person we saw being hypnotized, who turns out to be a nuclear engineer, arrives in a rush to halt the detonation process, but he has forgotten the combination. Diana Prince, an intelligence agent, has been watching the test, and as the men take shelter in a bunker, she transforms into Wonder Woman to throw the detonator far away, where it explodes harmlessly. This is the explosion repeated in *Technology/Transformation*, which at the time might have been associated with the threat of nuclear war. We return to the disco and discover that the hypnotizing dancer—Nick Marino—has stolen part of the engineer's memory. Prince locates another man, Franklin, who is able to read minds but, not using his ability, has failed at a series of manual jobs. He is followed by one of the criminals and is invited to the disco—called the Styx (in Greek mythology forming the boundary with the underworld, where also to be found is the river of forgetfulness, Lethe) by the woman who brought in the engineer. Later, he and Prince are trapped by the criminals. While he is taken down to the garage, Prince escapes, transforms

Stills from *Technology/Transformation: Wonder Woman*, 1978–79.

into Wonder Woman, and protects him from their bullets with her bracelets (a clip used by Birnbaum). Franklin is hidden by the intelligence agency but is captured by the criminals and taken to the Styx, where the female boss decides to use him instead of Nick. Following him there, Prince repels the attentions of an overeager dancer and ends up in the mirrored room, where she transforms into Wonder Woman, cuts through a panel, and dives through the wall, discovering Franklin. (Birnbaum in *Technology/Transformation* inverts the cutting and the transformation in the mirrored room, disrupting the "logical" narrative sequence.) While Franklin neutralizes Nick's power, Wonder Woman deals with the gang leader and bends the pistol of the DJ. Nick, it turns out, has also forgone the memory that would have enabled him to identify Prince as Wonder Woman.

It is not difficult to see why this episode might have appealed to Birnbaum: in addition to the explosion, bullet-repelling, and mirror sequences, it contains the reference to disco that she will adopt for the rolling text that concludes *Technology/Transformation*. With the theme of memory theft, it suggests both a mind-controlling mass media and a countervailing "theft" of images, which artists such as Birnbaum herself were, at that very moment, performing. Moreover, Birnbaum was showing her videos using appropriated TV footage in New York nightclubs, so *Technology/Transformation* was effectively reinserted into the disco context that provided the inspiration for the TV show itself.

While *Technology/Transformation* draws from popular television (a context to which the artist had intended to return the work), it may also be compared to artworks. In its use of a comic-book character, *Technology/Transformation* alludes to Pop art. It is distinct, however, in its break from a straightforward aestheticizing of the mass image. Closest perhaps to Warhol in her use of the repetition of the mass-produced image and her interest in the modes of circulation and popularization of the image, Birnbaum aims not to submit the image to aesthetic contemplation but rather to provoke on the part of the viewer an analysis of the image (by repeating or slowing it) and a consideration of what it implies for the transformation of social and gender relations.[6] Further, *Technology/Transformation* also includes the critique of the conditions for any such realization in the way that the transitions are subject to repetition and failure. Yet neither does it negate the potential implied by both the unrepresentable quality evoked by the explosion, and by the ecstasy of the lyrics that close the work.

Around the period that *Technology/Transformation* was being made, Richard Prince was rephotographing advertising images from magazines, removing the words and putting the results into series of similar images. In 1977, Douglas Crimp curated the exhibition "Pictures" at Artists Space in New York, which included work by Troy Brauntuch, Jack Goldstein, Sherrie Levine, Robert Longo, and Philip Smith, most of which was based on the reproduction or reworking in a different medium of already existing images and stereotypes.[7] At the time, this work tended to be seen as critiquing or deconstructing originality and expressive authorship, as well as, like Marcel Duchamp's readymade, drawing attention to the institutional context of art.[8] To a certain extent, such work followed Pop art in displacing images from the sphere of the circulation of images in mass media to that of the art world. By contrast, Birnbaum appropriated and manipulated clips from popular television, in such works as *Technology/Transformation, Art Break, MTV Networks, Inc.* (1987), and *TRANS-VOICES: Transgressions* (1992), with the intention that they should reenter mass media and be shown on TV: "I decided to use the medium 'on itself,' rather than translating television imagery into a different form of presentation."[9] Accordingly, it was shown on Manhattan cable TV, programmed into the same time slot as the "real" *Wonder Woman* TV show, so that if viewers were channel surfing they might happen on both the original and Birnbaum's version. This approach foreshadowed that of artists of the first decade of the twenty-first century, such as Seth Price and Cory Arcangel, who appropriate digital material—images, sound, video clips—from the internet and return it to that same sphere, as well as showing it in art galleries.[10] *Technology/ Transformation* was also shown on a TV monitor as part of a window installation at SoHo H-Hair Salon de Coiffure in New York, a display that associated the work with the way in which a window-shopper's self-image is reflected in the glass pane that separates him or her from the commodities inside. The violent dimension of a combination of sexual and commodity fetishism had been reflected in a contemporaneous work by Jeff Wall, the light-box transparency *The Destroyed Room* (1978), with its slashed mattress and scattered—or arranged—women's clothes and jewelry, which Wall showed in a gallery window in Vancouver as if it were a shopwindow.[11] Marcel Duchamp provided a model to both Birnbaum and Wall with his 1945 window display at Brentano's bookstore in New York for André Breton's book *Surrealism and Painting*. The later artists' shopwindow displays connect appropriation with the mechanisms by which desire is sutured to the commodity, and it is in these terms that the readymade tended to be interpreted at the time.

Through editing, Birnbaum places her emphasis on appropriation as a potential form of transformation, while also drawing attention to its blockage.[12] Jack Goldstein's films and vinyl records provided an important model for this approach to appropriated image and sound. *Metro-Goldwyn-Mayer* (1975), a two-minute loop of the studio's logo of a roaring lion, above which appear the words *art gratia artis* against a red background reminiscent of Barnett Newman's painting *Vir Heroicus Sublimis* (1950–51), suggests both the transformation of nature into corporate image and the assimilation of high art (represented by abstract painting) into mass media. Goldstein uses film to depict the becoming of the image: for the lion the image is a trap. In 1978 Goldstein made *The Jump*, a twenty-six-second somersault dive rotoscoped so that the body appears as red and orange stars extinguishing themselves in a dark void. The disappearance of the image—or into the void of the image—is

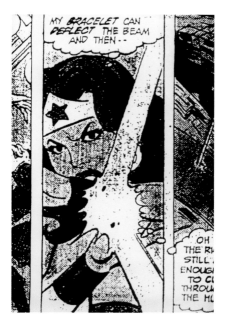

Multiple-generation photocopy of Wonder Woman comic-book page, from the archive of Dara Birnbaum.

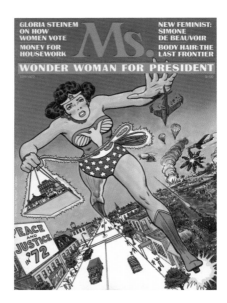

Ms. magazine cover, July 1972.

also the extinction of the subject. Birnbaum's *Technology/Transformation* is also about the relation between the subject and the image: Diana Prince becomes the "image" of Wonder Woman through her spinning transformation (which is not to say that she is not already an image in the first place). But in doing so she passes through a moment of absolute dissolution, which ties together the flash and the explosion. As the theme-song lyrics make clear, this moment is one not of death—or not only of death—but of extreme, unrepresentable, unspeakable enjoyment or *jouissance*.[13] It's an enjoyment that does not last, since it is recuperated into the fetish image and the commodified forms of mass-cultural pleasure, such as disco.

While the image may be a commodity and therefore comparable to a commodity-object, it is at the same time something both other than and more than an object in the world. The image is simultaneously something mental and something outside the perceiving subject—capable, therefore, of becoming an outside-on-the-inside that possesses the subject in the paradoxical combination of taking the image in through its consumption and the very impossibility of its being appropriated in its combination of emptiness and excess. Indeed, *Technology/Transformation* could be read as an allegory of the simultaneous appropriation and failure of appropriation of the image, split as it is between its unrepresentable excess and its reduction to commodity. As in the episode of *Wonder Woman* from which it is taken, it is a matter of being possessed in the very attempt at possession. It would not be too far-fetched to compare *Technology/Transformation* to Duchamp's *The Passage from Virgin to Bride* (1912), as well as *The Bride Stripped Bare by Her Bachelors, Even (The Large Glass)* (1915–23). With their stalled consummations, these works combine the evocation of passage and transformation with a sense of frustration and impotence. *Technology/Transformation* is less pessimistic about access to excess—it is, after all, a work by a woman artist dealing with *jouissance* rather than a work by a male artist concerned with impotence—but more so about its blockage and diversion into mass entertainment in the context of the expansion of that domain and its absorption of art from the 1960s onward.

One dimension of the transformation of Wonder Woman is that she assumes power and agency—she becomes an active subject able to save the man, who, in the clip Birnbaum uses (as well as elsewhere in the series), is put in the passive position. The cost of assuming agency, and thereby taking on a threatening, masculine, phallic authority, is that she becomes a fetish. Wonder Woman appears doll-like and artificial, wearing a costume that emphasizes her breasts while protecting them with metallic bands like armor.[14] *Wonder Woman* may have been one of the so-called "jiggle shows" produced for TV, as a response to criticisms about violence on television, but it is also clearly a response to the rise of feminism.[15] Gloria Steinem used the image of Wonder Woman in July 1972 on the cover of the first issue of the feminist magazine *Ms.* Wonder Woman, according to the story laid out in the series, is the product of an all-female society: she is the daughter of the queen of the Amazons and comes from Paradise Island, inhabited only by women until a wounded pilot from the United States Air Force intelligence service washes up on their shore. She wins an athletic competition to take him back to Washington. Despite her alien origin, the red, white, and blue of her Wonder Woman costume emphasize that she is a patriotic American. Emerging

Still from Jack Goldstein, *The Jump*, 1978.

Multiple-generation photocopy of a video still from *Technology/Transformation: Wonder Woman,* 1978–79, from the archive of Dara Birnbaum.

from an exclusively female yet hierarchically monarchial provenance, she ends up serving, on the one hand, as a feminist inspiration and, on the other, as a sexual fetish and a nationalist emblem.

According to Sigmund Freud, "A fetish is a substitute for the woman's (mother's) phallus, which the little boy once believed in and which . . . he does not want to give up."[16] On perceiving that the mother doesn't have a penis, the little boy feels his own organ threatened, and with it the narcissism that constitutes his ego. The fetish serves simultaneously to acknowledge and to deny the lack of the maternal phallus: the child "both retains this belief, and renounces it." Freud also remarks that in later life, "an adult might experience a similar panic on hearing that king and country are in peril, and it will have similarly illogical consequences," making all the more plausible the combination in the figure of Wonder Woman, at the time of the Cold War, of both national and sexual fetish.

In psychoanalytic terms, the role of the fetish is to disavow lack and therefore difference. The fetishist fixates on something seen prior to the horrific discovery that the woman lacks a penis, thereby threatening the fetishist's possession of one. So fur (pubic hair), leather (skin), and shoes (feet) become typical fetish objects. Equally, the whole body of the woman may become a fetish through the way that it is adorned and rendered artificial, and that is the case with Wonder Woman. The castrating threat of the active woman—indeed, that of the postwar protofeminist—is simultaneously acknowledged and neutralized by her body being turned into a fetish.

The fetish is often something that is excessive in its tactility (fur, leather) or visuality (shiny plastic or metal). The example with which Freud begins his analysis is unusual, since the fetish in question has a linguistic as well as a metonymic dimension:

The most remarkable case in this respect was one in which a young man had elevated a certain "shine on the nose" into a fetishistic prerequisite. The surprising explanation for this was that the child had been brought up in England but had then come to Germany, where he almost completely forgot his native language. The fetish, which stemmed from earliest infancy, needed to be read not in German, but in English: the "shine [Glanz] on the nose" was actually a "glance at the nose," so the fetish was the nose—which, incidentally, he could endow at will with this particular sheen, invisible to others. (p. 90)

Wonder Woman, once she has transformed, has many parts that are shiny and reflective, especially the bracelets with which she repels bullets. The explosions seem to herald a transition into a realm of altogether heightened visuality. Perhaps, after all, the fetish was nothing other than the "shine" itself, a secondary fetish that blindingly conceals the fetish that simultaneously acknowledges and disavows the lack. For Christian Metz, it is the very technique of cinema—those skills, procedures, and machines that enable the force of presence of the film to coexist with the absence on which it is constructed—that is the fetish:

As for the fetish itself, in its cinematic manifestations, who could fail to see that it consists fundamentally of the equipment of the cinema (= its "technique"), or of the cinema as a whole as equipment and as technique?[17]

The extension of fetishism to the technique of a medium is brought back to the question of gender by Laura Mulvey. She offers a reading of fetishism as a form of heightened visibility, citing the following passage from Dana Polan:

Mass culture becomes a kind of postmodern culture, the stability of social sense dissolved (without becoming any less ideological) into one vast spectacular show, a dissociation of cause and effect, a concentration on the allure of means and a concomitant disinterest in meaningful ends. Such spectacle creates the promise of a rich sight: not the sight of particular fetishized objects, but sight itself as richness, as the ground of extensive experience.[18]

For Mulvey, this "rich sight" as an excessive visuality of surface becomes a fetishistic mask "disavowing the traumatic sight of nothing, and thus constructing phantasmatic space, a surface and what the surface might conceal" (p. 11). The glitter of this surface—we might think of Warhol here—is there "to hold the fetishist's eyes fixed on the seduction of belief to guard against the

Untitled and undated lithograph, c. 1975.

encroachment of knowledge" (p. 12). She writes of "the magical sheen of the screen" that the 1960s and 1970s avant-garde took upon themselves to demystify. The critical turn of feminist film theory was to show how the disavowal of production (on which Metz based his theory of the cinematic fetish) was "complemented by the construction of an image that finds its ultimate realization in the eroticized feminine." In this way, the media image as commodity fetish, concealing its mode and relations of production, is supported by turning the feminine body into a fetish. This whole process is condensed in the caption Birnbaum applied to a sequence of images of *Technology/Transformation* in her 1987 book *Rough Edits*: "Technology/Transformation: Wonder Woman/Special Effects."[19]

If, according to Mulvey's argument, the woman's body is turned into a fetish, Birnbaum's video raises the question of the agency of this woman-become-fetish. What appears as a traumatic threat to the fetishist may not be the same to the woman.[20] Without going into the detail of the psychoanalytic arguments,[21] it is not difficult to see that the excess that threatens the "phallic" desire of the fetishist is not necessarily threatening in the same way to women, insofar as their relation to the Oedipus complex is different. The excess may also be understood as an enjoyment (*jouissance*) that goes beyond both pleasure and desire and might be potentially transforming. By repeating the explosions, Birnbaum makes something insist that may otherwise be considered unrepresentable within the framework of commodity, fetish, and spectacle. The repetition of the explosion in *Technology/Transformation* recalls the blowing up of the luxurious desert mountain villa in Michelangelo Antonioni's film *Zabriskie Point* (1970), an explosion-as-spectacle repeated in slow motion to music by Pink Floyd that suggests the combination of destruction and enjoyment (which recalls the mixture of pleasure and pain in the Sublime as defined by Edmund Burke).[22] Filmed from a number of vantage points, the detonation is repeated at least thirteen times, with one silent scene of anticipation, before a further slow-motion sequence of exploded objects, again accompanied by Pink Floyd. We witness the destruction of the house and commodities of a corporate executive. We see a television blowing up, as well as an open refrigerator, a wardrobe of clothing, and a package carrying the word *Wonder* of Wonder Bread. The explosion sequence is preceded by a conference of businessmen discussing the exploitation of the desert, and the film ends with the sun sinking into the desert landscape, as if the act of destruction removed the house as an intrusion—subtracted it to return to the desert as a figure of the Real. The repetition of the explosion, and its slowing down to give it a sensation of weightlessness and floating, turns it into the figure of *jouissance*. The fetishistically architect-designed house on the hill has been exploded, its phallic unity shattered into myriad fragments. The explosion sequence cuts to the enigmatic smile of Daria Halprin, who has in its execution taken revenge for the shooting of a man, acted by Mark Frechette, with whom she made love at Zabriskie Point: the house belongs to an executive who wants to take her as a lover (and whom she no doubt considers to be a part of the "system" responsible for Mark's death). In both *Technology/Transformation* and *Zabriskie Point*, the explosions also need to be considered in historical terms; they are associated with Cold War fears of nuclear destruction but also with a liberating, revolutionary violence directed at the destruction of the commodity.[23]

The repetition in *Technology/Transformation* similarly has a double function. On the one hand, it shows the way in which the woman is trapped in dual roles as secretary and Wonder Woman, with the latter no less a trap than her secretarial subservience. On the other hand, it renders insistent the explosion that is the "special effect" of the transformation. In Freudian psychoanalysis, repetition is associated with the death drive, which Freud opposes to Eros. The former unbinds libido (as opposed to the binding of desire with the object and the narcissistic reinforcement of the ego), which becomes at once destructive and potentially liberating. Eros favors gestalt unities, the beautiful image, whereas Thanatos smashes the image. The moment of explosion in *Technology/Transformation* is thus a shattering of the image, which is at once destruction and the condition of possibility for transformation.[24] The video shows that, however frequently repeated, this transformation gets recuperated in the fetish that combines the technology of visuality with the objectification of the woman's body. The repetition brings this process itself to a campy excess that exposes a concealed truth of popular genre TV: it serves at once to acknowledge subversive and utopian energies and to recuperate them.

Technology/Transformation may be understood as taking the inverse approach to the same question Birnbaum tackles in *Chaired Anxieties*. The "anxiety" of the title is in the plural and may be considered as at least double. On the one hand, there is the anxiety of the woman trying to determine what acceptable posture to adopt—demure, submissive, concealing—in relation to the male look. But there is another anxiety involved that becomes more emphatic as Birnbaum, wearing a skirt, exposes her sex to the viewer—the anxiety provoked by the exposure of a "lack." This anxiety-provoking lack is, of course, precisely what the fetishist wishes to disavow and does so by over-investing in an object or image.

What guards against this lack, while depending on it, is the Law manifest in language—which appears explicitly as writing in the credits. At the end of a film or TV program, the credits that roll have a dual role. At the mundane level, they convey information, a list of proper names that is usually mandated contractually and by union regulation. The appearance of the credits, then, is a manifestation of the law, including copyright, after the end of the film or program. Conventionally, in cinema and television, the credits create a frame referring to the symbolic dimension of language around the dimension of image. The words that take the role of credits in *Technology/Transformation* are not "outside" the work, however, but rather add another side to its appropriation; the "credit" sequence incorporates a pop song with rolling lyrics on-screen, and it occupies an ambiguous position on the margin. The disco music and karaoke-style words invite an identification that is no longer alongside an image. These elements highlight an attempt to indirectly represent sexual enjoyment in *Wonder Woman*—combined with the disco song at the end of a woman's voice singing of a woman's pleasure. That is, the words that are read are tied, through the song as it is heard, to the experience of the woman's body—as heard, not as a fetishized unity, as the object of the gaze. Unrepresentable in the imaginary (except as explosion), the manifestation of this dimension in language is like rhythm and alliteration, which Julia Kristeva associates with the expression of the subjective drives.[25] As the text scrolls, the words disintegrate into their component letters, including the series of *O*'s that could be envisaged as circles around voids as the attempt to provide

Multiple-generation photocopy from the archive of Dara Birnbaum, used during the conception of Birnbaum's cover for the Zone Books edition of *Masochism*, by Gilles Deleuze and Leopold von Sacher–Masoch.

a visual equivalent to the sounds of ooos and orgasmic gasps. This is not to say that this potentially subversive enjoyment is not recuperated into the pop song as commodity, to which the subject is sutured by being invited to sing along.

> THIS IS YOUR WONDER WOMAN
> TALKING TO YOU
> SAID I WANT TO TAKE YOU DOWN
> SHOW YOU ALL THE POWERS THAT I POSSESS
> AND OO-OU-U-UU-UUU-UUUU

<p style="text-align:center">IV</p>

However transformed and adapted by editing and montage, appropriation necessarily implies a degree of assimilation to the economic and political context from which the material is taken. By the early 1980s, a time of increasing political conservatism combined with a burgeoning market, Birnbaum had turned to making videos out of material that she had shot herself in a working-class Italian American community, as if to assert both her independent agency as an artist and her acknowledgment of the politics of class and gender. Birnbaum's *Damnation of Faust Trilogy* comprises the videos *Evocation* (1983), *Will-o'-the-Wisp (A Deceitful Goal)* (1985), and *Charming Landscape* (1987). *Evocation* begins with a boy in a playground holding a swing, trying to look a little tough, inviting a girl to swing with him: "Georgeann, I'll take you up." "No, that's all right," she says. The motion then slows, and the image catches the boy's expression. Cut to a young woman in a room, hands on a

book; given the trilogy's title, one might make the viewer think of Goethe's Faust in his study, isolated from the townsfolk. The pages blow in the wind like leaves, and, together with pulsing electronic music in which synthesized grunts grow increasingly rapid and overlaid, this image gives the impression of a current of energy or emotion that is somehow alienated. A contrast is suggested between reading and action. The video then cuts to a young woman's face and a man at a drinking fountain, but a vertical wipe to the image of a wire-mesh fence suggests separation. The sequence evokes another borderline: that between childhood/adolescence and sexual self-awareness. We are then shown a sequence of shots of groups of boys and girls on both sides of this boundary. Sexualized interaction as a game—which we find in *Attack Piece*—is here set in relation to an architectural and social environment.

The sound track becomes like electronic bells as rooftops and sky appear, transitioning into a fan wipe back to the hand on the book, then to the woman in a room. The fan wipes continue into playground scenes, now showing two girls on a swing together. An effect of the inset is to juxtapose two temporalities, implying that we may be seeing a memory. The music becomes more driving as we are shown tenement buildings and two girls winding down the swing seat to give them a greater arc, followed by more fan wipes, now rhyming with the girls rising high together. The video then cuts between the playground and foliage, then pulls back to show first ferns on the edge of a pond, then the woman we saw reading in the room now outdoors shaking her head from side to side in the wind like a model on a photo shoot, which suggests both pleasure in nature—being outside the confines of her room and the enclosure of the yard—and an awareness of being filmed.

With *Damnation of Faust Trilogy*, Birnbaum shifts from using video to document performance (*Chaired Anxieties*) and reediting appropriated footage (*Technology/Transformation: Wonder Woman*) to using specially shot footage with effects and techniques, such as wipes, inserts, and slow-motion sequences, that, though with precedent in cinema (for example, Dziga Vertov's *Man with a Movie Camera* [1929]), are in technique and facility specific to video. Video is a medium that may as often be designed over a two-dimensional surface as edited through sequencing strips temporally. This different relation between space and time transforms the relation of the viewer to the image, which may be conceived in terms of its multiple spatial connections and vectors, as well as its narrative sequence. It is precisely these aspects that Jean-Luc Godard explored in a film he made three years before the appearance of Birnbaum's *Damnation of Faust Trilogy: Evocation*. The film *Sauve qui peut (La vie)* (Everyone for Themselves [Life], 1980), released with the English title *Slow Motion*,[26] marked Godard's return to 35 mm film after a decade of experimenting with video and producing TV programs with Anne-Marie Miéville. Indeed, one of the three central characters, called Godard, is a TV director, and one of the scenes takes place in a classroom with a blackboard on which is written: "Caïn et Abel/Cinéma et Vidéo." In the film, Godard introduced video techniques into cinema to further extend his survey of ways of thinking about the image, an investigation he had begun earlier with montage and text. The film is divided into chapters indicated by intertitles, lending the action an allegorical dimension (which is also reflected in the three-part structure of *Damnation of Faust Trilogy* and its allusion to a work of literature that is itself allegorical). In *Sauve qui peut*, Godard uses various editing techniques,

including juxtapositions of images and extreme slow motion, that are clearly influenced by his experience in video. The slow-motion sequences, in particular, transform the temporality of the image and invite the viewer to look at an image in a way that combines aspects of stillness and movement. On the one hand, the image can be scrutinized with something like the kind of attention with which one regards a photograph. In the context of the fractured narrative, we look for gestures and expressions exchanged between characters that might reveal some truth we might otherwise have missed. On the other hand, as moving image, the slow-motion sequences function like nodes between different trajectories in the film, drawing attention to movements and disclosures that might be missed or desired in the trajectory of the narrative beyond the image that is presented. These moments in Godard's film can be compared with the slow-motion moments in the first playground sequence of *Damnation of Faust Trilogy*, especially the sequences involving the swings. Instead of proceeding with a forward drive, the slowly moving image seems as if loaded with potential. Or, to put it another way, that which passes—the everyday, ordinary moment—is turned into an image as if by being folded back on itself, as a result of which the task of the viewer becomes the unfolding of it.

Before the release of *Sauve qui peut*, Godard made a "scenario" video, an essay film on his working methods and ideas for the larger movie, using a combination of text, voice-over, still and moving images, and sequences of footage repeated in order to explain how they work.[27] It begins with an IBM "golf ball" typewriter lettering over an image and the voice of Godard saying that he was writing on the typewriter "horizontally," as we do in Western writing, and was surprised by the "sudden appearance of the image" (*le surgissement de l'image*). But then, Godard says, he was intrigued by the "sudden vertical emergence" of an image, "like something rising to the surface," which made him "think of Japanese or Chinese writing—about pictograms, ideograms."[28] He concluded that he should be able to write both horizontally and vertically and not always horizontally first—"which is to say, death first." The cinematic devices of slow motion and superimposition may be interpreted as attempts to change or interrupt the "horizontal" movement—the linear movement of narrative that subordinates images—with other vectors, allowing both for the image to operate as an emergence or withdrawal and for "vertical" readings linking, for example, the different sequences in slow motion. What he wants to show is a "way of seeing," "using slow motion, either during superimposed images or a regular shot, to see if there is something to be seen, about which something can be said, and which might then alter the arc of the story." Godard associates these possibilities not with the image detached from writing but rather related to non-Western forms of writing, and by implication other ways of relating time and space. He speaks of an image "diving" in an opposite direction to the meaning and discusses characters in *Sauve qui peut* as images with different kinds of height, depth, motion, direction, vector, and speed: character becomes image, and image becomes event.

In her videos appropriating television footage, Dara Birnbaum had already broken with the "linear" narrative organization of moving images, through repetition and by means of various insets and wipes. In *Damnation of Faust*, where we also find the use of slow motion that Godard describes, this spatialization

Stills from *Damnation of Faust Trilogy: Evocation*, 1983.

of the image using fan wipes, as well as column-shaped and "window" insets to create complex temporal interrelationships, may be compared with a non-Western source, the Japanese woodblock print, and its descendent in comic books. This spatialization is further emphasized in the way that the work has been installed.[29] Monitors playing *Damnation of Faust* have been placed in relation to enlarged still images from the video, which were curved like Japanese woodblock fan-shaped prints.

In the *Scenario* video to *Sauve qui peut (La vie)*, Godard speaks of cinema as the organization of a system of images that won't necessarily take a horizontal form or relate to the human body. Similarly, in *Damnation of Faust*, Birnbaum explores a fundamental transformation of the experience and concept of the moving image; as with Godard, this transformation emerges out of the possibilities for editing opened up by video. While Godard, concerned with maintaining the perfection of the images achieved in cinema, applies these possibilities back to 35 mm film in *Sauve qui peut*, and thus restricts them, Birnbaum develops them within video itself. The themes of disappointment and loss in *Will-o'-the-Wisp*, which follow the potential contained in the adolescent energy of the first part, are counterpointed by the energy and multiple vectors of the subsequent images, including those in *Charming Landscape* of extracts from footage of political demonstrations. The use of fan wipes, recalling Japanese fan prints, suggests a break with the straightforward rectangular "window" model of representation that derives from Renaissance pictoriality and became the Western norm for four hundred years.[30] The fan and column wipes emphasize that the screen is a surface across which transformations take place rather than a window on to a pro-filmic scene, an event in front of the camera. The static nature of the architectural display in the work's installation, within which the viewer rather than the image moves, serves to emphasize by contrast the dynamism of the video. At the same time, the architectural dimension of the installation carries the viewer beyond the frame of the monitor and by implication prompts him or her to think about what is being seen beyond the way in which the media frames images, in a manner that extends into actual bodily life. In effect, the lesson of Minimalism—that the body absent from the object is the body of the viewer himself or herself experiencing space and time—is being applied to mediated images and sound.

In yet another affinity with Godard, Birnbaum works with the image in terms of different spatial and temporal trajectories, which concern different relationships to life conceived as energy and potential. In *Evocation*, the movement of the figures has a surging, upward dynamic; as with *Technology/Transformation*, it is a matter of transition, in this case from adolescence to adulthood. *Evocation* is full of hands-on physical activity, play, and flirtation. The second part, by contrast, conveys the experience of detachment and thoughtfulness resulting from disappointment and loss. While taking the title of the work as a whole from Hector Berlioz's opera *The Damnation of Faust*, the title of this part, *Will-o'-the-Wisp (A Deceitful Goal)*, alludes to a strange, hybrid scene in Wolfgang von Goethe's *Faust*, a witches' Sabbath in the Harz mountains, which plays on the relation between enlightenment and rationalism on the one hand, and myth, fairy tale, and the erotic on the Other. Will-o'-the-wisps were believed to be spirits that led travelers to their destruction; they were explained as being the effect of phosphorescent swamp gas. The

Photocopies of Japanese comic books, c. 1983, from the archive of Dara Birnbaum.

idea of a mechanically produced figment of the imagination could be applied to image media. Birnbaum attaches the title to a part of her *Damnation of Faust Trilogy* that is concerned with the relation of sexual desire to distance. If in *Evocation* a woman takes the part of Faust with his books, here it is as if the female narrator takes the point of view of Marguerite, as she talks about the absence of her lover. Looking out the window, she talks about how you deform the past according to your desires, because you never really know what the other person in a relationship thinks. The affair was conducted at a distance—"there would be letters, and occasionally phone calls" that would "feed a kind of passion." She says, "Even if our being together had driven us apart, the distance would bring us together again." The relationship takes place in a bubble: "He had cut off his social life." It seems that it existed in the mode of the past and the future, without a present: "There were always more things to look forward to than things to regret. . . . That was only in the end." During this monologue, the image alternates between shots of the woman in her room looking out the window and inset frames showing young people in the street seen from above. *Evocation* is full of anticipation, combining a camera closely framing the children and young people with movements upward, whether in the exhilaration of the swing rising higher and higher or the upward pans of the building, all culminating in the roof, sky, and sense of free horizon of the coast: a journey to be embarked on. In *Will-o'-the-Wisp*, by contrast, a downward regard dominates. The window as a viewpoint of the subject onto the world, broken through by the fan and column wipes of the first part, is here reinstated as a perspective within the image, framed within the frame, now with a meaning not of making the world present but of separation and loss. The solitary woman in her room becomes a figure of melancholia.

Toward the end of part two of Goethe's drama, Faust believes that the spirits of the dead under Mephistopheles' command, who are digging his grave, are laborers working on a land-reclamation project that will benefit mankind. *Charming Landscape*, the third part of Birnbaum's *Damnation of Faust*, begins by showing that the housing and playground of the first part have become a construction site, which results in the dispersal of the community that had surrounded them. Insets show children playing in the ruins. A young woman's voice declares, "As you get older, and you think back, you realize that this really affected me. I'm trying to find where I stand." Another young woman's voice tells us that if people were in trouble, "you always helped them out." The destruction of the key site of their childhood calls forth a search for a ground, somewhere one can take one's stand, and the recollection of a lost community.

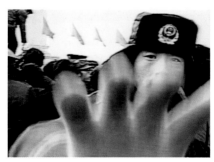

Stills from *Damnation of Faust Trilogy: Charming Landscape*, 1987.

The shot of the building site in *Charming Landscape* merges seamlessly into sequences of footage in black-and-white and color of political struggles since the 1960s: episodes from American civil rights protests in the South, the riots at the Chicago Democratic National Convention of 1968, May '68 in Paris—many of the sequences show violence on the body, such as people being beaten by police—and finally Tiananmen Square in Beijing in 1989, where soldiers or police are shown videotaping demonstrators, and the filmmakers themselves, until one of them puts his hand over the lens, effacing the scene.[31] This sequence recalls Chris Marker's extended retrospective reflection on the politics of the 1960s and 1970s, *A Grin without a Cat* (1993), reedited from *Le Fond de l'air est rouge* (1977). In Birnbaum's ending, state power is

Planning sketch for *Damnation of Faust (Installation)*, 1984.

shown to attempt to control the image and obliterate its oppositional use. During this sequence, the women talk about themselves in the past: "I was loud"; "I was free. . . . I was carefree"; "I see how much is still the same." At the end of the video we see the dedication: "For Pam and Georgeann, born May 1968 and February 1969." The whole of *Damnation of Faust Trilogy*, thus, may be understood as a gift for the two girls seen swinging together in the first part and later recalling the past against the destruction of the place where they grew up. Just as Robert Burton's seventeenth-century *Anatomy of Melancholy* ascends through levels of the affliction, from physical to sexual to religious melancholy, so the *Damnation of Faust Trilogy* seems to pass from the melancholy brought about by the loss of the sexual love object to an act of political love, which takes the form of a gift of memory—Mnemosyne—by the artist. It is a gift, from the artist, of political memory.

V

If *Technology/Transformation: Wonder Woman* shows Woman spinning between the roles of subordinate and fetish, and *Damnation of Faust Trilogy* passes through expectation and melancholy to political love, *Erwartung/Expectancy* uses projections of hysterical speech and anamorphic imagery to "deframe" the image of Woman. While the work expresses extreme anxiety in its fragmented text, it presents the feminine as escaping the impasse of *Technology/Transformation*, in which no real transformation occurs. The fixity of options in *Technology/Transformation* is expressed through the appropriation of the image from television, while in *Damnation of Faust Trilogy* and *Erwartung*, the turn to an identification with the subjective position of the feminine as melancholy and hysteric involves allusion to opera: *Erwartung*, which translates to "expectancy," is based on the opera of this title by Arnold Schoenberg. The defining characteristic of opera is the voice as excess, and Birnbaum foreshadows the transition from the visual "sublime" to vocal excess with the titles accompanied by disco music in *Technology/Transformation*. *Damnation of Faust*

and *Erwartung* explore different relations to excess: in *Will-o'-the-Wisp*, the middle portion of *Faust*, what is stressed is detachment, distance, and the necessity to come to terms with loss; in the latter, it is rather the opposite: a proximity that becomes horrifying.

Birnbaum has made two different installations of *Erwartung*. Both involve projecting video of still images of a woman in white and fragments of the opera's libretto on to an enlargement of a sketch by Schoenberg for the set. One features an exterior projection in public space, the other an interior installation in a "black-box" gallery. While these variations change the relation of the image of Woman to light, both versions end with her disappearance: "What am I to do alone here? . . . In this endless life . . . in this dream without limits or colors . . . light will come for every one. . . . But me, alone in my darkness? Morning separates us." In the outdoor, architectural version, Birnbaum projects on the facade of the Kunsthalle Wien an enlargement of the Schoenberg watercolor, in which, Birnbaum says, "the forest seems to also form an ocular, centrifugal, center: an eye within the storm of absence and abandonment."[32] During the day, this is all that can be seen. As the daylight fades, the image of the woman emerges, in seventeen mise-en-scènes, one after the other with fragments of Marie Pappenheim's libretto as text in white over the image, only to disappear again with the coming of day, leaving behind the empty oculus of the forest.

The version of *Erwartung* shown at the Jewish Museum, New York (mounted in 2003), was installed in a darkened room and accompanied by sound consisting of a manipulated extract from Schoenberg's opera. The move away from direct appropriation in *Damnation of Faust* freed Birnbaum from the subjection to the given that is a risk that accompanies the use without transformation of appropriated material. It introduced a transformative process while positing the subject as a melancholy one. *Erwartung* involves a return to appropriation, incorporating Schoenberg's watercolor stage design and Pappenheim's text, which in the process is freed from its status as libretto, subordinate to the music, and made the focus. These elements are combined with the images of a woman in a white dress—garb that alludes to both the mental patient and the operatic trope of the doomed woman. A DuraClear

Planning sketch for *Damnation of Faust* (Installation), 1984.

print of a drawing by Schoenberg for the stage set of the opera is mounted on four hanging Plexiglas screens, forming a single image. A video consisting of stills is projected onto the panels. The image of a woman is thus reflected both from the Plexiglas and from the wall behind, which embeds the image of the woman into the Schoenberg drawing. Text has been added into these images, which morph into one another by means of fade-ins and fade-outs. The woman comes to seem like a ghost, manifesting herself from different angles, a return of the repressed. What the gallery installation makes possible (different from the architectural projection in Vienna) is a transformation of a space involving projected images and words by a confrontation with an excess that is associated with, simultaneously, horror and enjoyment. The installation involves the viewer in this transformation as an embodied being, standing and moving around the space rather than seated and fixed in place—and therefore to a degree disembodied—as in a typical opera performance. Further, images surround the viewer, as the central projection is reflected onto Plexiglas from a ninety-degree angle. This side projection distorts the images into anamorphic forms. If the traditional setup of perspective offers a unified point of view, which could be taken to coincide with the position of camera and projector in cinema, Birnbaum has thrown this into question in the way she installed and edited her previous videos. In *Erwartung*, subject positions are rendered ex-centric and multiplied, triggering the distortions that might be associated with fantasy and hysterical delusion.

Damnation of Faust, as we have seen, is explicitly concerned with separation and loss. *Erwartung* takes this concern further, into a confrontation with death: the woman stumbles over what seems to be the corpse of her lover, which is at once an objectification and a delimitation of the dimension of death. This death is not, however, that of a heroic "being-towards-death"[33] but rather death as the other side of what Julia Kristeva calls the "semiotic chora," in which drive has the chance of finding "voice" in the symbolic.[34] The installation creates a choric space that envelops the viewer and in which image and text are multiplied, dissolved, and re-formed. In a sense, Birnbaum frees Pappenheim's text from the traditionally patriarchal genre of opera, dependent on the male composer and maestro-conductor, while also reclaiming it as "chora": a maternal space in which fusion and separation, drive and the possibility of its forming and symbolization, meet. This dimension had always been present in opera's emphasis on the materiality of the voice independent of its linguistic content.[35]

The explosion that appears in *Technology/Transformation* stands in contrast to the fragmentation of language by Pappenheim in her text for *Erwartung*. The explosion presents an unrepresentable power or drive; the transformation to which it gives rise nevertheless remains a symbol of the nation in red, white, and blue, and its shattering potential is disavowed in the fetish. Without denying the possibility and use of female fetishism, Wonder Woman is a figure split between being both an object of identification for women (identification with her agency, at the cost of "being" the phallus) and an object of disavowal of the lack of maternal phallus in men: placating castration anxiety through the suspension of the fetish, she is a repudiation of a threatening sexual

Untitled drawing from a sketchbook, c. 1970s.

difference, associated historically with the rise of feminism during the time of the *Wonder Woman* series. In relation to chora, fetishism acts as the disavowal of the maternal dimension of symbolization. The fragmentation of language—specifically of syntax—in *Erwartung* opens the possibility of another speech, of which rhythm, syncope, and tone are essential elements.[36] A parallel movement occurs in the image that concerns not just its gestalt but also its ground or matrix.[37] The mirror of *Technology/Transformation* becomes a screen. This screen not only implies a behind-of-the-image—that is to say, the impression that there is something other covered by the image—but also generates an anamorphic projection and perception. In *Erwartung*'s gallery installation, the images—in particular, the images of the woman—are multiplied by Plexiglas screens and projected onto the walls at an angle, which means that the images are distorted when viewed straight on and corrected when seen from an angle. In their distortion, they approach the character of a stain. A stain is something that is in a sense always too close however far away it is. In relation to anxiety, it functions as a phobic object, like a spider for those who are averse to it: rather than objectifying and distancing the anxiety— a distance that allows the temporary transformation of anxiety into fear—the stain marks the place of a nonobject that threatens to spread and increase the more the subject tries to erase it. As in fetishism, the subject is threatened, but this time the threat is not to the ego from a lack; rather, the threat is to the being of the subject from an excess, from something—both pleasure and horror—that comes too close, that in the darkness of the forest cannot be distinguished. The woman sees what she thinks is a bench until she stumbles over it, at which point she believes it is the corpse of her lover. This shift from a possibly illusory vision to a tactile encounter, with its collapse of distance, does not necessarily resolve the delusional character of the woman's experience, if she is in a state of hysteria and there is no perspective offered outside her own.

As noted, in the gallery version of *Erwartung*, the projected images partially bounce off the Plexiglas screens onto the side walls, and the angle of reflection causes the images to distort when seen from directly in front of the wall. Images bounce from the Plexiglas screens as mirror images onto the walls and floor and reflect back from the screens in corrected form. The imagery and text are thus manifest as reflection, in anamorphosis, and then as second reflection. This doubled effect of entrapment and dispersal or excess becomes a homology to the experience of the female subject of the opera. This operation of anamorphosis performed on the image implies that something—some "thing"—that is not otherwise represented becomes manifest when seen from an oblique angle, when the subject is displaced from its centered position in relation to the vanishing point of traditional perspective (which originated, of course, in experimentation with a mirror). The effect undermines the authority of the central viewpoint of perspectival painting, and the stage sets based on it, which developed in the sixteenth century—that is, the point in relation to which all lines converge and from which space and the truth of representation are organized and the image coincides with its "readability."[38] The suggestion is that otherness can only be encountered anamorphically, which also means in relation to an edge, and at the point where the image, seen at an extreme angle, vanishes.[39] It is as if we are on the point of passing through the surface of the image, to a place where distance and the distinction between inside and outside collapse, and something unspeakable and unrepresentable might be encountered.

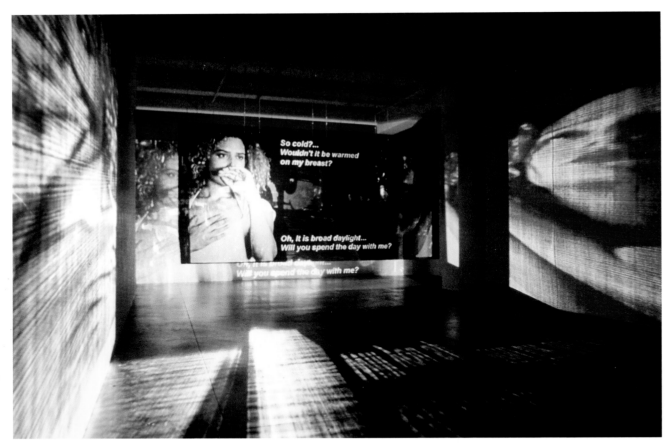

Erwartung/Expectancy, 1995/2001, installation view at Marian Goodman Gallery, New York, 2002.

Marie Pappenheim drew on the language of hysteria for her libretto for *Erwartung*. Peter Brooks argues that a convergence of melodrama and psychoanalysis occurs around the hystericized body, which is typically a woman's body.[40] According to descriptions and case histories of the late nineteenth and early twentieth centuries, the hysteric's body speaks in physical symptoms like tics, paralyses, and coughs. Brooks argues that opera combines two apparently contradictory tendencies of melodrama: the extreme embodiment of meaning and lyric self-expression (Brooks, p. 121). It involves spectacularization of both body and voice, to the point of an acting out of emotion, "not merely of imitating affect but of reproducing it before our eyes" (Brooks, p. 123). This amounts to what Freud in "Remembering, Repeating, and Working-Through" describes as acting out where remembering takes the form of a repetition.[41] But "the hystericized voice does something that the hystericized body cannot do":

The aria offers us at once the symptoms of the hysterical impasse and the working-through of the impasse. Voice unleashes passion, and thereby brings . . . the solution, in the lyrical assumption of self and situation. (Brooks, p. 125)

In other words, Brooks finds opera to be both symptom and "talking cure" (p. 126). This conception of opera as the resolution of an impasse is precisely what Susan McClary questions in her discussion "Excess and Frame: The Musical Representation of Madwomen."[42] She traces the way that in opera the monstrousness of the diva as "madwoman," which manifests itself musically

through repetitive, ornamental, or chromatic excess, is controlled by "normative procedures representing reason," which "are erected around them to serve as protective frames preventing 'contagion'" (McClary, p. 81). She compares this operatic manifestation of the feminine with famous paintings celebrating psychiatry, Tony Robert-Fleury's *Pinel Freeing the Insane* (1876) and André Brouillet's *A Clinical Lesson with Doctor Charcot at the Salpêtrière,* (1887), in which the madwoman is exhibited by the male doctor as a sexually titillating display: "The frame of masculine rationality is constantly visible to guard against the male-constructed (or framed) image of the madwoman" (McClary, p. 85). Hysterics became enigmatic and troubling objects of visual scrutiny in the name of medical science, as acutely demonstrated by the photographic "iconography" produced in Paris at the psychiatric hospital of La Salpêtrière under the direction of Jean-Martin Charcot.[43] For some months during 1885–86, Freud studied with Charcot and later, together with Joseph Breuer, founded the practice of psychoanalysis, thereby breaking with Charcot's specular and physical relation of doctor to female hysteric and turning instead to an aural relation—namely, that of the doctor listening to the patient. The first of the founding case histories, published in *Studies in Hysteria* in 1895 under the title "Fräulein Anna O.,"[44] concerned Bertha Pappenheim, who should be credited as the co-creator of the "talking cure." Pappenheim, a relative of the young medical student who wrote the libretto for *Erwartung*, became a leading feminist and social worker. Specular objectivation and the symptomatic character of the speech of the so-called hysteric and its relation to women's writing have since been a crux of feminist theory, as well as sources of inspiration to artists, writers, and composers.[45]

André Brouillet, *A Clinical Lesson with Doctor Charcot at the Salpêtrière,* 1887.

Music differs from visual representation in both seeming to manifest interiority and collapsing the defensive distance of perspectival visual representation. It thereby increases the risk of contagion, which means that—at least in traditional opera—the frame has to be enacted all the more dramatically (McClary, p. 86). McClary argues that in the work of Richard Strauss—especially in "the monstrosity of Salome's sexual and chromatic transgressions"—"the frame itself has lost its hegemonic authority" (McClary, p. 100). What is happening is an assimilation of the avant-garde of the transgression and excess represented by the operatic madwoman—"the signs of their madness are usually among the favorite techniques of the avant-garde" (McClary, p. 101). This act culminates the appropriation of feminine creative attributes by the male "genius" in Romanticism.[46]

In Marie Pappenheim's libretto, the masculine "frame" has turned into a corpse, possibly murdered by the madwoman, and in Schoenberg's music any possibility of tonal resolution or framing has disappeared into a total chromatism. If opera's "frame" has disappeared, the traditional binary has not. In his 1911 treatise *Theory of Harmony*, Schoenberg "affiliates himself with what had always been defined as the 'feminine' side of all the binary oppositions governing tonal procedures and narratives," while at the same time avoiding mapping the binary onto gender by aligning his atonality with "resistance against oppressive political authority" and "the properly masculine business of revolution" (McClary, p. 105). McClary writes:

Not surprisingly, his metaphorical surrogate in Erwartung—*the piece in which he committed his supreme violation, his break with tonality—was once again the*

figure of the madwoman. . . . Schoenberg's celebrated "emancipation of the dissonance" is self-consciously presented as the liberation of the female lunatic, of the feminine moment of desire and dread that had driven most nineteenth-century narratives. . . . If he managed in his theoretical writings to construct transgression as a heroic deed, his artistic enactment of that transgression in Erwartung *betrays his inability to dismiss or transcend traditional binarisms and their gendered associations.* (McClary, p. 107)

After apparently collapsing the rational frame in *Erwartung*, through both atonal chromatism and his use of Pappenheim's narrative, Schoenberg creates an entirely rationalized system in the twelve-tone scale, but he continues the identification of the madwoman with genius and the avant-garde. The probable murder by the woman of her lover is indicative of the dispensing with the "masculine" frame around "feminine" madness. Atonality is then identified with this feminine excess, despite being recuperated by Schoenberg in his writing for the "masculine" project of revolution.

Birnbaum's *Erwartung* is thus the reappropriation of the appropriation by Schoenberg of the "madwoman"—and if the video monitor of *Chaired Anxieties* is a framing of her own performance of insanity then the later installation could perhaps be understood as what has been described as "de-framing." In the third and final part of *Chaired Anxieties*, titled *Addendum: Autism*, Birnbaum presents herself as a madwoman—hair disheveled, animal movements, exposing her sex unself-consciously (which compares to the display of the hysteric in the painting of Charcot). The monitor acts as the "frame," like the window with bars at the seventeenth-century madhouse where lunatics were a public spectacle, to keep the excess within bounds—bounds determined by patriarchy—and to keep the contagion from spreading. It is precisely on the frame, the edge, the side walls, that Birnbaum works in her version of *Erwartung*. Indeed, her installation could be seen as an act not so much collapsing or transgressing the frame as what in cinematic theory has been called "deframing." Pascal Bonitzer, in his essay "Décadrages" (Deframings),[47] complicates the way film theory of the early 1970s drew on the theories based on Renaissance perspective by suggesting that something happens in cinema that is distinct from the positioning of the spectator by perspective in painting, and that this has something to do with the "movement" characteristic of cinema (Bonitzer, p. 81). Bonitzer contrasts the centrifugal composition of Diego Velázquez's *Las Meninas* (1656) with an emptying out or effect of the void in what he calls *décadrage*. In *décadrage*, something is missing from within the frame; for example, we see the look of horror in the face of the woman, but we don't see its cause. Whereas this would remain enigmatic in a painting or a photograph, movement allows cinema to resorb and deploy the effects of the void by means of reframings. By suggesting that continuity in cinematic editing is a form of reparation (Bonitzer, p. 82), Bonitzer implies a traumatic dimension to the deframing void within the frame. The solution of continuity, Bonitzer argues, is double, scenographic and narrative, and these do not coincide. Certain filmmakers—Bonitzer names Antonioni, Straub-Huillet, and Marguerite Duras—introduce a nonnarrative, that is to say scenographic, suspense by means of strange and frustrating framings (Bonitzer, p. 83). This "lacunary scenography" prevents the resolution of the fragments into a total image and is thus opposed to the dialectical cinema established through montage by Sergei Eisenstein. In this nonnarrative suspension, a tension perdures

from shot to shot that the narrative does not and cannot resolve. Bonitzer claims that in the center of the image, where in the classical tableau one would expect to find a symbolic presence, in *décadrage* one finds "nothing," even if this "nothing" or void is not—and here he refers to Godard—the loss of classical unity (and therefore its negative replacement or recentering) but rather a multiplier, the generator of new configurations. It is precisely this connection of deframings with the generation of new configurations that we find in Birnbaum's gallery installation of *Erwartung*. This siting, like the nightclub screenings of her appropriated TV videos and the architectural and pictorial installations of *Damnation of Faust*, represents the effort to exceed the frame.

As installation using image projection to rework an opera, *Erwartung* creates a topology that has characteristics of both deframing cinema and what has been called "postdramatic theater." Hans-Thies Lehmann argues for a theater that combines the characteristics of Kristeva's semiotic chora with the presence of text as an interruption of the self-sufficient imagery of the stage.[48] Language "loses its immanent teleological temporality and orientation towards meaning and becomes like an *exhibited object*" (emphasis in original, Lehmann, p. 147). He argues that such theater marks a shift from a "dramatic" space that is metaphorical and symbolic and that functions like a mirror of the world of the audience that is separated from it to a "postdramatic" space that is rather a "metonymic space," which instead of producing another symbolic world is in continuity with the real space of the theater (Lehmann, p. 149). Effectively, this deframed theatrical space invites the audience to engage in an energetic, bodily relationship with the performance. In Birnbaum's *Erwartung*, too, we find an interruption of the image through the presence of text and, by means of the anamorphic projection, the incitement of a bodily relationship with a mobile viewer. Yet, unlike in theater, since Birnbaum is using projected image, the actual body of the performer is absent—or, perhaps more accurately, present as absence, at once multiplied as image and set in relation to the void provoked by "deframing."

Transformation is a central concern of *Technology/Transformation*, *Damnation of Faust*, and *Erwartung*. In each case, a blockage is confronted: the media image in the first, the loss of a home ground owing to the capitalization of property in the second, and the stereotypical framing of the "madwoman" in the third. The energetic dynamic of the image finds its resource in feminine *jouissance*, the potential of which is considered in relation to the political situation. *Technology/Transformation* is dynamic but pessimistic, since the ecstatic is recuperated into fetish and commodified mass culture, practically without remainder. *Damnation of Faust* is melancholy but has an ending that implies the resource for future social transformation contained in political memory. *Erwartung*, through its extension of projection into reflection and anamorphosis, hints at the possibility of breaking the frame, with the release of energy that would result. The models according to which the visual artwork is conceived have

Untitled drawing from a sketchbook, c. early 1970s.

also changed: from the appropriated image with its roots in collage and the readymade to a recovery of opera, the concept of an art for a collective audience in an age when audiences have become fragmented. Whatever its nineteenth-century limitations as a bourgeois art form, to invoke opera now is to recall and to anticipate the possibility of a political community.

<div align="center">VI</div>

At the center of Maurice Blanchot's *récit The Madness of the Day*, a favorite of Birnbaum's, the narrator is rendered blind by the light.[49] This event marks a kind of hinge between what is possible to narrate and what exceeds all narration. In addition to the experience of a blinding light, an excess of lucidity on a knife edge with madness, the story contains the figure of a revolving door. It thus hints for us at the connections between Birnbaum's different works, from the spinning of Wonder Woman in *Technology/Transformation* through the encounter with the everyday and the experience of loss in *Damnation of Faust* to the disappearance of the image in a blinding light in *Erwartung*. Blanchot represents the Law in the form of an ophthalmologist and a doctor—the medical gaze—but, in addition, there appears in the story a female personification of Justice, who asks for responsibility to singularity. Thus Justice has to do with an accord with the event as singularity that interrupts the dominion of the Law. In 1999, Birnbaum produced a political poster that showed a cartoon image of a woman against an explosion with the words "end violence celebrate peace now": it is ambiguous whether the woman has been blown away by the explosion or is dancing.

Poster designed by Dara Birnbaum, 1999.

1 The other participants in *Attack Piece* included Dan Graham, David Askevold, Ian Murray, Cyne Cobb, and Christina Ritchie.

2 For the reception of video in terms of immediacy, see William Kaizen, "Live on Tape: Video, Liveness and the Immediate," in *Art and the Moving Image: A Critical Reader*, ed. Tanya Leighton (London: Tate Publishing, 2008), pp. 258–72.

3 Rosalind Krauss, "Video: The Aesthetics of Narcissism," in *New Artists Video: A Critical Anthology*, ed. Gregory Battcock (New York: E. P. Dutton, 1978), p. 179; reprinted from *October* 1 (Spring 1976), pp. 51–64.

4 Dara Birnbaum, "Transformation/Technology" (1987) project notes, Dara Birnbaum Archive. In this book, p. 97.

5 Theodor W. Adorno and Max Horkheimer, *Dialectic of Enlightenment* (New York: Herder and Herder, 1972).

6 See Benjamin H. D. Buchloh, "Allegorical Procedures: Appropriation and Montage in Contemporary Art," *Artforum* 21, no. 1 (September 1982), pp. 43–56.

7 See Douglas Crimp, "Pictures," *October* 8 (Spring 1979), pp. 75–88; reprinted with variations, including a discussion of work by Cindy Sherman, who was not in the "Pictures" exhibition, in *Art After Modernism: Rethinking Representation*, ed. Brian Wallis (Boston: David R. Godine, 1984), pp. 175–87. For a discussion of appropriation art in New York in the late 1970s and early 1980s, see my *Richard Prince: Untitled (couple)* (London: Afterall Books, 2006).

8 See Buchloh, "Allegorical Procedures," pp. 43–56.

9 Dara Birnbaum, *Rough Edits: Popular Image Video, Works 1977–1980*, ed. Benjamin H. D. Buchloh (Halifax: Press of Nova Scotia College of Art and Design, 1987), p. 12.

10 See "Do It 2: Cory Arcangel and Dara Birnbaum in Conversation," *Artforum* 47, no. 7 (March 2009), pp. 191–98.

11 The gallery was Nova Gallery. For a discussion of Jeff Wall and Marcel Duchamp, see my "Towards the Reinvigoration of the 'Western Tableau': Some Notes on Jeff Wall and Duchamp," *Oxford Art Journal* 30, no. 1 (2007), pp. 81–100.

12 For an interpretation of the readymade and appropriation more in line with Birnbaum's approach, see John Roberts, *The Intangibilities of Form: Skill and Deskilling in Art after the Readymade* (London: Verso, 2007).

13 According to Jacques Lacan, while the pleasure of the Freudian pleasure principle is limited by its relation to reality, *jouissance* (which is usually translated as "enjoyment") is "beyond the pleasure principle" in that it is excessive (a "plus" not a lack), a transgression of limits and refusal of oneness. Rather than involving a simple experience of pleasure, it involves pain or suffering, which may be mixed with pleasure, and is the encounter with the impossibility of a full satisfaction (therefore it is not the orgasm). Rather than being in relation to the limits of reality, it is in relation—an impossible because unmediated relation and therefore traumatic—to what Lacan calls the Real, which is the dimension of the drives. *Jouissance* is prohibited by the Oedipal Law of the Father, which calls for symbolic substitution (desire) rather than a relation to the Real that refuses substitution (*jouissance*). The *jouissance* excluded by the Symbolic Order and that is not caught in the chain of signifiers of language appears as what Lacan calls "object a," a piece of the Real that manifests itself in the imaginary (in the image conceived as a screen) as a hole that is covered or masked, for example, by a stain or anamorphic figure; in the field of the visible this is the place of the gaze (see Jacques Lacan, *The Four Fundamental Concepts of Psycho-Analysis* [London: Penguin, 1977], pp. 105–16). In *The Seminar of Jacques Lacan. Book XX: Encore. On Feminine Sexuality: The Limits of Love and Knowledge 1972–73*, ed. Jacques-Alain Miller, trans. Bruce Fink (London: W. W. Norton, 1998), Lacan developed the distinction between "phallic" and "feminine" *jouissance*. Phallic *jouissance* is dominated by the impossibility of establishing the sexual relationship as a One or unity, so enjoyment is related not to the (body of) the Other but to the oneness of the phallus. According to Lacan's reading of women mystics, women (and some men) have access to a specifically feminine *jouissance* "beyond the phallus" (p. 69). (Lacan interprets the idea of the Other as God as based on feminine *jouissance*.) This is because, given that their relationship to the Oedipus complex is different from that of men, women's being is not entirely subsumed to the phallus. However, because access to the Symbolic Order depends on symbolic castration—acceptance of the Law of the Father—this feminine *jouissance* is for Lacan "ineffable" (p. 21), unsayable and unsymbolizable. Julia Kristeva's theory of the semiotic dimension of language as expression of the drives, and the chora, would question this unsymbolizability of feminine *jouissance*. For discussions of jouissance in Lacan, see the entry in Dylan Evans, *An Introductory Dictionary of Lacanian Psychoanalysis* (London: Routledge, 1996); and Néstor Braunstain, "Desire and Jouissance in Lacanian Teachings," in *The Cambridge Companion to Lacan*, ed. Jean-Michel Rabaté (Cambridge, UK: Cambridge University Press, 2003), pp. 102–15.

14 The metallic bra cones used for Wonder Woman in the TV series are similar to—and may derive from—a dominatrix costume. See the undated photograph from Paula Klaw/Movie Star News, "Cone bra and *cache-sexe*," in Valerie Steele, *Fetish: Fashion, Sex, and Power* (New York: Oxford University Press, 1996), p. 135. Bras with circular, whirlpool cups were popular in the 1940s and 1950s (p. 136).

15 See Jason Mittell, *Genre and Television: From Cop Shows to Cartoons in American Culture* (New York and London: Routledge, 2004), pp. 161–62.

16 Sigmund Freud, "Fetishism," in *Penguin Freud Reader*, ed. Adam Phillips (London: Penguin, 2006), p. 91.

17 Christian Metz, *The Imaginary Signifier: Psychoanalysis and the Cinema* (Bloomington: Indiana University Press, 1982), p. 74.

18 Dana Polan, "Stock Responses: The Spectacle of the Symbolic in *Summer Stock*," *Discourse* 10 (Fall/Winter 1987–88), p. 124, quoted in Laura Mulvey, "Some Thoughts on Theories of Fetishism in the Context of Contemporary Culture," *October* 65 (Summer 1993), pp. 5–6.

19 See Birnbaum, *Rough Edits*, pp. 32–33.

20 This is not to exclude the possibility of *female fetishism*. See Lorraine Gamman and Merja Makinen, *Female Fetishism* (New York: New York University Press, 1995).

21 See Parveen Adams, "Of Female Bondage," in *The Emptiness of the Image: Psychoanalysis and Sexual Differences* (London and New York: Routledge, 1996), pp. 27–48.

22 See Edmund Burke, *A Philosophical Enquiry Into the Origin of Our Ideas of the Sublime and Beautiful*, part 5, sects. 1–8 (Notre Dame, IN: University of Notre Dame Press, 1958).

23 An artwork that deals with the historicity of the explosion is Johan Grimonprez's film *Dial H-I-S-T-O-R-Y* (1997), on explosions in relation to the Palestine Liberation Organization airplane hijackings of the 1960s. Today, by contrast, explosions have come to be associated with car bombs and "terrorist" suicide attacks, while the violence of the State directed toward those designated as enemies is hidden behind the mimicry of computer-game type simulations, as in the first Gulf War.

24 For an account of the shattering of the gestalt of the image in terms of the effect of the death drive in disintegrating the ego, see the excellent discussion in Richard Boothby, *Freud as Philosopher: Metapsychology after Lacan* (New York: Routledge, 2001), pp. 150–54.

25 See Julia Kristeva, "Revolution in Poetic Language," in *The Kristeva Reader*, ed. Toril Moi (Oxford: Basil Blackwell, 1986), pp. 90–136.

26 The title for the U.S. release was *Every Man for Himself*; for the U.K., *Slow Motion*.

27 *Scénario de "Sauve qui peut (La vie)"* (1979) is included as an extra in the 2006 Artificial Eye DVD release of *Slow Motion* (1980). This film, together with the "scenarios" for other films that followed, was to lead into Godard's reflection from the point of view of video on the history of cinema in *Histoire(s) du Cinéma* (1988–98).

28 This translation is slightly modified from the subtitles.

29 See illustrations of installations of *Damnation of Faust* at the Whitney Biennial (1985) and Long Beach Museum of Art (1986). See also the catalogue *Dara Birnbaum* (Valencia: IVAM–Centre Del Carme, 1990), pp. 8–10, 48–49.

30 See Gérard Wajcman, *Fenêtre: chroniques du regard et de l'intime* (Lagrasse: Verdier, 2004), and Paul Chan, "On Light as Midnight and Noon," in *Paul Chan: The 7 Lights* (Cologne: Walther König, in association with Serpentine Gallery, London, and New Museum, New York, 2007), pp. 114–20.

31 In 1990 Birnbaum made a five-channel video installation work *Tiananmen Square: Break-In Transmission*.

32 Dara Birnbaum, project notes for *Erwartung/ Expectancy*, 1995.

33 Death as it figures in Martin Heidegger's *Being and Time*, trans. John Macquarrie and Edward Robinson (Oxford: Blackwell, 1978), pp. 279—311.

34 See Kristeva, "Revolution in Poetic Language," pp. 93–95.

35 See Roland Barthes, "The Grain of the Voice," in *Image-Music-Text* (New York: Hill and Wang, 1977), pp. 179–89.

36 See Catherine Clément, *Syncope: The Philosophy of Rapture* (Minneapolis: University of Minnesota Press, 1994).

37 See Bracha Lichtenberg-Ettinger, *The Matrixial Borderspace* (Minneapolis: University of Minnesota. Press, 2006).

38 See Mary Ann Doane, "Remembering Women: Psychical and Historical Constructions in Film Theory," in *Psychoanalysis and Cinema*, ed. E. Ann Kaplan (New York: Routledge, 1990), p. 51; see also Judith Barry, *Public Fantasy: An Anthology of Critical Essays, Fictions and Project Descriptions*, ed. Iwona Blazwick (London: Institute of Contemporary Art, 1991), p. 21.

39 This is precisely the case with Holbein the Younger's painting *The Ambassadors* (1533), which may have been originally hung near an exit from the room, so that as the viewer passes by the picture, he or she sees the "stain" in its center turn into the image of a skull. This painting is used as an example in the discussion of the implications of anamorphosis for the relation of the object "gaze" to the subject in Jacques Lacan, *The Four Fundamental Concepts of Psycho-Analysis* (London: Penguin, 1977), pp. 67–119.

40 Peter Brooks, "Body and Voice in Melodrama and Opera," in *Siren Songs: Representations of Gender and Sexuality in Opera*, ed. Mary Ann Smart (Princeton, NJ: Princeton University Press, 2000), pp. 118–34, 120). Hereafter cited in text.

41 Sigmund Freud, "Remembering, Repeating and Working-Through," *The Standard Edition of the Complete Psychological Works*, vol.12, ed. and trans. James Strachey (London: Hogarth Press, 1957), pp. 147–56.

42 Susan McClary, "Excess and Frame: The Musical Representation of Madwomen," chap. 4 in *Feminine Endings: Music, Gender, and Sexuality* (Minneapolis: University of Minnesota Press, 2002), pp. 80–111. Hereafter cited in text.

43 For a brilliant discussion of these images, see Georges Didi-Huberman, *Invention of Hysteria: Charcot and the Photographic Iconography of the Salpêtrière*, trans. Alisa Hartz (Cambridge, MA and London: MIT Press, 2003).

44 Sigmund Freud, *Studien über Hysterie* (Leipzig and Vienna: Deuticke, 1895).

45 See Catherine Clément, "Enslaved Enclave," in *New French Feminisms: An Anthology*, ed. Elaine Marks and Isabelle de Courtivron (Amherst: University of Massachusetts Press, 1980), pp. 130–36; Elisabeth Bronfen, *The Knotted Subject: Hysteria and its Discontents* (Princeton, NJ: Princeton University Press, 1998); and *In Dora's Case*, ed. Charles Bernheimer and Claire Kahane (New York: Columbia University Press, 1990).

46 See Christine Battersby, *Gender and Genius: Towards a Feminist Aesthetics* (London: Women's Press, 1989).

47 Pascal Bonitzer, "Décadrages," *Cahiers du cinéma*, no. 284 (January 1978). Later published in book form as *Décadrages: peinture et cinéma* (Paris: Éditions de l'Étoile, 1985). Hereafter cited in text.

48 Hans-Thies Lehmann, *Postdramatic Theater*, trans. Karen Jürs-Munby (New York: Routledge, 2006), pp. 145–46. Hereafter cited in text.

49 For further discussion, see Michael Newman, "The Trace of Trauma: Blindness, Memory and the Gaze in Derrida and Blanchot," in *Maurice Blanchot: The Obligation of Writing*, ed. Carolyn Bailey Gill (London: Routledge, 1996), pp. 153–73.

on my 27th
birthday ~ with
much love
dara

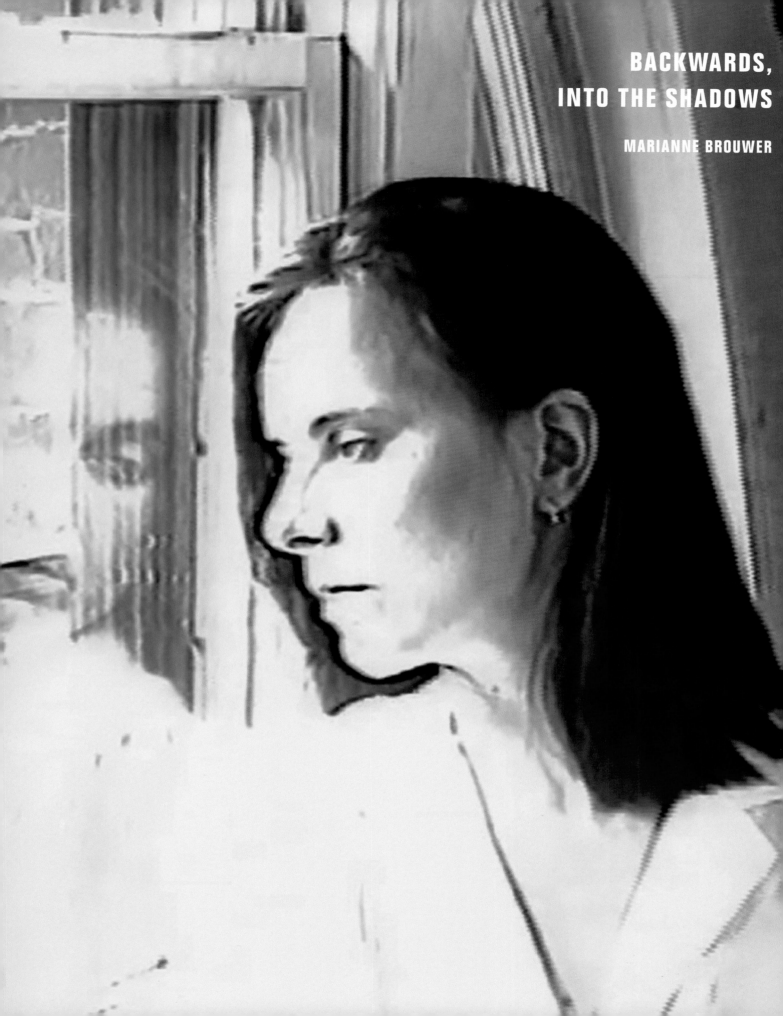

BACKWARDS,
INTO THE SHADOWS

MARIANNE BROUWER

Es ist das Schattenwerfen, mit dem sie der Erde ihr Dasein heimzahlen.

HUGO VON HOFMANNSTHAL [1]

To go "into the shadows" is to enter that which is "cast" (occurring after the fact of the original), and which is the other part (the dark matter) of what is in the light. Usually one thinks of being "followed" by one's shadow, or having it cast behind oneself. Of course, all this becomes metaphorical.

DARA BIRNBAUM [2]

This text is a journey into the dark. It began by my wanting to understand what links two works by Dara Birnbaum that are exceedingly different from each other: *Technology/Transformation: Wonder Woman* (1978–79) and *Erwartung/Expectancy* (1995/2001). *Wonder Woman* appropriates the (once) popular American TV transformation of an average woman into Wonder Woman, while *Erwartung* reaches back to Arnold Schoenberg and the beginning of atonal music, to early twentieth-century Europe and its deep, dark psychology. What I found was a key image enclosed in the light like the dark matter Birnbaum refers to above: Woman in search of herself, running through a dark forest, trapped in a hall of mirrors, pivoting on her axis like a mechanical ballerina. I have traced this image in Birnbaum's works, trying to understand what or, more specifically, *why* it is. In so doing, I have stuck close to that figure of Woman, forgoing the pleasure of art-historical reflection and leaving much unsaid on monumental works like *Damnation of Faust Trilogy* (1983–87), which merits an essay of its own. Far from wanting to "psychologize" the works I discuss, my search follows what I believe to be their unique political path, which descends into frightening regions where speech stops and language has no power— the domain of hysteria, which Slavoj Žižek has described as the obscene underside of (male) domination.

Hysteria, as defined by Sigmund Freud, is the inability of language to articulate the immensity of trauma and horror of personal events. The hysterical body wants to tell what the subject cannot say. The body withdraws into the purely semiotic (realm of signs), because it can only act out, not articulate, the unspeakable. Jacques Lacan was the first to define hysteria as part of the sociopolitical realm. According to Lacan, hysteria is the oldest of all psychopathological states. It predates language, which establishes within the subject the symbolic order of phallocentric rule. This rule is *in itself* male and male-dominated. The question "What is femininity?" is therefore first and foremost an ontological question, and one for both women and men: "An individual is interpellated into subjecthood, this interpellation fails, and the 'subject' is this failure. This is why the subject is irreducibly divided: divided between its task and the failure to remain faithful to it. It is in this sense that, for Jacques Lacan, the subject is as such hysterical: hysteria is, at its most elementary, the failure of interpellation, the gnawing worm questioning the identity imposed on the subject by interpellation—'Why am I that name?,' 'Why am I what the big Other claims I am?'" [3] For French feminism, finally, hysteria can be seen as a product of personal as well as public repression, a

Stills from *Chaired Anxieties: Abandoned*, 1975.

response to what is repressed in history. French feminists, Luce Irigaray in particular, see hysteria primarily as a form of protest: the disruption of the symbolic through the disorganization of speech and linguistic discord is a way of rejecting patriarchal authority and prescribed cultural identity. But hysteria is limited as a form of subversion and is potentially self-destructive: "Radical change is initiated not by a retreat into the semiotic but through an eruption of the semiotic in the symbolic."[4] In other words, the eruption of the unspeakable breaks up the symbolic order of language and that of the phallic. Emancipation starts with the beginnings, however inarticulate, of a new and different narration, which must be forced from within language itself, because language is owned by those who inflicted the unspeakable pain on the subject.

At the very beginning of her career, Dara Birnbaum addressed the fundamental hysterical questions "Who am I?" and "What defines me?" in a series of short videos: *Chaired Anxieties, Mirroring, Bar(red), Control Piece* (all 1975), and *Pivot: Turning Around Suppositions* (1976). The title of the three-part work *Chaired Anxieties* is a versatile pun—*chaired* meaning the location (seat) of anxiety, anxieties relegated to a chair, anxieties presided over, etc. The first sequence of *Chaired Anxieties*, *Abandoned*, opens with a shot of a simple wooden folding chair, standing on a studio floor marked with chalk lines, like the floor of a dance studio. The artist enters, sits down on this chair, stands up again, sits down while showing signs of impatience and ennui, repeatedly leaves the space and comes back, obviously at a loss for what to do with herself. In the next sequence, titled *Slewed*, this behavior is intensified. The conflict between her body's energy and its confinement to one place increases into a frenzy. By the end of the sequence, the chair has become much more than a dancer's prop; turned around and around, pushed, shoved, folded, kneaded, gripped, stroked, it has turned into an unwieldy substitute lover in the impatient hands of the artist. The third sequence, *Addendum: Autism*, shows her bent forward on her hands and toes, swaying to and fro like a monkey. Having abandoned the chair, she directs her attention to the lens of the camera, looking into it with questioning eyes. She starts to rock back and forth, up and down, her movements becoming increasingly frenzied and sexually charged. We hear the creaking of the chair, which we cannot see but which must now be lying under her, folded on the floor. *Autism* ends with her moaning softly, turning a questioning, almost begging, look at the camera.

Still from *Chaired Anxieties: Slewed*, 1975. Still from *Addendum: Autism*, 1975.

Altogether, *Chaired Anxieties* lasts about a half hour. Starting with a rela-tively "normal" reaction to having been abandoned—by a lover, a parent?—the sequence develops into a merciless inquiry into a woman's intimate state of mind. Initial feelings of anger and boredom are acted out with an increas-ing violence of movement and painful shifts into animal-like behavior until the coming-into-being of Woman's hysterical body.

Simultaneously we see a gradual shift in the role of the camera. Filmed from a distance and at a low angle, focused mainly on the legs and torso of the performer, *Chaired Anxieties: Abandoned* suggests a more distant, therefore more "objective," camera view. In *Chaired Anxieties: Slewed,* the camera zooms in closer. In *Addendum: Autism*, finally, it focuses on the performer's torso and face in close-up. Distinct from the artist and the viewer, the camera becomes a third presence, acquiring a life of its own. It captures the artist from slightly above; she is literally under its gaze, an object of clinical study. That we per-ceive her like this is due not to her increasingly alienated and alienating behavior but to the fact that she directs her attention toward the camera in the same way she directed it toward the chair, simply substituting one inani-mate object for another. The camera, on the other hand, has changed into an authority whose approval the artist is pitifully seeking, a desire that reduces her to endlessly deliver her thwarted *jouissance* before its unresponsive eye.

What makes *Addendum: Autism* truly remarkable, however, is the shift in the position of the viewer, from the moment the performer starts to act like a monkey in love with the camera. For this makes the viewer superior. Involuntarily, perhaps even unbeknownst to himself or herself, the viewer iden-tifies with the dispassionate, clinical viewpoint of the camera. The viewer knows something she (the observed subject) doesn't seem to: that the camera will never react. From that moment on, all possibility of emotional identification with the performer breaks down: being trapped in her alienation, to the viewer, she is no longer a woman. If sexuality relies on another's gaze, here that gaze is not returned. Instead it is countered by cold, manipulative indifference, which marks the cruel, sadistic side of the superego. It defines, in fact it creates, the hysterical body now before him. (*Addendum: Autism* reveals that anyone in the role of the viewer, whether male or female, is capable of assuming the role of the superego, however much that may come as a shock; even if only as a fleeting thought, the cold feeling of superiority is infinitely alluring. From now on this rejected body will be condemned to turn on itself in pursuit of the "Other.")

Stills from *Mirroring*, 1975.

Mirroring shows a close-up of the artist looking at herself in a mirror. She turns her head incessantly, repeatedly looking over her shoulder to catch the reflection of her face at different angles. We (the viewers) reach a point at which we are no longer able to tell the original from its reflection; as if the woman's face has ceased to be "real," having become a multiple through mirror reflection. Birnbaum achieves this with an extremely simple effect: the mirror takes up the whole image, without the frame being visible, not allowing the viewer to distinguish what is in front of and what is in the mirror—which part is real. Rather than being answered, the questions addressed by the artist in *Mirroring*—"Who am I?" and "What am I?"—are thrown back at her with an echoing din. Intriguingly, *Mirroring* anticipates the visual space in which Wonder Woman finds herself after her miraculous transformation: within a forest of mirrors, surrounded by multiple reflections of herself.

In *Bar(red),* we see a (studio) wall divided in two by the line of a vertical plumbing pipe. On the wall hangs a framed photo of a happily smiling woman wearing a scarf. The woman is mature, perfectly groomed; the photo could be a cutout from a fashion magazine or the portrait of a beautiful, stylish mother. At the far right end of the studio, we can make out the dark shape of what is probably a door. The artist, clad in a plain shirt and jeans, repeatedly attempts to walk past the portrait to exit the space, but she never seems able to make it. In the end, she just stands at some distance from the portrait, a little lonely and forlorn, as if to invite a comparison.

Bar(red) presents the image of the older woman as both obstacle to and ideal for the younger artist. We have no way of knowing what the real relationship between the performer and the woman in the portrait is. If we take her as the younger woman's projected self, she could appear under many signs: of loyalty, of tragedy, of competition, of jealousy. All we know is that there is no getting "beyond" her, no way of putting her in the past. If we follow Lacan, the portrait is the image of Woman. Not of a woman existing in reality, but Woman who, as an embodiment of the big "Other," pertains to the order of the symbolic. As such, she is not only out of reach for women but also unattainable to men. To a woman, therefore, she can only mean abandonment or failure—either of them already inscribed in her figure.

Control Piece shows a still image of an artist's studio. There are big windows in the distance and a scaffold on the right, with a black square, possibly a painting, suspended from the ceiling above. We can make out the dark

Still from *Bar(red)*, 1975.

Stills from *Control Piece*, 1975.

silhouettes of two figures motionless in the space. The first could be the artist herself seen from the back, standing in the midground. Farther back stands a person in profile that looks toward the scaffold and the black square. Clad in a knee-length smock and pants, this figure recalls nineteenth-century photos of painters and sculptors in their studios. Slowly, a life-size hand appears, superimposed over the image of the studio, which is now revealed to be a projection. The studio is thus reduced to the size of a dollhouse. The hand seems literally to be trying to get a grip on what is in the projection, touching things as if to flip them over, pointing at them as though to claim ownership. Gradually, more of the body is revealed until, eventually, the face of the artist confronts the viewer, as if attempting to block out the image of the studio and replace it with her own. In the end, she thrusts herself almost entirely over the image of the studio, which, far from disappearing, is now projected onto her body, suggesting that instead of overcoming her problem she has internalized it.

What we see, of course, is a classic juxtaposition: younger artist versus older artist. What is new is that the younger artist is a woman. To try to identify the figure of the older artist as, for instance, Kazimir Malevich (hinted at by the black square) would be to miss the point. What matters is that this archaic figure is usurping a studio that clearly belongs not to it but to the present day and possibly to the young woman standing on the right, in the demure posture befitting a newcomer. The pairing breaks down into woman artist versus male authority, her story against his, herstory against history.

One could argue that *Control Piece* mocks its own title, showing past authority internalized, looming all the larger because it cannot be wiped out by external efforts. Wouldn't it have been more "morally" gratifying for Birnbaum to have resolved this situation with a clear victory of the woman artist over male domination, through a strategy of attack and self-empowerment? The video certainly does not shy away from the struggle to "take control," but, rather than answer with a "positive" countermove, it opens up an abyss from which the figure of authority rises in its full, dreamlike quality, neither as a particular artist nor even one of any distinct gender, but as authority *tout court*—another form of Lacan's big Other. Here, in 1975, Birnbaum already concludes what she will express much later apropos alternative media: "Regardless of their ostensibly radical messages [they] have generally reproduced the dominant spectacle-spectator relationship. The point is to undermine it . . . which ultimately means challenging the social organization that produces that conditioning."[5] In other words, Birnbaum refuses to be lured into the trap presented by an outright fight, one that can only serve to reinforce the dominant, discursive power structure.

Pivot: Turning Around Suppositions (1976) addresses yet another aspect of the dynamic between the camera and the female artist-performer. The video is presented in an antiphonal form. On-screen we see only the woman performer; the camera is "embodied" by the male voice of an invisible director, giving the woman simple but different, contradictory instructions: "You are my lover" or "You really must be the devil." He then commands a camera pivot. The woman enacts his instructions, filmed by the pivoting camera. After each camera pivot, the woman's voice repeats his instructions verbatim, before she executes her own pivot in front of the camera, which is now still: "You are always there when needed," "You treat badly the people you know

best," etc. Strikingly, she does not make the sentences her own ("*I* am always there when needed," "*I* treat badly the people *I* know best"). As a result, what happens at the psychological level is very different from typical acting or role-playing; the woman relinquishes control over what she actually is (a performer), while the camera acquires the role of a critical parent, dissenting adult, or psychologizing friend (you are the devil, my friend, lover, always there when needed). This seems to be confirmed by the contrast between "camera pivots" and "performer pivots"; while the camera registers the woman's movements and expressions in a way that suggests what the sentences imply, the woman addresses the camera by attempting to change into who or whatever she is supposed to be, trying to win its approval. This process is remarkably similar to what occurs in *Addendum: Autism*; in both works, we see the commanding superego and the woman who tries to satisfy its orders but who finds her efforts are never enough.

Still from *Pivot: Turning Around Suppositions*, 1976.

In *Pivot*, the relationship between the camera and performer is even more disembodied because it is strictly limited to the invisible director's neutral voice and its effects on the performer. This means that the fundamental hysterical questions, "Who am I?" and "What am I?" (which the woman in *Mirroring* seems to be asking herself), are replaced by the superego's direction: "You must become what I want you to be." In other words, the superego defines a woman as subject, yet whatever she tries, however much she turns the suppositions around and around, however much she pivots, she will always fall short of knowing just who she is.

I have discussed *Chaired Anxieties*, *Mirroring*, *Bar(red)*, and *Pivot* at length because I believe them to be of great importance. Even though the works come at a very early stage in Birnbaum's career, they already present an astonishing summa of the demons (to use this venerable word) that Woman is fighting. The videos show the complexity of arguments and images that Birnbaum was exploring before making *Wonder Woman* in 1978 and that laid the groundwork for the *Faust Trilogy* and *Erwartung*. Showing the necessity for women to represent themselves, they link the shadowy regions of the subconscious to the invention of a female iconography. Acting out each scene through to its final consequence, Birnbaum has been willing to descend into the innermost recesses of self, without shunning impotence and regression, even risking ridicule, in order to achieve this. This is all the more extraordinary in context, since feminist strategies at the time tended to emphasize the positive and were mainly directed toward women's empowerment, pure and simple. Hysteria was something of a taboo subject owing to its stigma as a "woman's illness," associated with the clinical errors of nineteenth-century medical science. But under Birnbaum's dialectical scrutiny, hysteria develops into a timeless narrative that uncovers and exposes power altogether, showing the hysterical body to be the product of male superstructure.

In Birnbaum's video *Wonder Woman*, the demanding voice of the director that we saw in *Pivot*—the voice of the superego—has disappeared, not because the director is gone but because the presence of his voice is no longer needed, as his commands have by now been completely internalized by the performer. Woman has become capable of "pivoting" entirely on her own initiative in order to be her transformed self: the mythological figure of the Amazon, "The Woman Who Goes Out to Save the World" (Birnbaum).

Stills from *Technology/Transformation: Wonder Woman*, 1978–79.

Wonder Woman starts with the image of a firestorm. It is composed of a repetitive montage of the explosions that announced the appearance of Wonder Woman in the TV series. Then, there follows the hallmark of the show: our ordinary secretary becomes Wonder Woman by pivoting on her axis three times. We see Wonder Woman running through the woods, then finding herself locked in a cabinet of mirrors. Having escaped through a hole she has made in the wall, she encounters a man who, like her, wants to return to reality. She tells him: "We have got to stop meeting like this." In its final scene, Wonder Woman is alone, striding forward through a hilly countryside, before the video ends with another cataclysmic series of explosions.

Birnbaum's *Wonder Woman* is the first full-fledged representation in art of hysterical Woman in all its complexity and with the force of myth. On the surface, Wonder Woman is a revolutionary pop icon; the image par excellence of Woman as superhero, but in truth she is entirely two-dimensional. Like a performing animal, she knows only one trick: an endlessly repeated burst into *jouissance*, providing the public with the instant satisfaction that it counts above all; in Birnbaum's words, "the speed at which issues are absorbed and consumed . . . when psychological needs are visually expressed as physical transformation—in a burst of blinding light."[6] In *Wonder Woman*, we encounter the hysterical body as the product of the superego, just as we did in the earlier videos. Birnbaum is placing the viewer in the chilling position of feeding off of the distress of the performer, as Birnbaum had in *Autism*, creating a spectacle for all: "The humorous superego is the cruel and insatiable agency which bombards me with impossible demands and which mocks my failed attempts to meet them The superego is, at its most elementary, not a prohibitive but a productive agency. Nothing forces anyone to enjoy except the superego. The superego is the imperative of *jouissance*: 'Enjoy!' . . . We are not dealing with simple pleasures but with a violent intrusion that brings more pain than pleasure."[7] In *Wonder Woman*, Birnbaum also introduces the image of the male who remains trapped in the domain of the superego, the only place where he can meet with Woman. We thus see in *Wonder Woman* a symbolic power structure from which both Man and Woman try to escape, with neither being able to succeed.

As Birnbaum has described: "The 'hysteria' you see in the work is there, probably with regard to taking it on to effectively 'display' it—allowing for a gaze into this previously nondisclosed and nonoccupied (by the female)

position. I felt that by taking it on, there was a sense of empowerment. *Wonder Woman* also shows the imbalance of that idealism as portrayed in 'pop' culture—that one could go from 'normal' (diminished, as a secretary with glasses) into the role of 'wonder' (or super hero)."[8] And in an interview: "I knew from the very beginning . . . that [*Wonder Woman*] reflected a very technocratic view of a woman You either heroize her or you underrate her as a secretary. And where did you ever create for me this meaning, my representation? Where am I, if I am in-between? There was no space in-between. The burst of light said that I am a secretary, I'm a Wonder Woman, I'm a secretary, I'm a Wonder Woman, and nothing in-between."[9]

The empowerment of which Birnbaum speaks starts with this recognition, for it inverts the sense of helplessness originating from the superego's diktat, "This is what you are." From *Wonder Woman* on, the (female) figure of hysteria has the potential to become independent as an image, carrying new and precise connotations and its own iconography. This is the political domain that Birnbaum is opening up for us and that will necessitate a completely different approach to the representation of Woman.

Since the completion of *Wonder Woman,* Birnbaum has repeatedly stated that in her work she wanted to slow down "technological speed": "I consider it to be our responsibility to become aware of alternative perspectives which can be achievable through our use of media—and to consciously find the ability of expression of the 'individual voice'—whether it be dissension, affirmation, rather than a deletion of the issues and numbness, due to the constant 'bombardment,' which this medium can all too easily maintain."[10] In a 1986 interview, she refers to her new approach in *Damnation of Faust*: "By now my work is much softer, although it's the same hard technology. I try now . . . to look at the smallest kind of gesture, because I, almost, felt I had to go backwards . . . instead of trying to be as hard as the technology itself or to compete with it."[11]

Her choice of the word *backwards* is really quite extraordinary here. In terms of video, to go backwards has the connotation of replaying a scene from the end to the beginning. To go backward could also express the need to slow down, to step back, or to wait for something or someone to catch up with you, someone or something left behind or passed by. In these statements, Birnbaum reiterates the resolution of her video *Control Piece*: to forgo competition with the existing discursive power structure and what it contains and controls. To go backwards becomes a metaphor of a renewed retreat into the subconscious. To stop, to step back, back into the shadows, for, as Birnbaum states: "Philosophically, the shadow is the other and the parts of ourselves that cannot be revealed."[12] To go backward, into the shadows, means to return to *Wonder Woman* to find there once more, as the dark matter enclosed in her fiery image, the figure of pain that is hysteria.

In 1999, Birnbaum published a work titled "Elemental Forces, Elemental Dispositions: fire/water" in *October* magazine. It is a compilation of cartoon images from many different sources, juxtaposing images of disaster—floods, firestorms, etc.—with images of men and women gasping at the horror of what threatens to engulf them. In the accompanying text, Birnbaum writes:

The need to portray reaction, to enforce one's position upon action, is a necessary part of the representation; a key component of the narrative flow. Reaction is, after all, not necessarily regression: it can be seen as the ability to grimace at the primary factors of life that are outside of one's control. The victim is no longer victim, *in the sense that the strength of the reaction, as expressed through bodily gesture, can overpower even the worst of the disaster. The representation of reaction restores a sense of humility to the disaster; it re-establishes a body for its victim. Even in the most stereotypical of signs, the grimace can be seen as a form of emancipation."* [13]

To quote Žižek once again: "If you cannot change the explicit set of ideological rules, you can try to change the underlying set of obscene unwritten rules." [14] Only by descending into the realm of shadows, by "moving the waters of the Acheron," [15] is it possible to uncover the obscene underside of the (male) superego: "under duress and beyond duress, in answer to the entreaty which strips and flays me and destroys my ability to answer, outside the world, where there is nothing save the attraction and pressure of the Other." [16]

Shortly after the completion of *Wonder Woman*, Birnbaum tackled the hugely ambitious project of reworking the Faustian myth for new media, basing her version on the opera by Berlioz and on Goethe's *Urfaust*. [17] To Birnbaum, reworking Faust equaled redressing a historical wrong: she was "looking at the Faustian myth through a female voice to ask, 'Who is Marguérite? What role is she portraying? Can that image be looked at in a different way?'" [18] In order to give the feminine both a voice and an image, Birnbaum once again turns to the figure of hysteria but this time as it is contained in European literature and music: "Mythological figures, placing the voice of the male on a pedestal as the woman became increasingly hysterical, needed a more philosophical vocalization." [19] Birnbaum explains her remaking of *Faust*, as well as her appropriation of Arnold Schoenberg's *Erwartung*, when she states: "These operas propose myths of the feminine comparable to the way television presented Wonder Woman. They were equally created for the big public. The dramas they narrate are just as elaborate and exaggerated as the representations offered by television." [20]

In 1983, Birnbaum completed *Evocation*, the first part of her *Faust Trilogy*. Set in a New York playground, *Evocation* conjures the carefree days of youth, much as Goethe's *Faust* does. But contrary to Goethe, they are not evoked by Faust but rather are seen from the perspective of the girls at the playground. Images of nature and play, suggesting freedom and independence, alternate with shots of chain-link fences as symbols of confinement. Among the unforgettable scenes of *Evocation* is one in which two young women get on a swing. Turning and swinging, they climb higher and higher through the dark courtyard, past the fence of the playground, past dark windows and fire escapes toward a patch of light, up in the air, where the swing carries them beyond gravity toward the free sky. As a viewer, it makes you wish that the girls can retain that daring, and not somehow drift into marriage as life's best solution.

Still from *Damnation of Faust Trilogy: Will-o'-the-Wisp (A Deceitful Goal)*, 1985.

The second part of the trilogy, *Will-o'-the-Wisp (A Deceitful Goal)* from 1985, shows a young woman sitting in a room facing a small window. In what verges on an interior monologue, she softly recounts her failed relationship

Stills from *Damnation of Faust Trilogy: Evocation*, 1983.

with her former boyfriend. As she speaks, images from *Evocation* appear inserted in the window like memories framed by the present: we see the playground, places where she and her friends hung out as children, some fluttering of leaves and blades of grass. But the inserts are all barred by stripes or enclosed in frames—images of erstwhile freedom and play, now forever closed off to her.

The third and final part, titled *Charming Landscape* (1987), records the destruction of the same New York playground. While Georgeann and Pam, the two girls who were the protagonists of *Evocation*, talk about what the playground meant for them, we see the devastation of their past: "That's where you lose your identity," one of the girls says. Images of bulldozers and the playground are followed by historical footage of police brutality during demonstrations against the Vietnam War, the earlier civil rights demonstrations in the United States, as well as the later student uprising at Tiananmen Square.

Charming Landscape is crucial to understanding the first two parts of the *Faust Trilogy*. Birnbaum institutes a causal symmetry between the joyous freedom of the young women in the first part and the violence perpetrated by civic authorities in the last. Violence and destruction seem to be the inevitable punishment of innocence and hope. "The more innocent they are, the more they deserve to die." Joseph Stalin's statement, made during the great purges in Russia in the 1930s, is repeatedly cited by Žižek as the manifestation of the superego at its purest. Birnbaum wants her work on *Damnation of Faust* and *Erwartung* to be "an attempt to displace or deconstruct the masculine identity of the hero and to offer to Woman, who is in fact the principal hero of each work, a different voice."[21] "I felt it was important for me to approach, without the use of appropriation from TV, large myth . . . above and beyond the television image. . . . I've always been interested in the representation of Woman, because it brings me closer to an experience of my own voice. When I looked at the historical basis of *Faust* it seemed to assign to the woman certain roles, stereotypical of a certain hysteria, an inability to have responsibility within certain areas. So I tried to approach that and I wanted the approach to be through the personal into the social and the political."[22] The story of Marguerite reveals that, at its core, *Faust* is, for all its modernity, a sacrificial myth. In madness and despair, Marguerite kills her child; she accuses herself of causing the death of her mother from grief; her brother curses her as he dies by Faust's hand. For her, to give up her lover and die by the executioner's hand is the only way to redeem herself before God and society.

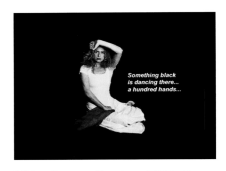

Still from *Erwartung/Expectancy*, 1995/2001.

But this figure of hysterical madness is what male myth in fact *needs her to be*; the truly unspeakable, enclosed in Goethe's modern version of the Faustian myth, is the sacrificial offering of the feminine, which allows the symbolic order to continue to exist.

Birnbaum has repeatedly stated how decisive her participation in the student protests of the 1960s was for her own development, both as a woman and as a political being. The goal worth fighting for is formulated by the middle part of the *Faust Trilogy*. It shows the way out of the Faustian pact as "a pedestrian bridge, where only one person can go at a time to reach the other side. And then when you get to the other side—where does the individual position oneself in society and where is the awareness of that?"[23] This question will be posed in full in *Erwartung*.

Erwartung was originally created as a site-specific video work for the Kunsthalle in Vienna. Birnbaum appropriated Schoenberg's monodrama, commissioning a New York DJ to create a twelve-minute electronic sampling of the original score. She used the sketches made by Schoenberg for the stage design as a backdrop for her video, which centers around a single key figure: a woman in a white dress, alone in a dark forest. As the video unfolds, sentences from the original libretto are projected across the screen. Art critic Robert Fleck gives a vivid description of its impact:

> *In October 1995, Vienna's Karlsplatz was steeped in an unfamiliar atmosphere. A dark painting on paper, verging on the abstract and charged with symbolism, had been enlarged by computer and projected onto the sidewall of the Vienna Kunsthalle, with a "visionary" opening in the middle. By day, thousands of cars filed past this ten-by-fifteen-metre work of media art that reiterated a turn-of-the-century painting by Arnold Schoenberg. By night, it was illuminated. Projected onto the picture plane were a female figure wandering mechanically through the painted scene and the Expressionist libretto of a tormented woman's inner monologue written in 1909 by the twenty-seven-year old medical student Marie Pappenheim.[24]*

Erwartung traverses the fantasy of a woman desperate to find her lover. Running alone through a dark forest, she searches for the man who did not come to see her that day. Overcome by panic and fright, she starts seeing fearsome, ghostlike apparitions everywhere along her path. When she arrives at her lover's house, finding it dark and shuttered, she understands that love is finally denied her. Exhausted and abandoned, overwhelmed by a feeling of powerlessness and jealousy toward an assumed rival ("Oh, you love them, the white arms . . . you redden them with your kisses"), she sinks down on a bench, only to discover there her lover's bloody corpse. As dawn breaks, and the first human beings will shortly appear on the road nearby, she must once again enter the diurnal world, the world of the real, while feeling only despair: "What am I to do here all alone? . . . In this endless life. . . . Light will dawn for all others . . . but I, all alone in my darkness?"

For the first time, *Erwartung* gives us the figure of hysterical Woman as herself, unadorned by myth and the fantasies of the superego. The "indecency of speaking for others," which Birnbaum has laid bare in *Wonder Woman* and in her *Faust*, is put to a stop. In Birnbaum's description,

"[*Erwartung*] was almost like a cyclic return to *Wonder Woman* in some ways. The character is extremely alienated. She is looking in a deep, dark forest for her lover, but what she is really looking for is her own image."[25] But where do we go from here? The woman in *Erwartung* remains trapped in her darkness. We cannot reach her; she cannot speak for herself. *This is all there is.* All we know about Woman, all she ever was, is summed up in this autistic image of the dark region called femininity enclosed within the symbolic order of the phallic. She is the superego's Maya Desnuda, its Bride Stripped Bare. She is the Suicide by Society, the product of its Theatre of Cruelty. It is now up to society to look itself in the face. And this makes her image incomparably strong.

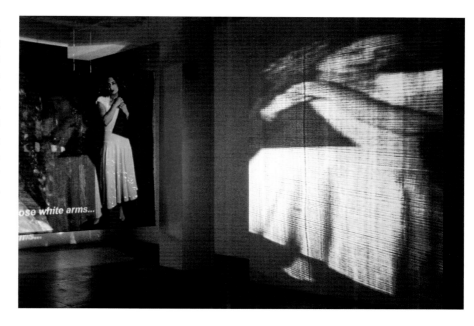

Erwartung/Expectancy, 1995/2001, installation view at Marian Goodman Gallery, New York, 2002.

Thus revised, Birnbaum returns Schoenberg to his native Vienna. Schoenberg left Vienna in the 1930s, as did Birnbaum's grandparents, who fled Vienna for the U.S. when fascism stopped European modernity (of which Freud, Ludwig Wittgenstein, and the Viennese School were the larger-than-life models) dead in its tracks. The suppression of a critical modernity, which claimed so many victims by exile, war, and suicide, haunts Austria's art and literature from the beginning of the twentieth century through to the present day—from Karl Kraus and Georg Trakl to Ingeborg Bachmann, Thomas Bernhard, and Elfriede Jelinek.

For society, a confrontation with the narrative of female hysteria means much more than the empowerment of women alone. To "let the semiotic erupt within the symbolic order" as a resistance to that order means to resist the violence that is the pathology of power (against not only women but anything innocent and weak). To have recognized hysteria as a political issue is Birnbaum's extraordinary achievement, which finds its first, full expression in the double figure of Wonder Woman. A woman's voice, a woman's project, Birnbaum's appropriation of *Erwartung* brings hysteria full circle, back to Vienna, where Freud diagnosed it as mental illness for the first time. But the images of hysteria presented by Dara Birnbaum are shadows no longer. Hysteria's "speechlessness" has entered the symbolic and acquired an explicit position within historical and political discourse.

1 "It is by casting shadows that [human beings] pay back to earth for their existence." (Hugo von Hofmannsthal, *Die Frau ohne Schatten, Erzählung* [Munich: Bibliothek der Erstausgaben, 2006], p. 16. My translation.)

2 Dara Birnbaum, email to the author, March 7, 2008.

3 Slavoj Žižek, *In Defense of Lost Causes* (London: Verso, 2008), p. 344.

4 See Emma Parker, "A New Hystery: History and Hysteria in Toni Morrison's *Beloved*" *Twentieth Century Literature* (Spring 2001), online at http://findarticles.com/p/articles/mi_m0403/is_ 1_47/ai_79208846/ (accessed April 30, 2010).

5 Dara Birnbaum, "Overlapping Signs," in *War After War*, ed. Nancy J. Peters (San Francisco: City Lights Publishers, 1992), p. 26.

6 Dara Birnbaum, *Talking Back to the Media: Time Based Art* (Amsterdam: de Appel, 1985).

7 Žižek, p. 343.

8 Dara Birnbaum, email to the author, July 14, 2008.

9 Dara Birnbaum, interview by Hans Ulrich Obrist, in *Art Recollection: Artists' Interviews and Statements in the Nineties* (Florence: Zona Archives Editori, 1997), p. 46. See also in this book, p. 24.

10. Dara Birnbaum, "Talking Back to the Media," p. 49.

11 Dara Birnbaum, "To Talk Back or to Talk With," interview by Willem Veldhoven, *Mediamatic Magazine* 1, no. 1 (May 1986), p. 37.

12 Dara Birnbaum, "Sighting the Collective Shadow," interview by Jo Ann Baldinger, *Pasatiempo* (June 18, 2004), p. 56.

13 Dara Birnbaum, "Elemental Forces, Elemental Dispositions: fire/water," *October* 90 (Fall 1999), p. 109. See pp. 328-37, in this book.

14 Žižek, *Welcome to the Desert of the Real! Five Essays on September 11 and Related Dates* (London: Verso, 2002), p. 32.

15 *Acheronta movebo*: the famous motto of Sigmund Freud's *The Interpretation of Dreams*, taken from Virgil's *Aeneid*, book V11, line 312, in which an outraged Juno says, "*flectere si nequeo superos, Acheronta movebo*" (if I cannot make the heavens bend, I will move the underworld), before descending into the underworld to enlist the help of the Furies. It is remarkable that Freud uses the Furies as the very image of the subconscious. In 0chylus's *Oresteia*, they are the last defenders of ancient matriarchal law and matrilinage, losing out to the new law of patriarchy advocated by Apollo and Athena. Superos, in Lacanian terms, would equal the symbolic order of language and the phallic, while the Furies represent the eruption of the unspeakable within the symbolic order.

16 Maurice Blanchot, *The Writing of Disaster*, quoted by Birnbaum in "Elemental Forces, Elemental Dispositions: fire/water," p. 109.

17 Goethe's *Urfaust*, which centers almost exclusively on the story of Gretchen, dates some sixty years before the publication of *Faust. Eine Tragödie*, in 1808. Hector Berlioz based *La Damnation de Faust* on the *Urfaust*, completing his opera in 1846. Birnbaum informed me that the opera was "in part an apology to [Berlioz's] wife." (Birnbaum, email to the author, March 7, 2008.)

18 Dara Birnbaum, "Sighting the Collective Shadow," interview by Jo Ann Baldinger, p. 55.

19 Dara Birnbaum, "A Statement of Manifestation for the Conference: Radical Chic," *Radical Chic Reader* (Stuttgart: Künstlerhaus, 1993), p. 61.

20 Birnbaum, quoted in Elisabeth Lebovici, "L'Américaine Dara Birnbaum déconstruit en vidéos l'image télévisée: Manipuler la télé comme elle nous a manipulés," *Libération*, January 10, 2001. My translation.

21 Ibid.

22 Birnbaum, interview by Susan Canning, *Art Papers*, no. 6 (November/December 1991), p. 55.

23 Ibid.

24 Robert Fleck, "Father Figure and Innovator: Reflections on Arnold Schönberg's Topicality," in *The Visions of Arnold Schönberg: The Painting Years*, ed. Max Hollein and Perica Blazenka (Ostfildern-Ruit, Germany: Hatje Cantz, 2002), p. 32. Marie Pappenheim studied with Freud and was a fledgling poet whose poems (written under the pseudonym Maria Heim) were published by Karl Kraus. She met Schoenberg in 1909 through the composer Alexander von Zemlinsky, his one-time teacher of counterpoint and brother-in-law. According to the Schoenberg Institute, she stated in later years that Schoenberg did not influence her text and that she would not have permitted him to do so had he tried.

25 Dara Birnbaum, "Sighting the Collective Shadow," interview by Jo Ann Baldinger, p. 56.

"ALL ACTIVITY MUST OCCUR WITHIN A GIVEN SPACE": DARA BIRNBAUM'S TACTICAL MOVES IN HER CRITIQUE OF REPRESENTATION

SIGRID ADORF

I think working with video is . . . like playing chess. I felt video was like this: I had to be seven moves ahead and seven moves behind. And I could never see any one move at a time, nor see an image directly; I only saw it in my mind.

DARA BIRNBAUM [1]

C hess: move by move, the attempt to restrict the opponent's scope for action, to recognize his or her moves and capture him or her. Dara Birnbaum uses the metaphor of this game of strategy to explain the appeal that the medium of video had for her in its early years. But who is playing with whom? And for what? Birnbaum's work in video became famous for its early critical grappling with the visual world of television.[2] The legendary *Technology/Transformation: Wonder Woman* (1978–79)—in which she reedited images from the then-popular television series *Wonder Woman*, exaggerating grotesquely their artificiality and emotionalism—set the tone for the approach she pursued through her large video installations of the 1990s, which has been called deconstructivist and postmodern[3]: television images are appropriated as found-footage material, then dissected, repeated, and reedited, so that the principles of the original image's construction become evident. This form of "close looking"—to use a term analogous to that of close reading[4]—enabled Birnbaum from the outset to play a game with images from the media: "'Talking Back to the Media. And I think this was what I wanted to do—I wanted to arrest the image without translating it. . . . People said that I became a pirateer: 'Oh, she's the one who pirates the images.'"[5] Birnbaum was looking for a way to question television's world of popular images from within, to arrest the image, to capture it move by move, to *apprehend* it.[6] Her montage techniques trace the affective moments of the sequences of images, juxtapositions, and motifs. For example, at the beginning of *Technology/Transformation*, where the seconds-long transformation scene is condensed and repeated so that the image and sound seem to be stuck in place, the reedited form of the image provokes its confession, so to speak. The image starts to reflect on itself, with the perception of repetition emerging more strongly in the acoustic repetition than in the visual. The recorded climax, with the female office worker turning in the ball of fire that transforms her into an American Amazon, becomes merely an effect, circling only around itself. This "technology transformation" captures the power of the spectacle and of large media companies, the opponents in Birnbaum's tactical game.[7] Conceptual sketches from the artist's archive reveal that this famous video was originally planned as part of a group of works that would have concerned four prominent series on national prime-time television: *The Incredible Hulk*, *The Bionic Woman*, *The Six Million Dollar Man*, and *Wonder Woman*. In a series of notes, Birnbaum recorded the topological motifs around which this series would have revolved: monstrous transformations of nature resulting from technological interventions, super-human hybrids of human beings and machines that figure allegorically as female bodies ("fem-bots"), technoid fantasies of new heroic figures. The notes make it clear that *Technology/Transformation* was to be the general title

The Kiss of Death 20th C, with Respect to Edvard Munch, c. 1971.

TRANSFORMATION / TECHNOLOGY
NOTES

This grouping of work(s) will concentrate on four nationally-
aired American network programs that are shown during 'prime-
time' on Friday or Saturday evening.

SELECTIONS:
THE INCREDIBLE HULK
WONDER WOMAN
THE 60 MILLION DOLLAR MAN
THE BIONIC WOMAN

To be related in the following manner:

THE INCREDIBLE HULK ⌐ fantasy/comic
WONDER WOMAN | change of appearance from norm /
 ⌐ changes are biologically inherent

THE 60 MILLION DOLLAR MAN ⌐ $ invested in technology
THE BIONIC WOMAN | towards a 'betterment' (of what
 ⌐ is now biologically possible)

THE INCEDIBLE HULK: instinctual nature out of control
 regression to 'animal (instinctiveness /
 primalness)' with a causal factor of
 'modern technology' / trying to re·establish
 the balance between aggressivity and passivity
 -- but also extensions of balance between
 past and present -- biology and technology --
 morality and amorality / value structures

THE BIONIC WOMAN: technology puts biology back in control
 (but better). "fem-bot" as woman's new role(s)
 are examined -- physicality (instictive
 sexual drives -- externally/ exteriorly we
 deal with a 'total whole' as woman yet internally/
 within the interior there is a 'breakdown of
 parts' - some become mechanical/a·sexual) /
 psychology (supporter/ provider)

THE BIONIC WOMAN⬋⬊ THE 60 MILLION DOLLAR MAN the $ value of
 American Techno-
 logy and its
 'chosen invest-
 ments'

WONDER WOMAN ⬋⬊ THE INCREDIBLE HULK

past / historical / past / that which is 'of the
a civilization once existent primate' -- instinctual to us
whose value system / morality all but alienated from us.
is seen as better than our own.
 Each returns to a past state
 to "do good".

Notes for the *Technology/Transformation* series, 1978.

Sketch for *Lesson Plans (To Keep the Revolution Alive)*, 1977.

for a series of video analyses that were intended to explore America's investments in technological development, the longing for bygone days of moral integrity, and schemes for distinguishing between "good" and "evil." Moreover, Birnbaum's notes indicate that the cinematic procedure of the "intercut"—a technique using contrasting cuts—was one of her thematic concerns. At least two of the *Technology/Transformation* works were to have been related to one another spatially in a joint screening area so that the space between them could be entered and their motifs thus "edited" together in the observation: "an automatic inter-cut response takes place now within the viewer (one that originally had occurred within the actual broadcast material itself). Here the set(s) of information can be formed/re-formed at the viewer's command from the more clearly defined separated sets of info (two entities whose descriptive patterns have been deconstructed for clearer definition in a restructuring of time intervals)."[8]

As Christian Kravagna emphasizes in his reflections on Birnbaum's "media critique of the media," her artistic approach differs from both that of early video art and that of the media activism of the early 1970s. Her found-footage montages neither share the euphoria of the time, in which video was generally seen as an alternative medium to television, nor were concerned exclusively with the perception of space and time, nor took part in destruction of equipment, playful and helpless in equal measure, such as the burning or smashing of television sets.[9] Rather, Birnbaum worked with the means of analysis and critique and entered the opponent's field directly: for example, the *Wonder Woman* video was shown in the shopwindow of a trendy New York hair stylist; *Local TV News Analysis for Cable Television* (1980), a project made with Dan Graham, used cable to examine the transmitter-receiver relationship of a local television news program; the video *Remy/Grand Central: Trains and Boats and Planes* (1980) explored the critical possibilities of a commissioned work by formulating a faux commercial; and *Rio Videowall* (1989) was installed at the Rio Shopping and Entertainment Centre in Atlanta, mixing live images of passing consumers with the live stream of the satellite broadcasts from CNN's nearby studios.[10] As a result, according to Kravagna, video art as a frame of reference for considering Birnbaum's works is "a framework that obscures things rather than producing understanding."[11] In his view, Birnbaum's

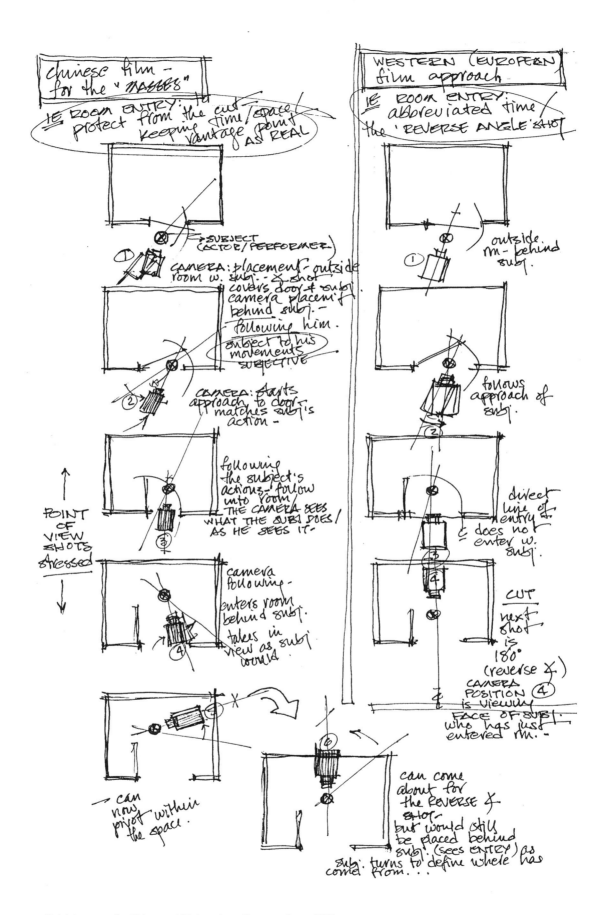

Sketch for comparing Chinese and Western cinematic approaches, c. 1975.

central interest is comparable to apparatus theory in film and contributes to an examination of television as a media apparatus—that is, an examination of the interplay between production, reception, and medium.[12]

This assessment, which dominates the critical reception of Birnbaum's work, is no doubt correct, but it overlooks the video performances produced two to three years before *Technology/Transformation,* which testify to her effort to come to terms with the video art of her day and which can help flesh out important aspects of our picture of her reflection on media.[13] This group of works includes *Chaired Anxieties, Mirroring, Bar(red), Control Piece* (all 1975), and *Liberty: A Dozen or So Views, Pivot: Turning Around Suppositions,* and *Everything's Gonna Be . . .* (all 1976). Although they might appear to be sketches, early screenings of some of these works demonstrate that they were intended for public view—for example, on the occasion of an open screening in 1975 at Anthology Film Archives in New York and at the Second Annual Video Festival in New York in 1976. In addition, *Liberty: A Dozen or So Views* was shown on the video program of the Manhattan public-access cable channel D as early as 1976.[14] Because these works were hardly shown at all, and thus could not find their way into the canon of the history of video, they are capable of confronting us with a rawness, simplicity, and permanence that vex our habits of perception. More than works that have been seen many times, they enable viewers to be drawn into the perplexing aesthetic of the video experiments of the time, and they make it possible to perceive Birnbaum's work in video from a broader perspective.

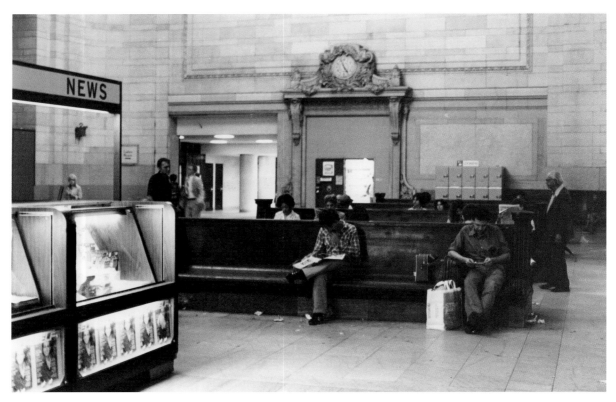

View of the waiting room, Grand Central Station, New York City, 1980.

Stills from *Everything's Gonna Be . . .*, 1976.

IMAGE CONSUMERS: STUDIES ON THE INTERACTION OF PUBLIC AND PRIVATE

Everything's Gonna Be . . . and *Liberty: A Dozen or So Views* are Birnbaum's two earliest videos to be explicitly concerned with questions of the appropriation of circulating images and their repetition, inscription, and transcription in the private sphere. Moreover, *Everything's Gonna Be . . .* is the artist's earliest-known video montage to employ found footage—albeit not yet a montage of television images but rather a mixing of a recorded video scene with still images from the popular press. The work begins with a rhythmic noise that recalls the beat of a metronome and a muted woman's voice mechanically repeating "Everything's gonna be all right," a line from the Bob Marley song "No Woman, No Cry," until finally Marley's version of the song enters. A couple is dancing to it, imitating a freestyle reggae manner. Photographic portraits—typical celebrity shots—occasionally fade in. The dance scene is also interrupted by handwritten text cards that occupy the image while an off-screen female voice relates newspaper stories. The appearance on-screen of headlines such as "JFK Wasn't the Only One," "Teddy's Midnight Swim," and "Nixon and the Chinese Mystery Woman" alludes to the scandalous love lives of American politicians. The politically effective mix of public and private emerges as a theme. "In this great future you can't forget your past . . ."—the last panel quotes the song. Lyrics, rhythm, movement, and subtext fold into one another. The video becomes an intersection of various media and narrative strands that interweave, intersect, and force one another out. Something that soon afterward would mature during the formal heyday of music-video editing is already inherent here as a visual space that makes it possible to read the meeting of various elements politically. The improvised-looking dance performance and the reported actions of the public figures become representations of the everyday blending of public and private. They demonstrate a kind of consumerist circle in an everyday culture shaped by the media. Popular representations of the "private lives" of the powerful, of "the rich and the beautiful," are woven together with the driving rhythm of the dancers and thus become images for what has been lamented around that time as the decline of political culture and the media's dissolving of the boundaries between private and public—prominently described in Richard Sennett's 1977 book *The Fall of Public Man.*

Birnbaum's play with pop culture is by no means arbitrary, nor is it a purely formal game; rather, it is one in which the apparently most trivial statements—found objects from her own present—become critical statements

about her time. She emphasizes, however, neither a form of metaphorical exaggeration nor the contrary form of exposing the vacuity of content in favor of focusing on that which escapes explanation and thereby unfolds as symptomatic power. Birnbaum's analytical look at the identity and polyphony of media culture can be called psychoanalytical—it allows the media images to speak for themselves, repeating them as stuttering monologues and developing their symptoms. Like the writing in comic strips, the fragments of dialogue that she transcribes from films and television and uses as texts in her works do not function as explanatory commentaries on the images but rather as perplexing appendages and insertions. They are nearly as memorable as the images themselves, but as text fragments they point more explicitly to the unfinished nature of the narrative, to its fragmentary existence, which resists the logic of narration. As with the never-realized *Technology/Transformation* installation, the formal approach of the disjunctive collage of various recordings of noises and images is aimed at a virtual synthesis taking place on *inner* monitors—at the observers' ability to tie very different fragments into sensible strands but without thereby evoking a self-contained whole. For Alexander Alberro, this form of collage, which works with gaps that cannot be closed even by the viewers' associative ability, is a typical artistic strategy for deconstructing the dialectic complexity of everyday life, as found, for example, in Martha Rosler's work.[15] Like *Everything's Gonna Be . . .*, Rosler's *Domination and the Everyday* (1978) turns to the dense texture of the quotidian as the place where a wide variety of addresses and ambitions meet. Too, Rosler combines still images—shots from news broadcasts, her own family photos, postcards, and fashion photographs from magazines—with another scene, though in this case it is backed only with an acoustic track: mother and child (Rosler and her son) are heard in their small, daily power struggle over the necessity of brushing one's teeth and going to bed, while in the background a radio announcer discusses artists and questions of making art. *Domination and the Everyday* reflects the difficulty of studying the complexity of these ordinary encounters. Both Rosler's video and Birnbaum's make it possible to experience polyphonic or multidimensional audiovisuality as a synesthetic space. Unlike Gene Youngblood's visions of expansive experiences of space in his 1970 publication *Expanded Cinema*, it is the everyday itself, the entirely normal space of the present, that seems to be dominated by polyphony and demands a synesthetic competence to read sensible connections out of the overlapping narratives.

Birnbaum's video *Liberty: A Dozen or So Views* also focuses on the paradoxical connection of polyphony and uniformity. It adopts both social-science methodology and the television format of spontaneous interviews with passersby. To begin, one sees a moving surface of water and a ferry, followed by a series of stills of the Statue of Liberty accompanied by Birnbaum's off-screen voice saying, "A dozen or so views of liberty." The montage from slightly varying perspectives characterizes the diversity of tourist views that are photographed daily from the ferry that departs from Manhattan's southern tip, but it also symbolizes a variety of views on the motif of liberty in the democratic sense. The latter is reinforced by the interviews that Birnbaum recorded on the South Ferry in summer 1976. The people surveyed provide information about their height, age, weight, background, and the color of their hair and eyes, and they range from a young, self-confident American

Martha Rosler, *Domination and the Everyday*, 1978.

woman, to a small, shy girl, a nun, an eloquently reserved white man in his mid-forties, an African American in mirrored sunglasses, and several more, including a nine-year-old Chinese American boy and a young woman who thinks she is too heavy. A conceptual sketch for the piece shows Birnbaum's careful planning of the partial portrait, the background revealing part of the New York skyline with the twin towers of the World Trade Center and recalls a commercial advertisement for New York ("We're crazy to live here"—as Birnbaum notes in a sketch for the piece) and the stage sets of late-night shows.[16] Interspersed between the interviews are videos taken of the Statue of Liberty by the interviewees. The piece ends with a photographic portrait of Birnbaum at the ferry's railing. A glance at YouTube makes

it clear that this tape made some thirty-some years ago is a precursor to today's visual practices: numerous private videos on that internet platform present similar pans of the same location, between the Statue of Liberty and the ferry, between images of oneself and images of other passengers. What has changed in the thirty years since Birnbaum's work is not so much the purpose of the images as their technology. The gesture of putting oneself on view, of posing for the camera is approximately the same. Then as now, "private" visual practices seem to react to the quotidian regime of the gaze of switched-on cameras. They express the will to be perceived, to participate in the worldwide media culture, and thus to demonstrate in a sense one's own status as a citizen—a governmental expression of contemporary subjectivization.[17] *Liberty: A Dozen or So Views* functions like a net trawling the everyday stream of private images. In the way that it captures dispersed yet similar, repetitive private images, it already resembles the recording strategies that Birnbaum would later make the hallmark of her approach to transient television images.

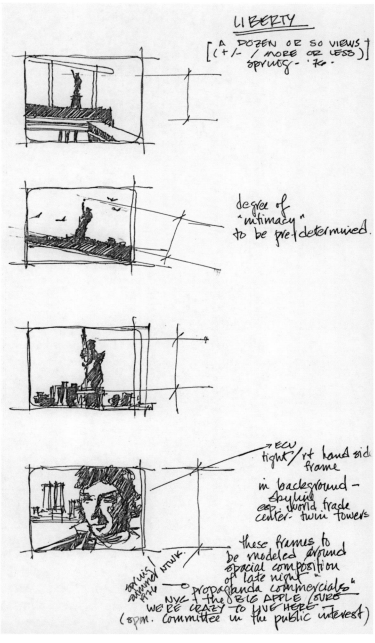

Sketch for *Liberty: A Dozen or So Views*, c. 1976.

TRACED OUT? STUDIES ON THE RELATIONSHIPS BETWEEN VISUAL HISTORY, GAZE, AND THE SPACE OF PERFORMATIVE MOVEMENT

In her early video works, Birnbaum not only captures our now-daily dealings with the visual regime of the recording media as observer but also explores them systematically. For example, her *Pivot: Turning Around Suppositions* deals with the relationship between the actions of camera and performer and experiments with the possibilities for their reactions toward each other in order to influence the

Stills from *Pivot: Turning Around Suppositions*, 1976.

depiction from their respective positions. Ten brief sequences, each of about thirty seconds, illustrate various spoken statements as general as they are personal: "You are my friend," "You are my lover," "You really must be the devil," "You treat badly the people you know best," "No one can get close to you," "You are always open to meeting new people," "You are always there when needed," "All one has to do is reach out to get help from you," "You never speak to people directly," "You don't know how to confront new situations." We see each sequence in two variations. "Camera Pivot," the first variation in each case, is backed by a male voice from off-screen that announces its place in the overall sequence and its theme: "No. 1. You are my friend. Camera pivot," and so on. The camera runs through various possibilities of constructing the shot, while the performer, a woman, stands still. It approaches and moves away; it moves around her or shows blurry close-ups; it zooms in, jumps into various cuts, and so on. The relationship between each variation on camera technique and the statement with which it is paired reveals an effort to interpret the statement based on formal aesthetics. By contrast, in the second sequence of each pair, the camera remains fixed and the performer interprets the statement, heard this time as spoken by a woman, through movement and facial expression. Now it is the performer who approaches or moves away, turns, decides which detail of herself to reveal, and searches for a different expression for each corresponding statement. Although the work is strictly conceptual in its structure and the definition of the positions of "camera" and "performer" are neutral as such, it does not appear to be a coincidence that the part of the camera is accompanied by a male voice, whereas a woman is in front of the camera. As the feminist film theory of the period emphasized, the positions of the subject of the gaze—the camera—and the object of the gaze are not neutral but rather highly coded within the framework of the Western visual tradition. As Laura Mulvey demonstrated in her landmark essay "Visual Pleasure and Narrative Cinema" (1975), classic Hollywood cinema, in particular, knew how to play with the tension between the male gaze, embodied by the camera's movement, and the female object of desire.[18]

Another group of works by Birnbaum from 1975, the three-part *Chaired Anxieties*, *Bar(red)*, *Mirroring*, and *Control Piece,* seems to make the tension between camera and the object the explicit topic of investigation. These videos of varying length show the artist trying to express performatively various descriptions of psychological states. The first part of *Chaired Anxieties*, *Abandoned,* begins with a shot of a wooden folding chair in the center of the

Still from *Chaired Anxieties: Abandoned*, 1975.

image, in a room that appears to have been emptied. The performer steps into the frame, barefoot and wearing jeans and a shirt. She adopts various poses: sometimes she stands in contrapposto stances next to or behind the chair; sometimes she sits on it, facing forward or backward; and sometimes she steps out of the frame only to return soon to her place within it. The fixed framing by the camera appears to have been measured precisely. Chalk marks on the floor suggest that the space for movement was traced out in the most literal sense. The woman's head and face are never seen. The only sounds we hear are noises from the chair sliding and her steps on the floor. The poses—which sometimes look like snapshots of ordinary seated positions and sometimes like the deliberate repertoire of forms of drawing models in the studio— alternate in rapid sequence. Now and again, the nervously tapping hands underscore a form of anxiety. The term *abandoned*, which suggests a deserted, forsaken place, is transferred from the physical space to a psychological one. And yet it is not about a form of individual soul-searching. Rather, the strict framing by the camera makes the events abstract. As in numerous video performances of the 1970s, the duration, repetition, and monotony characterize a form of experimental arrangement and underline the work's conceptual, analytic structure. The sequence recalls Vito Acconci's *Step Piece* of 1970, in which the artist documented his morning exercise of stepping up onto a stool as often as possible. *Step Piece* demonstrates—as do many other comparable works from this period—a changing concept of the subject that was part of Minimal, Conceptual, and Body art. The piece has been related to behaviorist research and seen as the expression of a positivist attitude that distinguished itself from the expressionistic subject of late modernism in the United States and instead treated the artist's body as a seemingly neutral object and "dese-manticized" it.[19] In Acconci's piece, the relationship between human being and stool is presented as a mechanical-seeming pattern of movement. Unlike such superficially formal relationships of body and space, which can be interpreted as an extension of Minimalism's studies of the relationship between (perceptual) space and object (such as Bruce Nauman's *Wall/Floor Positions* of 1968),[20] Birnbaum's video performance shows a clear opening or turning toward the viewers' space—an imaginary, projected space that the performer cannot experience directly but that is embodied by the camera's gaze. She seems to be posing for that gaze. Her positions, which sometimes recall the classic poses of models, allude to the legacy of the European pictorial tradition and seem to toy with the longing gaze. This is reinforced in *Slewed*, the second sequence of *Chaired Anxieties*. The chair from the first sequence is now at center. The performer enters the frame from the right. All we see are her bare

Still from Vito Acconci, *Step Piece*, 1970.

Still from *Chaired Anxieties: Slewed,* 1975.

legs and the lower part of a broad floral skirt. She sits down, stretches her legs forward, surrounds the front legs of the chair, and begins to move the chair in place, to shift it slightly and turn it. Alternately, she pushes back with the tips of her toes or lifts the legs of the chair. In a choreography that seems equally dancelike and manic, her repetitive gestures increase. She turns sitting on the chair and puts its back between her legs. We hear her breathing and her increasing breathlessness, which underscore the erotic suggestion of her bare legs spread over the chair, as do her stroking hands and her spread fingers. Again and again, she changes positions, sitting forward then backward on the chair, enticing us with the promise that we will be able to peek under her skirt. Finally, she slips forward off the chair, bends over, and crawls; hiding, she folds the chair together and removes it from the frame. Later she brings it back, and the thirteen-minute sequence ends with her taking her place on the chair again, turning, standing up, and circling it in gamboling steps.

Birnbaum's work, in its obvious address to a longing viewer's gaze, seems comparable to a video by the Belgian artist Lili Dujourie. In the video *Sanguine* of 1975, Dujourie adopts various poses on a chair, lasciviously pulling up her short skirt while coquettishly trying to attract the gaze of the others with her high heels and low-cut neckline. The title and the action combine into an unconventional allusion to the art-historical tradition of depictions of women in which a term for a classical technique associated with high-quality drawings is countered with the poses and gestures of banal erotic culture. The video becomes a form of desublimation. Dujourie's series *Hommage à . . .* (1972), with five sequences in which the performer sprawls naked on a bed with rumpled sheets, has been described by Marianne Brouwer and Mieke Bal as citing recognizable poses of reclining beauties in works ranging from Titian to Manet.[21] Looking unconcerned, as if she did not notice the camera's gaze,

the supine woman adopts various positions in a dim room. As Bal argues, however, the obvious citations of these poses testify to an awareness that she is being watched and—supported by a slightly elevated camera position and the dim lighting—anticipate the viewers' voyeuristic perspective. The images in *Hommage à . . .* look back without the performer's looking into the camera. Similarly, Birnbaum's anxious posing on the chair seems to follow a hidden stage direction that can be read as an anticipation of the viewers' longing gaze. The resemblance of these two video works from the same year, which were created entirely independently of each other, makes it clear that Birnbaum and Dujourie were both daughters of an age that recognized the emancipatory promise of the new medium and tried to employ it strategically and/or tactically. The women in the videos, staged by the artists themselves, attest to a concept of the subject that recognizes its own constitutive embedding in the symbolic order and acts semiotically—that is to say, employs its own status as a sign in order to critique representation. The object of observation—*the woman in the image*—thus becomes the subject of a critical semiotic operation and reverses the tension-filled axis of vision.[22] To return to the epigraph's metaphor of chess, we might say that these artists show that they recognized the limited freedom of movement of their characters but nevertheless tried to construct the course of the game in such a way that it would not get bogged down in rules. That raises the questions again: Who is playing with whom here? And for what?

Still from Bruce Nauman, *Wall/Floor Positions*, 1968.

Still from Lili Dujourie, *Sanguine*, 1975.

In the context of art, chess automatically makes one think of that legendary photograph showing "old master" Marcel Duchamp playing chess with a young, naked female opponent at the Pasadena Art Museum in 1963. As vague as this association may be, it still offers a lead: Duchamp had himself photographed through his *Large Glass* (1915–23) as he sat at a table playing chess with the unidentified nude woman.[23] In 1976 Hannah Wilke responded to it with her performance *Through the Large Glass* at the Philadelphia Museum of Art. Filmed through Duchamp's key work, the performer is seen in a cream-colored suit, with a hat and high heels, slowly undressing.[24] Duchamp as "ALLREADYMADESOMUCHOFF," as Lucy Lippard once put it, was doubtless the most colorful and important father figure for the (anti)art discourse, to whom one had to relate if one wished to be a part of its lineage.[25] Even if there is no direct connection between the work by Wilke described here and Birnbaum's early videos, the fields they mark out seem comparable, not only historically (since both artists were directly associated with the New York art scene of their day) but also in terms of their ideas. Wilke's *Through the Large Glass* should be seen as a performative visual work that understands and uses the image as a place of action. The piece reveals the effort to make itself visible within the framework of an acknowledged image in the history of art. As one possible embodiment of the bride stripped bare, it trivializes Duchamp's work and deprives it of its power; at the same time, it recognizes that its action can only be observed and understood through the earlier work's frame.[26]

Édouard Manet, *Olympia*, 1863.

Hannah Wilke, *Through the Large Glass*, at the Philadelphia Museum of Art, 1976.

The referential frame of Birnbaum's videos from 1975 and 1976 is neither as concrete nor as obvious, in art-historical terms. Nevertheless, there are similarities between these works and Wilke's. For example, the theme of an erotic relationship between the camera's gaze and the woman in the image becomes even more intense in *Addendum: Autism*, the third sequence of

Still from *Addendum: Autism*, 1975.

Chaired Anxieties. It begins with a close-up of Birnbaum's face. Restlessly, she rocks back and forth and moves up and down while breathing quickly and rhythmically, first through her mouth, then through her nose; she stares fixedly at the camera, and hence at the viewer, with her eyes wide open. Occasionally she relaxes a bit and looks to the right and left. Then she bends backward and, propped on her arms behind her, rocks slightly forward and backward. The reference to the sexual act is unmistakable. It seems obvious the camera's gaze should be identified with that of a lover, and Birnbaum's interaction with the camera should be understood as an allusion to penetration. In cinema, the rhetorical use of the camera is as the gaze of a person who is present but outside the field of vision. Here, however, unlike in a feature film, viewership cannot be assigned to another character, and we as the real viewers are invited to identify ourselves with this penetrating gaze. The effect is disturbing, and in its urgent, sexual form it recalls videos by Acconci, especially *Undertone* (1972), in which he sits facing the viewer at one end of a table with his hands under the tabletop while fantasizing that a girl is stimulating him under the table. In other works, such as *Walk Over* (1973) and *Turn-On* (1974), he addresses his imaginary audience, which seems present to him in the gaze of the camera, repeatedly and emphatically as "you" and thus threatens to see through the desire of those opposite him.[27] The relationship between seducing and threatening his imaginary audience is latently aggressive and is treated as a power relationship. If there is a similarity between Birnbaum's early videos and Acconci's works—and Birnbaum has described her first encounter with them, in Florence in 1974, as a key experience—it is in the way the camera is positioned and incorporated as that of a future audience: the way the camera becomes representative of a longing, importunate gaze and provokes an interaction.[28] Unlike these works by Acconci, however, Birnbaum dispenses with language in her early videos, they do not so much employ threatening gestures as they reveal herself as threatened or at least driven.

SHARED SELF-REFLECTIONS

Bar(red), *Mirroring*, and *Control Piece* take a different turn, one that is largely separate from the problem of the close relationship of camera and the longing gaze. In *Bar(red)*, we see a detail of a room that appears to be a private living space: the shot shows a wall cut off at an angle by a doorframe and a small, framed portrait of a woman. Again and again, Birnbaum walks quickly through the image from front right to back left, interrupted by cuts to a black screen. Every time she passes the center of the room, a noise occurs, which sounds like a door opening and then closing again. In the end, she remains standing in the middle of the room and turns around. When read together with its title, the sequence seems to offer an image of an autistic state in its play with repetition, interior, and the sound of the door, and hence it addresses the question of the subject—of *being* a subject. *Mirroring* takes this up via mirroring and splitting. Also constructed from a repeated movement, it shows Birnbaum approaching the viewers, and when she seems very close, she turns to the side, and a second, reflected profile of her becomes visible. She turns toward this profile, turns around, and then looks at us again. The scene is difficult to describe. It plays with the confusion that results from the camera's pointing at the mirror while remaining outside the field of vision, so that the real space cannot at first be distinguished from the reflected

Still from Vito Acconci, *Turn-On*, 1974.

Still from *Mirroring*, 1975.

space. A similarly vexing play with various levels of the image in the pictorial space of a video is found in Joan Jonas's famous *Left Side Right Side* (1972) and also in Lynda Benglis's *Now* (1973).[29] This is not the place to elaborate on the theme of the mirror and the subject in modernist pictorial invention, but the closeness of Birnbaum's *Mirroring* to the many videos of her period that used electronic mirrors, which were new at the time, testifies to a repeated effort to come to terms with this classic motif and characterizes a moment of crisis for the modern subject; for, contrary to the Cartesian cogito, the mirroring in these videos is not about verifying the self but rather about reflecting on something uncertain. In Jonas's work, the subject's attempt to point in the direction she names dissolves into uncertain gestures. In Benglis's work, the subject's attempt to verbally capture the place of her presence—"now"—dissolves into the repetition of images through the rerecording of previous takes. In Birnbaum's work, the subject's attempt to follow her movements and to decipher the construction of pictorial space dissolves into vagueness, since the artist plays with the camera's depth of field and causes a different part of the image sequence to go blurry with each repetition. What we see here is a break with the paradigm of presence, which modernism overall and Minimalism in particular took as a guiding aesthetic theme. The modern subject loses its fixed place in front of the (mirror) image and gazes instead at the logic of its representational condition.[30]

Even if many early video performances playing with the relationship of subject and mirror can be understood as solipsistic studies of the self and categorized as narcissistic, as formulated in Rosalind Krauss's 1976 essay "Video: The Aesthetics of Narcissism," they also operate at precisely the intersection between the private and the public that feminist theory recognized as political.[31] Consequently, feminist film and media theory was notably concerned

Still from Lynda Benglis, *Now*, 1973.

with psychological concepts of subject formation, which helped to explain how the body functions as a site for the media's gaze, and how public images are inscribed in what we perceive as our most intimate and private aspects—our feelings, our gestures, our perception of ourselves. Foucault went so far as to describe the soul—the expression of the most profound individual feeling—as a construct that imprisons and disciplines the body.[32] And Freud's recognition that the ego is not master in its own house announced the decentering of the modern subject that Lacan expanded to the claim that the ego is not even formed until the mirror stage and is irretrievably split when it enters into language. All these approaches explained and described the form in which culture is manifested physically and psychologically while also triggering thought regarding the transformational significance of media, of language, and of images and technology. Like many other artists since the conceptual turn of the 1960s, which has entered the history of paradigm shifts as "the linguistic turn," Birnbaum systematically explored this process of transformation. Her analysis of the interrelation of circulating images, texts, and narratives (on the production side), of the processes of consumption and resistance, of appropriation and rejection (on the reception side), and of the technological structures of this transfer of meaning is methodologically analogous to approaches found in cultural studies. It is clearly distinct from universal theories of media and focuses on the specific historical construct that existed between political promises and fears, perceptual tasks, body image, self-examination, the history of representation, the cultural field, and the history of technology that could be called, following Walter Benjamin, a "temper of [the] times."[33] This field of the apparatus is the point of departure for theories of the media that analyze culture. In his proposals for "mediology," Régis Debray underscored the necessity for examining the question of the significance of media on three related levels: the technical, the semantic, and the political. Regarding the physical, the question is what technique or what machine is at work. Regarding the semantic, the question is what meanings are inherent in the machine, the question of what discourse is to be understood and pursued. Regarding the political, the question is what is the power relation within the machine—that is, what power is exercised and over whom.[34]

Birnbaum's media works are distinguished by precisely such simultaneity of questions revolving around the relationship of power, representation, and gender. I am tempted to describe her approach—which can be associated with her studying video editing at the New School for Social Research and working on the participatory architectural projects of Lawrence Halprin's studio—as that of a videologist.[35] The term was introduced in 1971 by Alfred Willener, a sociologist and psychologist at the Université de Lausanne, Switzerland, to characterize his approach to research: "We shall provisionally define the videologist as the actor who, in working with video, resituates his action, continuously or intermittently, in response to existential, social, or cultural considerations, that is to say in relation to a socio-logic."[36] The term *videologist* intentionally evokes the Latin meaning of the word *video*, or "I see," and derives from a scientific approach that is similar to participant observation but emphasizes not the study of the observed but rather the fact that the observed transforms the observer. Videologists describe their path with the medium as a path from identification to "alterification"; they associate the perspective of television viewers with mimetic identification, while "alterification" addresses the experience of perceiving oneself by means of video: "Returning to video,

what is particularly inspiriting is the alterophilism [*sic*] that usually develops in those who see themselves on tape in a feedback session We shall designate as ALTERIFICATION the process whereby EGO, OTHERS, and THIRD [the medium] reciprocally transform each other; by means of criticism and redefinition, which include invention and even innovation."[37] Alienation is given a positive turn, becoming a way of getting distance from oneself. The relationship between the self and the image is not static but is rather formulated in a processual way—that is, as an alterable sequence, as a reciprocal process of communication. The Brechtian ideal of the reversibility of transmitter and receiver is brought back, in a sense, to its smallest psychological unit: the act of a mirroring that is described as an act of becoming—a pedagogical process of transformation. The new technology of video made it possible to transfer the intimacy of a scene in a mirror image for a later viewing. Birnbaum utilized this operation to encourage entirely new encounters that literally enable a viewer to participate in a subject's self-reflection.[38] Although her later found-footage montages do not use this kind of mirroring, and the artist no longer appears in the image, works such as *Mirroring* nevertheless address a perspective that continues to appear in her later art: the participation of the viewers in the viewed, their *engaged observation*. The opening of the space to the beholder and the *mode of address* remains connected to the idea of the intercut as a technique of using contrasting cuts within a space, as elaborated by Birnbaum in her aforementioned sketch.

Another video by Birnbaum from 1975, *Control Piece*, leaves the frame of the preceding sequences behind, going beyond direct reflection to construct a picture-within-a-picture relationship. The work begins with the projection of a beam of light onto a wall, which the performer slowly penetrates. Birnbaum reaches her hand and arm into the projected frame and begins "feeling" the contours of the field of light. Then she feels the wall, as if tracing forms that are not immediately visible. She turns around and is faded out. Next we see the projection of a sparsely furnished studio with two backlit figures, with Birnbaum's hands again reaching into the projection from the left. They are covered by the image and cast shadows. Gradually, she advances into the field of the projection; the dark upper part of her body and her long, dark hair swallow up part of the image. She turns and faces the viewer—that is, the camera. The next cut is followed by another close-up of the same scene, which now concentrates on an apparent close-up of the studio and the performer's face. Her eyes appear to seek contact, and her lips show that she is saying something, but we cannot hear what it is. Valie Export has used the term "ontological leap" to describe her own comparable conceptual photographs, in which a "real" leg or arm is shown in front of a photograph of itself and functions like a doubling, which makes it possible to distinguish between reality and representation. But this discernment is possible only at first glance. For it is the nature of picture-in-picture reflection that it not only points to the difference between the pictorial levels but also draws attention to the fact that everything we see is *within* the image; everything is semblance, representation. In *Control Piece*, the performer's wooing gaze, her inaudible words—it all addresses the viewers and involves them in a dialogue that is not actually taking place. Or is it? Image and the act of observation do not seem to share the same plane of reality, not if the latter is related to the coincidence of spatial and temporal coordinates. But they do share a space of projection, in which the gazes and gestures really do meet, provided that the meeting of the gestures is understood to mean more than

Still from *Control Piece*, 1975.

physical contact. And that is what seems to be suggested by the caressing, affectionate gestures with which Birnbaum, in the final sequence of *Control Piece*, turns first toward the image on the wall and finally toward the viewers' anticipated gaze. She behaves as a mediator. *Within* the image, she draws attention to the intimate relationship *with* the image and thematizes that relationship itself, before turning around and offering herself *as* an image for the encounter with the viewers' own groping, attentive gestures.

Chaired Anxieties—the anxieties have taken their seats; they are "chairing" or presiding. When read aloud, the title of this three-part video discloses also another meaning that sounds almost the same: "Shared Anxieties." In this title, the question of its message—the content or information it shares with the viewer—becomes a literal sharing, something the work and its viewing have in common. The various works that Birnbaum produced between 1975 and 1979 show just how systematically the artist explored the positions that make something meaningful. Clearly distinguished from the notion of a genius-based conception of the artwork, which emphasizes the intention or the will to express, Birnbaum's works undertake a semantic analysis of the various factors involved in any process of communication. That analysis, however—as should already be clear from her early videos from the years 1975 and 1976, such as *Chaired Anxieties*—does not remain "bloodless" or anemic but interrogates the medial grammar of the sensorial and the interplays of feeling and representation, affect and mechanism, sensory stimulus and sense.

study for
self. portrait
aprl '73.

study for
self. portrait
'75, Virgo

The title of my essay is from a quote by Dara Birnbaum.

1 Dara Birnbaum, in an interview by Hans Ulrich Obrist, first published in *Dara Birnbaum* (Vienna: Kunsthalle Wien, 1995), pp. 44–64; in this book, p. 20.

2 Birnbaum herself usually dates the beginning of her work with video as art to 1977 and justifies it by reference to her critical interest in television: "I started in video in 1977 when video first became accessible to artists thanks to the Portapak. At the time, I saw television as the dominant language in this country . . . and I thought it was important to take these images at hand and find a way to use them to perform a kind of investigation with a very critical edge." (Dara Birnbaum, "Sighting the Collective Shadow," interview by Jo Ann Baldinger, *Pasatiempo*, June 18, 2004, pp. 54–56, especially p. 54.)

3 In the mid-1980s, Benjamin H. D. Buchloh offered a very precise description of the form and effectiveness of Birnbaum's deconstructivist aesthetic of video: "Equally selective emphasis is put on the devices of television itself, since each tape by Birnbaum seems almost to distill the essence of the standard television strategies by excluding all other aspects (narrative, sequentiality, combination, and simultaneous operation of various devices). In this rigorous reduction of the syntax, grammar, vocabulary, and genres of the language of commercial television does Birnbaum's work follow the procedures of deconstruction as they were developed in the context of modernist collage and montage work, and the effects of her application of these high-art strategies are stunning: revealing to the viewer that the apparatus of television conveys its ideological message as much by its formal strategies and its technique as by its manifest subject matter." (Buchloh, "From Gadget Video to Agit Video: Some Notes on Four Recent Video Works," *Art Journal* 45, no. 3 [Autumn 1985], pp. 217–27, especially p. 20.)

4 On the method of close reading from the New Criticism movement to Jacques Derrida's concept of *différance*, see *Metzler Lexikon Literatur- und Kulturtheorie*, ed. Ansgar Nünning (Stuttgart: Metzler, 2008), p. 98.

5 Birnbaum, interview by Hans Ulrich Obrist, in this book, p. 20.

6 "Making this kind of work, I thought it was really important not to change the speed and not to change the medium. You don't speak from another voice; you speak from that voice." (Birnbaum, interview by Hans Ulrich Obrist, in this book, p. 20)

7 See Christian Kravagna, "Gibt es Orte der Kritik im postmodernen Raum? Dara Birnbaums mediale Medienkritik," in *Dara Birnbaum*, pp. 12–23. In referring to the artist's tactical approach, I am drawing on the distinction between strategy and tactics made by Michel de Certeau in *The Practice of Everyday Life*, which became so important for cultural studies because it made it possible to formulate opposed forms of appropriation and repetition and the productive perspective of consumption, as contrasted to the idea of the conscious, controlling, and intentional action of the

Cartesian subject. See Michel de Certeau, *The Practice of Everyday Life*, trans. Steven Rendall (Berkeley: University of California Press, 1984).

8 Birnbaum, unpublished project notes for *Technology/ Transformation* (1978). Archive of Dara Birnbaum.

9 Kravagna has drawn attention to an anecdote Birnbaum has associated with her critical approach to media. At a demonstration against the Vietnam War, one of the speakers at the rostrum complained about the power of media images and in response to the question, "Are we listening to this?" punched a switched-on television, causing it to explode; see Kravagna, "Gibt es Orte der Kritik im postmodernen Raum?," p. 15. Nam June Paik's distortions of a television picture by using magnets (*Magnet TV* [1965]) and Wolf Vostell's shooting and burning of a television (*YOU Happening* [1964])—iconoclastic gestures deriving from Fluxus—are also among the earliest forms of a critique of television and video art. By contrast, Birnbaum sought a critique that went beyond symbolic destruction and rejection by countering the opposition with forms of appropriation and repetition inherent to the medium's own means.

10 As Kravagna emphasizes with a reference to a study by Anne Friedberg, 85 percent of the shoppers in malls are (or were) female. (Kravagna, "Gibt es Orte der Kritik im postmodernen Raum?," p. 22.)

11 Ibid., p. 13.

12 See ibid., pp. 14ff. Buchloh makes a similar differentiation in reference to Dan Graham's oeuvre when he distinguishes it from Vito Acconci's introspection and Bruce Nauman's Postminimal, sculpturally conceived explorations of the relationship of body, time, and space. See Buchloh, "From Gadget Video to Agit Video," p. 219.

13 I refer here to the works of the 1970s that employed the possibilities of the new medium of video in order to produce and address a specific relationship between the scene of the recording and the observation. There were two primary fields of experiment: (1) the *spatial* separation of action and audience in the situation of the recording (numerous gallery performances by Vito Acconci, Valie Export, Dan Graham, Sanja Iveković, Allan Kaprow, and others), and (2) the *temporal* separation of action and audience, in which the camera—as demonstrated here with reference to Birnbaum's work—is addressed as the representative of a future audience and incorporated into the performance. See Willoughby Sharp, "Videoperformance," in *Video Art: An Anthology*, ed. Ira Schneider and Beryl Korot (New York: Harcourt Brace Jovanovich, 1976), pp. 252–67; Chris Straayer, "I Say I Am: Feminist Performance Video in the '70s," *Afterimage* 14, no. 4 (November 1985), pp. 8–12; Sigrid Adorf, "Video-Performances: Eine Infragestellung des Unmittelbarkeitsparadigmas in der Performance-Theorie (am Beispiel einer Videoarbeit von Elodie Pong)," *FKW: Zeitschrift für Geschlechterforschung und Visuelle Kultur*, no. 44 (August 2007), pp. 14–22.

14 These references to early exhibitions are found in the artist's archival documents, but they are rarely listed in catalogues.

15 Alexander Alberro, "Die Dialektik des Alltags: Martha Rosler und die Strategien der Verlockung," in *Martha Rosler: Positionen in der Lebenswelt*, ed. Sabine Breitwieser (Cologne: Walther König, 1999), pp. 151–86.

16 Suggestions for these conceptual considerations are found on a sketch for this work kept in the archive of Birnbaum.

17 On Michel Foucault's concept of governmentality and his related concept of subjectivity, see Thomas Lemke, "Gouvernementalität," in *Michel Foucault: Eine Einführung in sein Denken*, ed. Marcus S. Kleiner (Frankfurt: Campus, 2001), pp. 108–22. Nicholas Mirzoeff also draws attention to the panoptic form of subjectivization that radiates from the apparatuses of screens and the daily flood of media, which Foucault described as a specific, primarily visual regime. See Mirzoeff, "The Subject of Visual Culture," in Mirzoeff, ed., *The Visual Culture Reader*, 2nd ed. (London: Routledge, 2002), pp. 3–23.

18 Laura Mulvey, "Visual Pleasure and Narrative Cinema," *Screen* 16, no. 3 (Autumn 1975), pp. 6–18.

19 See Barbara Engelbach, *Zwischen Body Art und Videokunst: Körper und Video in der Aktionskunst um 1970* (Munich: Schreiber, 2001); Anja Osswald, *Sexy Lies in Videotapes: Künstlerische Selbstinszenierung im Video um 1970; Bruce Nauman, Vito Acconci, Joan Jonas* (Berlin: Gebr. Mann, 2003); and Buchloh, "From Gadget Video to Agit Video," p. 219.

20 "Making himself into a 'minimalist' prop sculpture in the manner of Richard Serra, Nauman moves through various poses in relation to the floor and wall. While other sculptors were using wood planks, pieces of lead, or sheets of steel, Nauman uses his body to explore the space of the room, turning it into a sort of yardstick to investigate and measure the dimensions of the space." See http://www.vdb.org, as of September 9, 2009.

21 See Marianne Brouwer, "*Homage to . . .* : The Pensive Images of Lili Dujourie," in *Inside the Visible: An Elliptical Traverse of 20th-Century Art in, of, and from the Feminine*, ed. M. Catherine de Zegher (Cambridge, MA: MIT Press, 1996), pp. 265–69; and Mieke Bal, *Hovering between Thing and Event: Encounters with Lili Dujourie* (London: Lisson Gallery, 1998).

22 See Sigrid Adorf, *Operation Video: Eine Technik des Nahsehens und ihr spezifisches Subjekt; Die Videokünstlerin der 1970er Jahre* (Bielefeld: Transcript Verlag, 2008), esp. chap. 4, "Operationen am 'Bild der Frau': Sichtbare Bewegungen in einem festen Rahmen."

23 The famous image is of Marcel Duchamp playing chess against Eve Babitz, photographed by Julian Wasser. But in fact there are two opposing pictures, one with elements of *The Large Glass* in the background, which has been frequently used as an illustration, and the other photographed through the work, showing part of the bachelor

machine (the drums) in the foreground, shown in Tony Godfrey, *Conceptual Art* (London: Phaidon, 2005), p. 285.

24 The date given in the literature for Wilke's work varies; occasionally it is dated 1977. I am following the information supplied in the documentation by Electronic Arts Intermix (EAI), New York.

25 Wilke's quotation of Duchamp is diverse. The very title of her photography and text work *I Object: Memoirs of a Sugar Giver* (1977–78) clarifies the various levels with which the feminist attempt to reappropriate one's own body saw itself confronted: it alternated between "I" as the object of a question of self-image, the "eye object" as a question of the longing gaze, and "I object" as a political objection. Using the strategy of the pun concealed in her title, Wilke works *with* Duchamp, so to speak, to work *against* him. See Alfred M. Fischer, "Die wirkliche Braut, entkleidet," in *Übrigens sterben immer die Anderen: Marcel Duchamp und die Avantgarde seit 1950* (Cologne: Museum Ludwig, 1988), pp. 263–71.

26 "History is a dialectical process. To honour Duchamp is to oppose him. The bachelors, after all, have separated themselves from their feminine parts. To reconcile this dilemma is not to coopt the feminine, but to be . . . Feminine. To strip oneself bare of the veils that society has imposed on humanity is to be the model of one's own ideology. The role model is now both the woman and the artist herself—Hannah Wilke, *Through the Large Glass*—no longer an ornament for society to wear but, in the face of nudity, beyond transparency . . . transcendent." (Hannah Wilke, "I Object: Memoirs of a Sugar Giver," in *Übrigens sterben immer die Anderen*, pp. 263–71, especially pp. 269–70.)

27 See the information on this video available from Electronic Arts Intermix, at http://www.eai.org/eai/artistTitles.htm?id=289, as of September 9, 2009.

28 Birnbaum has said that she first saw video works by Vito Acconci, Dennis Oppenheim, and Bruce Nauman in a gallery in Florence in 1974: "It was a powerful experience for me. I saw it as a tool, a truly outstanding tool." (Birnbaum, interview by Hans Ulrich Obrist [Vienna: Kunsthalle Wien, 1995], p. 58.)

29 Peter Campus's video *Three Transitions* (1973) can also be mentioned for comparison in this context. In it, in contrast to his text works, he plays a perplexing game with the actual site of the reflection by using a blue screen.

30 See Adorf, *Operation Video*, especially chap. 1, "Das Medium ist politisch? Fernsehen, Video und Subjekt um 1970," and chap. 4, "Das Bild operiert an der Geschichte (des Subjekts)."

31 In 1969 Carol Hanisch, one of the first participants in a consciousness-raising group in New York, published an essay titled "The Personal Is Political," which soon became one of the most important slogans of the feminist movement. See Kathie Sarachild, "Consciousness-Raising: A Radical Weapon," in *Feminist Revolution: Redstockings of the Women's Liberation Movement* (New York: Random House, 1978), pp. 144–55. See also Adorf, *Operation Video*, esp. chap. 2, "Das Private ist politisch! Repräsentationskritische Eingriffe im 'Alltag.'"

32 "It would be wrong to say that the soul is an illusion, or an ideological effect. On the contrary, it exists, it has a reality, it is produced permanently around one, within the body by the functioning of a power that is exercised on those punished— and, in a more general way, on those one supervises, trains and corrects. . . . The man described for us, whom we are invited to free, is already in himself the effect of a subjection much more profound than himself. A 'soul' inhabits him and brings him to existence, which is itself a factor in the mastery that power exercises over the body. The soul is the effect and instrument of a political anatomy; the soul is the prison of the body." (Michel Foucault, *Discipline and Punish: The Birth of the Prison*, trans. Alan Sheridan [New York: Vintage Books, 1995], pp. 29–30. See also Judith Butler, *Psychic Life of Power: Theories in Subjection* [Stanford, CA: Stanford University Press, 1997], p. 86.)

33 See Walter Benjamin, "Little History of Photography," trans. Edmund Jephcott and Kingsley Shorter, in Benjamin, *Selected Writings, Volume 2, 1927–1934*, ed. Michael W. Jennings, Howard Eiland, and Gray Smith (Cambridge, MA: Belknap Press of Harvard University Press, 1999), pp. 507–30. On the relationship between painting and photography, which takes as its starting point the question of a specifiable media approach, he remarks (p. 523): "Many of those who, as photographers, determine the current face of this technology started out as painters. They turned their back on painting after attempts to bring its expressive resources into a living and unequivocal relationship with modern life. The keener their feel for the temper of their times, the more problematic their starting point became for them."

34 See Régis Debray, "Primary Definitions," in *Media Manifestos: On the Technological Transmission of Cultural Forms*, trans. Eric Rauth (London and New York: Verso, 1996), pp. 11–21, esp. pp. 17–18; as well as Debray, *Introduction à la médiologie* (Paris: Presses Universitaires de France, 2000).

35 For information on Birnbaum's education, see *Dara Birnbaum*, p. 152.

36 Alfred Willener, Guy Milliard, and Alex Ganty, *Videology and Utopia: Explorations in a New Medium*, trans. Diana Burfield (London: Routledge and Kegan Paul, 1976), p. 115.

37 Ibid., p. 145.

38 Birnbaum, too, points to the importance of *Mirroring* (1975).

CRITICAL FORMALISM OR MUSICAL CRITIQUE: SONGS AND SOUNDS IN THE WORK OF DARA BIRNBAUM

DIEDRICH DIEDERICHSEN

In *Pop-Pop Video: General Hospital/Olympic Women Speed Skating* (1980), a scene from the soap opera *General Hospital* alternates with images of an Olympic women's speed-skating event. As in many works by Dara Birnbaum from that time, one finds that, in her analyses of the images and sounds generated for mass culture, she less confines herself to typical critiques of media's sedative and repressive operations than scrutinizes its rousing and galvanizing effects—that is, she appraises its motivational mechanisms. Yet, when confronted with such deconstructed mass and countercultural languages, it is often difficult to distinguish between a stimulant that exploits and one that empowers.

Stills from *Pop-Pop Video: General Hospital/ Olympic Women Speed Skating*, 1980.

In her exploration of both television's attention to physicality and appearance and the social implications of the media's construction of the physical, organic, carnal, and natural, Birnbaum highlights, on the one hand, already exhausted television spectators and, on the other, images that are ever more rapidly losing meaning. *Pop-Pop Video: General Hospital/Olympic Women Speed Skating* marks the beginning of the period in media history when health and fitness become normative prescriptions. Birnbaum confronts this shift from a feminist viewpoint, questioning why and how it is women who are time and again cast as the subjects of a new compulsion. And it is precisely their bodies to which the imperative pertains: they must be either fit or invisible. The strip that separates the lanes of the speed skaters is made of snow. Workers at the stadium simply sweep the snow lying about or the ice dust created from razing the track into the middle—either by hand and a broom, or with ice-polishing vehicles. Incidentally, *snow* is a word, in all the languages that I know, for cocaine. The winning woman skater, from East Germany, who here dashes along a line of snow, seems boosted by a drug that in those years passed through the production centers of the culture industry, from the boundaries of subculture to the mainstream, to become the favorite of brokers and other representatives of post-Fordist capitalism. Like that of Wonder Woman, whom Birnbaum sampled from television two years earlier for *Technology/Transformation: Wonder Woman*, the female body is here stimulated by an external source, with potentially both positive and negative effects.

The technological hold over women's bodies is a theme that runs throughout Birnbaum's early works. These bodies burst with unimaginable powers but are nonetheless subjugated to a regime of emotionalization and sexualization. She does not denounce this classic phase of pop TV in a simple, moralistic sense, however. Instead, she dramatizes an ambivalence inherent in the mass media—the tendency to simultaneously restrain and empower the female image. Popular culture is not merely an oppressive apparatus; it is a highly developed and specialized instrument that is in tune with the times, entertaining and providing enjoyment while also ensuring productivity and

maintaining social stability. Consequently, critical analysis of it must not stop at questioning its repressive and sedative effects but must go on to probe its motivational and even emancipating moments.

Birnbaum's works are themselves driven—enhanced even—by the same feverish mechanism she critiques, as she further speeds up the already rapid pace of what she observes. Her method is unexpected: using exaggeration and decontextualization, she isolates moments where social norms masquerade as natural. Building on the seductive appeal of those images, she relies on the aesthetic effect of hyperbolic, compulsive repetition and rapid-fire editing. That her tactics succeed—without damaging the aesthetic integrity of her projects or glossing over the subject matter, the critiqued images and the apparatus of their production and dispersion—has to do, in my view, with the fact that she works within a pictorial paradigm with musical means; indeed, she simultaneously engages critical distancing and affirmative participation by deploying appropriated music and triggering its attendant social and political functions.

In an interview with the artist, Benjamin H. D. Buchloh suggested that Birnbaum could be reproached for "formalism" were her works concerned only formally with mass culture and its "strategy of oppression."[1] She replied that she longed for the day when people would finally perceive formalism not only as an oppressive but also as an empowering strategy: "then one could recognize that elements of repetition, dislocation, and altered syntax function as catalysts for creating alternative perspectives, rather than placing them on the side of the oppressor."[2] Perhaps it is possible to say that the social and political functions of music culture are connected and complementary to Birnbaum's postulate of a "critical" formalism.

Underlying *Technology/Transformation*, a chorus of women wails through a track by the Wonderland Band, "Shake Thy Wondermaker!" Clearly sexualized, the song is certainly a tool of oppression; at the same time, it can be seen within a completely different tradition. The Wonderland Band has only one single to show for itself, namely the one used by Birnbaum, which is available in several mixes as a twelve-inch record. Its producer, Morrie Brown, who most likely also made up the entirety of the band, went on to become a rather well-known and influential funk/soul artist. He managed the singer Kashif and his former band, B. T. Express, and above all produced a series of albums of 1980s diva Evelyn "Champagne" King. A strong soul queen, King symbolizes the alliance of gay culture, politicized hedonism, and female African American self-consciousness that developed in the early 1980s in funk and soul. These connections perhaps seem tangential to Birnbaum's *Technology/ Transformation*, yet their relevance is made clear when the lyrics of the song

Stills from *Technology/Transformation: Wonder Woman*, 1978–79.

appear on-screen in isolation against Birnbaum's chroma-key blue background in the style of a karaoke video, deprived of all seductive elements. The simplicity of this presentation does not take the simple approach of either exposing or denouncing a certain idiocy or mindlessness of pop; Birnbaum also displays ambivalence and discord via the song's campy pleasure.

Birnbaum tackles the architecture of spectacle, in a broad sense of the term. In fact, she took on spectacle and its implications at a time when the majority of American Conceptual and post-Conceptual artists tended to concentrate their critical energy on the art system and its institutions rather than on the connections of those institutions to the ideological systematics of mass culture in capitalist industrial societies. The critique of spectacle requires a knowledge of and relationship with the vocabulary of mass and popular culture. Birnbaum, who was decisively marked by the politics of counterculture, not least during her time in Berkeley in the early 1970s and through the inspiration of activist figures such as Abbie Hoffman, brings the additional dimension of subcultural politics into play, politics in which lifestyles are understood in oppositional political terms. This stance again distinguishes her from those left-leaning intellectuals for whom countercultures must always be seen as another component of the culture industry.

Describing Birnbaum's program within these coordinates is already sufficiently complex; to complicate matters further, she at some point added a postulate to her agenda that makes any characterization of her project even more difficult. Whereas critical artists of the previous generation critiqued the art industry only under extant conditions, she anticipated and questioned new media's technical, cultural-industrial, and aesthetic future. As a result, she created work beginning in the late 1970s that in many respects assumed the conditions that artists must deal with today.

Birnbaum's moving-image installations belong to no genre or discipline; rather, they challenge those that have emerged in the fields of media architecture and image production, for example, the problematic genre that has often been identified as media art. She addresses the various worlds of gallery art, technology art, mass culture, and subculture—each of them a relatively closed cosmos—without occupying a clearly defined position within this matrix. Hence we ask questions of her work today from a point of view that she had anticipated. To what extent is the role of music in this work conceived as a means to mark and to display the conditions of media architecture as simultaneously technical and formal, and at the same time to show these conditions as potential points of contact to particular and always distinct social and cultural milieus? Her work activates music as a scout in the undergrowth of media's disciplinary and aesthetic territories.

Music is present in three forms in Birnbaum's work: as a decontextualized production of the culture industry, a timekeeper of subjugation and conditioning that is nevertheless awkwardly independent; as a contribution from collaborators; and, finally, as an object of historical, critical, or respectful reflection on classic works by artists as diverse as Jimi Hendrix and Arnold Schoenberg.

Birnbaum followed *Pop-Pop Video: General Hospital/Women Speed Skating* with a sequel, *Pop-Pop Video: Kojak/Wang* (1980). In this case, the music was

arranged by guitarist and composer Rhys Chatham, and it was distinguished by its indistinct beat, which did not determine the editing of the image; rather, the music remains as almost a separate layer. Here again, Birnbaum features formulaic portrayals of affect. Scenes from the popular TV series *Kojak*, with Telly Savalas, are cut against a computer commercial with a "medial woman" (as defined by Klaus Theweleit[3]), who, in occupying the subordinate role assisting the male producer, serving his interests and technical needs, appears as helpless as she is eager, sitting in front of a computer screen at which strike magical, delicate, and colorful flashes. These scenes are repeatedly interrupted by a screaming test pattern. Image and sound are synchronized only in this section; otherwise, the music disassociates from image, diffusing through a force of affect.

Collage using stills from *Pop-Pop Video: Kojak/Wang*, 1980.

Chatham assumes a role here different from that of the collaborators who were commissioned directly by Birnbaum, such as Dori Levine, Sally Swisher, and Robert Raposo. He contributes music of the sort he would make normally as a musician, while the latter three process music conceptually and manifestly according to the artist's instructions. They make vocal tracks or funky accompaniment that have little life of their own but that are conceptually required for the artwork at hand and are largely symbolic—a certain backbeat, for instance, or the *idea* of a female folk voice. In *Kiss the Girls: Make Them Cry* (1979), which uses incredible footage of minor stars from the quiz show *The Hollywood Squares*—all forced cheerfulness, frozen effusion—Spike and Allan Scarth contributed sophisticated funk in the style of the emerging No Wave; the rest of the music comes from current top-of-the-charts material by the band Toto and the singer-songwriters Ashford & Simpson. Once again Birnbaum's choices are ambiguous, as they represent different concepts of the popular in pop music: whereas the Toto songs are entirely unlistenable, Ashford & Simpson's could be considered to have lasting value.

Pop-Pop Video performance with Sally Swisher, Robert Raposo, and Dori Levine, among others, at The Kitchen Center for Video and Music, New York, 1980.

The title of the two-part *Pop-Pop Video* reveals that Birnbaum was perhaps one of the first intellectuals and certainly the first visual artist to take the new format of the music video seriously. She recognized that the popular music videos of the time were, like her, dealing with mass-media images that had already been digested and stored in associational memory. The videos were often even similarly critical and, also like most of her own works, cut to the beat. But, at least in the early days of music television, commercial videos followed standardized formulas that placed the performing artist and the product at the center. In this dialectic of similarity and difference, Birnbaum's works only gain in critical sharpness.

By the late 1970s and early 1980s, the idea that critique could operate from an objectively distanced position had reached its conclusion, at least in art. Only a targeted or confrontational approach to symptomatic images could claim that the critic is also a consumer. From early on, Birnbaum had tried to forge an artistic strategy from this situation. She not only let the images speak for themselves, but she also engaged the logic of their allure and turned it against itself, as in a judo throw. This turn against logic did not involve a change of register or a leap to another level of criticism, of discourse, but was based on an antagonistic dance, a beat, a movement of aggression, rather than on knowledge of a higher order.

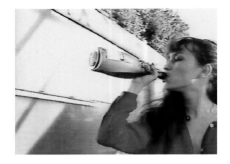

Still from *Remy/Grand Central: Trains and Boats and Planes*, 1980.

Nevertheless, in many pop videos (fewer in the United Kingdom, where Julian Temple and Derek Jarman shot them, than in the United States, where MTV culture was not yet so sophisticated), a formula based on agency was found in this tension between mass-culture images and a musicalized aggression/aggressive music. Birnbaum explored the possibilities of this method in her two so-called pop videos and, with particular clarity, in a video shot to Burt Bacharach's "Trains and Boats and Planes" that was commissioned by the cognac company Rémy Martin. The song is one of Bacharach's finest tearjerkers and became a hit for Dionne Warwick, who gave a voice to female misery borne with dignity. Here, as she had done with singer Dori Levine in earlier works, Birnbaum has Clarise Taylor perform a stylized vocal part within the aesthetic composition. The video's musical accompanist, Kelvyn Bell, as guitarist of Defunkt, had left a decisive mark on the New York fusion of No Wave and African American avant-garde jazz and funk; though this lineage might be unknown to many viewers of the videos, his presence does reflect the environment in which Birnbaum made her musical choices.

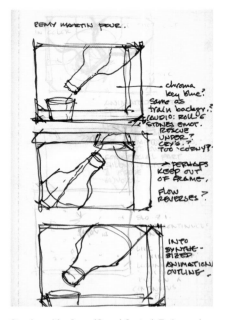

Storyboard for *Remy/Grand Central: Trains and Boats and Planes*, 1980.

Rémy Martin cognac—like the allegorical cocaine of *General Hospital/Olympic Women Speed Skating*—appears in this video as a drug that reaffirms the state of helpless reverie evoked by Bacharach's lyrics, Warwick's performance, and the images of trains and planes that pass by the dreamy, seemingly despairing woman. Here, Birnbaum begins to use an approach that she will continue in her *Damnation of Faust Trilogy* (1983–87): she treats material she has produced in a manner similar to how she has used found footage in her earlier works, and her methodologies with visual material come to resemble the techniques of music. Through repetition and permutation, the image, conventionally seen as a window onto the world, is reattached to its own frame. In a fractured parallel to the shaped canvases employed by painters twenty years earlier, she plays with unorthodox frames that generate their own forms for picture-within-picture arrangements. These compositions partially trans-

fer the movements of what is filmed in the frames—for example, a wipe across the screen follows the movement of a swing in *Evocation* (1983), the first part of the trilogy.

This strategy appears as a perfect example of what has already been posited: Birnbaum translates the operations of a composer, which are shaped by internal references and ideas of correspondence and relation, into visual methodologies. Though initially perceived as purely formal, they actually fulfill the task of critiquing ideology, critiquing implicit meaning and the culture of evidence with its syntactic conventions and deceptive claims of realism. The image is not merely a window onto the world.

Such a critique does not necessarily mean, however, that the conventions of image viewing themselves are the problem—a typical misunderstanding. The problem is that they are unmarked, "invisible." It is not possible to communicate without syntactic conventions, but real comprehension is lost when we don't recognize what we do semiotically and syntactically. For Birnbaum, music offers the possibility to demonstrate the conventions and, at the same time, to synthesize this critique of conventions with the pleasure that comes from an open and enabling syntax—a synthesis made possible by emptying signs of their clichéd meanings.

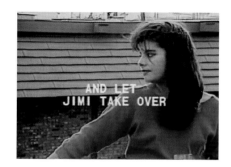

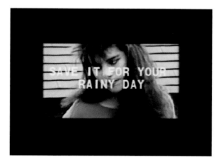

Stills from *Fire!/Hendrix*, 1982.

When she began working with music, Birnbaum had commissioned it simply to accompany her found imagery. By the mid-1980s, she had also created works with found songs and with music that could stand alone, independent from the imagery. In her formal music video for Jimi Hendrix's song "Fire" (*Fire!/Hendrix* [1982]), sexualized images of a woman collapse with the energetic, emancipatory aspects of the song. For *PM Magazine* (1982), which was shown as a multichannel installation at Documenta 7 in Kassel, she and several collaborators rerecorded the Doors' song "L.A. Woman." This hymn of a dominant masculinist subject, who constructs a sexual attraction based on the solitude of a woman, his Other, is fodder for Birnbaum's analytics.

She sets the association value, the notoriety of the Doors version, against the alienating effect of her slightly lethargic new interpretation. In effect, it denies Morrison's pseudocompassionate masculinism, so that a different kind of empathy can surprisingly emerge. In turn, the languid beat is an aesthetic tool of No Wave music, with which some of Birnbaum's collaborators from the downtown music world were involved. The lyrics (translated into German for Documenta) are placed within alienated, sumptuous images: images of excess, exuberantly distorted almost to the point of abstraction, follow the movement of the music, while the words, superimposed onto image, dramatically recall the violence of the song.

New Music Shorts (1981) comprises clips from two No Wave concerts: one by the Radio Fire Fight duo, one of whose members joined the Natural Sound Ensemble with another of Birnbaum's collaborators, Sally Swisher; the other, a performance of Glenn Branca's *Symphony No. 1*. Birnbaum documents the concerts, editing and montaging them in the same

Still from *PM Magazine/Acid Rock*, 1982.

way she cut her more "artificial" works: this material, though shaped by a real-time musical event, has the same status as the footage in Birnbaum's other works. Her critical formalist practice refers not only literally to music but also to music's internal logic; she borrows from music its intentional elusiveness, using the music as a heuristic device, without becoming absorbed in it.

Evocation (1983), the first part of the *Damnation of Faust Trilogy*, had juxtaposed music by Sonic Youth (one of the few protagonists as a canonized band who survived No Wave) with cool techno-pop by Joshua Fried—a music of intensity meets one of elegant, agreeable languor. In the later parts, *Will-o'-the-Wisp* (1985) and *Charming Landscape* (1987), the function of music changes: it is neither preexisting nor from the cultural milieu of the artist, nor is it a conceptual presentation of certain types of music. Instead, Birnbaum collaborated with the duo The Picassos to compose music so that the sound track serves more as a score. She would work with them again on *Canon: Taking to the Streets, Part One* (1990). For *TRANSVOICES: Transgressions* (1992), her contribution to the international AIDS Awareness Project, she similarly worked with the new-music duo tomandandy, who collaborated with her on various installations of the 1990s.

Collage with lyrics of Sonic Youth's "Protect Me You," written by Kim Gordon and used for the sound track of *Damnation of Faust: Evocation*, 1983.

Even with the different approaches of her later works, there remains a close connection with her earlier themes and procedures. Birnbaum's installation *Erwartung/Expectancy* (1995/2001), a multipart project that uses Plexiglas and projections based on Schoenberg's one-act opera of the same title, can be seen as a direct response to Jim Morrison's "L.A. Woman." In Morrison's gaze, the grieving woman, the object whom he can eroticize only as the result of a story of abandonment, appears in Birnbaum's paraphrasing of Schoenberg not only as a waiting subject but also as the creator of an erotic plot flush with expectation, projection, desire, disappointment, and self-resignation. In Birnbaum's interpretation, Schoenberg's music becomes a sound track: it involves rising and fading, relatively amorphous "nonmusical" electronic sounds, which assume the movement of the original not in composition but in terms of cultural connotation.

In many installations, Birnbaum brings into focus an idea expressed by Theodor Adorno and Hanns Eisler[4] in the 1940s, and even earlier, in 1932, by Rudolf Arnheim,[5] that sound film (and, by extension, sound video) is always installation-like, since sound adds a third dimension to

the two-dimensional image. Arnheim saw sound in film as problematic, as it put movies in competition with the theater; for Adorno and Eisler, sound completed the deceitful illusionism of the cinema. For Birnbaum, sound became a means by which she could confront the challenge of extending her montages into three-dimensional space. In the case of *Hostage* (1994), a work installed as a six-channel video with five sound tracks and four monitors, this process enabled her to develop synchronically running political statements and counterstatements, sound documents, and illegible ambient sounds. This impressively diverse sonic schema, with its merging of contradictions, counters the comparatively peculiar and rigid monitor constructions. Again, sound liberates image. Unlike other installation artists, who in this black-box age enforce a standardized image-sound-space continuity characterized by a longing for the cinematic, Birnbaum engages discontinuity. In place of black curtains, a heavily transposed sound track establishes the merging of opposites.

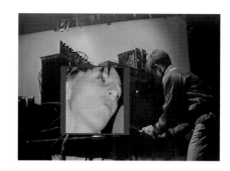

Many of Birnbaum's early questions regarding found imagery related to pop music and sound return, albeit in an installation format, in the multiscreen work *Tapestry: Elegy for Donna* (2005). The movement of the video montage imitates that of weaving, and the images are projected downward onto a loom.

Stills from *New Music Shorts*, 1981.

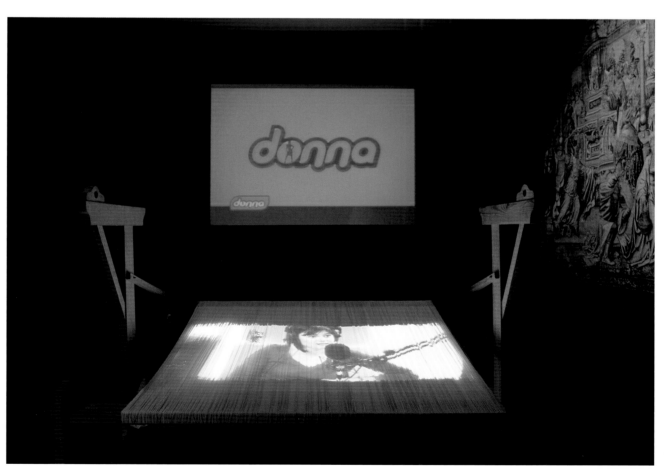

Tapestry: Elegy for Donna, 2005, installation view of "Dara Birnbaum: The Dark Matter of Media Light," at Museu de Serralves, 2010.

An upright projection shows the techno-style logo of the Belgian radio talk show *Donna*, as well as footage from its simultaneous television broadcast, in which the female host directs men carrying out various tasks. The loom projection shows material from the same television show, temporally transposed and highlighting various facets. The video clips consist of repetitions and permutations similar to those in Birnbaum's early video works, with two types of music—a looped track reminiscent of French house music like Etienne de Crécy and Daft Punk, and a montage of various celebrated voices—those of Elvis Presley, Johnny Cash, Leonard Cohen—singing Cohen's "Bird on a Wire."

In the early 1990s, Dara Birnbaum was often grouped with a generation of feminist artists and curators who had begun in the 1970s to rethink the connection between art by women—especially anti-essentialist feminist artists—and new media technology. Birnbaum, however, influenced by the first generation of feminist film theorists, such as Laura Mulvey, opened the critical panorama beyond art production by women to include the entire field of media production by women. In probing the technical as well as the social side of production, she did not lose sight of the decisive differences between the two. In *Tapestry*, she acknowledges that women work both for and with the media in social reality while at the same time they are symbolically constructed by and in the mainstream commercial media through its imagery.

Further, it appears as if *Tapestry* is positioning women in a fresh relationship with the media, by presenting a female media worker who is openly in control of media production and by referring to techno-culture. Since asubjective techno, with its multitude of romping, raving bodies, replaced the individualistic guitar-playing phallocentric male rock subject, its potential was recognized as a context for feminist politics. In the loop, Birnbaum knits together a particularly glamorous phase of techno-culture with broken singular voices. "Bird on a Wire" brings up an old, sexist term for "woman" as well as an outdated expression for radio to allude to the female commentator before us. The image projection on the loom, which operates like weaving, can be read as an homage to a feminism that binds the productivity of women to traditional women's work as a matter of identity politics. Birnbaum's metaphoric use of weaving and knitting, in the form of montage, exemplifies a mode of performing "musical criticism" or "critical formalism" in an age of digital media and post-techno music.

1. Dara Birnbaum, interview by Benjamin H. D. Buchloh, in *Rough Edits: Popular Image Video* (Halifax: Press of the Nova Scotia College of Art and Design, 1980), p. 86.
2. Ibid.
3. See, for example, Klaus Theweleit, *Object-Choice (All You Need Is Love)* (London: Verso, 1994), p. 20.
4. See Theodor W. Adorno and Hanns Eisler, "Komposition für den Film," in Theodor W. Adorno, *Gesammelte Schriften*, vol. 15 (Frankfurt am Main: Suhrkamp, 1976), pp. 7–146.
5. Rudolf Arnheim, *Film als Kunst* (Frankfurt am Main: Suhrkamp, 2002), pp. 189–260.

BETWEEN NONSITES AND NONPLACES: DARA BIRNBAUM'S DISLOCATED SPACES

STEVEN JACOBS

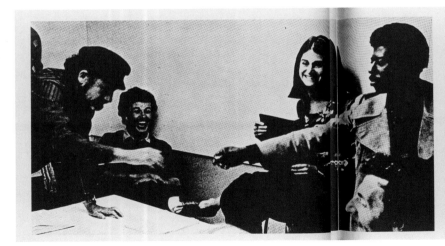

Dara Birnbaum in the studio of Lawrence Halprin & Associates, from the publication *Take Part*, 1972.

ENVIRONMENTAL ANXIETIES

"My original degree was in architecture and I had also worked a lot in environmental design. I saw that television was our new landscape," Dara Birnbaum once stated.[1] For Birnbaum, the virtual realm of the media always intersects with the physical structures of our private and public spaces. It is perhaps no surprise, then, that Birnbaum, an architect by training, has always shown a particular interest in the spatial and architectural aspects of her videos and installations or that in many of her works she explicitly deals with the topographic and social dimensions of public place. This interest in public space no doubt dates back at least as far as her work in the studio of Lawrence Halprin & Associates, in the early 1970s. To Halprin, a San Francisco-based landscape architect and urban planner, public space was an essential notion in his egalitarian democratic vision, which entailed citizen participation in the design process. Celebrating the city's dazzling vitality, his projects were marked not only by an attention to human scale but also by a profound understanding of user experience and of the way urbanites move through their public environments.[2]

Birnbaum exchanged architectural practice and environmental design for the visual arts in the mid-1970s. A distinct interest in the visualization of place and space can already be seen in a 1975 series of videos that included such works as *Mirroring*, *Chaired Anxieties*, and *Control Piece*, among others. In these performance tapes, Birnbaum turns anonymous private spaces into laboratories where the spatial relations between the artist's body, rooms, corridors, pieces of furniture, mirrors, projected images, and the camera are tested. Using mirrored and projected images, she creates spatial confusions that anticipate the conflation of literal, physical, metaphoric, and mediated spaces in her later oeuvre. Similar preoccupations underlie other early video works such as *Pivot: Turning Around Suppositions* (1976), in which she scrupulously investigates the relations between the movements of the performer and those of the camera.

Still from *Control Piece*, 1975.

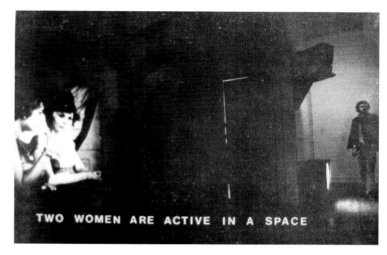

TWO WOMEN ARE ACTIVE IN A SPACE

Postcard announcement, showing an installation view of *(A)Drift of Politics*, 1978, at the Kitchen Center for Video and Music, New York, 1978.

TECHNOLOGY TRANSFORMATIONS

Reminiscent of contemporaneous works by artists and filmmakers such as Dan Graham and Michael Snow, who also saw the camera as a tool for sculpting mediated spaces, Birnbaum's early videos also show a Postminimalist interest in spatial fragmentation and doubling, a concern that can be noted even in the diegetic space of the videos themselves. Pivoting movements and mirrors, which played important roles in the early videotaped performances, recur in *Technology/Transformation: Wonder Woman* (1978–79), unquestionably Birnbaum's best-known video piece of the late 1970s and, by now, a key work in historical surveys of video art.[3] In the piece, which marks the beginning of the artist's use of appropriated television footage—along with *Lesson Plans (To Keep the Revolution Alive)* (1977) and *(A)Drift of Politics: Two Women Are Active in a Space* (1978)—Birnbaum recontextualizes a pop-cultural icon through fragmentation and repetition in order to subvert the intended meanings of a television program. Criticizing the construction of (women's) identities through TV-show stereotypes and the manipulative designs of vernacular images, *Technology/Transformation* also evokes a spatial paradigm that appears in many of her later works. The video opens with a series of explosions reminiscent of 1970s disaster movies. The bursts of blinding light suggest a catastrophe destroying all matter and boundaries. Apparently, we enter the biotope of Wonder Woman, a female iteration of the American superhero capable of transgressing temporal and spatial limitations. Spatial obfuscation occurs as the pivoting woman tries to cut through her own mirror-image identity in a room whose every wall is covered by mirrors.[4] The instant the secretary transforms into Wonder Woman, she is hurtled into another place. In so doing, the tactics of Birnbaum's Wonder Woman epitomize the so-called creative geography intrinsic to the media—a phenomenon that acquired new dimensions as the late twentieth-century television spectator gained the ability to switch between channels by means of a remote-control device.

Still from *Technology/Transformation: Wonder Woman*, 1978–79.

127

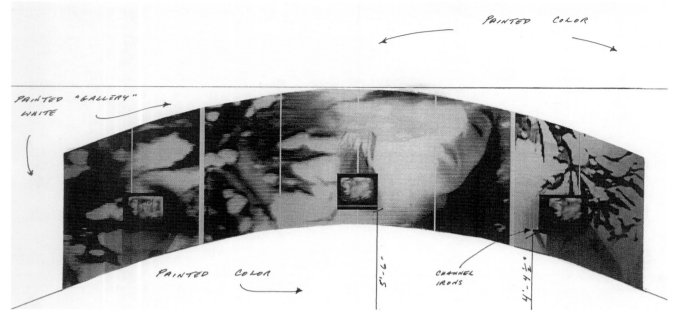

PAINTED COLOR

PAINTED "GALLERY" WHITE

PAINTED COLOR

5'-6"

CHANNEL IRONS

4'-4½"

Installation rendering for *Damnation of Faust: Will-o'-the-Wisp*, 1985.

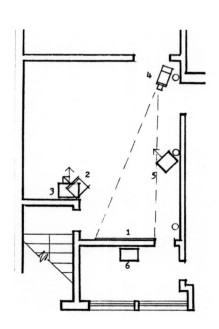

Installation rendering for *(A)Drift of Politics*, 1978, at the Kitchen Center for Video and Music, New York, 1978.

NONSITES

Birnbaum's early installations explore the diegetic space of popular television shows. *Lesson Plans (To Keep the Revolution Alive)* consists of a Super 8 film loop and twenty-five stills, with matching text panels, which she shot off the television screen while watching prime-time crime dramas—according to Birnbaum, "the C-major chord" of American television imagery at that time.[5] Transcriptions of the on-screen dialogue accompany each still photograph. Preliminary sketches of the project reveal Birnbaum's specific attention to the ways in which a spatial continuum is created by means of reverse-angle shots. Reminiscent of contemporaneous Conceptual art's predilection for the juxta-position of words and images, Birnbaum converts the logic of televised fiction into a system of, in Martha Rosler's words, "inadequate descriptive systems." As in Rosler's famous work *The Bowery in Two Inadequate Descriptive Systems* (1974–75), which comprises a series of photographs accompanied by labels showing typewritten statements, Birnbaum's *Lesson Plans* juxtaposes images with linguistic information in order to make explicit the discursive dimension of these images—in this case, the imagery of television's highly convention-alized television format.

Analyzing and deconstructing the mechanisms that create the illusion of a unified space in video and, then, in television, early Birnbaum pieces such as *Lesson Plans* and *(A)Drift of Politics* were also physically situated in exhibition spaces. Given this perspective, many of Birnbaum's works utilize the logic of nonsites in the way Robert Smithson had conceived them. For his 1969 series of nonsites, Smithson collected earth and rocks from derelict industrial areas to install in galleries, often combined with mirrors or glass. According to Smithson, a nonsite is "a three dimensional logical picture that is *abstract*, yet it *represents* an actual site."[6] In his peculiar combination of Minimalist formalism and documentary representation, Smithson created concrete objects that simultaneously were, he argued, abstractions. In

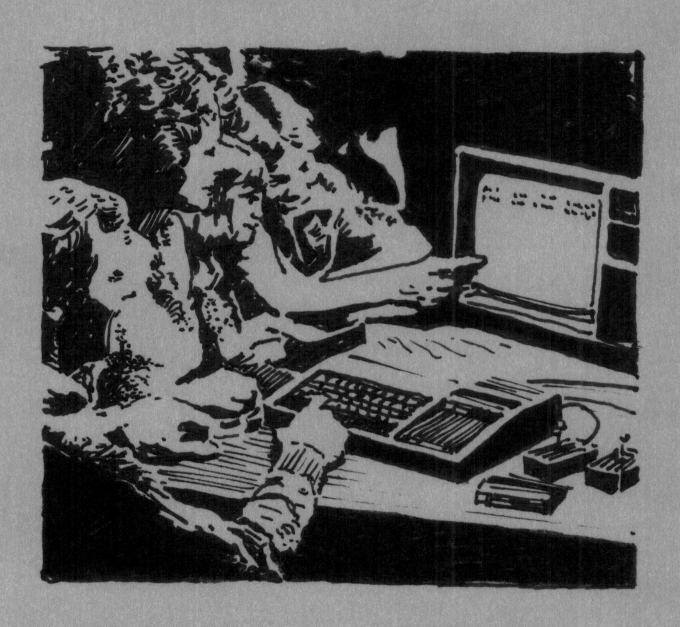

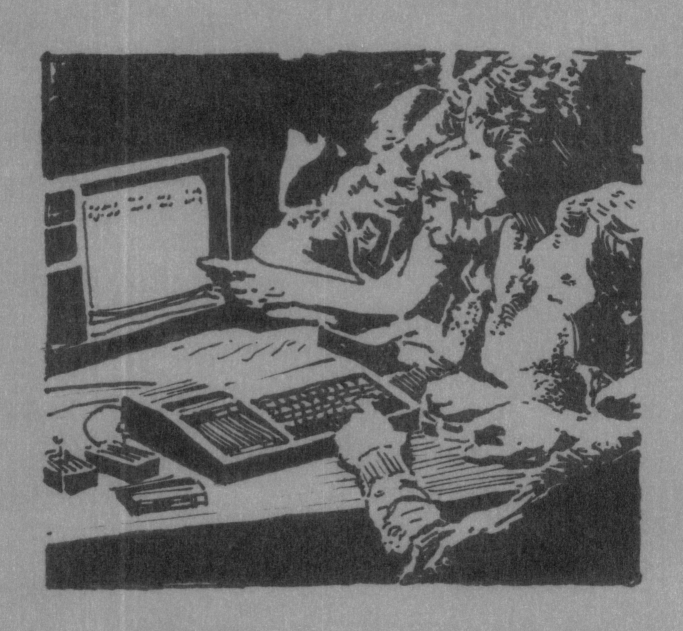

addition, Smithson enriched the Minimalist preoccupation with the spatial and physical relations between the exhibition space, the beholder, and Donald Judd's formulation of the "specific object," with a fascination for metaphoric, imagined, represented, and mediated places. Birnbaum has moved in parallel, combining a fascination for the actual presence of her works in the gallery space with various strategies of redoubling. To a certain extent, video screens in Birnbaum's work play the role that mirrors and maps played in Smithson's. Video images are presented as both representations and extensions of the real world. Furthermore, they help to constitute a new world—the virtual world of the media, which, in its turn, becomes one of the main topics of her work.

Throughout her oeuvre, Birnbaum bases her work on the juxtapositions and interrelations between the physical space of the gallery, public space, the virtual space of the media, and the diegetic spaces of the video and its source material. She has even gone so far, in the cases of single-channel video works such as *Kiss the Girls: Make Them Cry* (1979), as to reedit her material to conform to a sculpture-based site-specific installation environment. David Ross has noted that "in these works she has been able to create spatial extensions of the concepts that were introduced in the single-channel tapes."[7]

Early works such as *(A)Drift of Politics*, which uses imagery from the popular *Laverne & Shirley* television show, combine projected images with a television set that acquires a sculptural presence in the gallery space. In later works, the "objecthood" of the television monitor is exchanged for an environment with several screens requiring multiple viewpoints. The large-scale video installations of the early 1990s, such as *Tiananmen Square: Break-In Transmission* (1990), *Transmission Tower: Sentinel* (1992), and *Hostage* (1994), explicitly play on the presence of different objects, images, narratives, and spectatorial positions within an exhibition.[8] But the multiplication of screens and viewpoints and, therefore, the activation of the exhibition space by the beholder are not attempts to create theatrical effects or to redesign or decorate the gallery space. Instead, the fragmentary and architectural qualities of these video installations are fostered by the topics and themes they are dealing with. In *Tiananmen Square*, media images related to the 1989 Chinese student uprising were distributed on to video monitors placed according to the specific architecture of the gallery. Visitors to the gallery determined, through their movement in the exhibition space, the selection and sequence of the images, which resulted in a discontinuous flow that provided multiple viewpoints. In Birnbaum's words, "*Tiananmen Square: Break-In Transmission* introduces the themes of fragmentation and disunity in its examination of the relationship between viewer and television broadcast." Moreover, the work throws into question "TV's claim to render the viewer an omnipresent vision of 'eyewitness.'"[9] By juxtaposing footage of George H. W. Bush expounding his vision of global politics, along with students during a National Student Convention in 1988, and rhythmic footage of Allen Ginsberg reciting his antimilitaristic poem "Hum Bom!," *Transmission Tower: Sentinel* presents contrasting and incommensurable narratives and their concomitant audiovisual languages (highly technical imagery of broadcast television

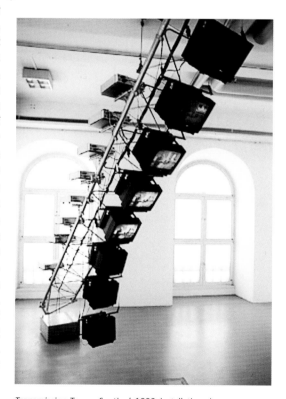

Transmission Tower: Sentinel, 1992, installation view at Documenta 9, Kassel, Germany, 1992.

versus personalized documentary footage). According to Birnbaum, strategies of dislocation go hand in hand with a multiplicity of languages. "Cyberspace can never be given as the existence of concrete, architectural (or even conceptual) space," Birnbaum writes. "Instead, the *spatial quality* of cyberspace must be articulated through a totality of overlapping discourses, arising from inside and outside its systems."[10]

NONPLACES

The fragmentation of spatial organization in Birnbaum's video installations, in short, relates to the implosion of traditional spatial coordinates by the virtual space of media and to the drastic transformations of public place in late-capitalist society. "In an age of increasingly rapid access to information, rapid transmission, and the electronic miniaturization of experience," Birnbaum writes, "the uses and meanings attached to public space have undergone a radical re-organization. Historically, public space has been thought of as a physical site: a place for people to engage the visual and aural components of information. Within this newly formed domain, we are confronted by an organization of information . . . whose boundaries are not fixed, but shift and move through a territory of receivership."[11] To Birnbaum, her works are inspired by a desire "to understand the profound reorganization of public space, especially as all notions of public life are increasingly subject to the dislocating effects of expanding interactive technologies. In this latter sense, cyberspace takes shape at precisely the point where traditional definitions of public space—as physical site, as historical monument, as street or town square—fail."[12]

Birnbaum's nonsites, consequently, are related to what Marc Augé has called *nonplaces*.[13] Augé juxtaposes nonplaces and the anthropological notion of public places, which are meeting places but also spatial structures capable of symbolizing collective identities (the traditional village square, the agora, the forum, the early modern square in front of royal palaces and government buildings). Nonplaces, in contrast, are not rooted in history or in the social relations between the inhabitants. They are anonymous and interchangeable zones in which people are nothing but passersby and to which they do not connect psychologically. According to Augé, the contemporary urban environment consists increasingly of such nonplaces. A large part of our lives is now spent in shopping malls, airports, hotels, and highways, or in front of TVs, computers, and cash machines. The multiplication of such zones results in turn in the proliferation of the vehicles and their hubs needed for the accelerated circulation of passengers and goods (high-speed roads, railways, interchanges, airports, refugee camps), which equally are such nonplaces. Today's urbanite is frequently in transit through nonplaces.

THE FALL OF THE PUBLIC SPHERE

An environment consisting of nonplaces and the concomitant dissolution and virtualization of public space are important topics in Birnbaum's oeuvre. In many of her works, she questions the status of the public sphere in electronic media. *Canon: Taking to the Streets, Part One: Princeton University—Take*

Stills from *Fire!/Hendrix*, 1982.

130

Storyboard for *Canon: Taking to the Streets, Part One: Princeton University—Take Back the Night*, 1990.

Back the Night (1990) consists of segments from a student's video recording of a Take Back the Night march on the campus of Princeton University.[14] By using low-fi, personal documentation, Birnbaum investigates the possibilities of developing a postmodern equivalent of public space as democratic arena and examines how the voice of the individual and the voice of dissent can make themselves heard in a technocratic society. Birnbaum in fact traces her own discovery of television as a topic and medium of her art to the street protests during her years at Berkeley, 1969 to 1974: "It was a demonstration in San Francisco, California, against the expansion of the Vietnam War to Cambodia (later chronicled by Todd Gitlin in an article entitled 'Television Without Tears') which turned my attention to *television* as the popular voice of, and to, the masses in America."[15] The artist deals with similar issues in the reflective third segment of her *Damnation of Faust Trilogy, Charming Landscape* (1987)—which she dedicates to "Pam and Georgeann, born May 1968 and February 1969"—and in her book project *Every TV Needs a Revolution* (1992), which is composed of anonymous street-poster images recycled from the events of May 1968.

Birnbaum's attention to this particular moment in Western history is telling. On the one hand, the events of May 1968 epitomize the idea of the urban environment as a public place in the sense of a site of democratic debate and emancipation. On the other hand, '68 marks the transition to what Guy Debord calls a "society of the spectacle," the dissolution of public space by the media. In addition, the physical and architectural transformations of the urban environment—on both sides of the Atlantic—were fostered by the continual rise of television, which went hand in hand with the process of suburbanization and, hence, with the neglect of the city center and (physical) public space by the middle classes.[16] The attempt to establish democratic control of public space—in both the physical and the virtual sense—appears again as a theme in the video installation *Tiananmen Square: Break-In Transmission*. In the context of the Chinese student protests of the late 1980s, however, the bodily occupation of a physical public site of historical significance and symbolic power shriveled into insignificance when compared with its global live satellite coverage by networks like CBS and CNN. Birnbaum noted that the idea of bringing about

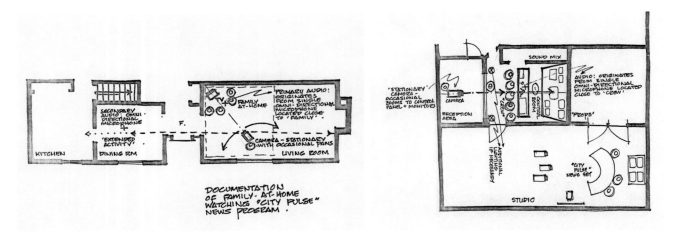

Architectural renderings made for *Local TV News Analysis for Cable Television*, collaboration with Dan Graham, 1980, showing floor plans of family home and television news studio.

political identity and revolutionary movement through *presence* in public space was no longer valid: "Instead of 'taking to the streets'—a strategy of the 1960s—or utilizing public pathways in a visible fashion, what seemed to be happening was that one needed to look toward a different street: not the urban streets and infrastructures which were already familiar to us in America and Europe, but the pathways and networks of the computer."[17] In the same source, she goes on to make a further, negative assertion: "Now with the computer, the Internet, and related developments, it becomes much more about a sense of the *invisible: to be visible, you must become invisible.* With the Internet, for example, there is a sense of democracy: that everyone can eventually surf the net, but my feeling is that the sense of freedom may, in fact, be false."[18]

The position Birnbaum espouses, then, is that, on the one hand, new means of communication and new media contribute to the creation of a virtual, electronic public space that could extend the idea of what Jürgen Habermas called "the public sphere"—a space of critical discussion, open to all, in which a public-minded rational consensus can be developed.[19] On the other hand, the virtualization of public space entails the dissolution of the public sphere and its possibilities. Together with bureaucracy, corporate capitalism, and mass consumption, the virtualization of public space has contributed to what Richard Sennett has called "the Fall of Public Man."[20] Birnbaum explores the complex relations between the virtualization of public space and the physical transformations of urban space in several of her works, creating a variety of situations in which the virtual space of the media is thrown back into the real private and public spaces of the city. *Local TV News Analysis for Cable Television* (1980), a project developed in collaboration with Dan Graham, shows a distinct interest in the spatial conditions of both the production and reception of TV images. The project consisted of continuous footage from a sixty-minute local news program from Toronto, where the project was based, along with a simultaneous video recording from within the living room of a typical local family viewing that program and a "behind-the-scenes" control-room view showing the technical director of the program with other technicians.[21] This material was then rebroadcast via a cablecast playback the day following the original broadcast. In working notes for the

project, Birnbaum draws an explicit parallel between the similar spatial arrangements of the broadcast studio and the family's enclosed or semienclosed living room containing a television set: both are framed areas that define their contents according to the principles of Renaissance perspective. Birnbaum further notes that this framed area could also be related to Western theater's proscenium arch (as well as to the beginning developments of television space from theater space).[22] As a result, the point of origin and the point of receivership of the TV transmission mirror each other. Birnbaum's meticulous study of the spatial conditions of television reveals how the virtual realm of the media is inevitably related to real and everyday places. Whereas the explicit attention to the relation between represented spaces and the places of representation echoes Smithson's dialectics of site and nonsite, the interest in the conflation of public and private spheres prefigures the debate on the proliferation of nonplaces in a media-saturated society.

SHOPWINDOWS AND SHOPPING MALLS

In Birnbaum's work of the late 1970s, the conflation of television imagery with public space also turns up with regard to the aforementioned *Technology/ Transformation: Wonder Woman*, since it was not only shown in galleries and at avant-garde film festivals but also placed in the display window of the SoHo H-Hair Salon de Coiffure.[23] A video dealing with television's construction of female identities was thus shown within the context of a place where identities were applied and *transformed* accordingly. In another turn of the screw, this television/monitor-turned-against-itself—used to critique commodity fetishism and identity formation—was integrated into the storefront window, a token of urban modernity that always had served similar consumerist purposes. Shopwindows not only contribute to an urban culture of visual hyperstimulation but also turn the metropolis into a phantasmagoric realm in which window-shopping implies a mode of consumer contemplation. In the words of Anne Friedberg (which recall Birnbaum's own observations on theatrical perspective), "the shop window was the proscenium for visual intoxication, the site of seduction for consumer desire."[24] Like movie and television screens, shopwindows have been interpreted as "screens of desire," and several commentators have pointed at the analogy between shopwindows and the cinema screen. Birnbaum's transferring of the television set, a domestic object, to a public realm prefigured the condition of the contemporary metropolis as a place almost entirely dedicated to consumerism and completely saturated by images. The SoHo salon that exhibited *Technology/ Transformation* in its display space was, in Birnbaum's own words, probably the "first store in New York to have a monitor in their window"[25]—an early adapter in an inner city soon to be transformed into a shopping mall.

Given the implications of this and other works, it comes as no surprise that Birnbaum has also directly addressed the phenomenon of the shopping mall in her work. With *Rio Videowall* (1989), a large-scale work sited to be permanent in the plaza of the Rio Shopping and Entertainment Centre in Atlanta, Birnbaum deals in various ways with the interaction between video imagery and the transformations of public space.[26] First of all, the work's location is significant. During the 1980s, Atlanta developed into a

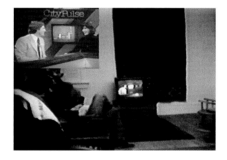

Video still from *Local TV News Analysis for Cable Television*, in collaboration with Dan Graham, 1980.

Control room of local television station, Toronto, Ontario, 1980.

Rio Videowall, 1989, installation view at the Rio Shopping and Entertainment Centre, Atlanta.

paradigmatic postmodern city, a gigantic non-place: "The real city at the end of the twentieth century could be found here," Rem Koolhaas wrote in a seminal essay dedicated to this urban environment.[27] Headquartering Coca-Cola and CNN, Atlanta embodies the logic of globalization and its reliance on communications technology and commercial image production. In addition, its topography is characterized by a centerless structure, low density, and basic "formlessness," as Koolhaas notes, generated by a highway system. These conditions erase traditional notions of public space. "Atlanta is not a city, it is a *landscape*," he writes.

In *Rio Videowall*, Birnbaum draws attention to the greedy logic of urban sprawl, which creates a landscape of suburbs, malls, and television where everything, including the natural environment, is enveloped by the low-intensity fictions of consumer culture. The twenty-five-monitor interactive wall, located in the open plaza of the Rio complex, displayed images of Atlanta's indigenous natural landscape taken at the site of the mall before construction. Two video cameras within the mall complex registered images of passersby, who appeared as silhouettes against the prerecorded landscape footage. The moving silhouettes were then filled with images from a direct satellite broadcast feed from CNN. This unmistakable reference by Birnbaum to the panoptic aspects of today's commercial areas, which are often scrupulously controlled by closed-circuit video-surveillance technologies, is part of her larger critique of the privatization of public space through video monitoring of traffic junctions, subway and railroad stations, state institutions, and bank buildings. With this attack, Birnbaum allies herself with critical observers of the postmodern urban condition, who have noted that both malls and atria—the latter of which, according to Koolhaas, were (re)invented in Atlanta as an ersatz, panoptic downtown—are not devised to cater to all segments of the population. Several urban theorists have demonstrated that in such places public space is being privatized and that accessibility is monitored and sometimes clearly restricted. Consequently, atria and malls have been called "pseudo-public spaces" and instances of a "post-public space" by critics like Mike Davis and Steven Flusty, respectively.[28] For Birnbaum, then, public images are constructed not only in television but also in video-monitored places.[29] According to Birnbaum, *Rio Videowall* represents an attempt to construct them differently: "The passersby's physical presence, within the architectural space of the mall, disrupts an historical 'electronic memory' with the influx of temporal information."[30]

In recent decades, as malls have been built abundantly throughout the industrialized world, they have become in the eyes of certain critics no less than the architectural and urban paradigms for the late twentieth and early twenty-first centuries.[31] An important factor in the suburbanization process and originally an entirely suburban phenomenon, malls have now found their way into city centers and airports. More importantly, they have increasingly included auxiliary, nonretail facilities like hotels, fitness clubs, banks, and medical centers and have made room for entertainment industries—which is the case in the Atlanta Rio Shopping and Entertainment Centre. They

became typical of today's urban condition because, ironically, they became urban models themselves: whereas originally malls imitated towns with their layouts of small streets, squares, and fountains, some city centers nowadays present themselves more and more as great open-air shopping malls. This process of *mallification* further illustrates the privatization and monoculturalization of public space, because the carefully controlled mall and the mallified downtown reduce the notion of civic participation to that of consumption. Over the past half century, then, the relationship between shopping and the city has been inverted. Rather than shopping just being an activity that takes place in the city, it has come to constitute the very notion of urbanity.[32] Although it is closely connected to the urban modernity of the nineteenth century, shopping is more symptomatic of the postmodern/posturban reduction of public space to a terrain of consumption.[33] The mall developed into a prime example of postmodern urban planning because of its production of new visual experiences (hence the inclusion in malls of multiplex cinemas and the turning of malls into major entertainment centers and mini theme parks). According to Anne Friedberg, the mall is a theatrical space, and it even propagates a subjectivity that is analogous to the subjectivity produced by cinematic spectatorship.[34]

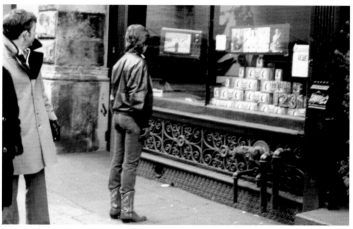

Technology/Transformation: Wonder Woman, 1978–79, installation view at the store window of SoHo H-Hair Salon, New York.

Transforming the ultimate nonplace into a nonsite and addressing a thicket of issues surrounding visuality and consumerism, *Rio Videowall* is a key work in Birnbaum's oeuvre. Dealing with the current conditions of displacement and placelessness, Birnbaum demonstrates that both the media and the process of mallification have modified the public spaces of today's posturban landscape. It is the same posturban landscape that Birnbaum evokes in *Fire!/Hendrix* (1982), which was shot at two nearly adjacent Los Angeles restaurant drive-throughs.

"Here, you can now consume without even leaving your extended home—the automobile," Birnbaum notes. "Human relationships as quick (and filling) as McDonald's hamburgers."[35] Los Angeles also typifies an urban landscape in which everything is commodified, without public space and without monuments that can symbolize collective or national identities—a theme Birnbaum had addressed in *Liberty: A Dozen or So Views* (1976), a video containing shots of the Statue of Liberty intercut with shots of people describing themselves as they face the camera. Already associated with agoraphobia and claustrophobia since the nineteenth century,[36] urban spaces have become the site of new forms of control and surveillance and new forms of paranoia, alienation, and anxiety.

Stills from *Liberty: A Dozen or So Views,* 1976.

Whereas Smithson had used maps and photographs to create nonsites commenting on the posturban landscape of New Jersey, Birnbaum uses the icons of cable television and video-monitoring systems in order to turn the nonplace of the shopping mall into a nonsite, which exemplifies the spatial implications of the fall of the public sphere and the development of the virtual realm of the media.

1 Dara Birnbaum, "Sighting the Collective Shadow," Interview by Jo Ann Baldinger, *Pasatiempo* (June 18, 2004), p. 54.

2 See Lawrence Halprin, *Cities* (Cambridge, MA: MIT Press, 1972); Lawrence Halprin, *Changing Places* (San Francisco: San Francisco Museum of Modern Art, 1986); and Lawrence Halprin, "Design as a Value System," *Places* 6, no. 1 (October 1989), pp. 60–67.

3 See, for instance, Chris Meigh-Andrews, *A History of Video Art: The Development of Form and Function* (Oxford: Berg, 2006), pp. 170–74; Michael Rush, *Video Art* (London: Thames & Hudson, 2007), p. 27; Yvonne Spielmann, *Video: The Reflexive Medium* (Cambridge, MA: MIT Press, 2008), pp. 157–59.

4 See Birnbaum, "Media's Continuous and Discontinuous Forms," *in Inszenierte Imagination: Beiträge zu einer historischen Anthropologie der Medien*, ed. Wolfgang Müller-Funk and Hans Ulrich Reck (Vienna: Springer, 1996), p. 188. In this book, p. 318.

5 "Dara Birnbaum: An Interview by Hans Ulrich Obrist," in *Art Recollection: Artists' Interviews and Statements in the Nineties*, ed. Gabrielle Detterer (Florence: Zona Archives Editori, 1997), p. 38.

6 Robert Smithson, "A Provisional Theory of Non-Sites" (1968), in *Robert Smithson: The Collected Writings,* ed. Jack Flam (Berkeley: University of California Press, 1996), p. 364.

7 David Ross, "Truth or Consequences: American Television and Video Art," in *Video Culture: A Critical Investigation,* ed. John Hanhardt (Salt Lake City: G. M. Smith, Peregrine Smith Books, in association with Visual Studies Workshop Press, Rochester, New York, 1986), p. 175.

8 See "Dara Birnbaum," p. 44. In this book, p. 23.

9 Dara Birnbaum, "Media's Affectation: Public Space," *Aris (Journal of the Carnegie Mellon Department of Architecture),* no. 2 (1996), p. 109.

10 Dara Birnbaum, with Scott Lyall, "Finding Anyplace in Cyberspace," in *Anyplace,* ed. Cynthia C. Davidson (Cambridge, MA: MIT Press, 1995), p. 161. In this book, p. 309.

11 Birnbaum, "Media's Affectation: Public Space," p. 101.

12 Dara Birnbaum, "Finding Anyplace in Cyberspace," p. 161. In this book, p. 309.

13 Marc Augé, *Non-Places: Introduction to an Anthropology of Supermodernity* (London: Verso, 1995). First published as *Non-Lieux: Introduction à une anthropologie de la surmodernité* (Paris: Editions du Seuil, 1992).

14 At the beginning of *Canon: Taking to the Streets,* Birnbaum also displayed street graphics and posters from the May 1968 student protests.

15 Dara Birnbaum, "Free Leonard Bernstein! A Statement of Manifestation for the Conference *Radical Chic*," in *Radical Chic Reader* (Stuttgart: Kunstlerhaus, 1993), p. 60. In this book, p. 306.

16 Guy Debord, *La Société du spectacle* (Paris: Editions Buchet-Chastel, 1967). For the relations between the proliferation of television and the process of suburbanization, see Lynn Spigel, *Welcome to the Dreamhouse: Popular Media and Postwar Suburbs* (Durham: Duke University Press, 2001).

17 Dara Birnbaum, "Media's Continuous and Discontinuous Forms," p. 197. In this book, p. 327.

18 Ibid., p. 186. In this book, p. 316.

19 Jürgen Habermas, T*he Structural Transformation of the Public Sphere: An Inquiry into a Category of Bourgeois Society* (Cambridge, MA: MIT Press, 1989).

20 Richard Sennett, *The Fall of Public Man* (New York: W. W. Norton, 1974).

21 See Dan Graham and Dara Birnbaum, "Working notes for Local Television News Program Analysis for Public Access Cable Television," in *Dan Graham: Video—Architecture—Television* (Halifax, NS: Press of the Nova Scotia College of Art and Design, 1979), pp. 57–61; and *Dan Graham: Works 1965–2000,* ed. Marianne Brouwer (Düsseldorf: Richter Verlag, 2001), pp. 183–84.

22 Dara Birnbaum, "Working Notes for Local Television News Program Analysis for Public Access Cable Television."

23 The monitor was preexisting and placed on a pivot so that it could turn both toward the interior of the shop or toward the street; normally it was used for entertaining customers. The owner agreed to show the work because, she informed Birnbaum, she had often been told that she looked like Linda Carter, the actress who played Wonder Woman. The soundtrack from the video was audible on the streets through speakers mounted into the grillwork of the windows.

24 Anne Friedberg, *Window Shopping: Cinema and the Postmodern* (Berkeley: University of California Press, 1993), p. 65.

25 "Dara Birnbaum," p. 36. In this book, p. 19.

26 See Dara Birnbaum, "The Rio Experience: Video's New Architecture Meets Corporate Sponsorship," in *Illuminating Video: An Essential Guide to Video Art,* ed. Doug Hall and Sally Jo Fifer (New York: Aperture, 1990), pp. 189–204.

27 Rem Koolhaas, "Atlanta" (1989/1994), in *S, M, L, XL* (Rotterdam: 010 Publishers, 1995), p. 835.

28 Mike Davis, *City of Quartz: Excavating the Future of Los Angeles* (New York: Verso, 1990), p. 26; Steven Flusty, "Building Paranoia," in *Architecture of Fear,* ed. Nan Ellin (New York: Princeton University Press, 1997), p. 51. See also Kenneth T. Jackson, *Crabgrass Frontier: The Suburbanization of the United States* (New York: Oxford University Press, 1985), p. 260; William H. Whyte, *City: Rediscovering the Center* (New York: Anchor Books, 1988), p. 208; Diane Ghirardo, *Architecture After Modernism* (London: Thames & Hudson, 1996), p. 66; and Nan Ellin, *Postmodern Urbanism* (Cambridge, MA: Blackwell, 1996), p. 73.

29 See Spielmann, *Video,* pp. 85–86 and 153.

30 Dara Birnbaum, "Media's Affectation of Public Space," p. 104.

31 See Margaret Crawford, "The World in a Shopping Mall," in *Variations on a Theme Park: The New American City and the End of Public Space,* ed. Michael Sorkin (New York: Hill & Wang, 1992), pp. 3–30; Ghirardo, *Architecture After Modernism,* p. 66; Lauren Langman, "Neon Cages: Shopping for Subjectivity," in *Lifestyle Shopping: The Subject of Consumption,* ed. Rob Shields (London: Routledge, 1992), pp. 40–82.

32 John McMorrough, "City of Shopping," in *Project on the City 2: Harvard Design School Guide to Shopping,* ed. Chuihua Judy Chung, Jeffrey Inaba, Rem Koolhaas, and Sze Tsung Leong (Cologne: Taschen, 2001), pp. 193–203.

33 Sociologist Gerhard Schulze has defined present-day society as an *Erlebnisgesellschaft* (lifestyle society), one in which aestheticization has become so important that the reigning illusion is that exchange value has elbowed out use value almost completely. See Schulze, *Erlebnisgesellschaft: Kultursoziologie der Gegenwart* (Frankfurt: Campus Verlag, 1992).

34 Friedberg, *Window Shopping,* p. 120.

35 Dara Birnbaum, "Up Against the Wall," *Artcom* 20 (1983), p. 26. *Fire!/Hendrix* was Birnbaum's contribution to a Jimi Hendrix video disk, produced by Videogram International, which commissioned a few well-known video artists to make clips for never-before-released mixes of several Hendrix songs.

36 See Anthony Vidler, *Warped Space: Art, Architecture, and Anxiety in Modern Culture* (Cambridge, MA: MIT Press, 2000).

A PATIENTLY CONSTRUCTED GENEALOGY

MARINA GRŽINIĆ

From the beginning of her career, Dara Birnbaum has strived not only to validate video as a medium but also to expose us to its capitalist functions. She has uncovered the mechanisms by which video and its big brother, television, have sought to collaborate, questioning the purpose of the images they produce while exposing the underlying system's core operational logic. She embraces television images in order to deconstruct and reappropriate them, to imbue them with her own identification with feminism and her interest in public space. For thirty-five years, her video installation projects have framed the aesthetic strategies of the Western world, exposing their codependence with technology. The survival of capitalism is dependent on the constant upgrading of media technologies, and for this reason Birnbaum has consistently worked with and questioned the operations of technology.

While Birnbaum's work can function as a veritable guide to the history of video, she does not set out to represent this history; on the contrary, she seeks to go beyond the parameters of any categorical "movement" that might claim her.[1] She should be seen as a rebel and provocateur who, with each new piece, stages a radical reconceptualization of the medium. In this essay, I will move through her work chronologically as it tracks significant shifts in the development of video art, while elaborating theoretical bases for her political and counteraesthetic installation work.

In the mid-1970s, Birnbaum used video as a personal recording device. With one of her first works, *Attack Piece* (1975), she sought to define a place for this new medium in the history of the moving image while working within the art context and with a feminist stance. *Attack Piece* is a two-channel video installation that stages a confrontation between Birnbaum, who is armed with a 35 mm still camera, and other participants who were directed by her to invade her space with a Super 8 camera. It is as though the work is a duel between parallel film technologies, while it also introduces video in its post-production presentation, the newest moving-image technology available. Birnbaum thus exposes these older technologies to video as a third eye capable of examining the other two. Her 1977 project *Lesson Plans (To Keep the Revolution Alive)* again placed video into a confrontation, a juxtaposition of stills from prime-time television with a Super 8 film loop. Birnbaum's rendering of the television image as simultaneously static and moving established her lifelong, pioneering research and obsession.

Pages from the book project *Every TV Needs a Revolution*, published by Imschoot Uitgevers, Ghent, 1992.

In subsequent years, Birnbaum began to explore the relationship between transmission and reception, source and audience. Edmond Couchot has pointed out that when we turn on the television we establish a connection with the authentic location of the broadcast and that at this point we witness the birth of the picture.[2] The picture materializes as it travels from the place of transmission to that of its reception. Owing to its high speed of transmission, the picture is thought to be in both places at once; viewers are never aware of a time lag. Birnbaum became increasingly interested in incrementally slowing down this interval in order to delink transmission and reception, revealing the schism between the two. Further, since there is ordinarily no perceptible delay between transmission and reception, video is well suited to the purpose of surveillance; thus video must be considered within the realm of biopolitics. Michel Foucault defines the term as the practice of a form of subjectification or domination that is connected to the regulation, control, surveillance, and constant administration of the public. Biopower, according to Foucault, is based on strategies of suppression that transcend paradigms of control through the persistent administration of punishment and discipline. A subtle means of control, biopower employs new-media technologies such as surveillance systems and personal identity research. Birnbaum's subsequent work explores multiple manifestations of biopower, breaking down its components and features to stimulate more critical, informed, and participatory reception.[3]

In her 1978 video installation *(A)Drift of Politics: Two Women Are Active in a Space*, Birnbaum deconstructs images from the popular television show *Laverne & Shirley*, which at that time aired nightly throughout the United States. She isolated the classic "two-shot" segments from the thirty-minute show in order to perform a structural analysis of its language. The viewer of the work sees *Laverne & Shirley* in a new way, broken up into an array of parts: a 16 mm slow-motion film shot in kinescope and a five-minute video loop with its accompanying sound playing separately. The silent video is installed with subtitles on a suspended monitor. In the piece, Birnbaum shows us two female friends, primarily through reconstructed, interwoven sequences.

Viewing *(A)Drift of Politics* produces a feeling of Brechtian estrangement, or *Verfremdungseffekt*—the emotional distance Brecht sought to impose on the audience to invite their critical and intellectual reflection. Birnbaum's similar *Video-effekt* aims to estrange viewers from two familiar TV characters. So what were the emotional, intellectual, psychological, social, and political implications of a deconstructed sitcom? The audience could respond to the reappropriated television images semiotically or in psychoanalytic terms, analyzing the protagonists' gestures and conversations as signifiers. Birnbaum's work demonstrates that video is not necessarily true to life; voices, for instance, are not necessarily fixed to characters.

In 1979, Birnbaum presented *Kiss the Girls: Make Them Cry*, in which she reworked iconic images from the nationally broadcast game show *The Hollywood Squares*. If film had generally been considered a public medium, then the television screen would enable the space of illusion to enter the private bedroom and living room. Here Birnbaum extracted, flattened, and displayed a televisual montage of flashing disco lights, full-screen close-ups, and long shots of contestants. *Kiss the Girls* is not a simple

appropriation but a precise articulation of the externalization of mass-media signs embedded within popular culture. The work breaks with the analytic, high-modernist style of video of the time (Vito Acconci, Bruce Nauman, etc.), instead embracing the popularity and appeal of the mass media's trashy glamour.

In the Pop-Pop Video series (1980), Birnbaum began to mix popular television images with original sound tracks composed and performed for her by musician friends and acquaintances such as Rhys Chatham, Robert Raposo, and Sally Swisher. On one hand, there are images from television commercials (such as for the Wang computer company), Olympic women's speed-skating competitions, and soap operas like General Hospital; on the other, scores right out of New York's experimental music scene. Both displayed a violent, unconscious sexuality that had been frozen too long beneath television's seemingly banal images.

Around that time, the influential London-based alternative magazine ZG, under the editorship of Rosetta Brooks, posited the potential of popular culture to influence art; this was regularly reflected in what the magazine covered and in its stylized writing. A list of contributors to ZG's issue no. 3, published in 1981 with the title "New York," offers a context for Birnbaum. The milieu, which included Robert Longo, Jack Goldstein, Neil Jenney, Thomas Lawson, Sherrie Levine, Richard Prince, David Salle, Glenn Branca, and Chatham, stood against what Lawson described as a narcissistic art-world system that was self-regarding, self-enclosed, and irredeemably boring, subverting it through the blatant irony of their appropriated images.[4] Brooks's editorial statements in ZG claimed that the new hybridization would challenge established orders in art and art history, which were mired in formalism and an overly analytical academicism based exclusively on high-modernist tropes, dissociated from mass media and popular culture as well as from countercultural movements like punk rock.[5] She stated that for "video artists like Dara Birnbaum . . . image editing . . . begin[s] to take on the electronic pulse of music. The video artist as the new member of the video rock band doesn't seem so far away."[6] Birnbaum, as part of a talk with John Sanborn for ZG in 1981, argued that "Video is dead; that is, in its defined role as video art and its relation to a defined art gallery system. But video is alive in its indefinable relation to the industry and the rate of conversation which exchanges the currency of TV for the currency of art."[7] Therefore the usage of disco lights in Birnbaum's *Kiss the Girls* should not be a surprise.

Birnbaum thus succeeds in extracting a certain night-marish seductiveness from these popular images, which contaminated the American popular-media-saturated mind with a range of sexual, populist, and subversive unconscious ideologies. It was therefore understandable that a decade later Jeffrey Deitch proclaimed that "Dara Birnbaum's videos . . . are communicating in an aggressive way and expanding the boundaries of public taste."[8] Deitch connected Birnbaum's work with a "tremendous expansion in the category of 'meta-art' in the advertising, marketing, entertainment and publishing industries."[9]

Sketch for *PM Magazine* for Documenta 7, c. 1982.

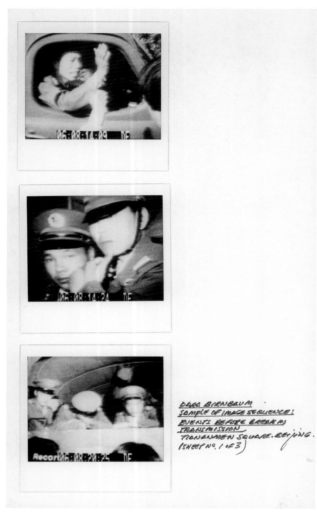

This and following page: Storyboards for *Tiananmen Square: Break-in Transmission,* with Polaroids, c. 1990.

In 1982, Birnbaum took part in Documenta 7 in Kassel, Germany, where she presented *PM Magazine. PM Magazine* exploits fast-moving, repetitive imagery taken from television commercials, turning the rhetoric of display against itself. Through its fractured visual and audio elements, it evokes the delirious state of the American psyche and the fallacy of the American dream. The piece disturbingly demonstrates how excess acts to conceal the true motives of the society that produces it. According to Peter Wollen, every period in history has its own rhetoric of display, because each has different truths to conceal.[10]

In the following years, Birnbaum created a work in three parts based on the stories of two young women growing up in downtown Manhattan called *Damnation of Faust Trilogy* (1983–87). The single-channel video project deals with alienation and community in an urban setting. The imagery in the first of the three works, *Evocation* (1983), resembles ukiyo-e ("pictures of the floating world"), a genre of seventeenth-century Japanese woodcuts and paintings. In the Japanese tradition, the ukiyo-e presents an idealized world of beauty cut off from everyday life. Birnbaum's "floating world" is downtown, urban New York during the 1980s. It is the artist's tribute to a moment when art, stimulated in part by the politicized energy of rap and graffiti, began to move out onto the streets and further into public consciousness. *Damnation of Faust's* second section, *Will-o'-the-Wisp* (1985), produced as both a single-channel video and a three-channel installation, deals explicitly with issues of sexuality and empowerment through its female protagonist, whose unfortunate demise is to succumb to the capitalist patriarchy of the world in which she lives.

In the trilogy's final installment, *Charming Landscape* (1987), we witness the demolition of a neighborhood playground, which crumbles along with the memories of the two girls who once played there. The conclusion brings in historical footage from television news that documents civil unrest across the globe, a further invocation of the artist's interest in public space and the machinations of democracy. Her argument runs parallel to that of Jean Baudrillard, who in *Simulations* states that contemporary social relations are constructed and identified entirely through imagery.[11] The Italian art historian and politician Giulio Carlo Argan has gone even further, claiming that aesthetic value can be measured through the social function of an artwork.[12] For Birnbaum, the social role of art is tantamount to its aesthetic value.

Works from the first decade of Birnbaum's career thus show her effort to filter the vocabulary of popular images and to emancipate it. In 1987, the critic Ernie Tee wrote in the catalogue for "The Arts for Television" at the Museum of Contemporary Art in Los Angeles, an exhibition that included the work of Birnbaum, that film is the medium of illusion, television is the medium of reality, and video is the medium of metamorphosis.[13] This conception is central to these

early works, as they pivot on the potentiality of video to transform and liberate.

In 1990, Birnbaum created the video installation *Tiananmen Square: Break-In Transmission*, focusing on contemporary Chinese student activism and its characterization by Western media. In it, she again examines systems of transmission and reception. The square, which sits just outside the Forbidden City (and whose name translates as "Gate of Heavenly Peace"), is where the protests occurred in 1989 against the Communist authorities, resulting in a massacre after troops opened fire on pro-democracy crowds. In the work, Birnbaum examined the Chinese government's ultimate use of censorship and how this event was narrated through the media in the face of censorship. The piece was designed to encourage the viewer to become an active participant, to lend a hand in the "reconstruction" of that gruesome event. The installation shows Birnbaum's renewed approach to some of her ongoing concerns regarding the fundamental characteristics of the medium of video and, in so doing, engages numerous questions pertaining to the theories of major contemporary media philosophers, such as Paul Virilio and Baudrillard.

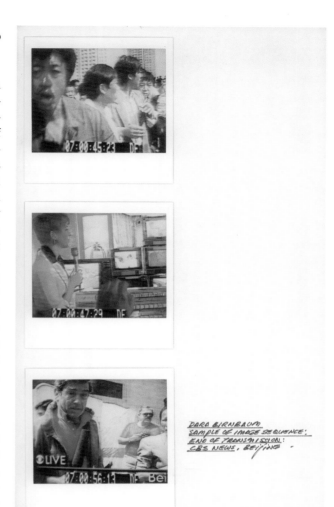

DARA BIRNBAUM
SAMPLE OF IMAGE SEQUENCE:
END OF TRANSMISSION:
CBS NEWS, BEIJING -

Birnbaum's installations in the 1990s deeply rearticulated what can be defined as a specific logic of the video medium and media installations. This logic is connected to dramatic shifts in the way we perceive space and time, information, history, and last but not least politics in public space and the constitution of the public. To understand Birnbaum's shift, it is necessary to refer precisely to the proposed historizations of images by Virilio. He identifies three logics of the image and their connection to three historical periods. First was the age of the formal logic of the image, which blossomed during the eighteenth century. This was the age of painting, engraving, etching, and architecture. Then came the age of dialectical logic, marked by the emergence of photography and film, or, if you will, the nineteenth-century frame—the actuality of the dialectical logic governing photographic and cinematic representation.[14] In the dialectical logic, it was only the delayed-time presence—the presence of the past—that made a lasting impression on the plate and then the film.[15] Then came, along with postmodernism, the third age: of paradoxical logic, beginning with the invention of video recording, holography, and computer graphics—a logic that revolves around the reality of an object's real-time presence.[16]

Virilio states that the paradoxical logic has an inherent time lapse: it represents "a collapse of mnemonic consolidation."[17] What do I want to say? Instead of the binary relations of the world, as for example the analog visible versus the invisible (a binary that is a characteristic of modernist analog film technique or of the image's dialectical logic), with electronic and especially digital technology, Virilio offers a third path. His proposal is that the paradoxical image introduces the virtual, which makes possible a world that

This and following pages: pages from the exhibition catalogue *Dara Birnbaum*, IVAM, Valencia, 1991, designed by Birnbaum.

is constantly altered. More precisely, what Virilio detects through the advent of new media technology, and let's not forget that Fredric Jameson speaks about video as the sine qua non technology of postmodernism, is the replacement of the depth-of-space (a mnemonic consolidation) with depth-of-time (that is the "Real Time" of transmission by digital TV technology).[18] This "replacement" is characterized by a splitting of view-points showing that the observer's moment of perception is no longer in sync with the actual time of exposure. Birnbaum's interactive video installations in the 1990s carefully position the viewer within this split; she displays a rearrangement of hidden and destroyed (sometimes not less bloody and suppressed) historical memories that have now the (technological) possibility to come back to life at any moment and in any space! This opens a space of critical and political potentiality of the image (that is technologically appropriated and reproduced).

In doing this, Birnbaum at once relates to and contests Baudrillard, who stated that due to new media technology we witness the collapsing of the normalizing, expanding, and positive cycle of the social into its opposite: an implosive, structural order of signs.[19] Baudrillard claims henceforth that the masses (the public, in our case) seek spectacle and not meaning, implying that this now "silent majority" signifies "the end of the social." In reading Baudrillard's analysis, Arthur Kroker and David Cook suggest that he announced that with new media technology would come the advent of brutal means for dehistoricization and desocialization, which will structure the communication order of a new, signifying culture.[20] Though on this point it is necessary to understand the processes of dehistoricization and desocialization as well, as argued by Kroker and Cook, as being two of Baudrillard's four "great refusals" concerning classical (or modernist) models: an outright rejection of history as a naturalistic discourse, and therefore a rupturing of a normalizing and cumulative conception of power.[21] Therefore, precisely in this violent movement of denaturalization, we can find possibilities for the social intervention of technological images in public space. Already in the 1970s, for example in *The Consumer Society*, Baudrillard develops "multiple forms of refusal" that are the opposite of what is conventionally perceived as an act of refusal. Baudrillard talks of convention and consumption that can be amalgamated in "practice(s) of radical change."[22] This is how we can understand Birnbaum's video installation *Tiananmen Square: Break-In Transmission*.

But we still cannot dismiss the context of television (as a repressive ideological apparatus) and its murderous effects on the social and the public. In today's world, television exists as a pervasive, imagistic sign system. Television is not just a technological ensemble, a social apparatus that implodes *into* society—here following Kroker and Cook—but rather is the emblematic

form of a culture's relational power structure. Television, thus, is not a mirror of society but the reverse: society is a mirror of television.[23] Television's social cohesion is provided by the pseudosolidarities of electronic television images, whose public is, according to Baudrillard, the dark, silent mass of viewers. They are never permitted to speak, while the media elite, having been granted a voice and authorized to use it, has nothing to say!

CARLES FRANCESC
Un momento de la manifestación a su paso por la calle de la Paz.

In 1992, Birnbaum realized her nine-channel video work *Transmission Tower: Sentinel*. The work was commissioned for Documenta 9 and uses part of a Rohm transmission tower, which Birnbaum fitted with an angled column of video monitors. As Birnbaum herself describes it:

> *Eight monitors, each equipped with stereo sound, are suspended to form a curved and descending line descriptive of the path of a bomb dropped from a carrier plane. A small, contained broadcast image of George Bush slides down the tower's length, and across each of the monitors. He recites a sanctioned version of global politics from his acceptance speech at the 1988 Republican National Convention. Simultaneously, footage of Allen Ginsberg at the 1988 National Students Convention at Rutgers University rhythmically descends the totem of monitors, coordinated with his reading of the antimilitarist poem "Hum Bom!" Ginsberg's words establish a connection with a radical student past, while the chantlike delivery of the poem sets a pace for the political messages. Documentation of the students (shot with a low-end Video 8 camera) climbs upward to challenge the representations of the two more authoritative figures.[24]*

As viewers of the piece, we witness a rhythmic crescendo and decrescendo. These cascading verbal protests represent the alternate dramaturgy of the (de)hegemonization of political and public spaces in neoliberal global capitalism.

Applying Virilio's framework, we can say that, in *Transmission Tower*, a shift takes place from the "thing" (the bomb, Bush) to its image and from space to time. An accompanying shift occurs from black-and-white dichotomies like real versus figurative to the more relativistic gray area of actual versus virtual. The problem, therefore, no longer has to do with mental images alone but is now concerned with the instrumental virtual images of science and their paradoxical factuality. The issue is one of the most crucial aspects of the development of new digital-imagery technologies and of the synthetic vision offered by electron optics: the relative fusion/confusion of the factual (or operational, if you prefer) with the virtual.

Electronic technology, it would seem, poses a set of crucial ontological questions in the genealogy interconnecting institutions, money, and power. This is the genealogy of economics, one that Foucault defines as one of the

more important processes of biopolitics. The politics of this economy and its subsequent distribution of wealth reveal how the nediberal government supports only those organizations, administrations, discourses, theories, and populisms that it regards as vital in its effort to process the social body. The dynamic formed from these forces structures the power relations throughout the regulated and/or deregulated social body. But, as Jacques Rancière points out, biopolitics is also a matter of redistribution of natural resources, types of organizations, living conditions, health and social services, and the allocation of capital. In this paradigm, the economic organization of biopolitics is no longer incidental or a mere effect of the expansion of capital. A key element in the economic organization of biopolitics is rationalization, which demands the intervention of an administration to normalize and pacify the public through its perpetual control operations. At its core, this administration demands efficient control over the lives of a population and assumes the right to "civilize" any other population it chooses.

The way the state administers and controls its populace is a central theme in Birnbaum's 1994 installation *Hostage*. The work centers on the kidnapping and murder of German industrialist Hanns-Martin Schleyer in 1977. In the fall of that year, Germany was practically under siege by its own police, security, and military forces as the notorious Red Army Faction (RAF) conducted a campaign that included a murder, the kidnapping of Schleyer, and an airplane hijacking. The kidnapping was an effort to negotiate the release of the RAF's most prominent members, Andreas Baader, Gudrun Ensslin, and Jan-Carl Raspe, who had been imprisoned for terrorist acts. When the kidnapping failed to secure their freedom, the group murdered Schleyer, and the leaders of the RAF were soon found dead in prison. The suspicious circumstances led many to conclude that they were murdered by the state, although officials declared and still maintain otherwise. To some, the treatment of the RAF group suggested the fears of the political left that the state was willing to use covert violence to silence its critics.

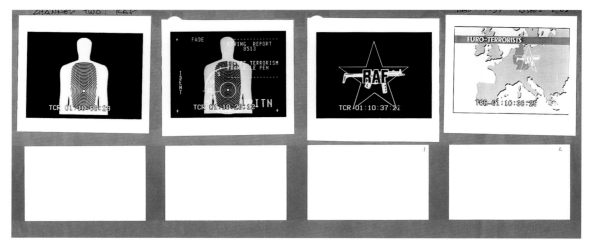

Storyboard for *Hostage*, c. 1994

Birnbaum's installation presents on five video channels television coverage of the events surrounding the kidnapping and so-called suicides of the three jailed RAF members. The sixth and final channel shows footage of the response to the events from newspapers in the United States. The viewer interacts by means of a laser beam; when the beam is blocked by a body, the image on the sixth screen freezes. The work is about alienation, insofar as Birnbaum is addressing the control of information and the individual's relation to repressive apparatuses.

In *Hostage*, the viewer becomes active by interfacing with a political event. Birnbaum evaluates how the medium of video interprets and reprograms political space as a result of capital, restoring a political consciousness and involvement. Each viewer can determine his or her own position in the midst of the crisis. Today, virtual technology has laid bare the institution of mass media as an important functionary in a capitalist society. Birnbaum implies that this relation might be combated by creating an electronic world of images that does not exceed the human perspective as the laser can be stopped and managed. She emphasizes rather than conceals the social antagonism of a capitalist society and its media.

Birnbaum's proposed humanizing ideological shift, captured in her video and installation work, can also be seen in the protocols and apparatuses of other ideological practices, rituals, media, and public institutions. While media apparatuses seemed to be entirely external to the events in Germany, Birnbaum's installation succeeded in showing that it is precisely because of their "external" position that such apparatuses are, in fact, the most "internal," and thus capable of presenting such an event to the public as an immediate (nonmediated) experience.

In 1995, Birnbaum created *Erwartung/Expectancy*, which added a new dimension to her work, linking biography and history via the theme of coincidence. Birnbaum creates a link from the date of her mother's birth, September 29, 1909, to the composer Arnold Schoenberg, who completed his one-act opera *Erwartung* on this same day. The opera was based on a libretto by Marie Pappenheim and takes the atypical form of a monologue for a solo soprano, backed by a large orchestra. Schoenberg described the work as a representation in slow motion of everything that occurs during a single second of maximum spiritual excitement.[25] The work and its haunting subject are derived from turbulent relations in Schoenberg's personal life at the time of its composition. Schoenberg's wife, Mathilde, had just left him for the young painter Richard Gerstl, then returned to her husband after his student Anton Webern persuaded her to do so, causing Gerstl to commit suicide shortly thereafter.

In 1948, Theodor Adorno likened *Erwartung* to a psychoanalytic case study, and since then a number of scholars have probed its backstory.[26] Pappenheim was a young medical student when she was commissioned in 1909 to write the work's libretto, which depicts a woman, *Die Frau*, wandering alone in a forest at night. She is searching for her lover, and as the fragmented, exclamatory text evinces, she is anxious, frightened, and possibly even mentally disturbed. In the fourth and final scene, she believes she discovers the corpse of her lover and angrily expresses her suspicions that he had been having an affair with another woman. *Die Frau* spends the remainder of the work mourning his loss, wondering aloud how she will go on living in his

absence. Many musicologists who have studied the text have claimed there was a familial connection between Marie Pappenheim and a woman named Bertha Pappenheim, the true name of Sigmund Freud and Josef Breuer's famous case-study subject, the hysteric Anna O. Though Bertha was Breuer's patient, she is still generally regarded as the first Freudian hysteric. She was the first person to have been treated using the "cathartic" method, which was called the "talking cure." Whether or not there was a familial relationship between the two Pappenheims is unknown; however, it has led to the supposition that Marie Pappenheim may have used Anna O. as the basis for her text. Birnbaum's subtle linking of *Erwartung* to her own mother makes for another disturbing mystery. *Die Frau*'s mental illness is especially traumatic given that Birnbaum's mother was diagnosed with paranoid catatonic schizophrenia and could not be saved from this horrible disease.

Birnbaum began work in 1995 on the video installation, which included a billboard-size enlargement of a drawing Schoenberg made for the set of *Erwartung*. *Die Frau* appears as well, but as a spectral image with a ghostly presence; her projected representation can only be seen in the dark, disappearing from view when the lights come on. In 2001, *Erwartung* was reinstalled, this time in an interior space that imbued it with a greater sense of internal, psychological event. The drawing was recomposed into a set of smaller screens made of refracting Plexiglas and scaled like a private black-box theater. The drawing was displayed as a DuraClear transparency mounted on Plexiglas panels, which gave it simultaneous realities: the literal surface of the screen and the light projecting through the screen and engaging all reflective surfaces in the surrounding environment.

Birnbaum's installation in its reworked state thus fully embraces multiple technologies of projected and reflected light. The piece can be seen as being about the transformation of our senses and perception due to the shift from optical light to electronic and digital light. Birnbaum's reconstruction of the project causes a change in its internal logic and presents the viewer with a very subtle shift: the redirection of light. Darkness in this context might imply "manipulated light" rather than "less light." Light is no longer seen as a binary system of illumination versus darkness, but rather as a phenomenon of gradual diffraction. This development of course leads even further toward a new significance of seeing: vision and perception in relation to the psyche, gender, and body.

Given this point, it becomes necessary to introduce the specter of a new kind of interval from Virilio's framework: the "interval of light," considered by Virilio to represent an imperceptible cultural revolution. If the interval of time (a positive sign) and the interval of space (a negative sign) give impetus to the construction of, respectively, history and geography, then according to Virilio, one is faced today with the sudden emergence of an "interval of light" or "zero-sign." This signals that we are undergoing an abrupt qualitative shift, a profound mutation of our humanistic relationship to the environment. In Virilio's thesis, time (duration) and space (extension) are argued to be inconceivable without light (absolute speed). If read back into Birnbaum's *Erwartung*, it is the character of light itself, not *Die Frau*, that occupies the position of the specter; it possesses an elusive pseudomateriality that subverts the classic ontological opposition between reality and illusion. Slavoj Žižek

argues that it is perhaps at this philosophical juncture that we should begin to look for the last resort of ideology, the formal matrix onto which various ideological formations are grafted. Says Žižek, we should recognize the fact that:

> there is no reality without the spectre, that the circle of reality can be closed only by means of an uncanny spectral supplement. Why, then, is there no reality without the spectre? Lacan provides a precise answer to this question: (what we experience as) reality is not the "thing itself," [rather] it is always-already symbolized . . . and the problem resides in the fact that symbolization ultimately always fails, that it never succeeds in fully "covering" the real. . . . This real . . . returns in the guise of spectral apparitions. Consequently, "spectre" is not to be confused with "symbolic fiction." . . . Reality is never directly "itself," it presents itself only via its incomplete-failed symbolization, and spectral apparitions emerge in this very gap that forever separates reality from the real, and on account of which reality has the character of a (symbolic) fiction: the spectre gives body to that which escapes (the symbolically structured) reality.[27]

Video is a conditional and alternative medium. It is a relatively new animal. And as such, it propounds a new paradigm for contemporary art, a break from old media. But the shift is a structural one, not accidental.

In her 2005 work *Tapestry: Elegy for Donna*, Birnbaum immersed herself in gender politics and questioned media's production conditions as well as the interventional logic of small production facilities. The video examines the program *Radio Donna* on TV1 in Belgium. Seeing it on television, viewers are exposed to how a radio control room works, including technical aspects of production and its DJ, Yasmine, known as DJ Diva. Yasmine made her musical debut when she was nineteen and soon thereafter came out as a lesbian. Thirty-seven years old at the time of her death in 2009, Yasmine was a well-known personality in Belgium's recording industry, radio, and television.

In the work, we see Yasmine spinning discs from two camera angles. We are surprised by the tiny production facility relative to its high visibility in Belgium. With this as the video's basis, Birnbaum creates a video tapestry: Its methods imply recomposition, reinsertion, decomposition, (re)production, and the literal "interweaving" of relations. These relations fall within the life of Yasmine and the conditions of production inherent to any radio station. Birnbaum is reminded of local media engagement in the United States during the 1980s, which has been assimilated in Belgium to the country's mainstream commercial media. Birnbaum's piece analyzes the television footage from a clearly gendered point of view, juxtaposing traditional women's work (weaving) with Yasmine's engagement with transmission technology.

In 2006, Birnbaum wrote her statement "Be Here Now (written in the year when the staphylococcus plague of 2006 wiped out 40 million people)" for the exhibition and catalogue *Arteast Collection 2000 + 23* by Moderna Galerija in Ljubljana. The project was initiated by the Maska Institute to celebrate the publication of its journal's one-hundredth issue. Maska invited a select group of artists to prepare projects about what form they thought their work might take in the year 2023. At that time, for the publication of *Maska* magazine's two-hundredth issue, the projects will be realized and published.

Birnbaum's title is taken from what she calls a late 1960s/mid-1970s mantra: be here now. The future, in other words, is now. Since she doesn't know if she will be alive in 2023, Birnbaum decided to base her research on people and institutions that have projected themselves into the future. To do this, she employed two internet browsers and found fifteen million results. We have no way of knowing what the technological landscape will look like in the year 2023.

* * *

In this essay, I have tried to display an opus of work that spans thirty-five years. I can only hope that Birnbaum will continue to work toward a socially emancipated tomorrow by her persistent subversion of the operations of new technologies and by critiquing their repressive and oppressive forces through a distinctive political approach to appropriation. For over three decades, she has examined in parallel the development of three different arenas: technology, contemporary art, and capitalism. Technology, Birnbaum reiterates, is not only the language of invention but also the condition and mode of production that leads to a modernized system of exploitation, profit, and privatization. Birnbaum has taught us that we should not blindly follow the neoliberal capitalist ideals that render new media and video technology comprehensible, transparent, rational, and "sexy." On the contrary, she shows that in order to imagine a more just and equal future, it is necessary to expose its past as well as its present destructive excesses.

Still from *Be Here Now*, 2006.

1 Recently Dara Birnbaum was included in the show with the title "The Picture Generation 1974–1984," held at the Metropolitan Museum of Art, New York, April 21–August 2, 2009. In the exhibition catalogue published in conjunction with the show is written with "first comprehensive examination of the Pictures Generation, a loosely knit group of artists working in New York from the mid-1970s to the mid-1980s." See http://www.specificobject.com/objects/info.cfm?inventory_id=13545&object_id=12529 (accessed October 1, 2009).

2 Edmond Couchot, "La Question du temps dans les techniques électroniques et numériques de l'image," in *3e Semaine Internationale de Vidéo* (Geneva: Centre pour l'image contemporaine, 1989), pp. 19–21.

3 The first time Michel Foucault identified the term *biopower* was in *The Will to Knowledge*, the first volume of his *History of Sexuality* (London: Penguin, 1998). The book was originally published in French as *La Volonté de savoir*, vol. I of *Histoire de la sexualité* (Paris: Gallimard, 1976).

4 Thomas Lawson, "We must embrace our joys and sorrows," in *ZG*, no. 3 (1981), p. 18.

5 Rosetta Brooks, "The Art Machine (editorial)," in *ZG*, no. 3 (1981), p. 2.

6 Ibid.

7 "Dara Birnbaum Talks to John Sanborn," in *ZG*, no. 3 (1981), p. 22.

8 "Post Human: Jeffrey Deitch's Brave New Art," interview with Deitch by Giancarlo Politi and Helena Kontova in *Flash Art*, no. 167 (December 1992), p. 66.

9 Ibid, pp. 66–68.

10 See Peter Wollen's introduction to *Visual Display*: *Culture Beyond Appearances*, ed. Lynne Cooke and Peter Wollen, Discussions in Contemporary Culture, vol. 10 (Seattle: Bay Press and Dia Center fot the Arts, New York, 1995), pp. 9–10.

11 See Jean Baudrillard, *Simulations* (New York: Semiotext[e], 1983).

12 See Giulio Carlo Argan, *The Renaissance City* (New York: George Braziller, 1969).

13 See Ernie Tee, "The Irreality of Dance," in *The Arts for Television*, ed. Kathy Rae Huffman and Dorine Mignot (Los Angeles: Museum of Contemporary Art and Amsterdam: Stedelijk Museum, 1987), p. 62.

14 See Gilles Deleuze, *Cinéma 1: L'Image-mouvement* (Paris: Editions de Minuit, 1983) and Deleuze, *Cinéma 2: L'Image-temps* (Paris: Editions de Minuit, 1985).

15 Paul Virilio, *The Vision Machine*, trans. Julie Rose (London: BFI, 1994), p. 64.

16 Ibid., p. 63.

17 Ibid., p. 7.

18 Ibid.

19 See Jean Baudrillard, *In the Shadow of the Silent Majorities* (New York: Semiotext[e], 1983).

20 See Arthur Kroker and David Cook, *The Postmodern Scene: Excremental Culture and Hyper-Aesthetics* (New York: St. Martin's Press, 1986), pp. 172–73.

21 Ibid.

22 See Jean Baudrillard, *The Consumer Society: Myths and Structures* (London: Sage Publications, 1998), p. 183. The book was originally published in French in 1970.

23 See Kroker and Cook, pp. 172–73.

24 Dara Birnbaum, "Transmission Tower: Sentinel," in *Anyplace* (New York: Anyone Corporation, 1995), p. 168.

25 Arnold Schoenberg, *Style and Idea* (Berkeley: University of California Press, 1984), p. 105.

26 Theodore Adorno, *Philosophy of Modern Music*, trans. Anne G. Mitchell and Wesley V. Blomster (New York: Seabury Press, 1973), p. 39.

27 Slavoj Žižek, "Introduction: The Spectre of Ideology," in *Mapping Ideology*, ed. Slavoj Žižek (London and New York: Verso 1994), p. 21.

WORKS 1975–2009

DESCRIPTIONS BY REBECCA CLEMAN AND LORI ZIPPAY

ATTACK PIECE

TWO-CHANNEL VIDEO, BLACK-AND-WHITE (TRANSFERRED FROM FILM AND SLIDE FOOTAGE)
TWO CHANNELS OF MONO AUDIO, 7:40 MIN.; INSTALLATION: DIMENSIONS VARIABLE
COLLECTIONS FUNDACIÓ MUSEU D'ART CONTEMPORANI DE BARCELONA (MACBA);
SAN FRANCISCO MUSEUM OF MODERN ART; TATE MODERN, LONDON,
THROUGH THE NEW ART TRUST, BEQUEST OF PAMELA AND RICHARD KRAMLICH

One of the earliest surviving installations by Dara Birnbaum involving moving-image media, *Attack Piece* pivots around the formal and conceptual differences between still and motion-picture photography. The two-channel installation may be shown with either monitors or projections placed opposite each other: one channel shows still photographs of Birnbaum's collaborators (David Askevold, Cyne Cobb, Dan Graham, Ian Murray, and Christina Ritchie) taking turns filming Birnbaum, while the other shows their subject seated and "armed" with a 35 mm still camera. As the filmmakers, one at a time, encircle Birnbaum with aggressive, predatory movements, she photographs them, "capturing" them against the pastoral backdrop of Halifax, Nova Scotia.

Birnbaum's static position bears a metaphoric relation to her camera's static shots, relative to the filmmakers' ceaseless motion around her. From the filmmakers' vantage,

Installation view, "Dara Birnbaum: The Dark Matter of Media Light," S.M.A.K., Ghent, 2009.

Birnbaum is shown in a submissive position, seated on the ground, confined by their hostile actions. The gendered role-play in *Attack Piece* makes it an important precedent for such later Birnbaum works as *Technology/Transformation: Wonder Woman* (1978–79) and *Artbreak, MTV Networks, Inc.* (1987), which decode the exploitation of women by mass media.

Though the elements of *Attack Piece* were originally recorded on 35 mm slides and Super 8 film, they were transferred to video to ensure that they would remain in sync when installed. The audio track for each channel—a rolling projector for the film documentation, a clicking slide projector for the photographs—reinstates the original media and creates another level of textural opposition between them. Completed in 1975, *Attack Piece* was digitally restored as part of Electronic Art Intermix's preservation program and first exhibited in 2002. (RC)

155

TWO SETS OF 35 MM SLIDES, TWO PROJECTION SCREENS,
AUDIOTAPE WITH STEREO SPEAKERS, DIMENSIONS VARIABLE
COURTESY OF THE ARTIST

Back Piece, Dara Birnbaum's first exhibited site-specific work, was created for a group show in an alternative gallery space belonging to Scott Billingsley, one of the group's members (others included Dan Graham, Alan Moore, Willoughby Sharp, and Robin Winters). The piece consisted of two screens, one placed on a horizontal platform on the floor of the gallery, the other hanging vertically at a ninety-degree angle to the wall. On the vertical screen, Birnbaum projected 35 mm slides showing the gallery's interior during the exhibition's installation. On the horizontal screen, slides showed the same scene with the artist's hand superimposed, displaying a series of photographs from her recent trip to Europe.

Stereo speakers, one installed on each side of the platform, played a recording of Birnbaum reading a passage from Carl Jung's *Psychological Types* in which he delineates two primary attitude types: introversion and extroversion. This duality would be a theme in many of Birnbaum's early, direct-camera performances, such as the *Chaired Anxieties* series (1975), in which the artist interpreted psychological states physically. In contrast to these videos, *Back Piece* emphasizes an internal process of introspection and memory. The European travel photos were taken during a trip of great importance to Birnbaum, one that would mark her introduction to Conceptual art and the beginning of that movement's influence on her work. The layering of these images over a sparse New York City loft offers a visual representation of the psychological experience of being in one location while remembering another, a collapsing of the present with the just past. (RC)

SINGLE-CHANNEL VIDEO, BLACK-AND-WHITE, MONO, 3:30 MIN.
COURTESY ELECTRONIC ARTS INTERMIX, NEW YORK

A stationary video camera obliquely frames a domestic setting: an open doorframe, a wall decorated by a woman's portrait, a closed door leading, perhaps, outside. A spotlight trained on the scene, however, creates a sense of drama and suspense. Suddenly, human breaths are heard; the spotlight dims and then brightens again to capture a figure, Dara Birnbaum, passing in front of the camera. As she walks through the doorframe, the sound of a door opening and slamming shut accompanies her, synchronized so that it seems as if her body is taking the door's place. She keeps her back to the camera, enacting the door's capacity to bar or banish, closing herself off physically and emotionally from the viewer.

Once Birnbaum is offscreen, the camera goes dark for several seconds and then opens again on the same scene. Birnbaum walks through the door frame several times without variation, but in her final pass she stops in the frame and turns to face the camera, looking directly at the viewer. As in other early videos—the *Chaired Anxieties* series (1975), *Mirroring* (1975), and *Pivot: Turning Around Suppositions* (1976)—Birnbaum combines introverted and extroverted performances for camera, either closing herself off from the camera's gaze or opening herself up to it, laying bare the complex dynamics between the camera, performer, and viewer. (RC)

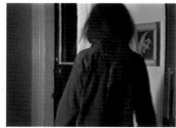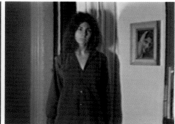

SERIES OF THREE SINGLE-CHANNEL VIDEOS, BLACK-AND-WHITE, MONO,
TOTAL RUNNING TIME 25:41 MIN.
COURTESY ELECTRONIC ARTS INTERMIX, NEW YORK

Chaired Anxieties is a series of video exercises that represent Birnbaum's earliest experiments with the medium. These performance works, in which the artist explores a woman's psychological states through physical gestures, are raw, direct, and unmediated. The young Birnbaum appears on camera, alone, as the performer. (By the late 1970s, she would no longer appear on-screen, although she would often employ female figures as surrogates.) The pieces introduce themes that recur throughout her work, particularly the articulation of a feminist subtext through the central figure of a woman who is presented as both strong and vulnerable. She investigates the body as a vehicle for intense emotional or psychological manifestations while also foregrounding the relation of the camera/viewer and subject/performer. Although Birnbaum famously broke new ground in video by engaging directly with popular television as source material, these earliest works reveal a link to the Body art and performance-video practices of the generation of artists who immediately preceded her, such as Vito Acconci, Joan Jonas, and Bruce Nauman. (LZ)

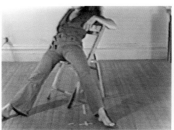 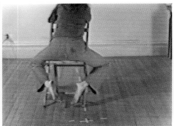 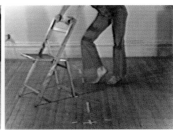

CHAIRED ANXIETIES
ABANDONED

SINGLE-CHANNEL VIDEO, BLACK-AND-WHITE, MONO, 5:15 MIN.
COURTESY ELECTRONIC ARTS INTERMIX, NEW YORK

In *Abandoned*, the first in the *Chaired Anxieties* series, Birnbaum enters a studio space that is empty except for a wooden folding chair. Barefoot and in jeans, the artist is seen from the neck down; her face is glimpsed only briefly. Performing in front of a fixed camera, Birnbaum enacts a series of poses that engage the chair as prop and support. She sits astride it, her legs spread and arms akimbo, her body open to the gaze of the lens. Alternately she stands, holding the chair or leaning against it, and assumes repeated postures. At times she taps her fingers or feet impatiently, as if waiting. Several times she walks slowly out of the frame, then returns to resume her interactions with the chair. Birnbaum's self-consciously choreographed posing, together with her careful framing of the image—tape on the floor appears to mark out the positions of the chair and her body—calls attention to the artist's awareness of and relationship to the camera. (LZ)

CHAIRED ANXIETIES
SLEWED

SINGLE-CHANNEL VIDEO, BLACK-AND-WHITE, MONO, 13:06 MIN.
COURTESY ELECTRONIC ARTS INTERMIX, NEW YORK

In *Slewed*, the second exercise in the *Chaired Anxieties* series, Dara Birnbaum again performs alone in front of a stationary camera. The artist's interactions with the wooden folding chair take on a heightened physical and psychological intensity. Birnbaum is first seen from the waist down, wearing a flowered skirt, her legs and feet bare. She sits astride the wooden chair, legs spread, and uses her feet and legs to push the chair around in a circle on the floor. Still sitting, she enacts a series of tense movements and anxious gestures, clutching at her calves and the chair with splayed hands.

Over the course of the piece, the artist's actions become increasingly agitated. Her breathing becomes labored as she falls from the chair to her knees, her long hair hanging. She wrestles violently with the chair on the floor, her limbs flailing, her thighs and crotch exposed. Relinquishing the chair, she squats and hops, animal-like, on all fours. Finally she sits in the chair again and performs a choreographed set of more benign but still agitated movements: crossing, uncrossing, and swinging her legs. In her final gestures, she skips around the chair, almost as if performing a dance. (LZ)

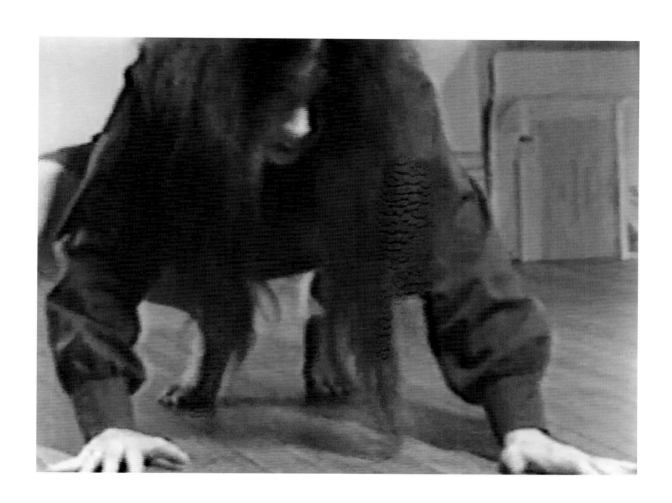

CHAIRED ANXIETIES

ADDENDUM: AUTISM

SINGLE-CHANNEL VIDEO, BLACK-AND-WHITE, MONO, 7:20 MIN.
COURTESY ELECTRONIC ARTS INTERMIX, NEW YORK

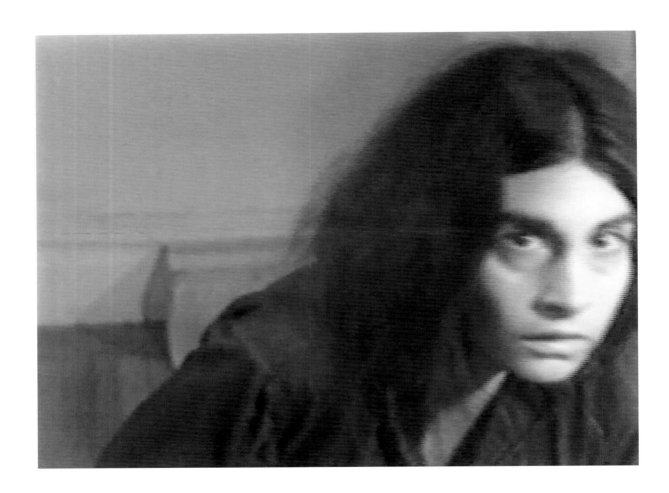

In *Addendum: Autism*, the artist faces the stationary camera in direct address; she confronts the viewer one-on-one, her head filling the frame in close-up. Her mouth slightly open, Dara Birnbaum stares with unblinking intensity into the camera. She performs a series of anxious gestures: she rubs her face, pushes her long hair behind her ears. Her breathing audible, she leans back and begins bouncing rhythmically, rocking up and down and back and forth in repetitive motions, without breaking her fixed, wide-eyed gaze. Her movements become increasingly sexualized, yet her insistent, trancelike stare remains uncannily child-like. The viewer is implicated in the camera's gaze, to unsettling effect. (LZ)

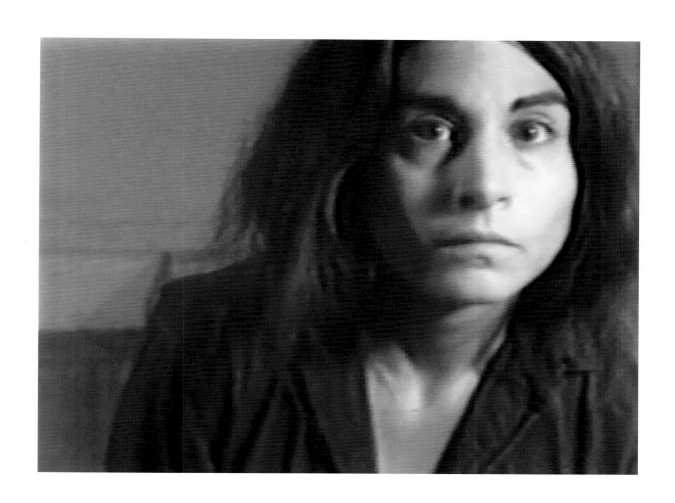

SINGLE-CHANNEL VIDEO, BLACK-AND-WHITE, MONO, 5:55 MIN.
COURTESY ELECTRONIC ARTS INTERMIX, NEW YORK

In the first section of this early video, Dara Birnbaum is seen placing her hands on the surface of a projection screen. Though the screen is glowing with the light of a projector, the surface is blank, foregrounding her gestures and the screen's physical dimensions. The artist's motions seem ritualistic and practiced, as if the arrangement of her hands were a form of communication. She turns away from the screen to look back at the unseen cameraperson, and the camera goes dark.

When shooting resumes, the projection screen shows the still image of an open loft/gallery space being prepared for an exhibition. The camera has moved closer to the screen, so that it takes up the entire frame and becomes an illusory window. Birnbaum's hand suddenly enters the frame, intercepting the projection and creating a trompe l'oeil effect; her arm looks like that of a giant as it reaches for a

refrigerator. She then places her whole body in the path of the projector, and the loft/gallery bends around her arms, torso, and face as she moves self-consciously in the camera's gaze. Her movements shift from being seductive and confrontational to shy and withdrawn. As in other early videos, Birnbaum explores the physical expression of psychological states, trying on different extroverted or introverted attitudes.

The camera shuts off again and resumes with a closer zoom on the projected image, and on Birnbaum, showing mostly her face and hands as she writhes either sensuously or seemingly in pain. After another break in the filming, Birnbaum's erratic behavior reaches a climactic fervor; and then she faces the camera one last time with a soulful, hurt expression, simultaneously implicating the cameraperson and the viewer in her physical and emotional exposure. (RC)

SINGLE-CHANNEL VIDEO, BLACK-AND-WHITE, MONO, 6:01 MIN.
COURTESY ELECTRONIC ARTS INTERMIX, NEW YORK

In this early performance-based work, Birnbaum investigates the notion of video as a mirror to create a psychological self-portrait. Devising a simple but ingenious formal exercise, she layers real and reflected images to articulate metaphorically the duality of internal and external selves.

As the piece begins, Birnbaum appears to stand facing the camera in a medium shot. She then seems to slowly approach the camera, gazing directly at the viewer. As she advances, her image goes out of focus. Then, coming into close-up, Birnbaum appears to turn simultaneously toward and away from the camera: we suddenly see her image as doubled or split. Her face, gazing at the viewer, is blurred. She turns her head slowly over her shoulder to face her reflected image. She stares into her mirrored face (which is in focus), her eyes meeting their reflection. She then turns her head to face the viewer again, before exiting the frame.

The sequence is confounding and disorienting; the viewer is at first unable to determine which image is real and which reflected or to parse the position of the artist in relation to the camera. Eventually the viewer realizes that the camera is in fact pointed at Birnbaum's reflection in a mirror. It is her reflected image that advances toward the camera, but it is her real image that comes into close-up as she passes in front of it. The artist seems to shift positions between real and reflected; in the doubled image, the viewer sees her simultaneously as subject and object of the camera's gaze.

Birnbaum repeats this sequence of actions eight times. With each iteration, she makes a slight but important shift: each time she begins, she first adjusts the focus of the camera lens. Over the course of the six-minute piece, the mirrored image increasingly goes out of focus while her real image increasingly comes into focus. By the final iteration, Birnbaum has brought her real self into sharp focus while her reflected self is now completely blurred.

Mirroring and the layering of real and reflected spaces as a metaphoric device recur in multiple forms throughout Birnbaum's work. In *Technology/Transformation: Wonder Woman* (1978–79), to cite one famous example, the superhero confronts herself in a hall of mirrors. Birnbaum's first use of the motif in *Mirroring* presents a female subject with a direct and confident address to the camera; she projects a serene glamour that prefigures the woman gazing in introspection at her reflected image in the 1985 *Will-o'-the-Wisp*. (LZ)

SINGLE-CHANNEL VIDEO, BLACK-AND-WHITE, MONO, 10:57 MIN.
COURTESY ELECTRONIC ARTS INTERMIX, NEW YORK

Everything's Gonna Be . . . is a single-channel video that features one of Dara Birnbaum's earliest uses of materials appropriated from mass-media sources. The artist brings together performance, photographic images from magazines and newspapers, handwritten and spoken texts, and popular music in a fragmented narrative collage. As such, *Everything's Gonna Be . . .* represents a departure from her earliest performance video exercises and a move toward her seminal investigations of the cultural and political meaning of mass-media texts.

The video begins with the artist rhythmically intoning the phrase "Everything's gonna be alright" while a young woman and man dance awkwardly. The dancers are overlaid with images taken from magazines, newspapers, and soap-opera digests depicting cultural figures that were well known in mid-1970s America: Patty Hearst, the TV character Mary Hartman, the soap-opera star Susan Lucci. The couple dances to the Bob Marley song "No Woman, No Cry," from which the title of the piece, and Birnbaum's chant, is drawn. Hand-lettered fragments of text that are presented as intertitles—"Feeling quite high, Claudette decides to go to 'the chateau' for some fun," for example—are dislodged from a melodramatic narrative that Birnbaum is heard reading in voice-over.

The dancing couple reappears at intervals, moving nonchalantly to the Marley song. We hear Birnbaum reading from a second text about presidential sex scandals, as iconic media images of JFK and Jackie alternate with more handwritten fragments: "The marriage certainly got off to a bad start"; "You're my ideal, Jackie, he once told her." The appropriated materials take on an increasingly topical tone as images appear of tabloid-newspaper headlines that allude to late 1960s and 1970s political sex scandals: "Nixon and the Chinese mystery woman," "Teddy's Midnight Swim."

Birnbaum has cited Jean-Luc Godard as an important influence on her early works, a relation suggested here by the disjunctive formal strategies and political undercurrent. At the end of the piece, Birnbaum again intones the phrase "Everything's gonna be alright," as if trying to convince herself of the fact. She then recites—and presents as handwritten intertitles—additional lyrics from the Marley song, concluding with the line, "In this great future, you can't forget your past." In an analysis that seems to speak to the personal as well as the social, Birnbaum formulates a fragmented narrative of the mediated culture of America in the mid-1970s, in which the future is refracted through the recent past. (LZ)

SINGLE-CHANNEL VIDEO, BLACK-AND-WHITE, MONO, 11:30 MIN.
COURTESY ELECTRONIC ARTS INTERMIX, NEW YORK

The title of this early video has a double meaning. Taken literally, it describes the iconic Statue of Liberty, seen from multiple vantages aboard the Staten Island Ferry. As the ship crosses New York Harbor, Dara Birnbaum interviews a dozen or so of her fellow passengers, asking them a series of classificatory questions about their weight, height, eye color, and race. These questions liken the interviews to the registration of immigrants arriving through the Port of New York at Ellis Island; the range of interviewees reflects the diversity of New York City and America overall.

The title *Liberty: A Dozen or So Views* might also suggest that Birnbaum's questioning would gather different opinions about liberty, but this is not among the questions asked. Instead, she had each interviewee use her camera to record his or her own vantage on the Statue of Liberty, contrasting the materiality of each person's physical being with that of the statue rising from the waters and relating physical views to conceptual ones. (RC)

PIVOT: TURNING AROUND SUPPOSITIONS

SINGLE-CHANNEL VIDEO, BLACK-AND-WHITE, MONO, 9:52 MIN.
COURTESY ELECTRONIC ARTS INTERMIX, NEW YORK

This early single-channel video is an investigation of the physical and psychological roles played by director, camera, and performer in the film or video shoot. Similar to the two-channel video installation *Attack Piece* (1975), *Pivot: Turning Around Suppositions* establishes a duality between the camera and its subject, pivoting between a moving camera recording an immobile performer, and a moving performer acting for a stationary camera. As in *Attack Piece*, these roles have gendered significance; Birnbaum herself is cameraman Michael Lanley's object, a loaded dynamic demonstrating a woman's subjection to a male gaze.

Over the course of *Pivot*, Dara Birnbaum and Lanley take turns calling out and interpreting ten "suppositions," generalized assumptions one person might have about another —"You really must be the devil," for example, or "You are always there when needed." Lanley's camera frames Birnbaum's facial expressions and bodily gestures, while she is a stationary model for his evocative movements around her, illustrating the symbiotic relationship between performer and camera.

The ambiguous nature of the suppositions leaves them open to wide interpretation, and Birnbaum's and Lanley's responses are improvised, likening the process to a Rorschach test, in which an individual is asked to interpret ten inkblot designs in the hope of revealing his or her personality traits and emotional conflicts. Birnbaum's interest in psychology and the characterization of emotional states can be seen in works throughout her career, as well as her rigorous analysis of the power structures implicit in camera-subject, viewer-performer, and male-female dichotomies. (RC)

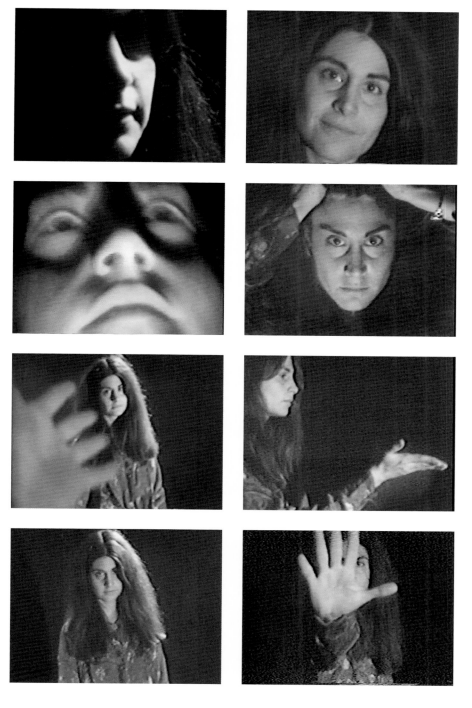

LESSON PLANS (TO KEEP THE REVOLUTION ALIVE)

THREE SETS OF BLACK-AND-WHITE PHOTOGRAPHS AND TEXT PANELS, 25 X 35.5 CM EACH
COURTESY MARIAN GOODMAN GALLERY, NEW YORK AND PARIS

Lesson Plans (To Keep the Revolution Alive) represents a significant development toward Dara Birnbaum's unique deconstruction and manipulation of the syntax of television. Her first work to be presented in an art gallery (New York's Artists Space), it is also her first exhibited work incorporating television imagery. Five popular prime-time TV programs—one for every evening of the week—are depicted in a series of twenty-five enlarged black-and-white photographs, hanging at eye level in a horizontal line that wraps around the gallery.

Each TV show is exemplified by a single scene. Five sequential photographs, framing one character at a time, breaks down the scene shot by shot. As in subsequent video works such as *Technology/Transformation: Wonder Woman* (1978–79) and the Pop-Pop Video series (1980), *Lesson Plans* is organized around a basic editing strategy used in television and film, in this case the reverse-angle shot, or shot/reaction-shot sequence, which assembles dynamic, fast-paced exchanges between actors. Birnbaum photographed the scenes off a television set with a 35 mm still camera, slowing the speed of television and calling attention to the abrupt transitions in points of view. Beneath each photo, a separate text panel transcribes the corresponding dialogue, using phonetic spellings and punctuation to convey the pacing and rhythm of the actors' delivery. Though the installation lacks an audio component, the inclusion of these panels hints at Birnbaum's interest in both the visual and the aural aspects of media and the profound influence of music and rhythm structures on her work.

In the 1977 Artists Space installation of *Lesson Plans*, a color Super 8 film of pedestrians window-shopping for TV sets in New York was projected on to one wall of the gallery. Subsequent installations have included only the photographs and text panels. (RC)

Installation view, "Dara Birnbaum," Artists Space, New York, 1977.

Installation view, "Dara Birnbaum," Artists Space, New York, 1977.

(A)DRIFT OF POLITICS:
TWO WOMEN ARE ACTIVE IN A SPACE

16 MM COLOR FILM LOOP (TRANSFERRED TO DVD), SINGLE-CHANNEL VIDEO, COLOR,
QUADRAPHONIC SOUND, 5:15 MIN.; WHITE PLASTIC GARDEN FURNITURE; DIMENSIONS VARIABLE
COLLECTION FRANÇOIS PINAULT FOUNDATION, FRANCE

(A)Drift of Politics: Two Women Are Active in a Space is one of Birnbaum's first video installations and an important example of her influential strategies of appropriating and deconstructing the language of popular television. This seminal installation features a 16 mm slow-motion film projection with a videotape loop and separate quadraphonic sound. As a critical, feminist intervention into TV syntax and conventions, the work is related to Birnbaum's classic early single-channel video works, such as *Technology/ Transformation: Wonder Woman* (1978–79) and the two Pop-Pop Video works (1980).

In *(A)Drift of Politics*, Birnbaum manipulates and reconstructs an episode of the popular American television situation comedy *Laverne & Shirley*, which was originally broadcast in the United States from 1976 to 1983. The sitcom follows the two eponymous protagonists as they "do it (their) way," to quote the show's theme song. Using for her source material an episode in which the friends embark on an ocean cruise, Birnbaum distills the thirty-minute program into six minutes of butt-edited "two-shot" scenes—that is, the scenes in which the women appear together in the frame. (Birnbaum saw the two-shot as the dominant vocabulary of the American TV sitcom.) These sequences foreground stereotypically "female" interactions: the women are seen berating, consoling, or competing with each other for romantic prospects on the cruise. This looped video plays silently on a video monitor suspended from the ceiling, with the women's dialogue rendered as subtitles. The on-screen titles force the viewer to read the dialogue while also "reading" the narrative action; the disconnect between the two elements exposes the subtexts of female competition and dependency that underlie both.

The same reedited two-shot distillation of the *Laverne & Shirley* episode is also projected as a 16 mm film, but in contrast to the video, the film is in slow motion. In the opening sequences of the film projection, the conversation appears as slowed subtitles. The text then drops out, directing the viewer to focus on the gestures and body language of the two women. The cinematic scale of the projection enhances the gestures of the women, allowing them to be seen "larger than life."

The displaced sound track of the sitcom episode is isolated from the images and presented in a separate space, functioning as a discrete installation element. Alienated and distanced from its original context, the audio becomes, in effect, a radio play. The relative positions of the film projection, the video monitor, and the audio allow the viewer to experience the elements separately or together, depending on one's location in the space.

The projected film is, in fact, a kinescope recording, which is created by filming a television program directly from a video monitor. The juxtaposition of the projected kinescope and the video monitor elicits yet another layer of analysis, that of the contrasting but interrelated systems of film and video, cinema and television.

Many of the radical strategies that Birnbaum pioneered in *(A)Drift of Politics* have since been thoroughly assimilated into the discourse around art and television: the activation of a feminist critique through an analysis of female gestures in popular media, the appropriation and reediting of a popular television source to expose its meaning, and the manipulation of the language and syntax of television as a critical, even political, intervention. (LZ)

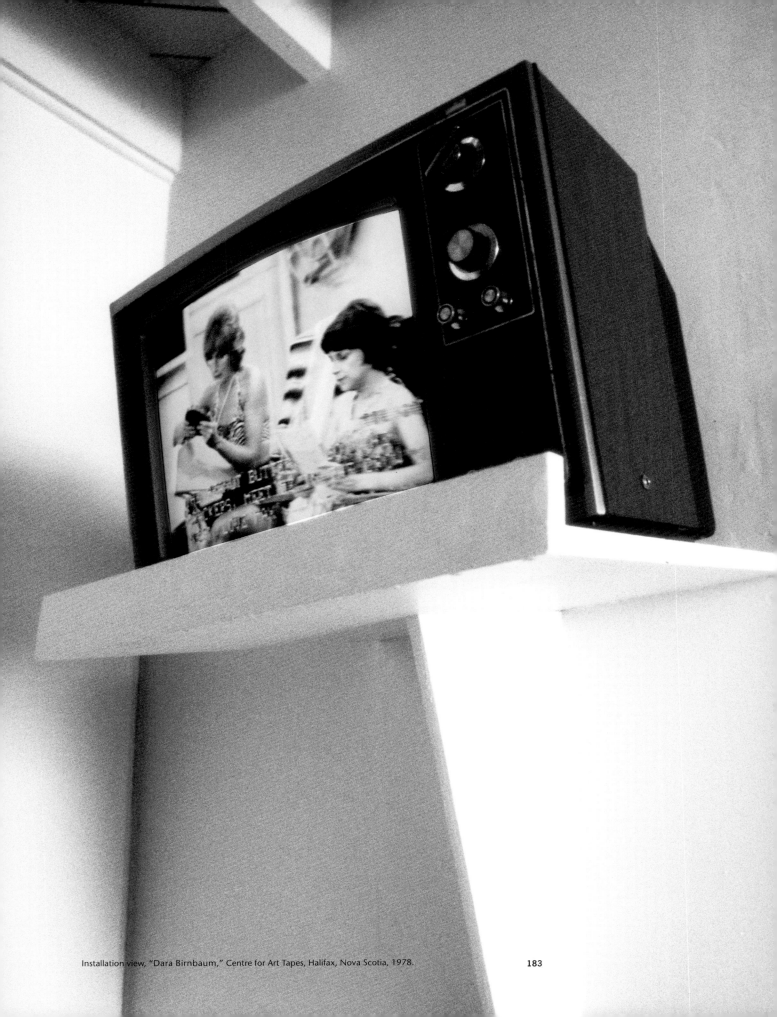

Installation view, "Dara Birnbaum," Centre for Art Tapes, Halifax, Nova Scotia, 1978.

183

Installation view, "Dara Birnbaum," Centre for Art Tapes, Halifax, Nova Scotia, 1978.

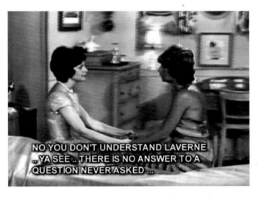

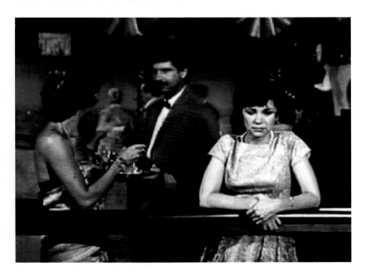

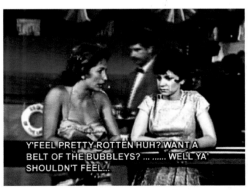

Above left: stills from the film.
Above right: stills from the video.

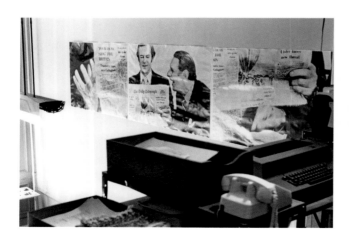

Installation view, Franklin Furnace, New York, 1978.

(READING) VERSUS (READING INTO): A "BANNER" AS "BILLBOARD"

NINE PANELS WITH BLACK-AND-WHITE PRINTS
(THREE OF WHICH ARE DOUBLE-SIDED),
DIMENSIONS VARIABLE
COURTESY OF THE ARTIST

Franklin Furnace Archive, founded in 1976 by artist Martha Wilson, is an important fixture of New York's downtown art scene. *(Reading) versus (Reading Into): A "Banner" as "Billboard,"* a site-specific installation for Franklin Furnace's original location at 112 Franklin Street, was a celebration of the organization's stated mission to "present, preserve, interpret, proselytize, and advocate on behalf of avant-garde art, especially forms that may be vulnerable due to institutional neglect, their ephemeral nature, or politically unpopular content."

Dara Birnbaum utilized both the exterior and interior of the building, installing a triptych of large photographic prints in Franklin Furnace's street-front windows, filling the upper-most panes of glass. These photographic enlargements depicted black-and-white images, appropriated from a nearby billboard advertising newspaper subscriptions. Birnbaum photographed the billboard, then enlarged and cropped the images, framing incidents of businessmen reading and discussing the newspaper. The central "panel" of the triptych, placed over the building's entrance, showed a man in a suit, gazing down on those who passed through the door. The two flanking panels showed men in close-up, turned toward him. All three men's mouths gaped slightly open, as if they had been interrupted midsentence.

On the reverse of these panels, visible from inside, Birnbaum reprinted the Franklin Furnace mission statement. When sunlight streaked through the windows, the outward-facing image of the men bled through, layering the text atop their faces. The installation of prints continued throughout the interior space, mounted high and adjoining the open mezzanine office space. The interior prints were also black-and-white photographic enlargements, showing different croppings from the same billboard source. A scroll of all of the prints was displayed in the gallery, serving as a model of the entire project.

The pun of *(Reading) versus (Reading Into)* was literalized by the installation. The reading of the street-facing panels, themselves a reading of a nearby billboard, was activated by the visitor's entrance into the gallery. This work was produced at about the same time as *Technology/Transformation: Wonder Woman* (1978–79), which in one of its original presentations was also installed in a street-front window. Both show Birnbaum's interest in deciphering the language of advertising and commercial media, and in encouraging the visitor or viewer to participate in this. (RC)

SINGLE-CHANNEL VIDEO, COLOR, SOUND, 5:50 MIN.
COURTESY ELECTRONIC ARTS INTERMIX, NEW YORK

Fiery explosions open *Technology/Transformation: Wonder Woman,* an incendiary analysis of the ideology embedded in television's form and pop-cultural iconography. *Technology/Transformation* is recognized as a seminal work in the history of video art for its groundbreaking use of appropriated television imagery to deconstruct its language and meaning. Dara Birnbaum applies a feminist critique, reediting and manipulating pop-cultural sources to examine representations of women and female sexuality. Of her early appropriation-based video works, Birnbaum has written, "I see them as new 'readymades' for the late twentieth century—composed of dislocated visuals and altered syntax; images cut from their original narrative flow and countered with additional musical texts."

Appropriating imagery from the popular American television series *Wonder Woman,* which ran in the United States from 1975 to 1979, Birnbaum isolates and repeats the moment of the "real" woman's symbolic transformation into superhero in a blinding flash of light. Entrapped in her spectacular metamorphosis by Birnbaum's repeated edits, Wonder Woman spins dizzily, like a doll in a music box. Arresting the flow of images through fragmentation and repetition, Birnbaum further condenses the comic-book narrative—Wonder Woman deflects bullets off her bracelets and cuts the reflected image of her throat in a hall of mirrors—distilling its essence and allowing the subtext of female empowerment and sexuality to emerge.

As Birnbaum states, "The abbreviated narrative—running, spinning, saving a man—allows the underlying theme to surface: psychological transformation versus television product. Real becomes Wonder in order to 'do good' (be moral) in an (a) or (im)moral society."

In a further layering and dislocation of pop-cultural sources, Birnbaum's sound track features inane dialogue from the television show mixed with an obscure disco song, "Shake thy Wondermaker!" by the Wonderland Disco Band. Birnbaum spells out the words to the song on the screen against a blue background, as if inviting the viewer to sing along. The lyrics' double entendres ("Get us out from under . . . Wonder Woman") and the singer's orgasmic moans ultimately reveal the sexual source of the superwoman's supposed empowerment: "Shake thy Wonder Maker/Ah-hh-hh Oh-hh-hh/ Show you all the powers I possess, baby."

Created in an era before the VCR made it possible to record off-air television imagery at home, Birnbaum's early video works—*Kiss the Girls: Make Them Cry* (1979), *Technology/Transformation,* the Pop-Pop Video series (1980)—were quite literally pirated: "Appropriated material had to be obtained by 'having friends on the inside,'" she writes. "Source material was gathered late at night in commercial studios through friends or through sympathetic producers of local cable TV." Birnbaum's use of mass-media source material as the subject and form of her video work, now a common art-making strategy, was radical for its time, and the contexts in which *Technology/Transformation: Wonder Woman* was shown extended Birnbaum's critical engagement with and intervention into popular cultural forms. In addition to cable television, alternative art spaces, and galleries, the piece was screened in unexpected public venues, including on a monitor in the storefront shopwindow of the H-Hair Salon de Coiffure in New York's SoHo neighborhood. To Birnbaum, the modes of production, distribution, and exhibition of these early, appropriated works furthered the discourse around issues of access and talking back to the media. (LZ)

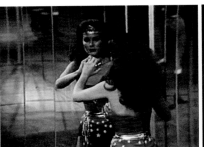

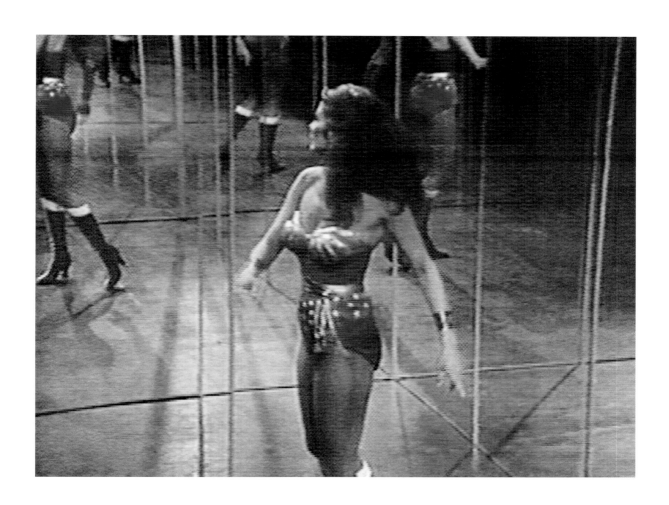

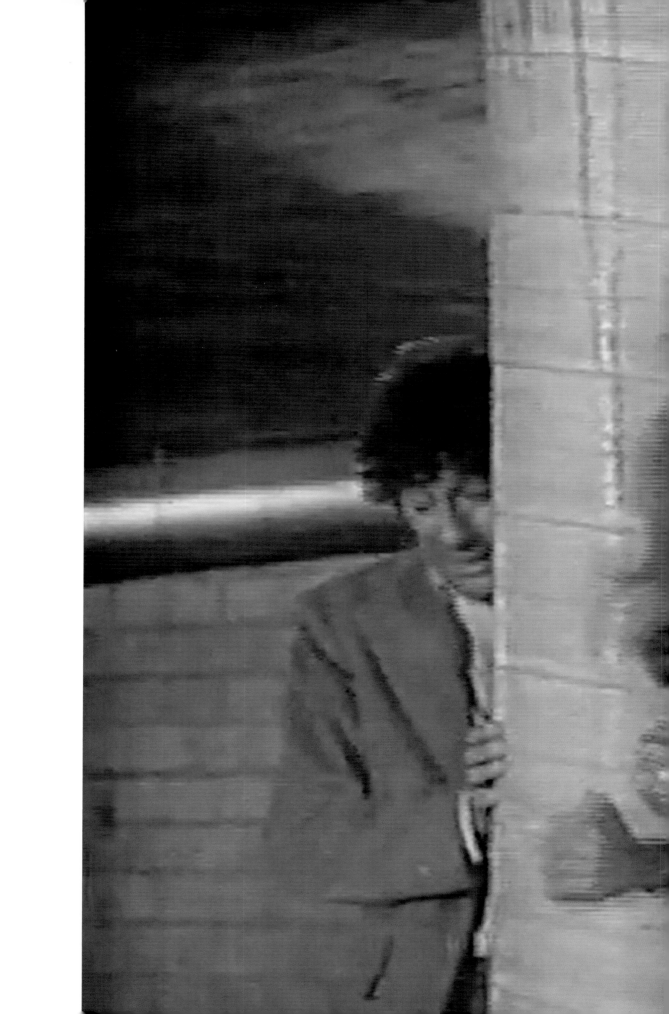

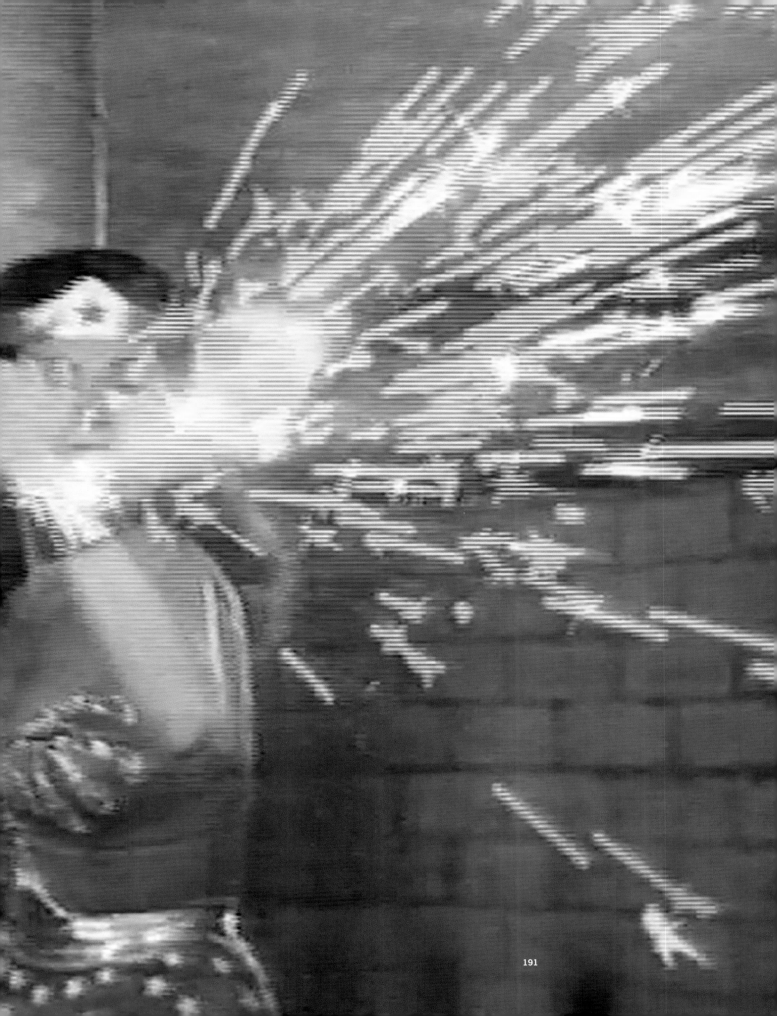

KISS THE GIRLS: MAKE THEM CRY

TWO-CHANNEL VIDEO, COLOR, STEREO, 6:26 MIN.
COURTESY MARIAN GOODMAN GALLERY, NEW YORK AND PARIS

SINGLE-CHANNEL VIDEO, COLOR, STEREO, 6:50 MIN.
COURTESY ELECTRONIC ARTS INTERMIX, NEW YORK

Kiss the Girls: Make Them Cry is one of Dara Birnbaum's key video works, exemplifying her pioneering strategies of appropriating pirated television footage in order to deconstruct it and expose its subtextual meaning. In this bold analysis of the gestures of sexual representation as they are embedded in television imagery and pop music, Birnbaum manipulates footage appropriated from the popular American TV game show *The Hollywood Squares*, a national daytime program that ran in the United States from 1966 to 2004. The installation presents two identical channels of video and audio playing on two monitors set atop their own packing crates.

Nearly forgotten TV personalities, confined in a stage set modeled as a flashing tic-tac-toe board, introduce themselves to millions of national TV viewers through exaggerated greetings. Birnbaum isolates and repeats the banal and at times bizarre gestures of the men and women, which she has called "repetitive baroque necksnapping triple takes, guffaws, and paranoid eye darts." She detaches these images from their original context in order to, in her words, "unveil TV's stereotyped gestures of power and submission, of self-presentation and concealment, of male and female ego." Three basic shots from the show are intercut: full-screen close-ups of what Birnbaum terms "receding men"; full-screen close-ups of "iconic women," each represented by a specific gesture; and a long shot of the set, which flashes like a giant upended disco floor.

These reedited and manipulated visuals are amplified and underscored by the video's brilliant sound track, which comprises two reworked disco hits, an original scored jazz interpolation, and a harsh New Wave coda. Linking commercial television and pop music, Birnbaum spells out as text onscreen the lyrics to Toto's "Georgy Porgy," a 1970s song (heard here in a remixed disco version) that takes up the well-known taunts of a child's nursery rhyme: "Georgy Porgy puddin' and pie / kiss the girls and make them cry." Fragments of the lyrics from Ashford & Simpson's classic disco track "Found a Cure," isolated against a black screen, are wailed as an ironic rebuke: "Found a cure / Love will fix it / Love will fix it / Love will fix it." The mirroring effect of the two simultaneous channels further magnifies the repetition and rhythmic insistence of the remade images and music.

With both visuals and sound taken from pop-cultural sources, *Kiss the Girls: Make Them Cry* is a powerful, layered analysis of mass-cultural idioms, an analysis that exemplifies Birnbaum's stated goal of "talking back to the media." As with all her appropriation-based works from this period, which predate the advent of the VCR for recording television at home, the off-air footage was gathered clandestinely from commercial studios or cable-TV sources.

Writes Birnbaum: "I had seen artists take images from popular culture and transform them into other mediums, but I wanted to use the medium on itself. . . . I chose—(and) perhaps this had to do with being a female artist examining stereotypes of women—to reoccupy it. Nobody believed they really had the power to talk back to the media before." Reflecting her interest in exploring alternate modes of disseminating and presenting her work, Birnbaum also created a single-channel video version of *Kiss the Girls: Make Them Cry*. (LZ)

Installation view, "Kill All Lies," Luhring Augustine Gallery, New York, 1999.

 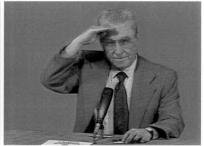

194

GEE – ORR – GEE
POOH ORR – GEE
PUDDIN' AND PIE

KISS THE GIRLS
MAKE THEM CRY

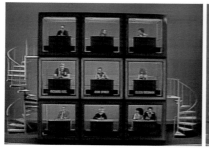
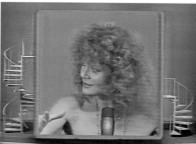

YELLOW BIRD
WAY UP IN BANANA TREE

YELLOW BIRD
HE SING FOR YOU AND ME

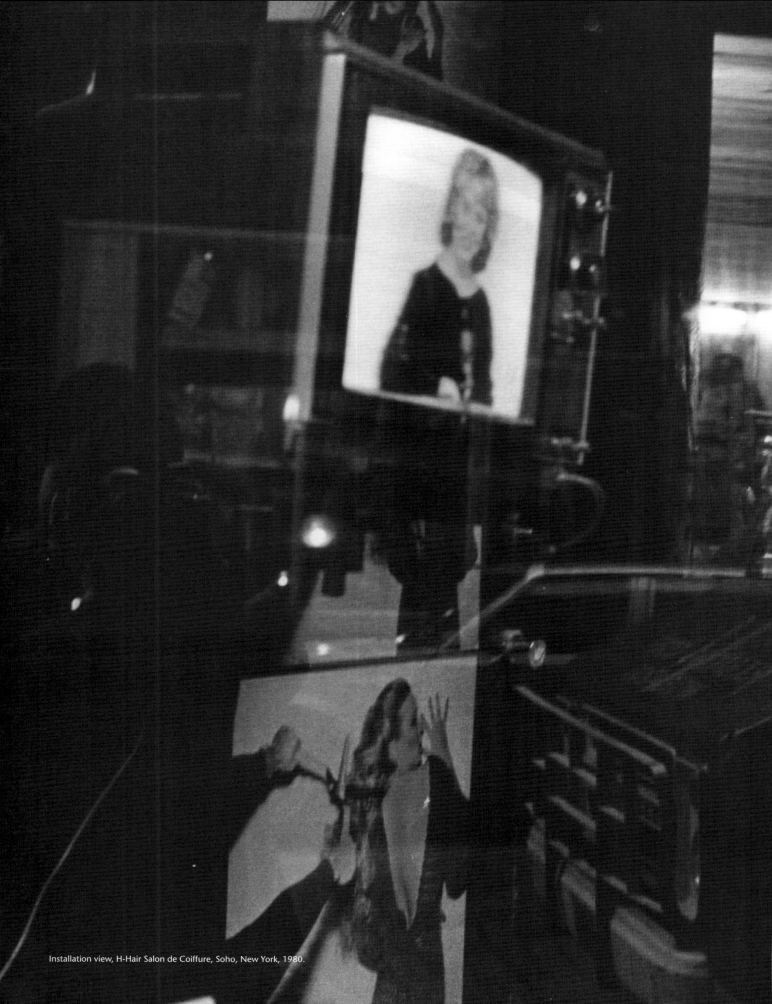

Installation view, H-Hair Salon de Coiffure, Soho, New York, 1980.

LOCAL TV NEWS ANALYSIS FOR CABLE TELEVISION

IN COLLABORATION WITH DAN GRAHAM
SINGLE-CHANNEL VIDEO, COLOR, STEREO, 61:16 MIN.
COLLECTION S.M.A.K., GHENT

In Dara Birnbaum's working notes titled "Local Television News Program Analysis for Public Access Cable Television" (published in *Dan Graham: Video/Architecture/Television* [Halifax, NS: NSCAD Press, 1979]), she schematizes the transmission of an evening newscast from the television studio to a viewer's living-room TV set. Birnbaum defines the broadcast as an "entity" that can be broken down into "three sets of concurrent realities": the television studio (the "point of origin"), the viewer's TV (the "point of receivership"), and the transmission itself. Applying architectural principles, Birnbaum delineates these areas temporally and spatially, suggesting that because the transmission of a live newscast from studio to living room occurs nearly instantaneously, the physical distance between these spaces is also collapsed. She writes: "The temporal dis-

Editing suite in Toronto, where production of the video work took place, 1980.

tance between the individuated areas can be (and usually is) minimal. Thus, we can speak of 'concurrency' in relation to time and the relative physical coexistence of these spaces to one another."

Birnbaum, collaborating with Dan Graham, developed an hour-long program for broadcast on a Canadian cable-access station; the program was a visual demonstration of the theories outlined in her working notes. Originally conceived as a broadcast over three separate cable channels—one for each of Birnbaum's defined spaces—the actual broadcast was condensed and presented on a single channel. The program's setting shifts back and forth from a broadcast studio to a living room where a family watches the local news on their small TV set. A recording of the newscast from the previous evening is displayed continuously as a corner insert over both spaces, representing the "transmission" between them.

Initially, the audio of each space remains distinct. In the studio, behind-the-scenes chatter and directives prepare the newscast for public consumption, while the living room is noisy with the sounds of distracted receivership. As the program continues, Birnbaum emphasizes the blurring of these "concurrent realities" by transposing the studio's audio into the living room and vice versa.

Local TV News Analysis was produced by A Space Gallery, Toronto, an artist-run center founded in 1971, advocating multidisciplinary art that engages in social critique. (RC)

Interior of control room, local television news station, Toronto, 1980.

TWO SINGLE-CHANNEL VIDEOS, COLOR, STEREO
TOTAL RUNNING TIME 8:18 MIN.
COURTESY ELECTRONIC ARTS INTERMIX, NEW YORK

In each of Dara Birnbaum's two Pop-Pop Videos, the artist deconstructs television's idiomatic grammar, thereby revealing hidden agendas and unexpected meanings. The videos take their underlying structure from the intercut, a type of edit that juxtaposes two contrasting scenes. Birnbaum pushes this technique to an extreme by editing together diametrically opposed TV sources, collaging a daytime soap opera with a sportscast, and a crime-drama series with a commercial for Wang word processors. The diversity of the selection represents a sampling of then-contemporary television programming—the Pop-Pop Videos might also mimic the experience of a viewer flipping from channel to channel. Music plays a key role in both videos; Birnbaum's precisely calibrated sound mix fuses the heterogeneous TV clips. (RC)

GENERAL HOSPITAL/OLYMPIC WOMEN SPEED SKATING

SINGLE-CHANNEL VIDEO, COLOR, STEREO, 5:32 MIN.
COURTESY ELECTRONIC ARTS INTERMIX, NEW YORK

In *General Hospital/Olympic Women Speed Skating*, the soap opera *General Hospital* and the 1980 Winter Olympics are intercut to a sound track that mixes original music, composed specifically for the footage, by Dori Levine, Robert Raposo, and Sally Swisher, along with an appropriated Donna Summer disco song. Opening the video, the lithe motion of women speed skaters is accompanied by Raposo's stirring instrumentation. His evocative guitar strands continue over the *General Hospital* fragment, in which a man and a woman are caught in the midst of an emotional exchange. The music draws attention to the heightened dramatic pitch of both clips, however distinct they may be, but the tone shifts when Raposo's instrumentation gives way to Levine and Swisher's bebop vocals and then Summer's swinging disco beat. The disparity between the clips is more absurdly delineated by the layering of upbeat pop music over the *General Hospital* scene, in which the woman contorts her face under the strain of emotional stress, while the speed skaters' graceful movements seem synchronized to the music. Stark polarities of balance versus imbalance, victory versus defeat, and physical versus emotional exertion are portrayed in this richly analytic "music video" that conveys a profound range of emotional and physical drives. (RC)

POP-POP VIDEO:
KOJAK/WANG

SINGLE-CHANNEL VIDEO, COLOR, STEREO, 2:46 MIN.
COURTESY ELECTRONIC ARTS INTERMIX, NEW YORK

In the other Pop-Pop Video, *Kojak/Wang*, Dara Birnbaum intercuts a fragment from the popular 1970s TV show *Kojak* with a commercial for Wang Laboratories, an early personal computer company and one of the first to advertise computers on television. A driving guitar solo composed and performed by Rhys Chatham, punctuated by gunfire from a shoot-out in *Kojak*, creates a volatile counterpoint to Wang's portrayal of a female secretary with dazzling rainbow-colored beams firing into her computer. The colored beams are echoed in the colors of a television test pattern that peri-odically flashes on-screen, disrupting the volley between *Kojak* and the Wang ad. Taken as a whole, *Kojak/Wang* depicts the violent potential of technology, especially when wielded by corporate America and commercial television. (RC)

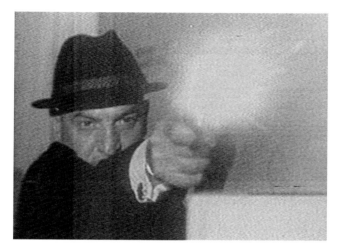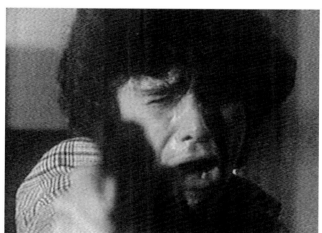

REMY/GRAND CENTRAL:
TRAINS AND BOATS AND PLANES

1980

SINGLE-CHANNEL VIDEO, COLOR, STEREO, 4:19 MIN.
COURTESY ELECTRONIC ARTS INTERMIX, NEW YORK

Remy/Grand Central is a faux advertisement with a deconstructive twist. In a syncopated collage of appropriated footage (from a well-known TV commercial of the time for Sergio Valente jeans) intercut with scenes of a young woman drinking Rémy Martin cognac on a commuter-train platform, Dara Birnbaum calls attention to how mass-media advertising uses a woman's body as a vehicle for selling products. In a stylized pastiche that she terms "a snack-en-route with a pretty girl, animated trains, updated Bacharach Muzak (Brazilian style), and pouring Rémy," Birnbaum turns the tables on the media's use of woman-as-commodity.

While *Remy/Grand Central* includes elements that are signatures of Birnbaum's video works of this period—

appropriated television footage, an inventively reworked version of a popular music source (Burt Bacharach's "Trains and Boats and Planes"), song lyrics spelled out as on-screen text, the dynamic mix of sound and visuals—it is distinctive in its use of original recorded material. Adopting the format of a television advertisement, Birnbaum then subverts its content and conventions as critique.

Birnbaum was commissioned by Rémy Martin to create the piece for an exhibition in the waiting room of Grand Central Terminal. Curated by Allan Schwartzman, the project also featured Brian Eno, Maren Hassinger, Jenny Holzer, and Randy Williams. Birnbaum's participation reflects her interest in presenting her works in public contexts outside the museum or gallery. (LZ)

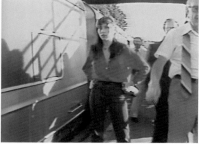

RADIO FIRE FIGHT, THE MUDD CLUB, NYC
GLENN BRANCA, SYMPHONY NO. 1, THE PERFORMING GARAGE, NYC

SINGLE-CHANNEL VIDEO, COLOR, STEREO, 5:41 MIN.
COURTESY ELECTRONIC ARTS INTERMIX, NEW YORK

The two short pieces that constitute *New Music Shorts* emerged from Dara Birnbaum's engagement with the downtown New York music scene of the early 1980s. These dynamic clips, created with analog technology, are multi-image documents of early live performances by experimental musicians Radio Fire Fight and Glenn Branca. Live footage is montaged with frame-in-frame compositions of the performers and the audience. The raw intensity of the music, together with Birnbaum's up-close, low-tech visuals, makes for a vivid snapshot of the Lower Manhattan post-punk scene.

In the first clip, Birnbaum documents the No-Wave noise band Radio Fire Fight at New York's legendary Mudd Club, a key venue for punk, New Wave, and experimental music in the late 1970s and early 1980s. Birnbaum applies spare formal devices, including multiple frames, to the performance footage. Static images of the performers and the audience appear in window inserts, creating a visual parallel to the jagged minimalism of the music.

The second clip captures rock iconoclast and avant-garde composer Glenn Branca performing his famous *Symphony No. 1* at an alternative theater space, the Performing Garage. Footage of Branca and his ensemble performing the propulsive symphony of massed guitars and percussion is punctured with inserts and composite images that link the performance inside with the stormy weather outside. Lightning and pounding rain provide a mesmerizing counterpoint to the thunderous percussion and driving guitars of Branca's radical orchestra.

Birnbaum made *New Music Shorts* in 1981, the same year that MTV exploded on to television. During this time, music videos were also being screened in downtown clubs. *New Music Shorts* can thus be seen as alternative music videos for the downtown scene. Birnbaum puts forth her intent in a written introduction that appears on-screen: "Avoiding off-air footage (opening the work to broadcast and cable) and using formal devices—corner inserts, repetition, dislocation, and altered syntax—an investigation of the powerful currency provided by contemporary downtown music will ensue, creating moments of arrest which will engage new aspects of popular culture. . . . 'A television language for popular song.'"
(LZ)

SINGLE-CHANNEL VIDEO, COLOR, STEREO, 3:13 MIN.
COURTESY ELECTRONIC ARTS INTERMIX, NEW YORK

In *Fire!/Hendrix*, Dara Birnbaum uses the stylized visuals and pacing of a music video to critique the representational economies of sexuality and consumerism. She translates the psychedelic fervor of the 1967 Jimi Hendrix song "Fire" into a contemporary visual vernacular and recasts the lyrics' meaning.

Birnbaum mixes rapidly edited footage recorded at fast-food restaurants in Los Angeles with on-screen fragments of the lyrics from the Hendrix song. Through formal devices such as window inserts, Birnbaum isolates a series of gestures: those of a young woman "protagonist," of young men hanging out in the restaurant parking lot, and of financial transactions at the drive-through window. In the fragmented narrative, Birnbaum focuses on images of American consumerism and commodities—fast food, cars, the exchange of money—and calls attention to the woman's relationship to advertising imagery: she is consumed as she is consuming.

Fire!/Hendrix, made at a time when MTV was a new force in the television and music industries, was commissioned for the Jimi Hendrix VideoGram, a compilation of video artists' visual interpretations of unreleased versions of Hendrix music. As such, it reflects Birnbaum's interests in experimenting with the music-video format and with disseminating her works outside traditional art-world contexts. (LZ)

PM MAGAZINE 1982

FIVE-CHANNEL VIDEO, COLOR, THREE CHANNELS OF AUDIO, 4:20 MIN.
BLACK-AND-WHITE PHOTOGRAPHS (FROM 180 X 241.5 TO 180 X 240 CM)
COLLECTIONS MUSEO NACIONAL CENTRO DE ARTE REINA SOFIA, MADRID;
ISRAEL MUSEUM, JERUSALEM; SAN FRANCISCO MUSEUM OF MODERN ART;
MUSEUM OF CONTEMPORARY ART, CHICAGO.

PM MAGAZINE/ACID ROCK 1982

SINGLE-CHANNEL VIDEO, COLOR, STEREO, 4:09 MIN.
COURTESY ELECTRONIC ARTS INTERMIX, NEW YORK

In *PM Magazine*, Birnbaum creates a delirious collage of appropriated TV imagery and dynamic pop music. Set to a recomposed, post-punk version of the Doors song "L. A. Woman," Birnbaum's video presents a continuous flow of emblematic images of self-satisfaction—the American dream or America's dream-state. Iconic female figures (an ice skater, a cheerleader, a little girl licking an ice-cream cone) enact gestures of leisure and consumerism. Appropriated from the opening sequence of the television program *PM Magazine*, these images are continuously framed and reframed, slowed and accelerated, colorized and abstracted. The visuals are mixed with the recurring image, taken from a segment of a Wang computer commercial, of a smiling secretary tapping at a computer: candy-colored beams of light fly into and out of the screen.

The news and entertainment program *PM Magazine* was in wide syndication across the United States in 1982; the show's introduction and theme were instantly recognizable to an American public. The recomposed Doors song serves as a driving counterpoint to the dislocated and reworked visuals. Sung by a woman, Shauna D'Larson, the lyrics ("Never saw a woman so all alone / So all alone"), which are also isolated as German text on the screen, are inscribed with new meaning. Inviting the viewer to "plunge headlong into the experience of TV," Birnbaum recontextualizes and subverts pop-cultural representations of consumerism and sexuality to challenge mass-media ideologies.

The five-channel installation *PM Magazine*, which has assumed different configurations for specific sites, features a layered mix of static and moving images, sound, and visuals. Two large panels display oversized enlargements of black-and-white freeze-frames taken from the highly manipulated video footage, the little girl licking the ice-cream cone and the secretary sitting in front of her personal computer. Video monitors are embedded directly into the panels, which are installed in the manner of a trade-show exhibit. One monitor plays silent, looped footage of the Wang commercial; another shows images of the ice skater and the little girl, moving toward the viewer. In these images, Birnbaum has written, "gesture is seen not as an opening to communication, [but] rather as a form of constraint." Three monitors (variously suspended, embedded, or set on a pedestal) present different, unsynchronized iterations of the video collage; together they form a composition of fractured visuals and ricocheting sound. Propelling the images and audio into three-dimensional space, the installation takes on an architectural scale that suggests the power of the mass-media environment.

The single-channel version titled *PM Magazine/Acid Rock*, which distills the visual and sound elements into a dynamic ten-minute collage. *PM Magazine/Acid Rock* was originally produced as one of four simultaneous video/music channels for a version of the installation *PM Magazine* at Documenta 7 in Kassel, Germany in 1982. (LZ)

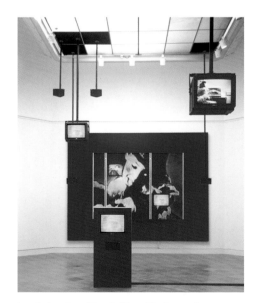

Installation view, "Thresholds and Enclosures,"
San Francisco Museum of Modern Art, San Francisco, 1993.

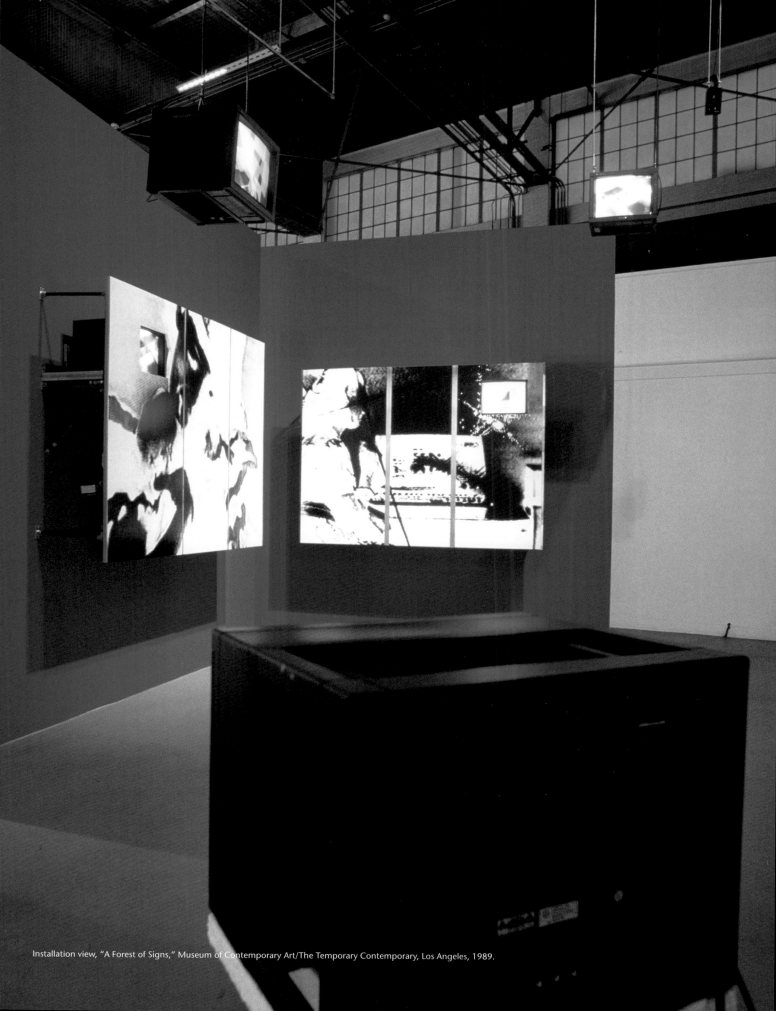

Installation view, "A Forest of Signs," Museum of Contemporary Art/The Temporary Contemporary, Los Angeles, 1989.

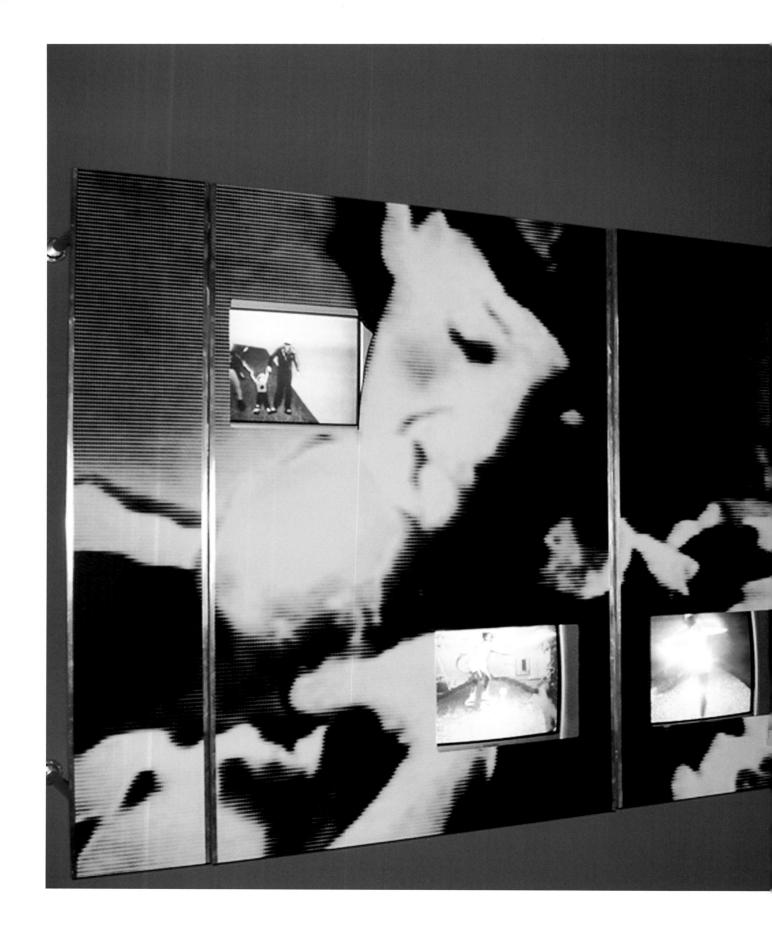

Installation view, "The First Generation: Art and the Moving Image, 1963–1986,"
Museo Nacional Centro de Arte Reina Sofía, Madrid, 2006–07.

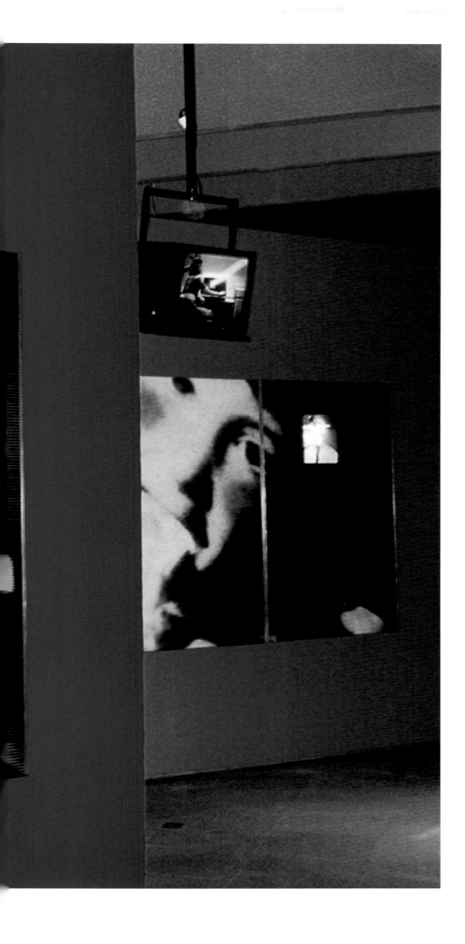

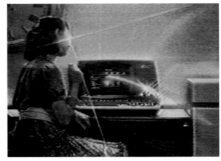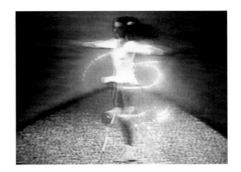

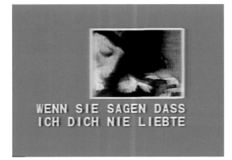WENN SIE SAGEN DASS
ICH DICH NIE LIEBTE

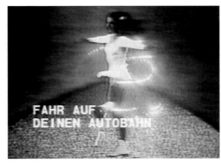FAHR AUF
DEINEN AUTOBAHN

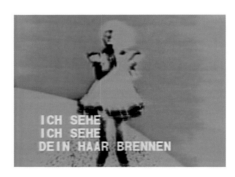ICH SEHE
ICH SEHE
DEIN HAAR BRENNEN

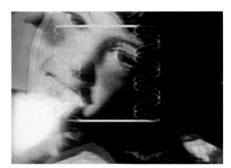

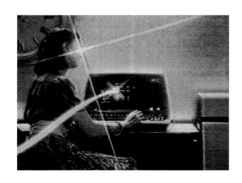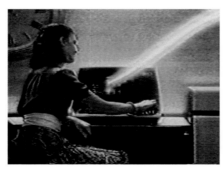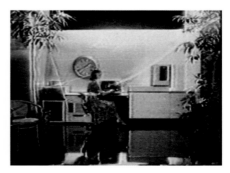

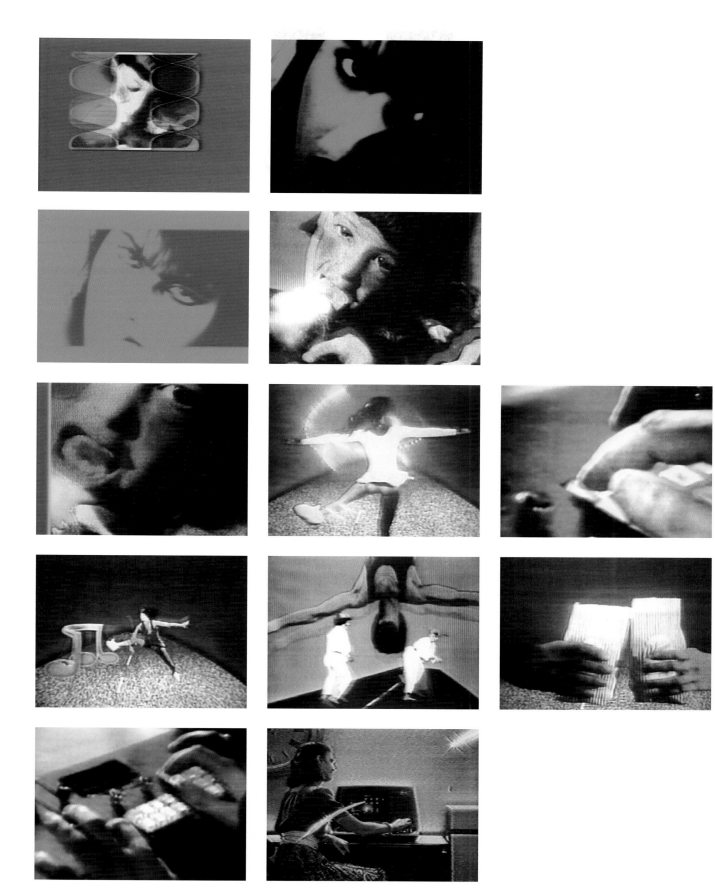

DAMNATION OF FAUST TRILOGY:

EVOCATION

SINGLE-CHANNEL VIDEO, COLOR, STEREO, 10:02 MIN.

Evocation is the prologue of the *Damnation of Faust Trilogy,* a series of works in which Dara Birnbaum invokes the Faust legend as a touchstone for dreamlike introspection on the duality of the self and the external world. Unfolding with minimal dialogue, *Evocation* is itself divided into three parts, each propelled by a distinctive original musical composition that together trace a young woman's arc from isolation to transcendence.

Shot in a Lower Manhattan playground, each section presents urban scenes of teenagers and children at play. Birnbaum focuses particular attention on two teenage girls on a swing, rendering their movements in lyrical slow motion. Woven throughout are images of a young woman watching. Ultimately the children and the woman are superimposed with footage of a lush, natural landscape, suggesting a literal and metaphorical escape from confinement. The progression of the three-part original score—Joshua Fried's propulsive electronic music, Sonic Youth's haunting, dirgelike incantations, and John Zieman's jubilant synth pop—mirrors this trajectory. Drawing her inspiration from Goethe's and Berlioz's Faustian myths, Birnbaum has written that *Evocation* derives its underlying tension from a longing for innocence and renewal, a desire to transcend everyday experience, which is evoked through the reawakening of a young woman's lost childhood.

Birnbaum brings her architectural background to the piece, employing video technology to articulate metaphorical spatial relationships. Multiple images and frames-within-frames articulate the conjoining of inner, psychological space and external space, past and present, memory and reality. Inspired by nineteenth-century Japanese Ukiyo-e forms, she introduces fans and vertical pillars as visual motifs to plunge the viewer into the picture frame; scenes unfold, and meaning is glimpsed like a fan being splayed.

Evocation signaled a transition in Birnbaum's work away from her previous analysis of the language and conventions of appropriated television footage and toward the use of original recordings and state-of-the-art electronic postproduction to achieve a metaphoric visual grammar. (LZ)

DAMNATION OF FAUST TRILOGY:

WILL-O'-THE-WISP (A DECEITFUL GOAL)

1985

SINGLE-CHANNEL VIDEO, COLOR, STEREO, 5:46 MIN.
COURTESY ELECTRONIC ARTS INTERMIX, NEW YORK

Will-o'-the-Wisp, the second part of Dara Birnbaum's *Damnation of Faust Trilogy*, is a reverie on memory and reality. A woman gazing through a window, reflecting on romantic loss and betrayal, gives voice to Marguerite/Gretchen, the character whom Faust seduces and abandons. Her monologue, which alludes to an absent male, a lost lover, weaves a tale of deception and abandonment. Infused with melancholy, the visuals and sound unfold in a progression of hypnotic, rhythmic fragments.

Using state-of-the-art electronic technology as a poetic language, Birnbaum creates elegant formal devices inspired by nineteenth-century Japanese Ukiyo-e motifs, including "diagonal rain wipes" and "transitional fan wipes." The woman, whose face is reflected in the glass, gazes from her window, while the children she sees on the street below appear simultaneously in "window" inserts. Birnbaum isolates the smallest, most ordinary gestures of the woman and the children. Her image doubled, the woman directs her gaze both inward and outward, on to memory and reality, past and present. Internal and external worlds are conjoined.

Will-o'-the-wisps, the ghostly lights of folklore that attempt to deceive and take one away from the right path, figure in the Faust legend and are linked to Marguerite in Berlioz's opera *The Damnation of Faust*. In her narration of female desire, Birnbaum's heroine, seen in close-up, speaks haltingly of her sense of confinement and self-doubt. Her monologue alludes to the illusory nature of memory and reality: "I think you tend to deform the past and fit it according to your desires or your needs." (LZ)

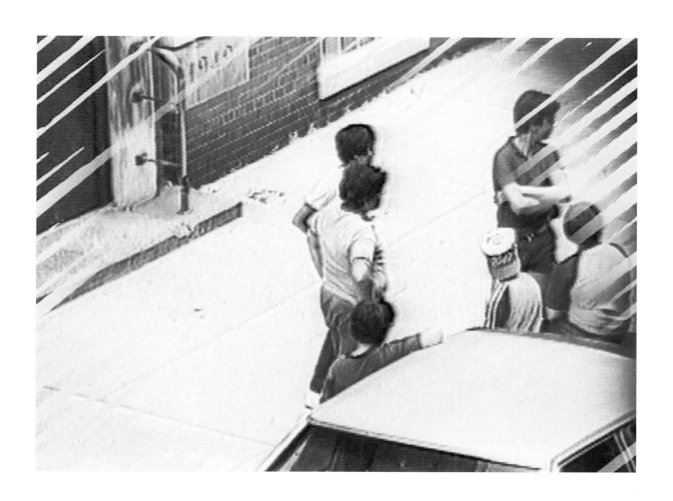

DAMNATION OF FAUST TRILOGY:

CHARMING LANDSCAPE

1987

SINGLE-CHANNEL VIDEO, COLOR, STEREO, 6:30 MIN.
COURTESY ELECTRONIC ARTS INTERMIX, NEW YORK

Charming Landscape is the final segment of the *Damnation of Faust Trilogy*. Here Dara Birnbaum shifts her focus from the individual to the social being to examine the collision of personal history and collective memory through technology and mediated images. She revisits locations and individuals from *Evocation*, part one of the trilogy: the neighborhood playground that is now being demolished was the locus of the earlier piece, and Georgeann, one of the girls in *Charming Landscape*, was introduced by name in the trilogy's opening sequence.

Birnbaum juxtaposes scenes of the demolition of the Lower Manhattan playground with images of two teenage girls reflecting on the time they spent there. Birnbaum isolates a series of ordinary gestures—the girls' expressive hand movements, a child jumping in the playground—in window inserts. This footage is interwoven with archival imagery as Birnbaum then constructs a historical time line of mass street demonstrations as chron-icled through found television-news footage, from the American civil rights movement and antiwar protests of the 1960s to the Chinese student uprising in Beijing's Tiananmen Square in 1989. From playground to police, across cultures and time, Birnbaum isolates the smallest and grandest of gestures, linking and questioning their meaning as signs of communication and dominance. The gloved hand of a military policeman, reaching out to cover the camera lens in a gesture of censorship, is the final image of the piece.

Charming Landscape ends with a dedication to the protagonists of this work: "For Pam and Georgeann, born May 1968 and February 1969." That historical moment was, of course, one of widespread international protest and cultural upheaval. In this summation of her Faust-themed works, Birnbaum examines the mass media's relation to history and memory, and the struggle of the individual voice to become a political voice. (LZ)

DAMNATION OF FAUST (INSTALLATION)

TWO-CHANNEL COLOR VIDEO, QUADRAPHONIC SOUND, 7:02 MIN.
BLACK-AND-WHITE PHOTOGRAPHIC ENLARGEMENT, DIMENSIONS VARIABLE
COLLECTIONS FONDS RÉGIONAL D'ART CONTEMPORAIN DE LORRAINE, FRANCE; NÖ-PLAN, AUSTRIA

Dara Birnbaum's two-channel installation *Damnation of Faust* is one in a series of Faust-inspired works that includes a single-channel-video trilogy—*Damnation of Faust: Evocation* (1983), *Will-o'-the-Wisp (A Deceitful Goal)* (1985), and *Charming Landscape* (1987)—as well as the 1985 installation *Will-o'-the-Wisp*. In these works Birnbaum draws inspiration from Goethe's and Berlioz's interpretations of the Faust legend, which she uses as a touchstone to explore the duality of the internalized self and the external world.

The central motif of the *Damnation of Faust* installation is a large, black-and-white sectioned photographic panel that takes the form of a twenty-two-foot arch or an opened fan. Set against a vivid, salmon-red wall, the photographic enlargement is flanked by two video monitors. The imagery in *Damnation of Faust* was derived from *Evocation*, in which Birnbaum introduced the theme of a young woman's trajectory from isolation to transcendence. Slow-motion scenes of children and teenagers playing in a Lower Manhattan playground are countered with images of a woman watching. The enlarged photograph captures the central figure in *Evocation's* playground scene, the teenage girl Georgeann.

Inspired by nineteenth-century Japanese Ukiyo-e forms, the fanlike aspect of the photographic enlargement is echoed in the pictorial language of the video footage, which includes transitional fan wipes. In *Evocation*, Birnbaum employed video technology to articulate metaphorical spatial relationships, with multiple frames suggesting the conjoining of internal and external spaces, past and present, memory and reality. In this installation, Birnbaum brings her architectural background to bear as she extends and literalizes these relationships in three-dimensional space. (LZ)

Installation view, Whitney Biennial, Whitney Museum of American Art, New York, 1985.

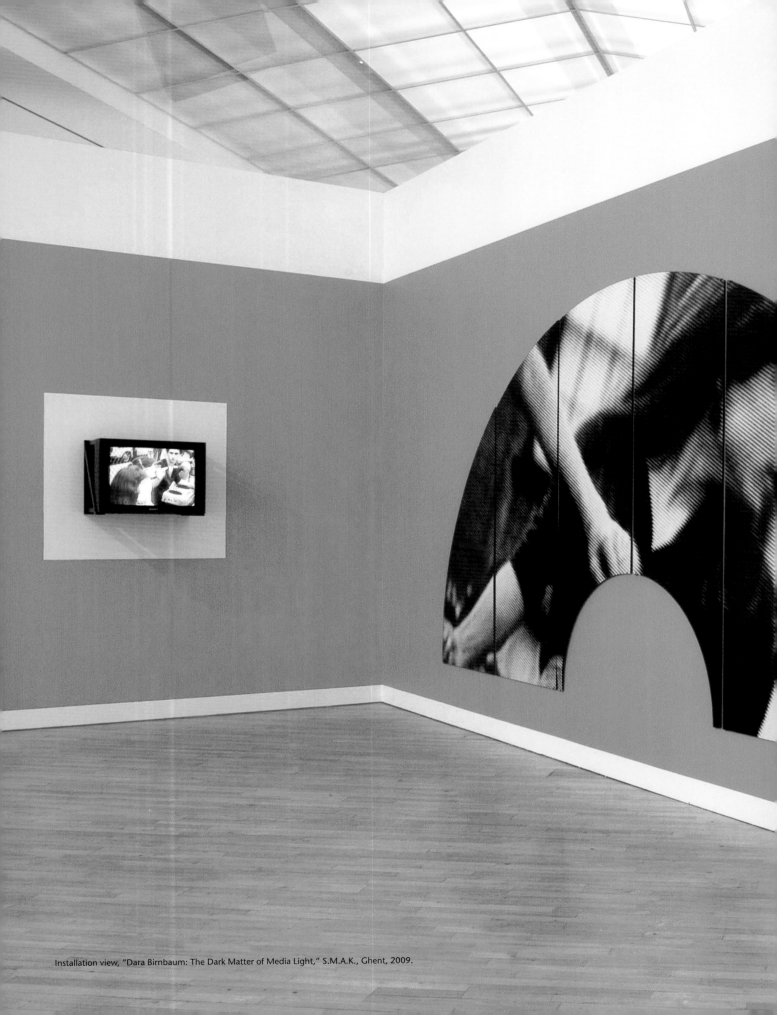

Installation view, "Dara Birnbaum: The Dark Matter of Media Light," S.M.A.K., Ghent, 2009.

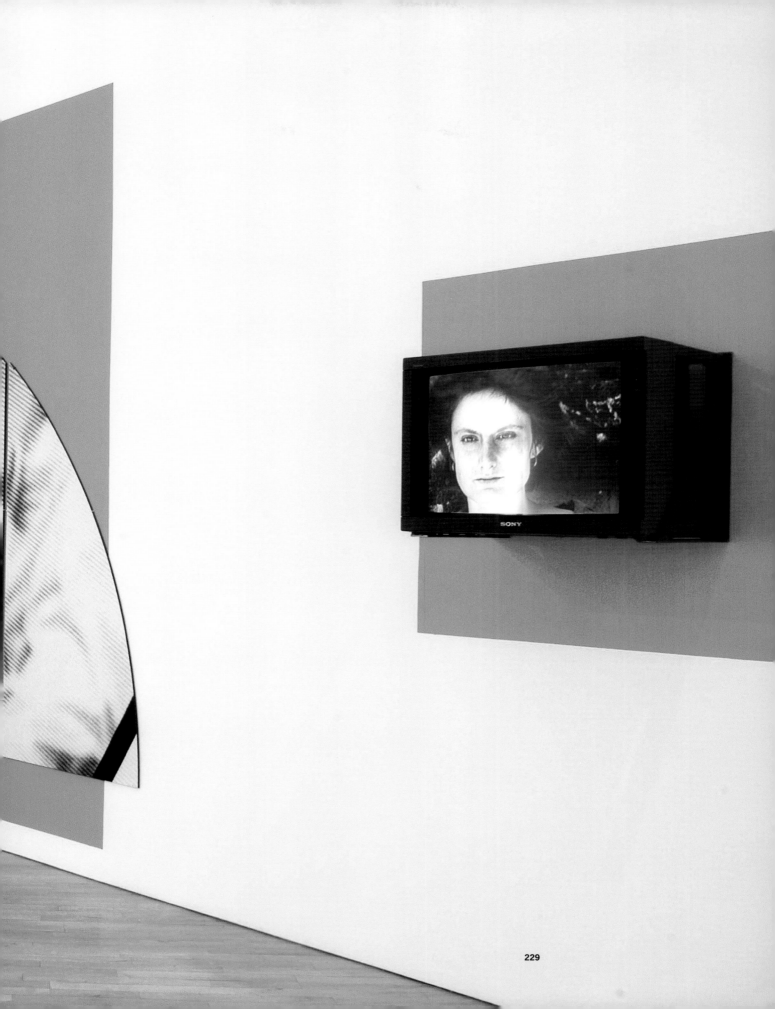

229

THREE-CHANNEL COLOR VIDEO, QUADRAPHONIC SOUND, BLACK-AND-WHITE
PHOTOGRAPHIC ENLARGEMENT (4.35 X 11.12 M)
COLLECTIONS CASTELLO DI RIVOLI—MUSEO D'ARTE CONTEMPORANEA, RIVOLI-TORINO,
DONATION ZERYNTHIA ASSOCIAZIONE PER L'ARTE CONTEMPORANEA; CARNEGIE MUSEUM OF ART,
PITTSBURGH, PENNSYLVANIA

The three-channel video installation *Will-o'-the-Wisp* is one of a suite of Faust-based works by Dara Birnbaum. Drawing inspiration from both Goethe's and Berlioz's interpretations of the Faust legend, the series includes the 1984 two-channel installation *Damnation of Faust*, as well as a trilogy of single-channel video works from 1983 to 1987. The installation *Will-o'-the-Wisp* is closely related to the second part of the trilogy, the 1985 single-channel video entitled *Will-o'-the-Wisp (A Deceitful Goal)*, which centers on a woman's reverie on romantic loss and betrayal.

As in the *Damnation of Faust* installation, the central motif of *Will-o'-the-Wisp* is a large, black-and-white sectioned photographic panel, suggesting the form of an arch or an opened fan, that depicts a delicate, almost abstract tracery of leaves. Three video monitors interrupt the panel; the monitors on the left and right sides project out into space, while the central monitor is inset.

The monitors show a woman seated at a window, gazing out at children on the street below; we see her reflected image in the glass as well. Her gaze is directed both inward and outward. Sporadic glimpses of the children appear, as does a lacelike patterning of leaves that mirrors the photographic panel. The images on the three monitors appear to flow from right to left, suggesting a passage of time as they shift in color from green to autumnal tones. We hear fragments of the woman's monologue, in which she reflects on an absent lover. In Berlioz's opera *The Damnation of Faust*, will-o'-the-wisps (spirits that attempt to lead one away from the correct path) are linked to Marguerite, the female character who was seduced, deceived, and abandoned by Faust.

Installation view, "Dara Birnbaum," IVAM–Centre del Carmen, Valencia, Spain, 1990.

The fanlike shape of the panel is echoed in the signature electronic edits Birnbaum uses in the video, which include transitional fan wipes and "diagonal rain wipes." Birnbaum drew inspiration for these formal elements from nineteenth-century Japanese Ukiyo-e ("pictures of the floating world") motifs, which she translates here into architectural space. (LZ)

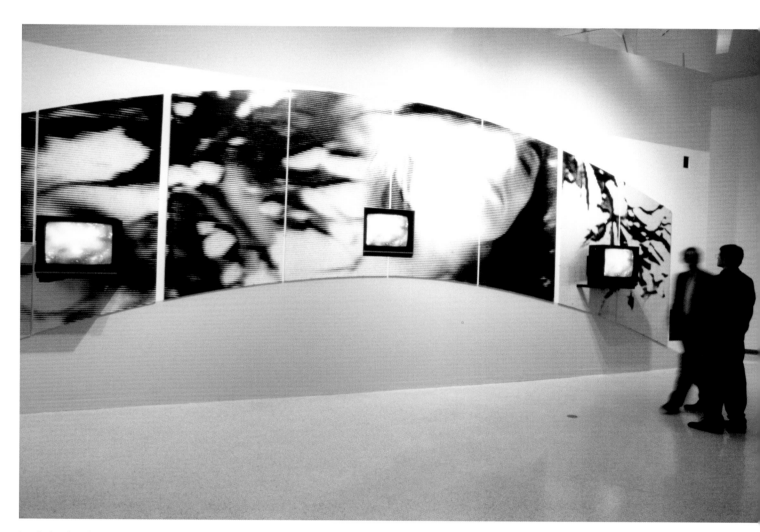

Installation view, Carnegie International, Carnegie Museum of Art, Pittsburgh, 1985.

SINGLE-CHANNEL COLOR VIDEO, STEREO, 00:30 MIN.
COURTESY ELECTRONIC ARTS INTERMIX, NEW YORK

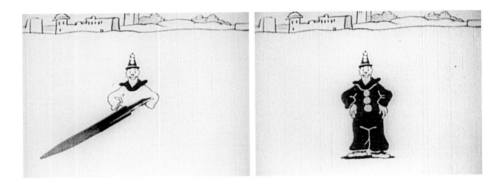

In this subversive thirty-second spot, commissioned by MTV as an "art break" to air during commercial breaks, Dara Birnbaum uses an appropriated Max Fleischer cartoon to comment on the representation of women in media. The Fleischer work is from his famous Out of the Inkwell series (1919–29), which is recognized for its use of Fleischer's pioneering Rotoscope, an animation device that enabled animators to trace over live-action film to create realistic movement. The Inkwell series was also noted for its mix of live and animated action; a cartoon typically began with a sequence in which Fleischer, working at his drafting table, interacted with his pen-and-ink creations as they were being drawn.

Birnbaum's Artbreak tells a succinct tale of cartoon genesis. One of Fleischer's most iconic characters, Koko the Clown, is delighted when a pen-wielding machine draws a woman into his animated world. From this point on, however, Koko's world is upended. Seamlessly mimicking Fleischer's style, Birnbaum collaborated with professional animators to draw new cel animation to continue the story with a dark twist. Koko's ladyfriend blows him a kiss, which turns into an MTV logo that falls, anvil-like, and pushes him out of the frame. The drawing machine goes berserk and frenetically redraws the woman into several different fashion plates, in the process upsetting an inkwell–which fills the screen with a black pool. Out of the spill, mini, live-action scenes of women, excerpted from music videos, bubble up via digital video effects. The chaos is interrupted by a flash of light, and a contemporary animator—a woman—is shown working at a drafting table, where an image of Fleischer himself is seen in her fully digital palette.

Among the topics loaded into Artbreak are questions of agency and creativity in a digital age and the reliance of popular culture on gender stereotypes. In an interview with Erkki Huhtamo, Birnbaum declared, "Bertolt Brecht has said that mass media, by its nature, is not negative, but that we should look for the holes which are created inside it. Maybe something can be said in these holes. That is how I thought of the spots on MTV." (RC)

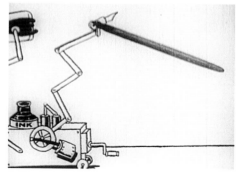 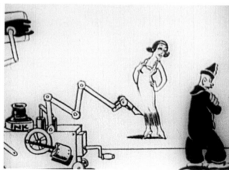 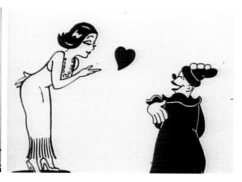

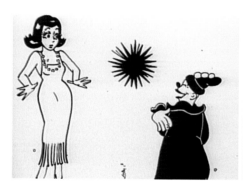 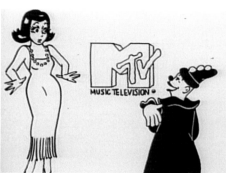

RIO VIDEOWALL

63.5 X 68.5 CM (25 X 27") MONITORS, CLOSED-CIRCUIT CAMERAS, CMX SWITCHER,
SATELLITE RECEIVER, CUSTOM-DESIGNED LIGHT WALL, STEEL, BLACK SPANDREL GLASS.
COLLECTION CHARLES ACKERMAN, ACKERMAN & CO., ATLANTA, GEORGIA

The winning proposal in an international competition held by real-estate developer Ackerman & Company, *Rio Videowall* was the first large-scale outdoor video-art installation in the United States. The piece was created as a site-specific, interactive digital video wall architecturally integrated within the public space of the Rio shopping complex in Atlanta, Georgia. Through an intricate layering of imagery in time and space, the piece created an interface between the physical body and the social body, between pedestrian flow and information flow through the site.

Positioned in the central plaza of the mall, *Rio Videowall* consisted of a monumental square grid of twenty-five monitors, arranged five by five. The supporting structure was a freestanding wall, whose surface was covered by black spandrel mirrored glass, visually similar to aspects of the surrounding storefront architecture. The monitors received two different layers of imagery that interacted in a play of constantly changing digital edits. One set of images was a direct, live feed from the satellite downcast of CNN news; the other consisted of shots of landscape that Birnbaum recorded in 1987 on the Rio site, before construction of the mall began. The landscape visuals, functioning as a kind of "electronic memory" of this lost aspect of the city, were disrupted when pedestrians moved through the plaza. As individuals crossed in front of two live closed-circuit surveillance cameras, their silhouettes were thrown onto the wall, each creating a "keyhole" that admitted a flow of live satellite-transmitted news.

In the late 1980s, CNN represented a new paradigm—that of twenty-four-hour cable-TV news reporting. The Atlanta-based company, run by media giant Ted Turner, was as inextricably linked with the city as its indigenous flora and fauna; as a result, the mediation of experience is one of *Rio Videowall's* essential, site-specific themes. The interplay between the two feeds resulted in a continual flux of landscape and media information, generated by the movement of individuals across the site; in effect, the body opened a Pandora's box, animating the wall with a torrent of mass-media information. The pedestrian-cum-shopper is dematerialized and transformed, just as the everyday space of the plaza is transformed through Birnbaum's intervention.

Birnbaum intended *Rio Videowall* to serve as a kind of landscape atrium, as well as an electronic kiosk or information system for this specific social space. The installation can also be read as a critique of consumer culture in a locus of commerce and entertainment. Although *Rio Videowall* was originally built as a permanent installation, the structure was razed in 2000 for further development. (LZ)

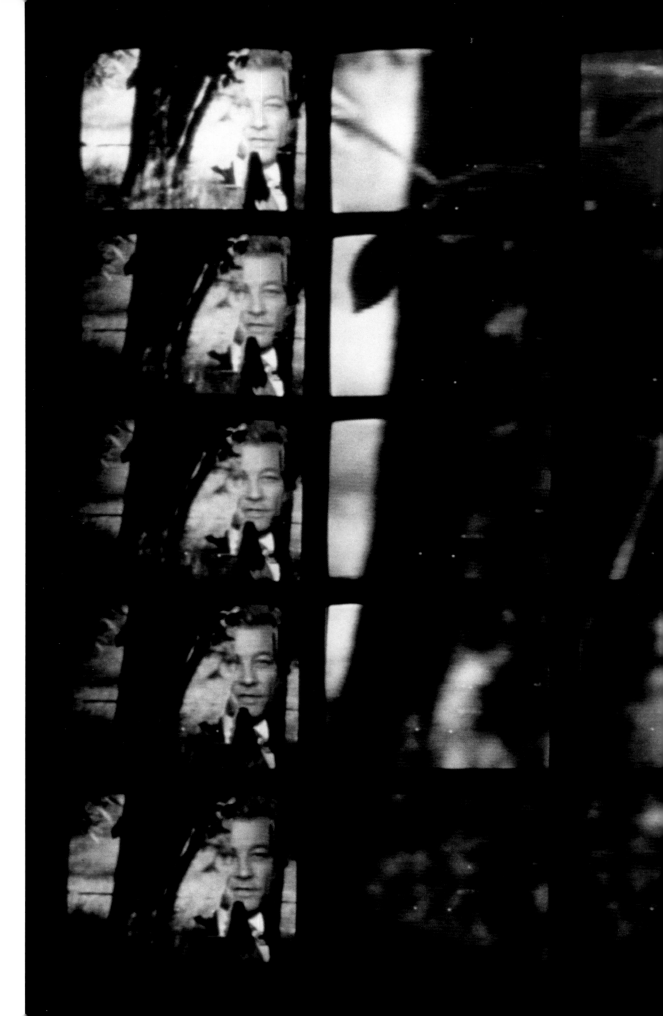

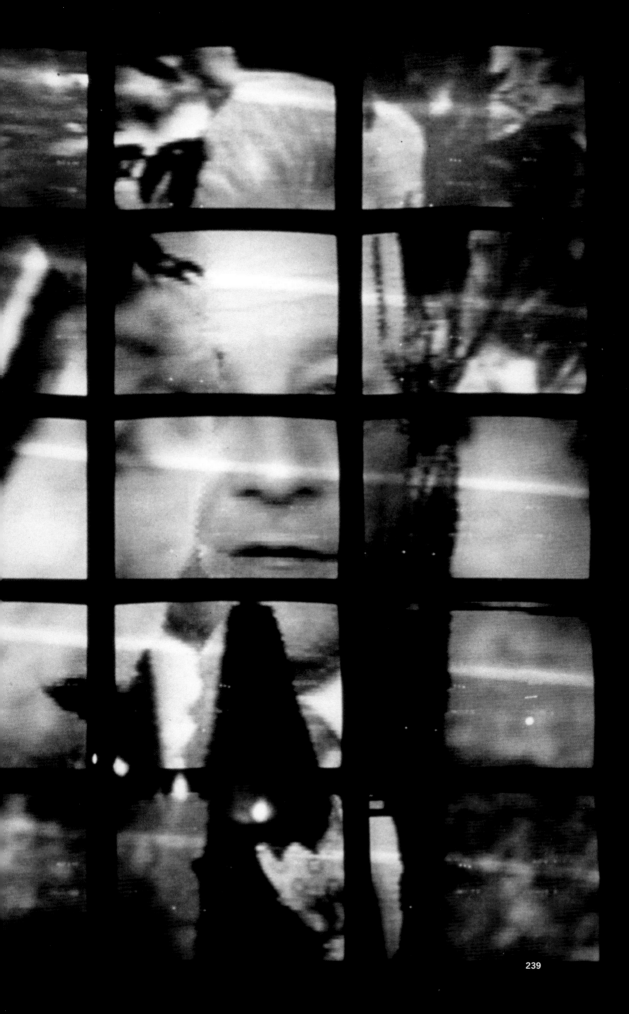

239

CANON: TAKING TO THE STREETS

PART ONE: PRINCETON UNIVERSITY—TAKE BACK THE NIGHT

SINGLE-CHANNEL VIDEO, COLOR, STEREO, 10:34 MIN.
COURTESY ELECTRONIC ARTS INTERMIX, NEW YORK

In *Canon: Taking to the Streets*, Dara Birnbaum employs an unconventional approach to the documentary format to examine student activism in the United States in the late 1980s. Although *Canon* focuses on a protest against sexual violence against women, Birnbaum links this specific action and community to a larger historical legacy of student activism.

Birnbaum opens *Canon* with an anonymous poem—spoken in English, written in French on-screen—that reads, in part, "I would like to write a poem. . . . I would like to write a hundred poems. But I am making a revolution." An animated collage of French political posters, evoking the May '68 student revolts, merges into slowed-down, hand-held footage recorded by students at the 1987 Take Back the Night march on the campus of Princeton University,

which was held by the Women's Center there. Take Back the Night events, which began in San Francisco in 1978, protest sexual violence against women and men. Foregrounding the intimacy of the amateur, low-end VHS footage, Birnbaum isolates the gestures, faces, and statements of the participants in the rally, from the chanting protesters to the hecklers who taunt them.

Highlighting a series of quotations as text on the screen, Birnbaum returns to the theme of the development of the individual's political awareness through personal as well as collective experience: "Between the distant world of national issues and the immediate project of self-transformation there has too often been a vacuum" (L. A. Kauffman, *The Nation*). (LZ)

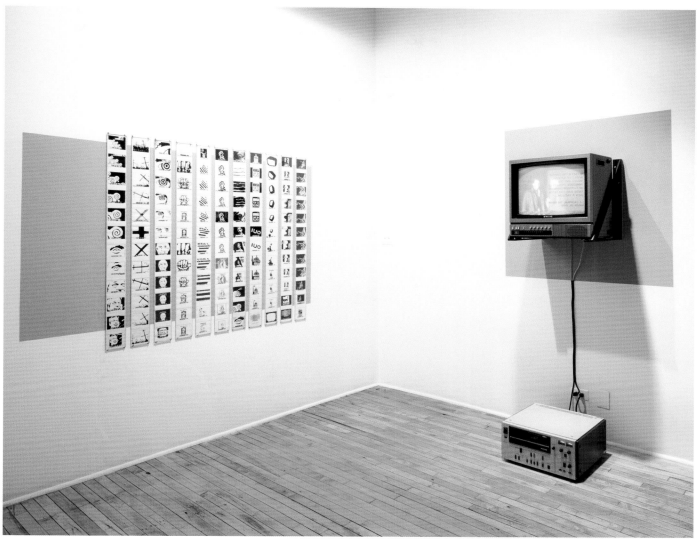

Installation view, Rhona Hoffmann Gallery, Chicago, 1991.

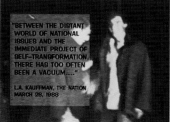

Black-and-white stills from the videotape, installation view,
Rhona Hoffmann Gallery, Chicago, 1991.

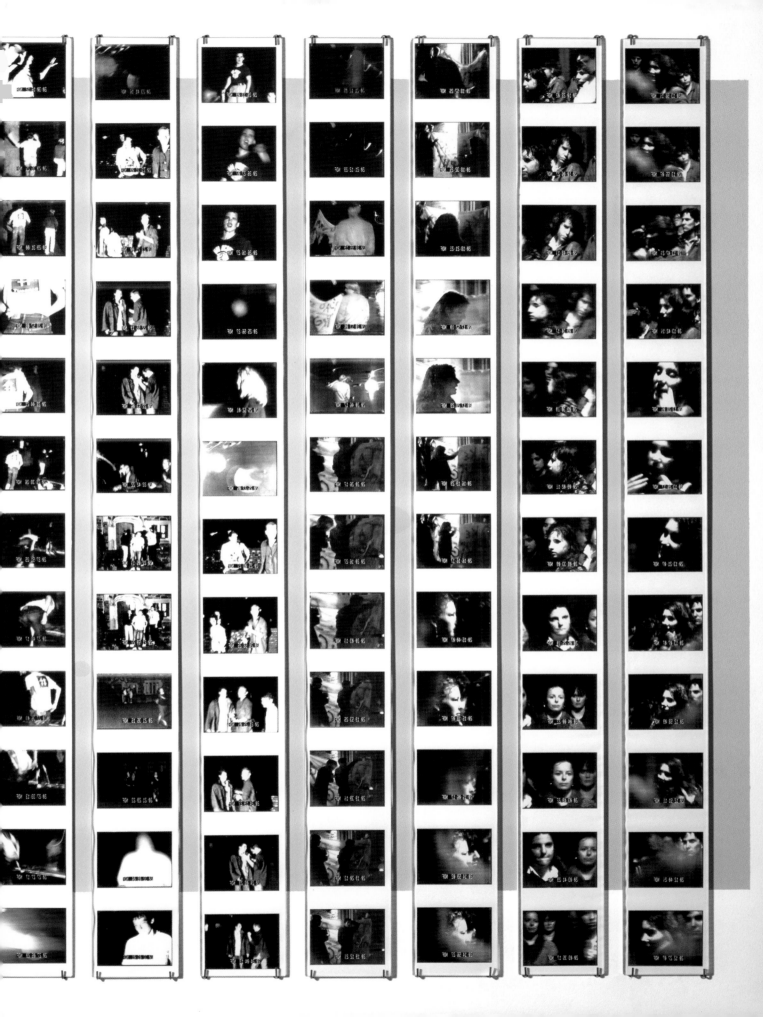

TIANANMEN SQUARE: BREAK-IN TRANSMISSION

1990

**FIVE-CHANNEL COLOR VIDEO, FOUR-CHANNEL STEREO SOUND, 20′ SURVEILLANCE SWITCHER,
4 X 160 CM EQUILATERAL TRIANGLES IN VARIABLE SPACE
COLLECTION S.M.A.K., GHENT**

In *Tiananmen Square: Break-In Transmission*, Dara Birnbaum addresses systems of transmitting and receiving information, focusing on the student protests in Beijing's Tiananmen Square in the summer of 1989. Following the Chinese government's violent suppression of student demonstrations in June 1989, the foreign press was banned and media coverage strictly controlled. In this work, Birnbaum focuses on the Chinese student demonstrations in relation to television-news broadcasting, reception, and censorship.

The installation's design implies disunity: four microsize LCD monitors, supported by custom-designed structural units, are suspended from the ceiling. Each of these displays images related to a different event from the demonstrations gathered from the original TV-news coverage: the first incidents of political violence, the exact moment when satellite coverage by the American networks CNN and CBS ceased, a pop song ("The Wound of History") sung by forty Taiwanese sympathizers, and the use by students of more direct, unimpeded routes of communication with the West (fax, computer) in the absence of satellite transmissions.

A fifth, larger monitor displays a randomly edited program constructed from images grabbed from the other four displays. The monitor is connected to an interactive surveillance switcher that is programmed to select and display sequences from each of the other channels. Birnbaum has written that the arbitrarily edited program on this large monitor "alludes to a dominant model of broadcast news."

In the work, Birnbaum foregrounds the relationship between the unfolding political events in Tiananmen Square and the attempt of a centralized communications system to broadcast a seamless flow of television news, even as transmission was cut by Chinese authorities. *Tiananmen Square* posits a more complex, diverse, and fragmented approach, as exemplified by the Chinese students who employed more accessible forms of communication technology to transmit information to the West. This approach to media is extended at least symbolically to the viewer, who is given no single vantage point from which to view the installation and therefore must actively construct the meaning of what she sees.

The installation's destabilized images find a correlation in the piece's audio elements, as each channel's distinctive sound track, taken together with the looped pop song by the Taiwanese sympathizers, creates a cacophony. (LZ)

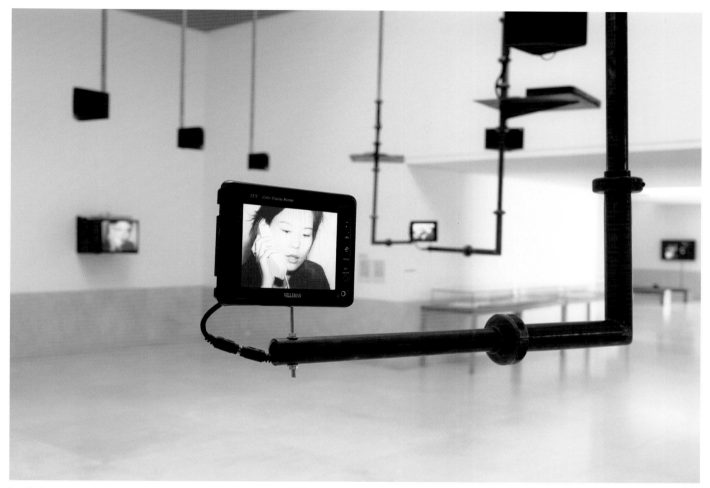

Installation view, "Dara Birnbaum: The Dark Matter of Media Light," Museu de Serralves, Porto, 2010.

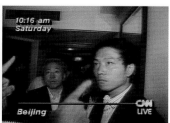

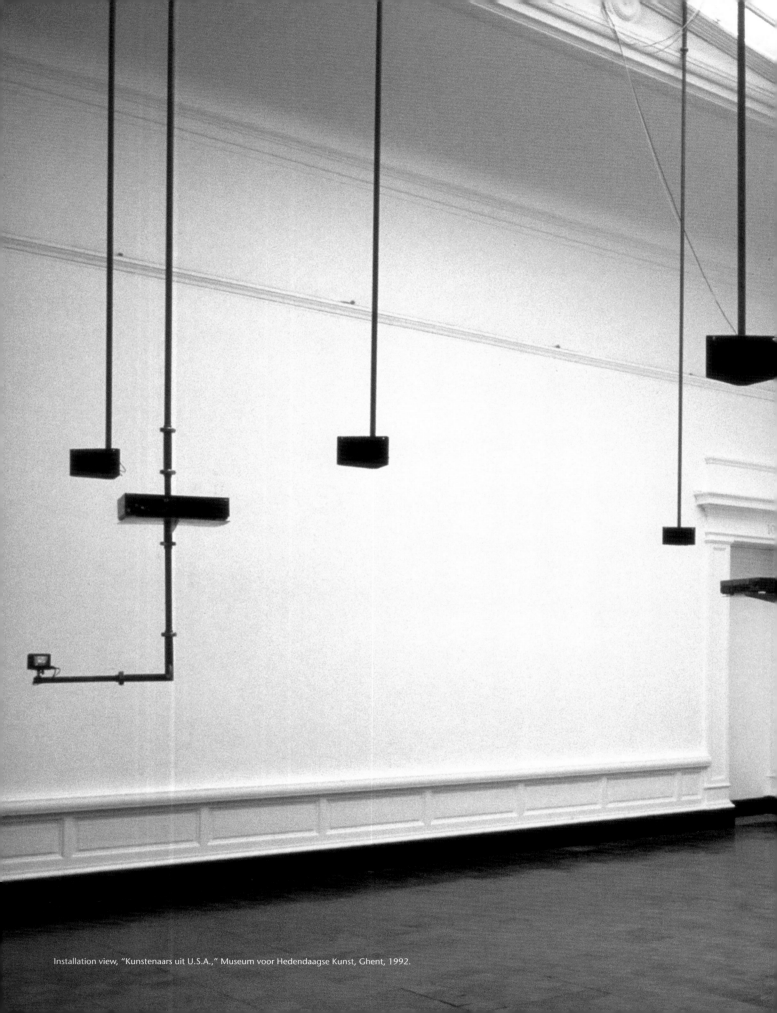

Installation view, "Kunstenaars uit U.S.A.," Museum voor Hedendaagse Kunst, Ghent, 1992.

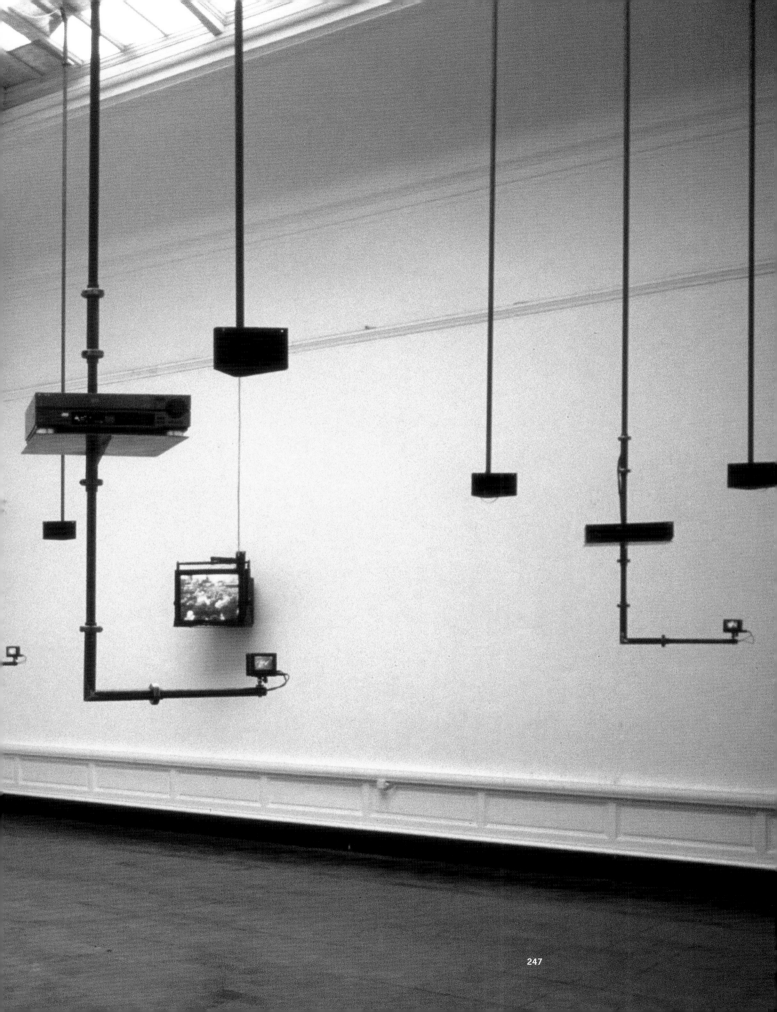

TRANSMISSION TOWER: SENTINEL 1992

EIGHT-CHANNEL COLOR VIDEO, 2:48 MIN.; 2 SECTIONS OF ROHM® TRANSMISSION TOWER
(300 X 66.5 X 66.5 CM EACH), 9 STEREO CHANNELS OF AUDIO, WITH CUSTOM HARDWARE
COLLECTION FUNDAÇÃO DE SERRALVES—MUSEU DE ARTE CONTEMPORÂNEA, PORTO

At Documenta 9 (1992), in the Neoclassical building housing Kassel's Kunsthalle Fridericianum, Dara Birnbaum erected components of a Rohm transmission tower that tilted from floor to ceiling. Eight monitors hanging from the tower's metal framework, each connected to its own stereo system and laser disc player, formed a linear vertical video wall.

Central to the rhythm of *Transmission Tower* is Allen Ginsberg's reading of his antiwar poem "Hum Bom!" at the opening night of the 1988 National Student Convention, held at Livingston College of Rutgers, the State University of New Jersey. Video documentation of that reading rhythmically falls from one monitor to the next in pace with Ginsberg's incantation: "Whom bomb? We bombed them! Whom bomb? We bombed them!" As the footage drops down the line of monitors, it leaves behind a trace in "nuclear" green, a color that is echoed throughout the installation's imagery.

Ginsberg's reading punctuates two autonomous streams of images that flow up and down the length of the tower. Rising up, again in nuclear green, is raw documentation of student meetings at the 1988 National Student Convention. Descending is a small corner insert of President George H. W. Bush giving his acceptance address, now known as his "Thousand Points of Light" speech, at the 1988 Republican National Convention. The earthward plummet of this footage is an arch evocative of a typical U.S. bomb dropping during the Persian Gulf War.

Bush's speech is visually represented by a nuclear-green wave-pattern, tracing the modulations of his voice. His practiced delivery is contrasted with the raw footage of the student convention, and Ginsberg's emphatic recitation, highlighting how tightly scripted and controlled the broadcast of Bush's speech was. The stark counterpoint of the images rising and falling is an allegory for the transmission and reception of broadcast rhetoric, while the tower's physical evocation of a bomb's downward path and Ginsberg's reading indict Bush's involvement in the Gulf War in 1991.

A ninth audio channel, fed to four speakers mounted at the top of the tower, pointed downward toward the prime viewing space and played a suspenseful ambient sound track created by the sound-design team tomandandy.

The installation's media content in part recalls Birnbaum's video art from the late 1970s and early 1980s, such as *Local TV News Analysis for Cable Television* (with Dan Graham, 1980) and the Pop-Pop Video series (1980), which deconstruct the grammar of television. (RC)

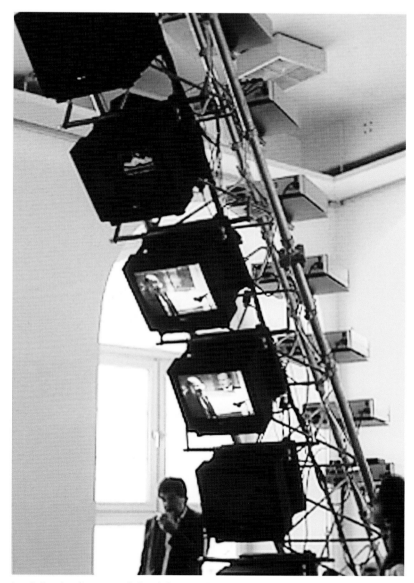

Installation view, Documenta 9, Kassel, Germany, 1992.

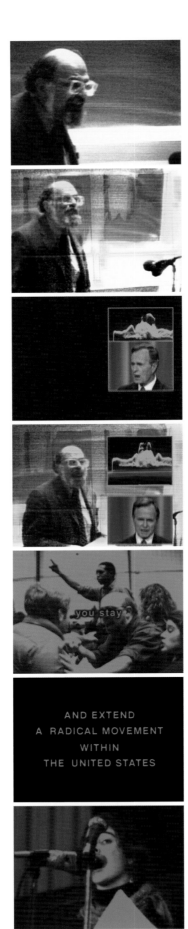

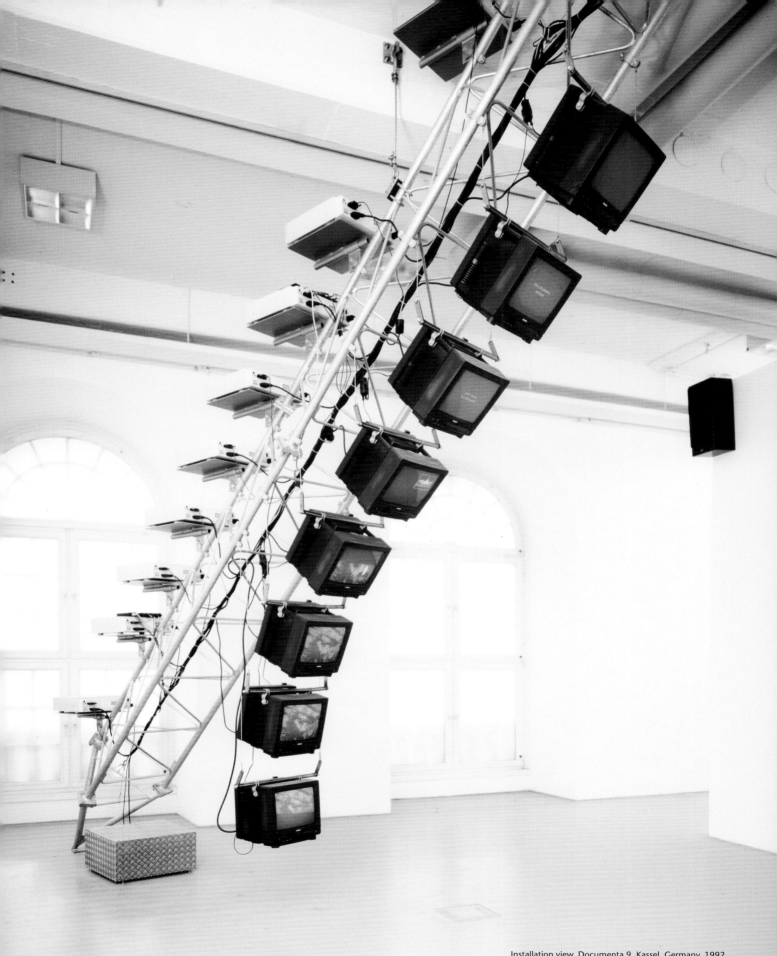

Installation view, Documenta 9, Kassel, Germany, 1992.

SINGLE-CHANNEL VIDEO, COLOR, STEREO, 60 SEC.
COLLECTION S.M.A.K., GHENT

Transgressions was created for *TRANS-VOICES*, a public art project coproduced by the Whitney Museum of American Art and the Public Art Fund, New York, and the American Center, Paris. The project commissioned seven American and seven French artists to portray political and social conditions in the United States and in France in the last decade of the twentieth century, for display in public locations. *Transgressions* is a sixty-second spot that was broadcast on MTV Networks and Canal Plus, France. Taking as her starting point the five-hundredth anniversary of Christopher Columbus's "discovery" of America, Dara Birnbaum created a condensed illustration of the expansion of both nations up to their current borders, revealing their absorption of other cultures and sovereignties. A slowed-down recording of then American President George H. W. Bush reciting the Pledge of Allegiance, which is repeated in French, creates an ominous sound track. Symbolic representations of the many hazards shared by the nations, including drug abuse, nuclear waste, and money laundering, paint a dark portrait of their contemporary condition. (RC)

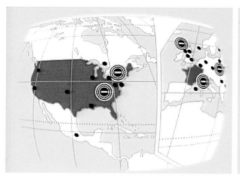

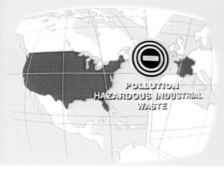

COMPUTER ASSISTED DRAWINGS: PROPOSAL FOR SONY CORPORATION

16 DRAWINGS ON PLEXIGLAS AND CUSTOM ALUMINIUM FRAMES,
375 X 40 X 3 CM EACH SET OF FOUR DRAWINGS
COURTESY MARIAN GOODMAN GALLERY, NEW YORK AND PARIS

These computer-generated drawings were produced as a proposal for the Sony Corporation's headquarters in New York City, after the company invited Birnbaum to create a video installation for the floor on which their meeting rooms were located. Birnbaum created these drawings at the Institut für Neue Medien in Frankfurt, Germany, where she was a guest professor from 1992 to 1993. She utilized the school's state-of-the-art SGI (Silicon Graphics International) equipment to render multidimensional forms in space. Similar in appearance to 3-D CAD (computer-aided design) imagery, each drawing depicted different components of Birnbaum's proposed installation: trusses with monitors would carry images sequentially across a suspended horizontal video wall, bookended on either side by larger high-end video screens, which would display two versions of Sony's history. While one screen would show images of some of Sony's most recognizable electronics, the other would show electronics in development, those destined to replace their precedents. The imagery on both screens would flow toward each other, across the horizontal bridge of monitors, crashing together in an explosion of digital special effects. Sony never realized this project. In turn, Birnbaum transformed the proposal drawings into an installation, in which the four sets of four drawings are sandwiched between Plexiglas panels and mounted at a ninety-degree angle from the wall in custom-made frames. In Birnbaum's words, the transparency of the panels, which allowed light to pass through, was a way to bring the Sony project "back to light." (RC)

Installation view, "Dara Birnbaum: First Statements and then Some . . .," Wilkinson Gallery, London, 2009.

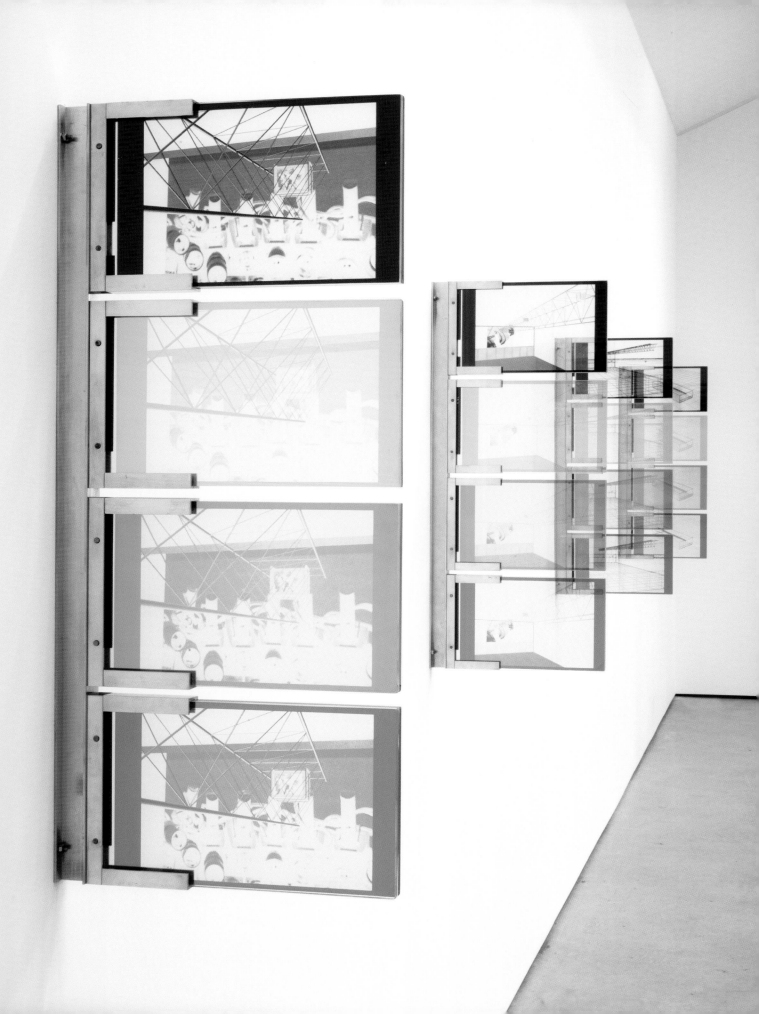

SIX-CHANNEL INTERACTIVE COLOR VIDEO INSTALLATION, SIX-CHANNEL AUDIO, LASER-BEAM SENDER AND RECEIVER,
FOUR SILKSCREEN PRINTS ON PLEXIGLAS PANELS DIMENSIONS VARIABLE
IMAGE: PETER EGGERS, PAT KELLENGHER
COURTESY MARIAN GOODMAN GALLERY, NEW YORK AND PARIS

In *Hostage,* a six-channel video and interactive laser installation, Birnbaum explores the mass media's coverage of the events surrounding the 1977 kidnapping of German industrialist Hanns-Martin Schleyer by the Red Army Faction. The kidnapping and murder of Schleyer and the subsequent deaths of three jailed members of the Baader-Meinhof Group defined a crisis of political terrorism that came to be known as the German Autumn. In *Hostage,* these incidents are Dara Birnbaum's point of departure for an inquiry into the media's complex relationship to the events that it covers.

The installation features six monitors of varying sizes. Four smaller monitors are suspended from the ceiling; each is paired with a Plexiglas panel printed with a firing-range target in the form of a man's upper body, which is hung parallel to the surface of the video screen, thus serving as a transparent but impenetrable shield. In its original installation at Paula Cooper Gallery in New York in 1994, the four suspended monitors were hung in a diagonal line across the gallery. Two larger monitors were mounted on the walls at a height lower than those suspended.

Five of the video channels feature visual and audio materials relating to the media coverage of the events surrounding the Schleyer kidnapping. The suspended monitors show, respectively, news images of Schleyer's funeral, materials relating to the Red Army Faction members, images of Baader-Meinhof Group members under arrest and in jail, and government antiterrorist forces training with security systems and sophisticated technologies. One wall-mounted monitor plays the iconic footage of Schleyer's forced speech on television, in which he declares himself an enemy of the State, alternately in real time and in slow motion.

The sixth channel, featured on the remaining wall monitor, focuses on the response of the mass media in the United States to these events and on the individual's reception of this coverage. Birnbaum presents an "archive" of press reports, newspaper headlines, and media images of the Schleyer kidnapping and its aftermath, all taken from the U.S. media. The flow of these images is affected by the viewer's interaction with a laser beam, which, when interrupted, freezes the images on the screen. The viewer becomes a "target," while at the same time holding the media information "hostage" until she resumes her movement.

In *Hostage,* Birnbaum creates a direct interface between media transmission and reception; the physical intervention of the body into the flow of mass-media information suggests the mediation of historical events. In a statement on this work, Birnbaum has written that she considers mass media to be a potential form of terrorism, with society and media each being held hostage by the other: "Baudrillard's *Fatal Strategies* holds true—the hostage is beyond the state of alienation and in a state of radical emergency and virtual extermination." (LZ)

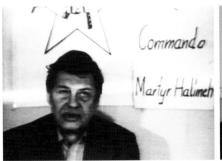 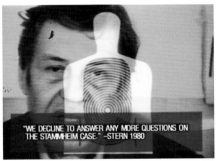

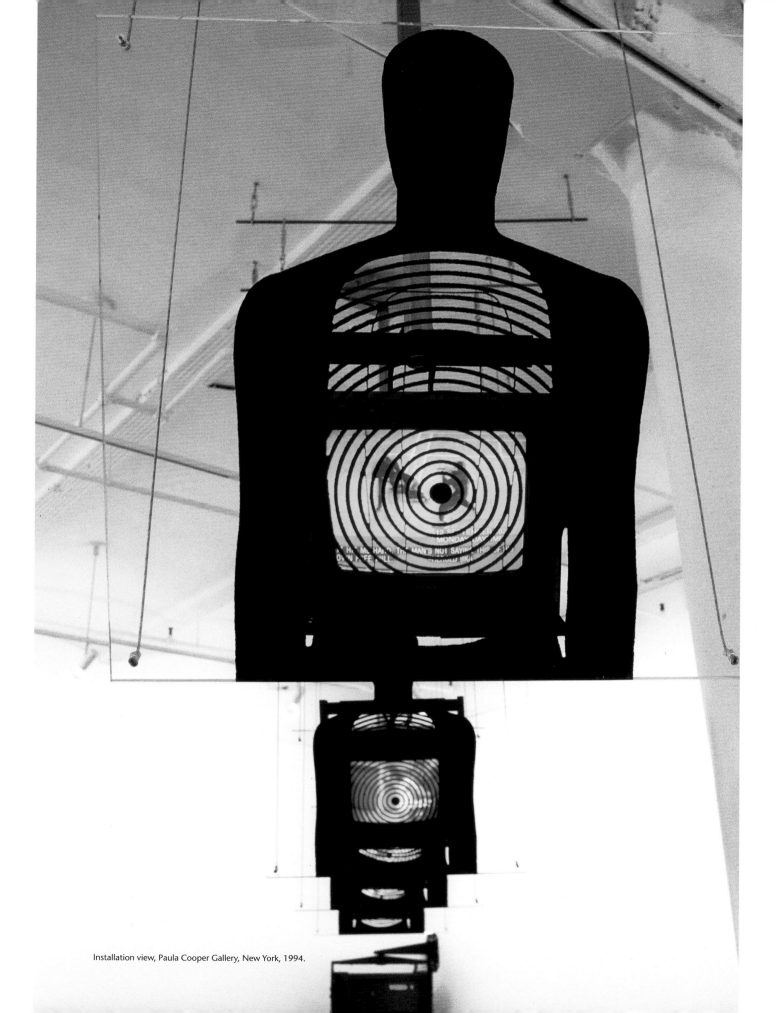

Installation view, Paula Cooper Gallery, New York, 1994.

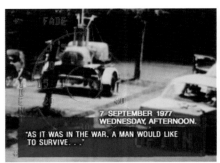

7 SEPTEMBER 1977
WEDNESDAY, AFTERNOON.
"AS IT WAS IN THE WAR, A MAN WOULD LIKE
TO SURVIVE . . ."

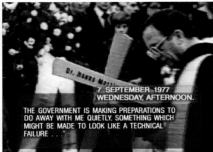

Dr. Hanns Martin
7 SEPTEMBER 1977
WEDNESDAY, AFTERNOON.
THE GOVERNMENT IS MAKING PREPARATIONS TO
DO AWAY WITH ME QUIETLY, SOMETHING WHICH
MIGHT BE MADE TO LOOK LIKE A TECHNICAL
FAILURE . . .

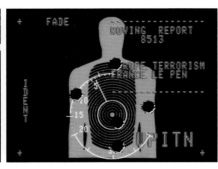

FADE
MOVING REPORT
8513
MORE TERRORISM
FRANCE LE PEN
UPITN

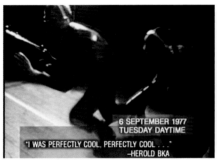

6 SEPTEMBER 1977
TUESDAY DAYTIME
"I WAS PERFECTLY COOL, PERFECTLY COOL . . ."
—HEROLD BKA

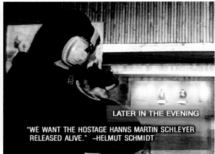

LATER IN THE EVENING
"WE WANT THE HOSTAGE HANNS MARTIN
SCHLEYER RELEASED ALIVE." –HELMUT SCHMIDT

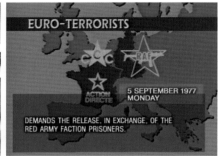

EURO-TERRORISTS
ACTION
DIRECTE
5 SEPTEMBER 1977
MONDAY
DEMANDS THE RELEASE, IN EXCHANGE, OF THE
RED ARMY FACTION PRISONERS.

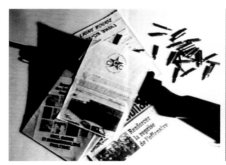

FADE
UPITN

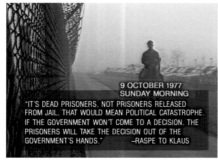

9 OCTOBER 1977
SUNDAY MORNING
"IT'S DEAD PRISONERS, NOT PRISONERS RELEASED
FROM JAIL. THAT WOULD MEAN POLITICAL CATASTROPHE.
IF THE GOVERNMENT WON'T COME TO A DECISION, THE
PRISONERS WILL TAKE THE DECISION OUT OF THE
GOVERNMENT'S HANDS." —RASPE TO KLAUS

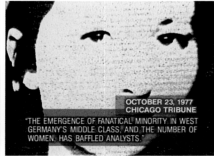

OCTOBER 23, 1977
CHICAGO TRIBUNE
"THE EMERGENCE OF FANATICAL MINORITY, IN WEST
GERMANY'S MIDDLE CLASS, AND THE NUMBER OF
WOMEN, HAS BAFFLED ANALYSTS."

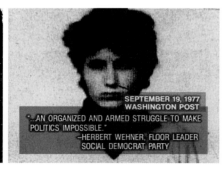

SEPTEMBER 19, 1977
WASHINGTON POST
"...AN ORGANIZED AND ARMED STRUGGLE TO MAKE
POLITICS IMPOSSIBLE."
—HERBERT WEHNER, FLOOR LEADER
SOCIAL DEMOCRAT PARTY

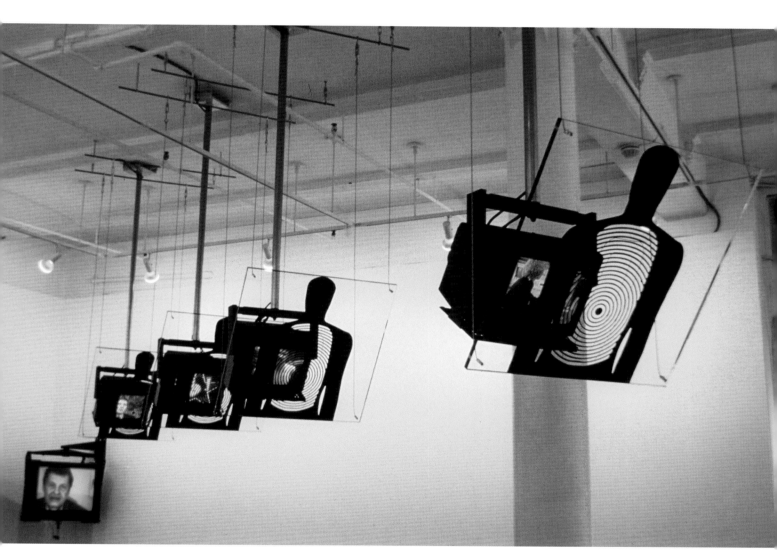

Installation view, Paula Cooper Gallery, New York, 1994.

TRANSLATED TEXT EXCERPTS FROM ROBERT WALSER'S "THE WALK," 1917
POSTER (36 X 95 CM) AND POSTCARDS (15 X 10.3 CM EACH)
COURTESY OF THE ARTIST

Robert Walser, Translated ©1994 Dara Birnbaum

....I had become an inward being,

and I walked as in an inward world;

everything outside me became a dream;

what I had understood till now

became unintelligible....

...me había convertido en un ser interior,
y caminaba como en un mundo interior;
todo lo que estaba fuera de mí se convirtió en un sueño,
lo que hasta entonces había comprendido
se hizo ininteligible.

Text excerpt: Robert Walser, *The Walk* ©1917
Mira como se mueven - 4 ideas sobre movilidad • Fundación Telefónica - Madrid, 2005

In 1992, Swiss curator and critic Hans Ulrich Obrist founded a movable "museum" in honor of the Swiss writer Robert Walser (1878–1956). Initially consisting of a modest vitrine on display in the Hotel Krone in Appenzell, Switzerland, Obrist envisioned the project as an "elastic institution," mobile and nonmonumental, in order to escape the fatigue and routine that might afflict larger, permanent museums.

Obrist commissioned contemporary artists to produce works for the museum/vitrine and invited Dara Birnbaum to participate in 1994. To prepare, she read several Walser texts in translation and did a site visit to the Hotel Krone, where Walser had often stationed himself. Birnbaum explored the dramatic landscape of the surrounding Alps, following routes Walser had taken on his famously rambling walks. Along the way, she took photographs, and from these she produced a series of five postcards.

On the face of each card, she superimposed a map of the area incorporating Walser's walking routes over one of her photographs. On the reverse side she reprinted five different excerpts from his short story "The Walk," translated into English and Spanish.

The postcards were placed in the Museum Robert Walser vitrine, which was left open to encourage visitors to take and use them. By sending the postcard, the visitor created, in Birnbaum's words, "a 'participatory' text, where the viewer is forced to become, for the moment, a writer or distributor." *Robert Walser, Translated* pursues several of Birnbaum's consistent interests: the insertion of art into a non-art context, in this case the Hotel Krone; the fragmentation of a text into smaller parts; and the activation of the work by its viewer, a strategy also seen in such installations as *Hostage* (1994) and *(Reading) versus (Reading Into): A "Banner" As "Billboard"* (1978). (RC)

SOUND INSTALLATION, 17:30 MIN.; VARIOUS PRINTED MATERIALS, DIMENSIONS VARIABLE
COURTESY MARIAN GOODMAN GALLERY, NEW YORK AND PARIS
SOUND DESIGN: TOMANDANDY

The Austrian composer Anton Bruckner (1824–1896) was canonized by Adolf Hitler during the Third Reich. The appropriation of Bruckner's music for Nazi propaganda forced an interpretation of his work that downplayed the composer's intended spirituality and put it in the service of Hitler's nationalistic fervor. In *Bruckner: Symphony No. 5 in B-Dur*, Dara Birnbaum juxtaposes two prominent conductors' interpretations of one of Bruckner's most celebrated works.

Otto Klemperer and Wilhelm Furtwängler were both conducting throughout World War II, but while Klemperer, who was Jewish, fled Germany, Furtwängler occasionally led concerts for the Nazi Party. Collaborating with the sound-design team tomandandy, Birnbaum edited together Klemperer and Furtwängler's performances of the same symphony, excerpting key phrases from the score and mixing the sound so that each version played distinctly on a separate channel. The piece has been presented (as at S.M.A.K. and Serralves for instance) in a listening-station format, with headphones and the symphony's score on display, enabling listeners to make direct comparisons between the two interpretations.

Interpretation and translation are among Birnbaum's primary themes. In works such as *Tiananmen Square: Break-In Transmission* (1990), *Transmission Tower: Sentinel* (1992), and *Hostage* (1994), she analyzes how historic events are interpreted and manipulated by mass media. In *Bruckner*, however, she reflects on how any artistic expression goes through a process of interpretation and cannot remain untainted by context. Bruckner's Fifth Symphony is an especially poignant symbol of the gap between an artwork's intent and its reception, as Bruckner never heard it performed by an orchestra in his lifetime. (RC)

Installation view, "Dara Birnbaum," Kunsthalle Wien, 1995.

SINGLE-CHANNEL COLOR VIDEO INSTALLATION, QUADRAPHONIC SOUND, 11:38 MIN.
FOUR PLEXIGLAS PANELS WITH DURACLEAR PRINT (243.8 X 121.9 CM EACH)
AUDIO: SEAN MCBRIDE
COURTESY MARIAN GOODMAN GALLERY, NEW YORK AND PARIS

The core of *Erwartung/Expectancy* is Dara Birnbaum's interpretation of composer Arnold Schoenberg's opera *Erwartung*, completed in 1909. This date and Schoenberg's home city of Vienna link the opera to the emergence of psychoanalysis at the beginning of the twentieth century; Schoenberg conceived of *Erwartung* as a representation of terrible psychological anguish. Composed to a libretto by Marie Pappenheim, *Erwartung* portrays a woman anxiously searching for her missing lover. She is alone, in a nighttime forest. When she finds her lover's corpse amidst the trees, she is overwhelmed by her grief. It is Schoenberg's Expressionist representation of extreme emotional states that attracted Birnbaum to this source material.

Birnbaum's multimedia installation has existed in two very different configurations. It was originally commissioned by the Kunsthalle Wien to accompany her retrospective there in 1995. In that iteration, Birnbaum used none of Schoenberg's music and focused instead on one of the composer's sketches for the stage-set design: a depiction of a thick forest, with an "ocular" opening in a tangle of tree trunks and branches. Birnbaum produced a billboard-size digital enlargement of the sketch and mounted it on the exterior of the Kunsthalle Wien, where it would be seen by pedestrians and street traffic.

During the day, the appropriated Schoenberg sketch functioned as a static urban billboard, but at twilight, a PANI slide projector began casting a series of fifteen images on to the surface of the sketch. These projected tableaux showed a contemporary woman posed alongside excerpts from Pappenheim's libretto, *Die Frau* (The Woman), physically conveying the mood of the accompanying text. Birnbaum

has stated that she "found it particularly meaningful that the libretto was composed by a woman and that this one-act opera's only character is a woman." The gendered implications of the woman's torment, and of her isolation, relate *Erwartung/Expectancy* to some of Birnbaum's foundational works, such as *Attack Piece* (1975) and *Pivot: Turning Around Suppositions* (1976), in which she herself appeared on camera, intentionally placing herself in a vulnerable and exposed situation.

In 2001, *Erwartung/Expectancy* was adapted to an indoor setting and was first exhibited at Marian Goodman Gallery, Paris, and later in the gallery's New York venue. Here Birnbaum traded the large-scale theatricality and urban billboard structure of the 1995 installation for a contained, interior space. As at the Kunsthalle Wien, fifteen tableaux of a woman accompanied by Pappenheim's text were projected on to Schoenberg's sketch, but in the gallery the image was reproduced as four smaller DuraClear prints mounted on translucent Plexiglas panels. This choice of material enabled the projected images both to pass through and to reflect off the panels and create a room of distorted and refracted images, a further interpretation of Schoenberg's tangled forest. The final projection dissolves to white and fills the gallery with the light of the projector. The converse of the original installation's presentation in darkness, Birnbaum intended this gesture to heighten the viewer's lonely physicality in the enclosed space, creating an analogous sense of isolation and abandonment. The indoor installation of *Erwartung/Expectancy* also incorporated music, a highly compressed, 12-minute digital recomposition of selected elements from Schoenberg's opera, which Birnbaum developed with DJ Sean McBride. (RC)

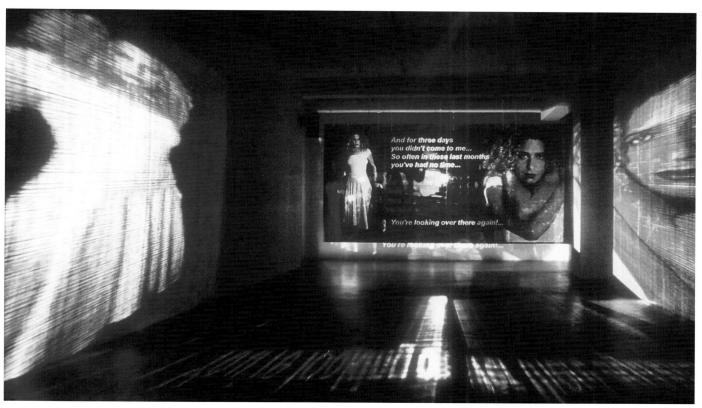

Installation view, Marian Goodman Gallery, New York, 2002.

CLOUDS HIGH IN THE SKY

What am I to do alone here?...
in this endless life...
in this dream without limits or colors...
Light will come for everyone...
but me, alone in my darkness?...
Morning seperates us...

But your eyes
are so strange...
What are you looking at?

Exterior view, "Dara Birnbaum," Kunsthalle Wien, 1995.

CD (TRANSFERRED TO MP3, 5:49 MIN.) WITH THREE UNITED STATES ARMY AMMUNITION BELTS,
HEADPHONES, WALL-MOUNTED PRINTS, INSTALLATION: DIMENSIONS VARIABLE
MUSIC: STEPHEN VITIELLO
COURTESY MARIAN GOODMAN GALLERY, NEW YORK AND PARIS

Operations was Dara Birnbaum's contribution to a project commissioned by Swiss Radio DRS, later distributed as the CD-and-book set *Other Rooms, Other Voices* (Memory/Cage Editions, 1999). For the project, curator Daniel Kurjakovic selected fifteen artists, among them Vito Acconci, Louise Bourgeois, and Lawrence Weiner, to create self-reflexive audio works analyzing sound as a medium. The results were broadcast in January 1999.

Birnbaum chose to reflect on the just-past events of December 1998, when over the course of four days the United States conducted "Operation Desert Fox," a massive bombing campaign in Iraq. Birnbaum collaborated with sound artist Stephen Vitiello to create three audio collages of radio reports covering the bombing as it happened, layered with staccato rhythms and ominous sound effects. The accompanying book includes fragments of the radio announcers' transcripts and illustrations of the score that reveal the editing structure of the collages.

One version of *Operations* in installation presented the work on three mp3 players, each inserted into a U.S. Army–issue ammunition belt with headphones. The belts were displayed beneath wall-mounted Plexiglas panels framing pages excerpted from the book. Viewers were encouraged to take the ammunition belts down from the wall, wear them, and walk through the museum with them as they listened to the audio. (RC)

As installed in, "Kill All Lies,"
Luhring Augustine Gallery, New York, 1999.

Installation view, "Dara Birnbaum: The Dark Matter of Media Light," S.M.A.K., Ghent, 2009.

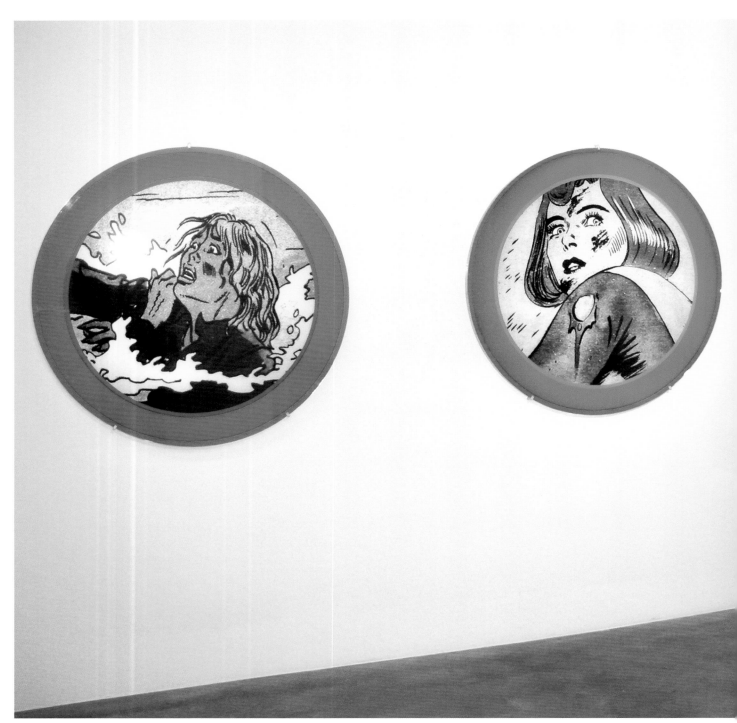

Installation view, "Hysterical," Dennis Kimmerich Gallery, Düsseldorf, 2004.

272

QUIET DISASTER: 1999
FIRE, WATER, LOOKING BACK

THREE CIRCULAR PLEXIGLAS PANELS WITH DURATRANS PRINTS, 111.7 X 3.8 CM EACH
COURTESY MARIAN GOODMAN GALLERY, NEW YORK AND PARIS

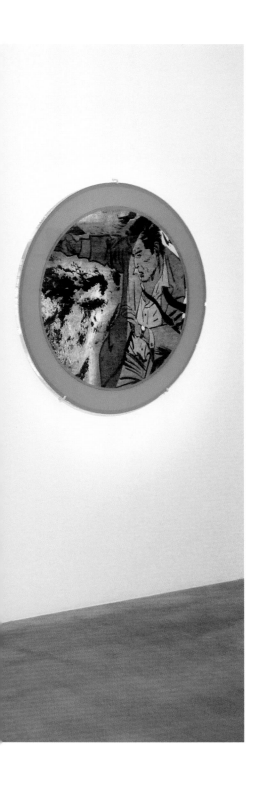

The three tondi constituting *Quiet Disaster* coalesce around a theme of individuals in moments of physical, perhaps mortal, danger. Each panel features an image appropriated from a comic strip: a woman bracing herself against a torrent of water; an attractive woman in a torn dress looking over her shoulder, eyes widened in fear; a man struggling to free himself from raging flames. These dramatic scenes are reproduced in black and white but are framed within three varying rings of fluorescent red, teal, and orange. Theatrical spotlights, one trained on each tondo, heighten the suspense and drama of the scenes. The panels share similar compositions; the protagonists are all shown in close-up, one arm extending out of the left side of the frame. In *Quiet Disaster*, catastrophe is suspended, but the characters' stricken poses suggest a precarious stasis, leaving the outcome of their predicaments unknown.

Throughout her career, Dara Birnbaum has used abruptly cropped or edited images to isolate distinct moments of ferocity, which threaten to overwhelm the individuals caught up in them, as in *Pop-Pop Video: Kojak/Wang* (1980) and *Technology/Transformation: Wonder Woman* (1978–79). Such video works also decode the strategies of mass media, showing how humans are swept up in the machine of commercial television. In a related visual essay for *October*, entitled "Elemental Forces, Elemental Dispositions: fire/water," Birnbaum writes: "The portrayal of force, action and reaction can be seen to infiltrate various forms of mass media, pan-culturally. It seems a necessary component to the portrayal of the everyday. While the means of drawing oppositional elements varies through cultures, it also remains surprisingly the same. Perhaps a similarity of need yields the consistency within varying representations." In static form, *Quiet Disaster* distills the portrayal of force, action, and reaction, and spells out tragedy's universal language. (RC)

COLOR VIDEO CLIPS FOR LARGE-SCALE ELECTRONIC BILLBOARDS
COURTESY MARIAN GOODMAN GALLERY, NEW YORK AND PARIS

On the occasion of Media_City Seoul 2000, Dara Birnbaum was commissioned by Hans Ulrich Obrist, curator of one portion of the exhibition, to create works for electronic billboards situated throughout the city center. Media_City Seoul's theme was "City between 0 and 1," to reflect the historic moment of a new century, and the emergence of the digital age, and to focus on Seoul as a locus for progress in an era that hoped to see the collapse of the division between North and South Korea.

As with Birnbaum's *Artbreak, MTV Networks, Inc.* (1987), a thirty-second spot for MTV that took on feminism and the history of animation, the two versions of *taegukki* compress profound subject matter into the duration of a commercial. On forty large electronic billboards in high-traffic areas, *taegukki no. 1* and *taegukki no. 2* were rotated into a program of paid advertisements. *Taegukki no. 1*, the longer of the two, animates the South Korean national flag to portray its symbolism. *Taegukki*, the word for the Korean

flag, is derived from *Taegeuk*, a cognate of *Taiji*, expressing the Taoist concept of yin and yang. The flag's design consists of a central yin-yang in red and blue, surrounded in four corners by trigrams from the *I Ching*, representing the four elements: water, fire, air, and earth. The symbols are prominently displayed on a field of white, traditionally interpreted as the color of peace.

Motion graphics spin the yin-yang and combine trigrams to create hexagrams in an animation evoking the throwing of the *I Ching*. The resulting hexagrams are interpreted in English and Korean captions and illustrated by figures and scenes appropriated from Ok-Lang Hwang's anime saga *The Sky Dragon and Eight Warriors*. In *taegukki no. 2*, the twenty-second version of the piece, the animation is limited to two hexagram combinations. At the conclusion of both versions, the North Korean flag is momentarily combined with the South Korean *taegukki*, graphically embodying the concept of Korean unity and peace. (RC)

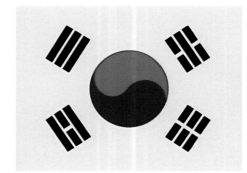

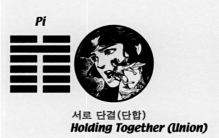

Pi

서로 단결(단합)
Holding Together (Union)

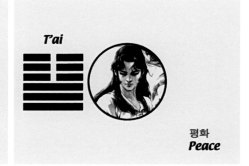

T'ai

평화
Peace

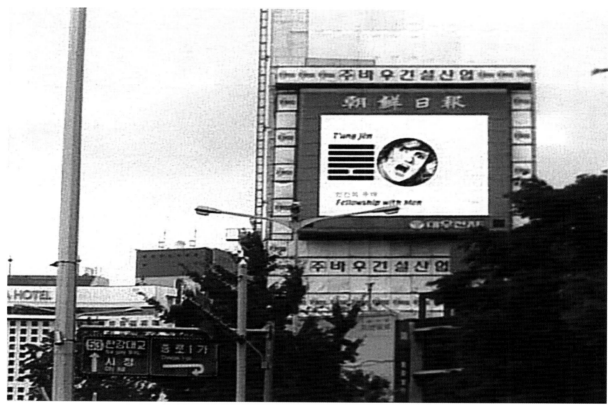

taegukki no. 1, installation view, "Media_City Seoul 2000," Seoul, 2000.

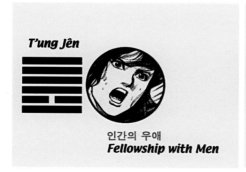

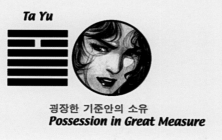

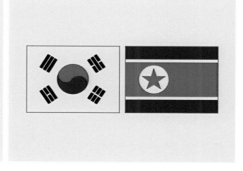

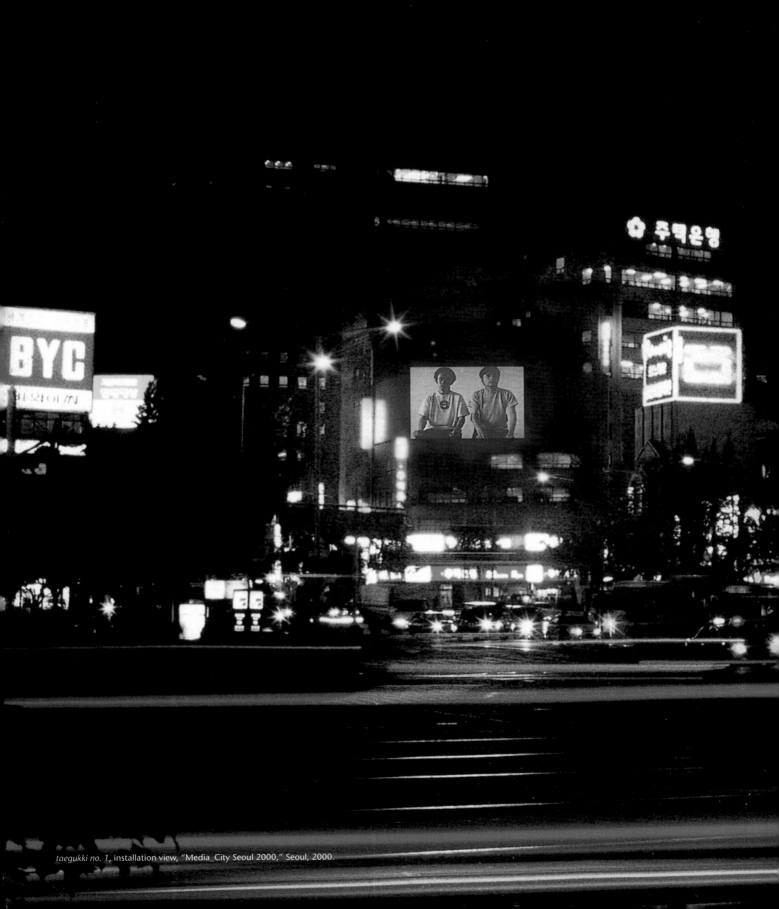

taegukki no. 1, installation view, "Media_City Seoul 2000," Seoul, 2000.

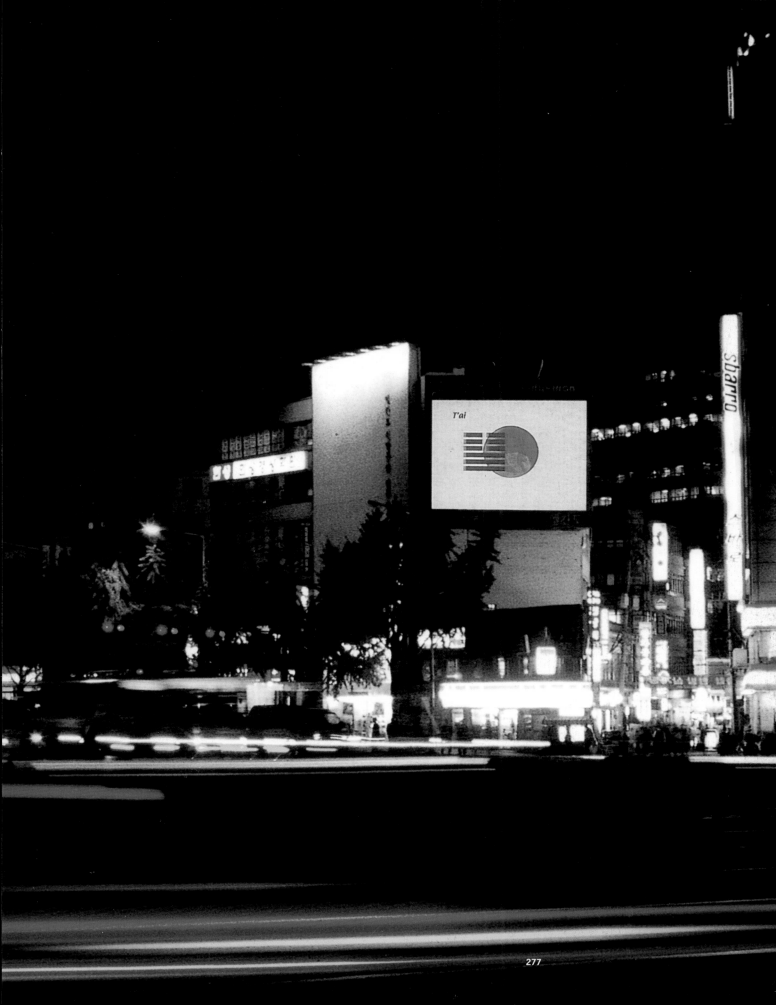

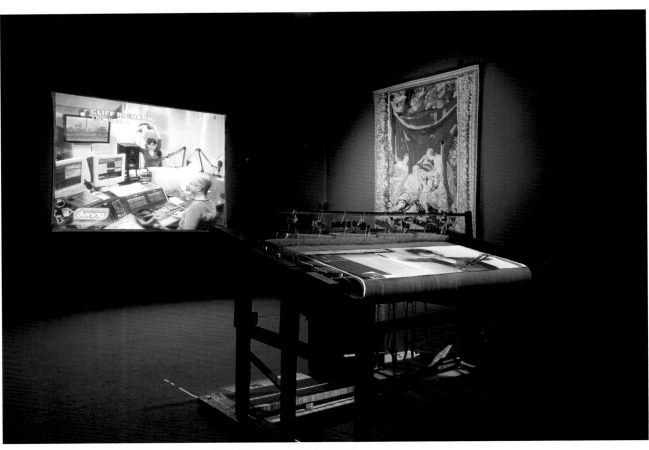

Installation view, "Dara Birnbaum: The Dark Matter of Media Light," S.M.A.K., Ghent, 2009.

TWO-CHANNEL COLOR VIDEO INSTALLATION WITH ANTIQUE WEAVING LOOM, QUADRAPHONIC SOUND, HANGING CANVAS FOR PROJECTION, FLEMISH TAPESTRIES; DIMENSIONS VARIABLE COURTESY MARIAN GOODMAN GALLERY, NEW YORK AND PARIS; CONTOUR MECHELEN AND MANUFACTURE DE WIT, MECHELEN, BELGIUM

Tapestry: Elegy for Donna brings together the historical technology of weaving and the modern technology of television broadcasting. In 2005, Dara Birnbaum was commissioned to produce a new work for Contour, a video biennial in Mechelen, Belgium, that focuses on the interaction between moving-image art and specific architectural locations. Birnbaum created a work in situ at the Manufacture De Wit, which houses in a fifteenth-century building the only workshop in Flanders to retain the age-old traditions of Flemish tapestry-making and restoration.

The original, two-channel installation was presented in a darkened room that holds the De Wit's antique tapestry collection. One image was projected onto a wall of the room, the other video directly onto the threaded surface of a historical loom. The source for the two channels of video is the Belgian pop-radio show *Radio Donna* and its television component, which was shown until January 2009 on Belgian television's TV1. Birnbaum focuses on Yasmine, a DJ and TV presenter well known to Belgian audiences both for her work on *Radio Donna* and for her long career as a pop singer until her death in June 2009.

The viewer sees projected onto the wall the television incarnation of *Radio Donna*, which broadcasts a basic, continuous shot of the radio control room, the broadcasting DJ, and the technical engineer. This straightforward TV presentation (and Birnbaum's re-presentation) of Yasmine playing recordings of pop music—that is, in the process of creating the radio content—recalls the deconstructive tactics of Birnbaum and Dan Graham's *Local TV News Analysis for Cable Television* (1980) as assimilated into mainstream commercial media.

The video projected onto the threaded loom isolates Yasmine's intimate gestures—laughing, talking—as she works in the studio; the imagery animates the fabric and creates, in effect, a video tapestry. In addition to linking the medieval and the modern, Birnbaum activates a dialogue between weaving, an art practiced predominantly by women, and the actions of Yasmine in her role as a weaver of cultural content.

The audio for *Tapestry* derives from the sounds of the *Radio Donna* television and radio programs, their respective "jingles," and an electronic score that reinterprets and mixes multiple versions of Leonard Cohen's "Bird on a Wire." (According to Birnbaum, Cohen was Yasmine's favorite songwriter; the "wire" of the title also suggests broadcasting transmission.)

Writes Birnbaum, "If a tapestry is, by definition, a heavy fabric with a woven pattern or picture, then can we consider what a contemporary tapestry—mosaic of daily life—offers to us, both in pictorial composition, as well as cultural content. Every 'stitch' in time leaves the trace of those images we will leave behind for generations to come." (LZ)

Installation view, Contour, 2nd Biennial for Video Art, Mechelen, Belgium, 2005.

SINGLE-CHANNEL COLOR VIDEO, 1:01 MIN. WITH PRINTED MATTER AND BOOKS, DIMENSIONS VARIABLE
COURTESY MARIAN GOODMAN GALLERY, NEW YORK AND PARIS

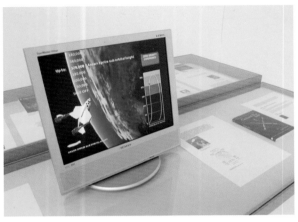

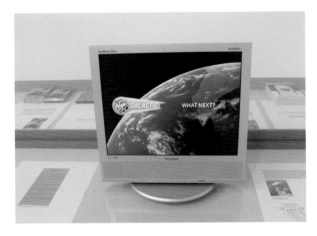

Installation views, "Arteast Collection 2000 + 23,"
Moderna Galerija, Ljubljana, 2006.

The installation *Be Here Now* was Birnbaum's response to an invitation from the Slovenian arts magazine *Maska* and the Moderna Galerija, Ljubljana. On the occasion of *Maska's* hundredth anniversary issue, the invited artists were asked to reflect on their art in the future, imagining the forms it might take in 2023, the projected year of *Maska's* two-hundredth issue.

Birnbaum's installation comprised a written text accompanied by books and DVDs, mounted in three vitrines, as well as one looped video shown on a flat-screen monitor. The books that were on display are all set in 2023. Birnbaum selected volumes—such as *Civilized War: 2023* (2000) by Slate Raven, *Getting Near the End* (2004) by Andrew Weiner, *Thy Kingdom Come* (2000) by Linda Paulson Adams, and *Sewer, Gas & Electric* (2004) by Matt Ruff— which encompass science-fiction, futuristic-fantasy, and apocalyptic narratives, and range from the satiric to the religious. The vitrines also hold an artist's statement, DVDs, and the artist's synopsis of the project.

In assembling a collection of popular works that speak to an imagined future, Birnbaum suggests that these imaginings say less about our future than about our present. Elaborating this commentary is the presence of the looped video, appropriated from a commercial by Sir Richard Branson for his Virgin Galactic commercial space-tourism shuttle, which is scheduled to launch in 2010.

The title *Be Here Now* is derived from Ram Dass's bestselling 1971 book of the same name, which outlines the author's countercultural spiritual teachings, including the significance of living in the moment. "As a child of the 1960s in Amerika—having personally grown up with the philosophies of people like Ram Dass," Birnbaum writes in her statement, "there was no way/need to project into the future, as to what my work would be like in 2023— instead I would deal with the more important positioning of the present." (LZ)

16 DOUBLE-SIDED FLAGS; DIMENSIONS VARIABLE
COURTESY OF THE ARTIST AND MARIAN GOODMAN GALLERY, NEW YORK AND PARIS

In this installation, which was first realized for S.M.A.K. and the Museu de Serralves, flags of varying sizes are hung from the ceiling throughout an exhibition space. The configuration of the flags is intended to change depending on the architectural space and institution presenting them. On one side of each double-sided banner, the flag of the United States is displayed, backed on the opposing side by the flags of one of sixteen countries currently occupied by U.S. armed forces. The selection was made to reflect the global American military presence at the end of the George W. Bush's presidency in 2008.

The size of the flags is determined by statistical information compiled from http://www.military_statistics_June2008, which recorded the number of active military personnel (over five hundred troops) broken down by region and country, as of June 2008. The larger the number of U.S. troops occupying a given country, the larger the banner in installation. (RC)

Flags and number of occupying U.S. troops in each country presented:

Iraq	83,100
Germany	5,145
Japan	2,966
Afghanistan	1,700
South Korea	5, 374
United Kingdom	9,613
Italy	9,515
Djibouti	1,900
Turkey	1,570
Bahrain	1,504
Serbia	1,289
Spain	1,238
Belgium	1,031
Cuba – Guantanamo	980
Portugal	792
The Netherlands	552

Installation views, "Dara Birnbaum: First Statements and then Some . . .," Wilkinson Gallery, London, 2009.

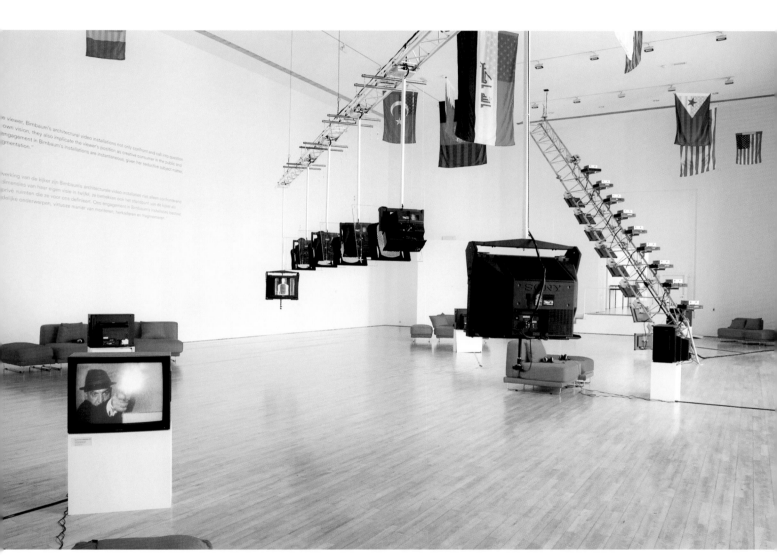

Installation view, "Dara Birnbaum: The Dark Matter of Media Light," S.M.A.K., Ghent, 2009.

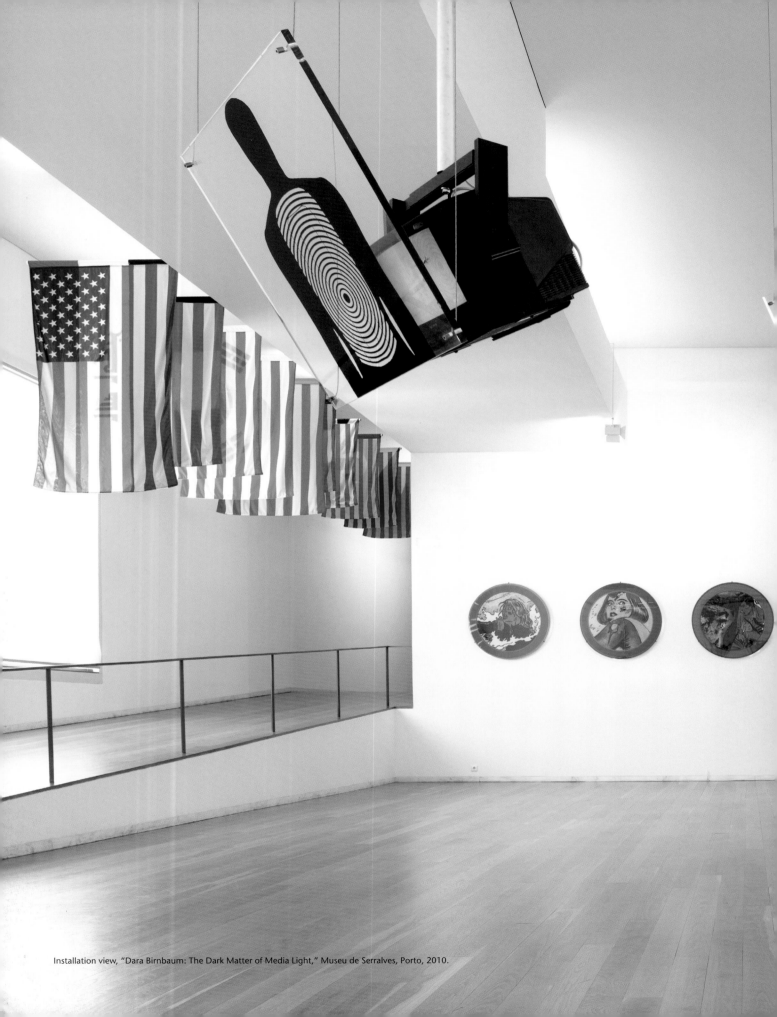

Installation view, "Dara Birnbaum: The Dark Matter of Media Light," Museu de Serralves, Porto, 2010.

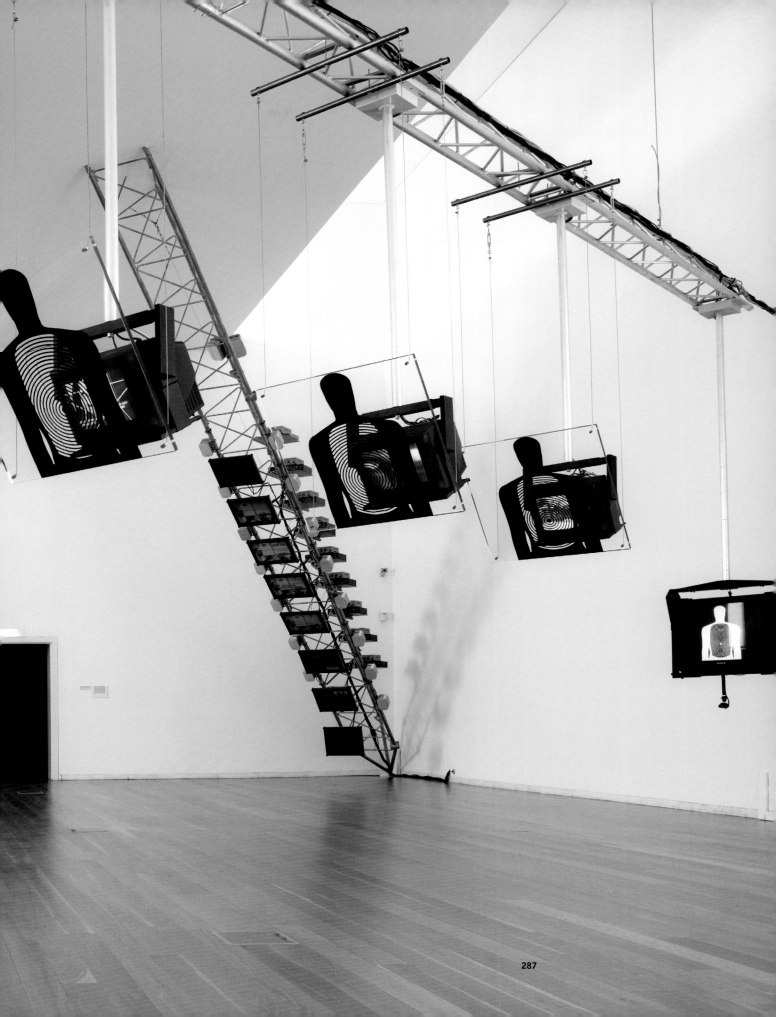

SELECTED WRITINGS AND PROJECTS FOR PUBLICATIONS
1984–1999

SEND MAGAZINE CENTERFOLD
Send, no. 9 (Spring 1984), pp. 46–47.

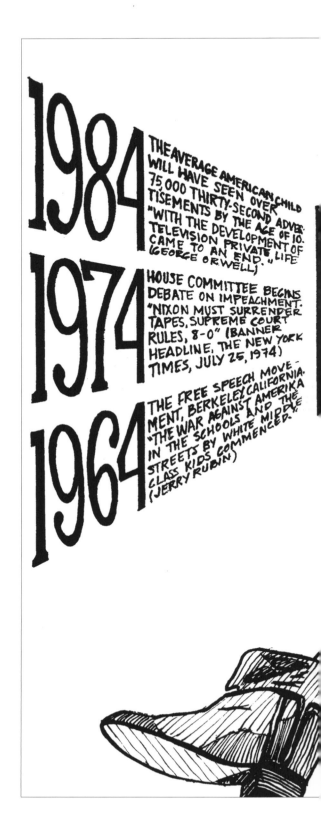

EVERY COLOR TV NEEDS A REVOLUTION

In *TV Guides*. Ed. Barbara Kruger.
New York: Kuklapolitan Press, 1985,
pp. 24–25.

Every Color TV Needs a Revolution
by Dara Birnbaum

Television doesn't always lead me to reflection of the "events" portrayed; rather, television frequently becomes an "event" itself—the watching of it. Yet, my "political conscience" was developed, in part, through the medium. The general political upheaval throughout America in the 1960s and 1970s reached me through the immediacy of live coverage of the SLA/L.A. police shootout, the assassinations of Robert Kennedy and Lee Harvey Oswald, and the funerals of Martin Luther King and John F. Kennedy. By 1964 the first student demonstration flashed on TVs across the country and in 1970 Yippie leader Jerry Rubin published *Do It!*—his "scenarios of the revolution," dedicated to "Color TV and Violent Revolution!" and including a chapter entitled "Every Revolution Needs A Color TV."

It was Rubin who stated that TV was raising generations of kids who want to grow up and become demonstrators: "Demonstrations last hours, and most of that time nothing happens. After the demonstration we rush home for the six o'clock news. The drama review. TV packs all the action into two minutes—a commercial for the revolution."

In August, 1968—to the cries of "the whole world is watching!"—TV made us aware that outside the Chicago convention hall housing the Democratic Convention, the real news was happening. "Eyewitness News" of "rioting in the streets," presented live, furthered our knowledge of "spectator" and "spectacle." Rubin states: "I've never seen bad coverage of a demonstration. It makes no difference what they *say* about us. The pictures are the story."

The events in Chicago that summer were not directly related to events in Paris only three months before. However, the 1968 Chicago Democratic Convention and May '68 both remain important historical markers. TV viewers in both the United States and abroad were exposed to the events of May '68—student demonstrators hurling bricks, ripped up from the Champs Elysees, at the police. These scenarios resembled our own demonstrations, but there was a radical difference in methodology between the two. That difference, very early on, related directly to different approaches to "the media"—especially television and film.

As the youth generation in the United States continued to develop their "student strikes," isolating and alienating themselves from others ("long-hairs" versus "hard-hats"), a philosophy of "using the system against itself" grew, a key structural difference between the American New Left and its French counterpart. Rubin's "Every Revolution Needs A Color TV" states: "Have you ever seen a boring demonstration on TV? Just being on TV makes it exciting. Even picket lines look breathtaking. Television creates myths bigger than reality... Television keeps us escalating our tactics."

In other words, the system was there to be used. Whereas, students and workers in France were united "against the system as it stood" and that "this system must be restructured."

It was on May 13th that nearly one million demonstrators marched from the Place de la Republique to Denfert-Rochereau in Paris. Within two days after this march, four young technicians created the Cinema Commission within the framework of the Sorbonne Action Committee. Thus, restructuring of film-television was begun. On May 16th, the beginnings of a distribution movement appeared within the universities, lycees, and factories. By May 17th, the coordinated movement to challenge the present structures of French Cinema-Television adopted the name "Estates General of French Cinema":

Given that in present conditions, a free Cinema and Television do not exist, given that an infinite minority of filmmakers and technicians have access to the means of production and expression, given that for all professional categories decisive changes are called for at all levels,

Given that the cinema has a major mission to fulfill today and that it is gagged at all levels in the present system.

Filmmakers, technicians, actors, producers, distributors, and critics in film and television, resolved to bring an end to the present state of affairs, have decided to convene the Estates General of French Cinema.

We invite you all to take part... The Revolutionary Committee of Cinema-Television.

How then did the French student and worker coalition envision effective action for their state of affairs in relationship to this powerful media? Cineastes/filmmakers, technicians, workers, students, and critics together announced a total strike "to denounce and destroy the reactionary structures of a cinema which has become a commodity." Even the Cannes Festival was immediately contacted:

The information and action assembly of French cinema... asks all filmmakers, producers, distributors, actors, journalists, jury members, present at Cannes, to oppose, in collaboration with their foreign counterparts and by the means appropriate to them, the continuation of the Festival in order to show solidarity with the workers and students on strike.

On May 19th a general assembly of the film technician's union issued an order for a total strike, further stating that these directives show the courage to recognize that film work is inseparable from the conditions in which it is exercised. To challenge the "now petrified structures" meant taking a political position. On May 21st, the Estates General demanded the creation of a body common to Cinema and Television, composed equally of representatives from the technical, artistic, and worker staff of these two branches of audio-visual expression. This body was to be charged with promoting the reorganization of the whole of audio-visual production. With this aim, the Estates General proposed:

1. An increase in television viewing time and a fixed minimum percentage for the national production of "new" programs.

2. The free circulation of technicians based on the harmonization of salaries and professional criteria.

3. The free circulation of films and programs through the various systems of diffusion.

At this time, it seems important to be able to focus on the medium of "television" within specific historical frameworks. 1968 provides a locus, revealing concurrent sitings for the medium, while having the ability to fix two different strategic and structural approaches. What remains of these previously employed strategies of 1968? Certainly "commodity" programming in France continues (frequently imported from the United States), the Cannes Festival goes on, recent terrorist activities covered by the media simply exhibit a more "radical" form of Rubin's 1960s Yippie philosophy: "TV time goes to those with the most guts and imagination.... Every guerilla must know how to use the terrain of the culture that he is trying to destroy."

Potentially, what remains in common regarding television-film work are the determinants basic to all thoughtful work: "where is that work to appear and what will be its appearance." These are questions no independent producer should proceed without; self-inquisition. An awareness of sociological terrain, of "where," "what," and "how," with recognition and declaration of past historical conditions, strategies, outcomes, and events, is an essential responsibility. I do not suggest that we adopt former procedures or strategies, such as those which occurred in 1968. Rather, it is an open invitation to examine former interventions in an attempt to locate for ourselves potent positions within television's expanding network. (END)

OUT OF THE BLUE

Artforum 26, no. 7 (March 1988),
pp. 117–19.

By "popular"... was meant a certain range of reference, a style of delivery, and a claim—mostly implicit, but flaunted on the right occasion—to be addressing one kind of audience and excluding several others....

—T.J. Clark, *The Painting of Modern Life*

Howard Beach, a predominantly white, working-class neighborhood in Queens, dominated New York City headlines in late December 1986. A group of white teenagers there had beaten a black man named Michael Griffith and his two companions with sticks, baseball bats, and other weapons. Fleeing his attackers, Griffith ran onto the Belt Parkway, where he was killed by an oncoming automobile.

Shortly after this time, in 1987, I conducted an interview for my videowork "Charming Landscape," the last section in my *Damnation of Faust* trilogy. In this interview, while discussing their own neighborhood, the two white teenagers attempt to relate to "larger" issues, including Howard Beach and Vietnam. Howard Beach was then a present tense. Now, at this writing, it has resurged as "headline news"—the Turner Broadcasting System advertises "CNN Headline News" as a "habit"—and has been "resolved" through a court decision reached December 21, 1987. Vietnam was then—as it is now—a "recurrent" past tense. Reemergent, and repackaged as "the Vietnam Experience," it has become almost a household cliché in the '80s.

Few comments from this interview made it to tape (the final version of which was broadcast on WNET in 1986, reaching an estimated audience of 187,500 per night, and on WNET and WGBH

Out of the Blue
A Project for Artforum by Dara Birnbaum

in 1987, reaching approximately 412,500 viewers per night). How and why did other comments get away during the editing process? Were they replaced—their space taken by other, more vital information? Or did they simply stay hidden—perhaps remaining as the "unseen"?

I'm curious not only about how these "exclusions" and "inclusions" relate to one another, but also about how these choices have *real* effect (*real* here meaning *larger* and more *visible*) on the audience. Had I, on my side of the dialogue that I desired between artist and audience, *committed the same error* that I feel presently prevails in the arts: acting on the assumption that art is capable of maintaining a history divided and separated from the "daily events" of our time and culture?

To consider the action of editing is to reemphasize *process* over *product*, or the continuously shifting and undercertain event over the definitive object and statement. Since the foregrounding of process still seems to provide the greater possibility for effecting change, I find it imperative at this time to look at my own most recent activities, my own *art-making* practice.

How does exposure to information, obtained through the interpretations of mass media, contribute to our formulating of perspectives? What mass media information had the jurors of Howard Beach been continuously exposed to prior to the time of the trial? What was the cumulative impact of the television shows they had seen? What determined their perspectives, enabling them to perform a critical function: to take actions and make decisions that could determine the life of another? A 1984 study projected that the average American child will see over 75,000 30-second television commercials by the age of ten. What exposure did the teenagers in my interview have to Howard Beach? How much were they able to identify with its *mass-media* representation, or with the even more distanced and dislocated representations of "the Vietnam Experience" (Time-Life's "What did you do in the war, Daddy?").

In an effort to explore these questions, I desire to reclaim the following extracted statements and images, which were originally "edited out"—which, in fact, had never been "edited in."

The statements and images that were included in the videotape "Charming Landscape" appear here in white; statements and images that were not used in the videotape appear in blue.

Pp. 118–119: Dara Birnbaum, *Damnation of Faust: Charming Landscape*, 1987, stills from color video, 6 mins. 30 secs. P. 118, top three rows: civil rights demonstration and march, Selma, Alabama, 1965; fourth row: training session for first Freedom Summer volunteers, Oxford, Ohio, 1964; bottom two rows: National Democratic Convention, Chicago 1968. P. 119, top two rows: National Democratic Convention, Chicago 1968; bottom four rows: protest demonstration in Lincoln Park during National Democratic Convention, Chicago 1968.

117

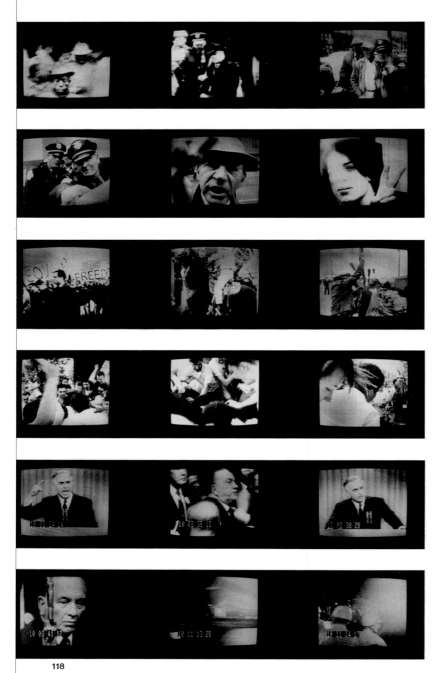

DB: What about something which affects you which is larger than your own neighborhood, like Howard Beach?

GD: When I found out about How- —about that *racist story*, where the white kids beat up on the blacks for supposedly no reason, I thought it was very uncalled for. *Everyone* knows it wasn't right. There may be a white guy sitting home and watching TV who's saying, "That's good for him!"—you know, for the black kid. But inside he knows he's wrong. Everybody *really* knows what's right and wrong—you feel it. What if it was one of theirs, if that was them or someone else, you know what I'm saying?

PH: Since I'm originally from another place, I can say that when I lived in California I went to school with a lot of black kids and there really wasn't much racism at all. Oh, there was a little bit, it's always there. There was a tension, but nowhere near what it is here in New York, in either direction. I never got beat up by blacks and blacks never beat up on the whites.

GD: The kids I grew up with in New York have never been anywhere but here. There were other kids who thought that this fight at Howard Beach was wrong—that is, for the three white guys to do it. But me and PH, we've been other places, different places. These kids haven't been anywhere, they only know the neighborhood. That's all they know, so they were brought up with what they had, it was very close-minded, just themselves with their own race. I was brought up like that too, but I went here, I went there, I explored and I talked to other people just to find out, out of curiosity, how they are. Here it's like being stranded on an island with the same people and they're all the same, 'cause that's all they know.

DB: Do you think there's any way either of you could change that?

PH: I think that it's, uh, oh God, no. [laughs] You have to —I understand a lot of where that attitude comes from, and so not only do *they* have to change, but the other side has to change too. Both sides have to change at the same pace. Otherwise nothing's ever going to really work out. The reason I started getting prejudiced is I went to school uptown with a lot of black kids and I saw what they saw. You're really thrown into it, you know. It's an instant battle. I got beat up. I got beat up here too, and then I didn't like guineas, I didn't like blacks, I didn't like anything. I liked myself—well, I didn't really like myself either.

GD: That's where we started judging people as *individuals*. Because we got abused from both sides, really, where everybody's wrong.

PH: I think that maybe you can change it on an individual basis but as a whole group, no. I don't think you can change the whole group.

DB: Do you realize that in the years in which you were born there was a movement to actively protest the war in Vietnam, that sometimes millions of people united in

demonstrations in the streets? What would happen if you didn't agree with actions which this government is now committing, like continuing to engage in nuclear weaponry? As an *individual*, do you have any feelings about this—the way you seemed to express your feelings about racism? Have you brought these issues up amongst yourselves?

PH: Well, we talk about it, but my views on government are still very confused. I don't always know how I feel. I do, but I don't. Sometimes I think in certain ways but I don't always know why I feel those ways.

DB: Well, do you see yourself as capable of having a direct relationship to current events now that you're of an age to vote? Does it concern you what your country's policies are? Do you see a way of directly playing into and affecting the policies of this country? In the '60s there seemed to be a belief that individuals united together, for a cause they believed in, could effect change. With a *larger*, more *visible* group it seems that you can begin to see the extent of people's reactions, for example with the demonstrations against the war in Vietnam. What do you think happened in Howard Beach? Is there any relationship we can draw? It seems that when similar conflicts, clashes on issues, usually occur it's typical to try to gain power by getting a *larger* number of people around you for support, or even protection. So, as an *individual*, how do you assert yourself? Let's say that if you were in a group whose thinking was, at times, different from your own—would you feel that you could still express yourself? Could you still maintain your identity in the group?

GD: That's where you lose your identity. That's where you say to yourself, "Well, should I let them know? How should I act?" Sometimes I say, "Oh well, if they don't like it, that's all right." Sometimes you split your personality and think, "I'll just be with them and be like they are for now." You'll talk to this person that's a certain way and you'll try to be that way, and that's the way you wind up for that few minutes or however long you're there. Then when you walk away, you become yourself again. I really don't know who I am yet because of these split personalities which I've created. But I have an idea. Even though I didn't find myself yet—I didn't find my one self, *me*.

PH: When *I'm* with a group of people, if they're very prejudiced, I'll let them know that I'm not. And if they don't like that, I'll leave. If they don't mind, then I'll stay with them and continue talking with them, but to myself I say "Well, that's the way they are. That's too bad for them. They're losing out and I'm not." *But I will express how I am different from them*—I can't let that go by. I can't fake it! In that way I feel comfortable. I wouldn't feel comfortable hiding my real feelings—I don't think I could.

GD: See, *I* have to. Because—there're too many of them. And there's just me. I'm one with them 'cause I grew up with them, and I can't really come out and say "Well, I'm not prejudiced." I can't be open enough. I can be, but I don't want to, 'cause I don't want the hassle.

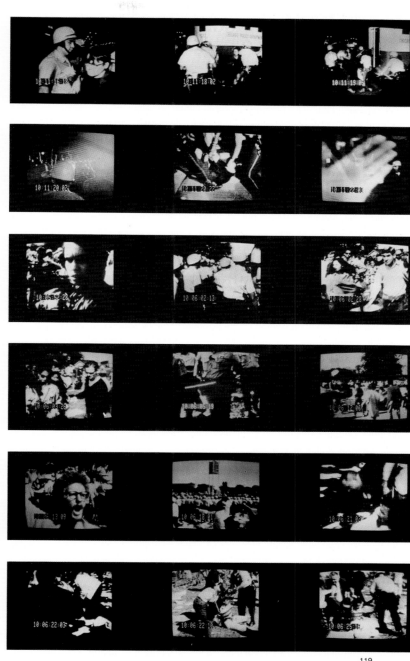

119

OVERLAPPING SIGNS

In *War After War*. Ed. Amy Scholder.
San Francisco: City Lights Publishers, 1992, pp. 27–36.

27

28

29

30

31

32

33

34

35

36

A STATEMENT OF MANIFESTATION FOR THE CONFERENCE: RADICAL CHIC

In *Radical Chic Reader*.
Stuttgart: Künstlerhaus, 1993, pp. 57–61.

Free Leonard Bernstein!

Tom Wolfe begins his 1970 retort, *Radical Chic,* with a self-de-
clared privy entry into the 4 AM dream state of Leonard Bern-
stein, whom he claims "woke up in the dark in a state of wild
alarm..." With Wolfe as guide, we co-commit a forced entry into
the inner thought, or conscience, of this well known personality.
But perhaps we should, in our committed action, also be forced
to question Wolfe's very portrayal of both this man and these
events?

If "Radical Chic" is to be a term to be reused in the 1990s, then
we must ask ourselves, for what exact purpose do we now again
position ourselves as in a similar position as the outsider, as
Wolfe did in the 1970s? The outsider: the one who is more capa-
ble of knowing the motivations of others than they might know of
themselves?

Thus, for a conference of the same name, I thought it best to
present some more personal remarks, which would recall my own
experiences in the 1970s, in "Berzerkly", California. These are
the "Radical" times that Tom Wolfe chose to write about. My own
memory readily recalls Tom Wolfe as a figure who lectured at the
Berkeley Campus' Student Union, dressed in three piece white
suit and hat. He condemned us "Radicals" for being so conserva-
tive – so all alike: wearing the same shoes, reading the same
books, etc.

However, what I still remember had hurt me the most, was his
cynicism – and nowhere is it more evident than in his essay,
Radical Chic. I decided to discuss these issues with Nina Bern-
stein, daughter of Leonard and Felicia Bernstein. Together, infor-
mally, we tried to recall the actual event "documented" in Tom
Wolfe's book. Nina Bernstein recalled Wolfe as the person who
crashed the Bernstein's party, in order to eventually turn it into
book form. We tried to think about what type of journalism Wolfe
was engaged in. Or, what sense of media consciousness that
could cause his term to travel across cultural boundaries, infil-
trate other languages, and obscure original voices and intent.
We then tried, together, to understand the reason why a confer-
ence in Stuttgart would, twenty plus years later, call itself *"Radi-
cal Chic"*.

I would hope that during these *recent critical* times, *Radical Cyni-
cism* does not become the mirror which you hold up to this past
emblematic period, entitled *Radical Chic.* A period which, per-
haps, was named for simple reflections, such as Tom Wolfe's
own (voyeuristic) position.

This "indecency of speaking for others" (Baudrillard), which Tom
Wolfe has, in part, chosen as his occupation, seems to run the
risk of engaging a worn out model of modernist polemics – in the
sense of oppositional components whose modus operandi may
limit, instead of providing a growth for, our ability to perceive
new pathways. Here "negativism" opposes "idealism".

My original invitation to this conference declared that:

"...on the one side the title (given to the conference) *is a refer-
ence to Tom Wolfe's essay ... describing a NYC party given by
Leonard and Felicia Bernstein for the Black Panthers and the
problems of the High Society behaving politically correct in this
Radical-Chic-Season. On the Other side I* (Ute Meta Bauer,
Künstlerhaus Stuttgart) *think it quite problematic to transfer po-
litical contents into the bourgeois art system..."*

58

It seems important for this conference to go well beyond those limiting generalities, which provide and enact yet other packaged systems for consumption.

The results of such "systems of packaging" are usually devastating. For example, look at the covers of two press relics from this period: *New York Magazine* and Tom Wolfe's book *Radical Chic* (reprint). Both make us attend to mocking representations which mask – and therefore seem to loose – the original intentions of the people and events portrayed.

What *"political contents"*? What *"bourgeois art system"*? Are these systems replete? On the one cover, Bernstein looms larger than life, and conducts the movement of many small black personages. According to Nina Bernstein, Wolfe had chosen to invade a territory in order to describe it. He crashed a cocktail party given, for the Black Panthers, by Felicia Bernstein, not Leonard Bernstein. Yet, the popular press chooses to take a representation of Leonard Bernstein for its cover. The male position conducts.

When representations of women are chosen for the cover of *New York Magazine,* it becomes equally cynical. The women are caused to loose their individual identities, as they become subsumed by their portrayed gesture and look. Even though they constitute the cover of the magazine, the power is still not theirs. They have become a simplistic concept of "women of all ages", adorned in the black glove salute of the Black Panther Party; as if in a fascist salute. We look down on them, as they adopt a seemingly male gesture in order to seize the moment to free

59

their adored male counter-part, Leonard Bernstein. These fictional caricatures service to block the original voice and subsequent representation of the very people they portray.

Have we chosen to look "through a mirror darkly" during these *radically critical times* of the 1990s, to a previous critical time of the 1970s? As Tom Wolfe, in his short novel, chose to focus on such anomalies as "...do the panthers like little Roquefort cheese morsels rolled in crushed nuts..." there where many of "us" who where politically concerned and engaged in Berkeley, California. "We" were attempting to direct our focus to a sense of productive action: such as the campaign to elect Bobby Seal Mayor of Oakland, California. Sometimes our accomplishments, such as the successful election of the first black to the office of Berkeley City Council in the early 1970s, forced us to learn from the incongruities between our idealism and our activism. (We then needed to expel this politically corrupt Councilman in the following year.) We needed to accept the incongruities as reflections of the fragmentation – and perhaps even the hypocrisy – of the images we helped make and form (and the images that were made and formed of us, through the ever pervasive mass media). Cynical humor, for me, neither resolves nor reforms; it perpetuates the "Yellow Journalism" of an American Dream that paints the past in order to "taint and whitewash" our future – and its full potential.

The art work which I accomplished from 1977-1993, was deeply affected by this period. My years in Berkeley (1969-1974) provided a bedrock for the formation of my art. It was a demonstration in San Francisco, California, against the expansion of the Vietnam War into Cambodia (later chronicled by Todd Gitlin in an article entitled *"Television Without Tears")* which turned my attention to *television* as the popular voice of, and to, the masses in America. Thus, it seemed absolutely necessary, by 1977 to *freeze* the videotape: presenting still frames of prime-time (crime-drama) TV for my first installation at Artists Space *(Lesson Plans*

60

to *Keep the Revolution Alive*, 1977). And, in 1978, it was impor-
tant not to transfer the medium of television to another, more
traditional form, but instead to use *"tv on tv"* – to *talk back to
the media*. Works, such as *"(A) Drift of Politics"*, 1978, were
directly quoted from the "fodder" of then contemporary Ameri-
can TV, such as *Laverne & Shirley*. Such popular TV-programming,
arrested in time and cut from its original narrative flow, allowed
for a fertile ground of examination of America's newly developing
nuclear family and subsequent ideologies.
Wonder Woman needed to be disrobed by 1978 *(Technology/
Transformation: Wonder Woman*, 1978). And as far as context,
this reconstructed Wonder *Woman* needed to appear both within
avant garde film festivals as well as H Hair, Inc., Salon de Coif-
fure in Soho, New York City... Faced out toward the street: *in
public.*
Mythological figures, placing the voice of the male on a pedestal
as the woman became increasingly hysterical, needed a more
philosophical vocalization *(The Damnation of Faust Trilogy,* 1983-
1987). And, the supportive pathway of *Take Back the Night* mar-
ches needed new forms of experimental documentation *(Canon:
Take Back the Night*, 1990). *Tiananmen Square* needed to be
provided with a totem of remembrance *(Tiananmen Square:
Break-In Transmission*, 1990); and the work for *Documenta IX
(Transmission Tower: Sentinel*, 1992) served as a base from
which to articulate America's posture, and contradicting voices,
at the onset of the Gulf War. These were the *necessities* that
caused my artistic statements from 1977-1993. there was no
"Radical Chic Season" in 1970. There was, however, the publi-
cation of one novelist who used a hip-term that yellow journalism
could sell and carry into the 1990s. Political contents are not
transferred into a "bourgeois art system", unless you are using
both as commodities. A challenge for the arts may be to de-
commodify our system and statements and place these into a
state of flux. *Questioning without resolution; process without
product.*

61

FINDING ANY PLACE IN CYBERSPACE
With Scott Lyall.
In *Anyplace*. Ed. Cynthia C. Davidson.
Cambridge, MA: MIT Press, 1995, pp. 160–70.

Between inside the system and outside the system is a semi-permeable membrane. And either-or is only a metaphysical question, not a practical one. ABBIE HOFFMAN, "REFLECTIONS ON STUDENT ACTIVISM (1988)"

In an era that requires rapid access to information, rapid transmission, and the shortest and surest means of encoding and decoding experience, cyberspace may be less an idealized destination for non-gravity-bound actors than a name given to represent a historically particular desire: to understand the profound reorganization of public space, especially as all notions of public life are increasingly subject to the dislocating effects of expanding interactive technologies. In this latter sense, cyberspace takes shape at precisely the point where traditional definitions of public space – as physical site, as historical monument, as street or town square – fail. Given the *absence* of community, of a *public*, cyberspace makes an appeal for (and to) new sensations of perception and movement whose significance is no longer fixed by chains of material cause or the once concrete terrains of the social. Conjuring cyberspace, we are in the realm of the performative. There is a sense of enactment and an attitude of inventiveness. Our programming decisions, the informational personae we adopt for easy maneuver – *all* of our actions exert an effective influence over what it is and how it will be constituted.

We are still between the fact of interactive technology and its final constitution as a positive concept. But, as such, the term *cyberspace* may already represent an assumption about technologies for the interactive communication of information: that these technologies can and *ought to* be thought of as spatial. We must not move too quickly to accept this assumption. Arising with a desire whose basic symptom is the absence of others – of community, of the polis – cyberspace can never be given as the existence of concrete, architectural (or even conceptual) space. Instead, the *spatial quality* of cyberspace must be articulated through a totality of overlapping discourses, arising from inside and outside its systems. Because no discursive totality is absolutely self-contained – there are always excluded elements that can distort its totality or make it precarious – the form of all technological systems will always be penetrated by basic instabilities, by the impossibility of achieving a full and final constitution. As such, using the term *cyberspace* to imply an assumption about the existence of constituted space may also suggest an aspiration against the politics that emerge within the discursive nature of our fragmented public lives – an

aspiration toward new virtual communities that tend by their programmatic constitution to elude, or cover up, the contingencies upon which they are initially planned and built.

This latter aspiration is suggested by many of the contemporary theories on cyberspace. Resounding in the ecstatic community, much of this writing requires our responsible critical attention. If cyberspace is envisioned as a utopian domain that refuses to be grounded by any limitation to personal freedom, we might also consider its proximity to (perhaps even its symptomatic status in relation to) a totalizing cultural logic that attempts to exclude the possibility of the individual qua subject.

CYBERSPACE: A new universe, a parallel universe created and sustained by the world's computers and communications lines. A world in which the global traffic of knowledge, secrets, measurements, indicators, entertainments, and alter-human agency takes on form: sights, sounds, presences never seen on the surface of the earth blossoming in the vast electronic night.

CYBERSPACE: The tablet become a page become a screen become a world, a virtual world. Everything and nowhere, a place where nothing and everything changes.

CYBERSPACE: Access through any computer linked into the system; a place, one place, limitless; entered equally from a basement in Vancouver, a boat in Port-au-Prince, a cab in New York, a garage in Texas City, an apartment in Rome, an office in Hong Kong, a bar in Kyoto, a cafe in Kinshasa, a laboratory on the Moon.[1]

According to these formulations, the full realization of cyberspace has as its corollary the neutralization of disparate geographies, the immobilization and erasure of the individual in his or her situated subjectivity. If cyberspace is here a name for that which betrays the absence of any *place* at all, it is the word *any* (modifying "computer" in the third of these descriptions) that underwrites and guarantees this sustained indifference. Access from anyplace corresponds with the assured invisibility of the local, of subjects: their absence from the realm of representability as such. This vision of cyberspace brings us very close to the constitution of a (virtual) public in terms of what has been called a majority of the margins.[2] We all take a place at the edge, in the margin, and precisely — perhaps paradoxically — this marginal status inaugurates our participation in the production and preservation of the officially public, the "public" as the visible space of the majority.

This marginal status, this phantom visibility caused by the absence (the *invisibility*) of actual subjects, poses the greatest threat to the validity of cultural projects aimed at the critical assessment of new technological frameworks. By now most of us are familiar with the idea that, as receivers of electronically transmitted information, we are not *eyewitnesses* to the events of history. Instead, we witness the mediation of "newsworthy" events, their telepresentation, and ultimately the processes by which these contribute to our own information. But because the critical representation of public life is linked to one's own sense of place within it, the all-encompassing quality of cyberspace ("cyberspace" here as that organization of public interaction that banishes the subject and the importance of its place) makes alternative critical and political positions difficult, if not impossible, to imagine.

Against this pessimistic conclusion, the constitutive marginality of the subject might lead us to envision a structured technological system that is always limited, surrounded "on all sides," by an excess of meaning that it cannot control. The subject's exclusion would here establish the condition for a permanent outside, an unincorporated, unmastered surplus with a potential for disrupting, breaking into, the internal organization of the structural

1. Michael Benedikt, "Introduction," in *Cyberspace: First Steps,* ed. Michael Benedikt (Cambridge, Mass: MIT Press, 1992), 1.

2. See, for example, Michel de Certeau, *The Practice of Everyday Life,* trans. Steven Rendall (Berkeley: University of California Press, 1988), xvii.

PAGE 160, OPPOSITE PAGE

system. Within this vision, cyberspace could never be grounded in any single unifying principle of organization: the exclusion of the subject would prevent such a totalization. Instead different configurations of the technological relationship would emerge, depending on contingencies developed from outside the system. In this formulation, individual subjects are able to enter from *anywhere*, but "any" would now refer to the system's own failure to view (or even predict) the subject's actions in advance of this entry. Thus our critical attention shifts from a concern about *who* the individual users are (within the system, my phantom identity may be whatever, however, I want it to be) to questions about *where* they are coming from (and *how* they manage to constitute themselves) within an incomplete, ever expanding system called cyberspace.

What, if any, is the *place* of the subject?

To speak about place within this formulation, the place of the subject *in relation to* cyberspace, we are led to consider the problems of an interface. Developed, in part, to enhance the marketing of computers, interface technologies (the graphic layout of individual screens, the "mouse," interactive icons) are conceived as a means to make "users" of subjects. The goal of interfacing is to achieve an ideal transparency: to encourage a passage from outside to inside by reducing sensations of alienation and intimidation. But by marking the moment of a certain solicitation (a seduction arising from the technology's desire to be used) the interface implies also the *lack* of the system. As such, the point of access for individual users can also be seen as the limit inherent in any attempt to envision technological systems as a fully positive spatial order. In relation to cyberspace, we can say that the gap opened up at the edge by the interface corresponds with the position of the subject at a place of a structural exclusion. In accounting for the interface *within* the descriptions we give to cyberspace, we can begin to develop an attitude that expands the potential for different forms of relationships developed out of the dynamic systems of the technology. These expanded relationships (relationships of receivership, circulation, and inclusion) lay bare not only a highly diverse structural complex but, simultaneously, the degree to which the system remains open to disruption, inconsistent and unpredictable.

PAGE 164–65

These attitudes toward access and use bring us close to the ideas inherent in hacker subcultures.[3] Positioning themselves against the consistent, bureaucratic use of computer technology (in part, hackers operate against the thoughtless, repetitive practices that guarantee the spatial quality of institutions and virtual communities), the hackers' primary goal is to break into esoteric or purposefully hidden codes. A successful hack amounts to a form of attack aimed at the point of a system's inconsistency. (Breaking and entering is the thrill, and information is the goal.) Central to hacking, then, is a belief in a ubiquitous, even a constitutive, inconsistency – *constitutive* because it is an integral part of the activity of programming itself. The outcome of a successful hack depends on where the hacker chooses to look for inconsistencies. This depends in turn on the relationship to a program and cannot be reduced to any general conceptual contradiction of the system. The individual identity of the hacker is not reliant on a name. Rather, it is a set of attributes that arises at the point of break-in, but that can only be identified later through a specific style, an *authorship*. Within a terrain of digital data and flows of information, the visibility of a successful hacker is established only as an effect of a presence that already has passed; an identity is known only through its specific history of influence on the system.

If hacking actualizes an attitude toward the political (and this, it seems, is exactly what is involved in practices whose goal is systemic rupture), it does so by focusing its attacks

3. See Slavoj Zizek, "From Virtual Reality to the Virtualization of Reality," in *Peter Weibel: On Justifying the Hypothetical Nature of Art and the Non-Identicality within the Object World* (Köln: Galerie Tanja Gunert, 1992), 131–32.

against existing systems of repetitive signification. As such, and even in its most abstract form, hacking represents a politics of activism and immersion, accessing and exploiting available (although sometimes invisible or suppressed) information.

It is not difficult to locate antecedents for the project of breaking into (occupying/exploiting) the space created by frameworks of media technology. For example, if we limit our focus, our backward glance, to a generation of Americans who grew up with television, we can summon the figure of Abbie Hoffman, whose writings, lectures, and (exemplary) political spectacles attempted to make clear that the place of modern politics was greater, more expansive, than that which could be contained by the city's streets and designated public forums:

> If you want to reach hundreds of thousands or millions of people, you have to use the media and television. Television has an immense impact on our lives. We don't read, we just look at things. We don't gather information in an intellectual way, we just want to keep in touch. [But] as bad as it is, television has the ability to penetrate our fantasy world. . . . We in New England would not have known there was a civil rights movement in the South. We would not have known racism existed, that blacks were getting lynched, that blacks were not getting service at the Woolworth's counter, if it hadn't been for television.[4]
>
> Throwing out money at the Stock Exchange or dumping soot on the executives at Con Edison or blowing up the policeman statue in Chicago immediately conveys an easily understood message by using the technique of creative disruption. Recently, to dramatize the illegal invasion of Cambodia, 400 Yippies stormed across the Canadian border in an invasion of the United States. They threw paint on storm windows and physically attacked residents of Blair, Washington. A group of Vietnam veterans marched in battle gear from Trenton to Valley Forge. . . . Dying [sic] all the outdoor fountains red and then sending a message to the newspaper explaining why you did it, dramatizes the idea that blood is being shed needlessly in imperialist wars. A special metallic bonding glue, available from Eastman Kodak, will form a permanent bond in only 45 seconds. Gluing up locks of all the office buildings in your town is a great way to dramatize the fact that our brothers and sisters are being jailed all the time. Then, of course, there are always explosives which dramatically make your point and then some.[5]

4. Abbie Hoffman, "Reflections on Student Activism (1988)," in Abbie Hoffman, *The Best of Abbie Hoffman* (New York: Four Walls Eight Windows, 1989), 417.

5. Abbie Hoffman, "Free Communication," in Hoffman, *The Best of Abbie Hoffman*, 239.

Hoffman's strategies for producing alternative news and media events (using the news to "advertise the revolution") imply a qualitative difference between media structures and their informational contents. He stressed television as a system in place, ready to be used by anyone who could provide dramatic software (soft goods) that would entice its general public "readership." As part of the home, it functioned as a medium for delivering events from the street to the home. Thus, the goal was to be on TV, to find one's platform — a "place" — and to use the screen as a delivery site for the dissemination of alternative political information.

Arguably, this response to the media's call, this desire to enter and "be there" as content, can be placed within the frame of an Althusserian ideological interpellation. (The content we enact for media presentation is a mode of how we recognize our position as an [interested] agent of the social process, how we experience our own commitment to ideological causes.) But in another register, Abbie Hoffman's screen image was working to make visible the *absence* of any term that could be used to confirm American culture. Individual and collective identities, family and social life, civic responsibility: the American dream was exposed as a fantasy space, an ersatz public sphere. Perhaps more than anything else the

image of Yippies represented the fact that the nation, America, as a field of shared and unified values was disappearing:

> We do not wish to project a calm secure future. We are disruption. . . . We are cannibals, cowboys, Indians, witches, warlocks. Weird looking freaks that crawl out of the cracks in America's nightmare. Very visible and, as everyone knows, straight from the white middle-class suburban life. . . . Long hair and freaky clothes are total information. . . . Blank space, the interrupted statement, the unsolved puzzle, they are all-involving.[6]

> The ground you are standing on is a liberated zone, defend it.[7]

Hoffman consistently recognized the importance of visual culture to the production of recorded history. His refraction of politics into television's visual culture was not an alternative to political speech but a means by which individuals might attempt to return to their public representations something of their outrage, their own sense of organization, and their impatience for radical change. It becomes clear that clothes and attitudes, turns of speech and visual gestures, represent a will for exaction – an evacuation and the expression of a status outside the dominant system. Instead of the previously identifiable places of public activity, television would bear witness to an uneven field of cultures that overlap and subsequently express a certain volatility. What was being enacted was precisely the unfinished quality, the *impossibility*, of any project whose goal is the production of a singular, unified public sphere.

In this sense Yippie ideas exemplify the place of the individual subject within technology's expansion and dislocation of public space. Of course, the coordinates of such a place can never be mapped nor even reduced to the "Yippie" or "hacker." Relative to an ever expanding technological system, what is emerging for the subject is a place that is actually no place at all. Masked by the effects of its actions toward an encodable surface, the subject is here marked with the *status* of an outsider who is incommensurate with the forms of the system inside. And this definition, this status as radical outsider, gives to the public act its condition of existence within the contingencies of breaking and entering, hacking and occupying.

In the 1960s the terminology *going underground* could be used to signify the radical externality of the place of the subject, but it also suggested the careful attention that individuals paid to their own visibility or invisibility. By remembering these individuals, their performances and disappearances, it may be that we can begin to formulate new images of our own public lives: *the public*, perhaps, in the effects of an experience of disruption and incongruity; the entrance of alterity into the everyday life of the individual subject. In this regard, the fact that Abbie Hoffman's public life was also evidence of a place outside the American dream is evidenced and memorialized by the presence of almost sixty-six thousand pages of FBI files[8] – an identity that cyberspace can only hope to miniaturize.

6. Abbie Hoffman, "Yippie! – the Media Myth," in Hoffman, *The Best of Abbie Hoffman*, 51.

7. Abbie Hoffman, "Free Is the Revolution," in Hoffman, *The Best of Abbie Hoffman*, 84.

8. Hoffman, "Reflections on Student Activism (1988)," 393.

PAGE 168–69, 171

DARA BIRNBAUM IS A NEW YORK-BASED ARTIST AND INDEPENDENT VIDEO PRODUCER. IN 1989 SHE COMPLETED RIO VIDEOWALL (ATLANTA, GEORGIA), A LARGE-SCALE, OUTDOOR, INTERACTIVE VIDEO INSTALLATION THAT COMBINES DOCUMENTARY FOOTAGE AND SATELLITE RECEIVERSHIP. SHE HAS RECENTLY BEEN COMMISSIONED TO CREATE FOUR GATES FOR ST. PÖLTEN, AN INTERACTIVE INSTALLATION FOR THE NEW GOVERNMENT CENTER FOR LOWER AUSTRIA, DUE TO OPEN IN 1996.

SCOTT LYALL IS AN ARTIST WITH A BACKGROUND IN LAW AND ECONOMICS. HIS RECENT SITE-RELATED INSTALLATION WORK, PLOT, ADDRESSING ISSUES OF SCULPTURAL PLACE, MAPPING, AND THE CRITICAL INTERPRETATION OF LEGAL TEXTS, WAS EXHIBITED IN NEW YORK CITY AND HOUSTON. HE CURRENTLY WORKS AS AN ASSISTANT TO DARA BIRNBAUM.

MEDIA'S CONTINUOUS AND DISCONTINUOUS FORMS

In *Inszenierte Imagination*. Ed. Wolfgang Müller-Funk and Hans Ulrich Reck.
Vienna/New York: Springer, 1996, pp. 185–97.

Media's
Continuous
and
Discontinuous
Forms

Dara Birnbaum

Edited transcription.
Presentation + Screening.
November 18, 1995.
Symposium *Inszenierte
Imagination*
ORF-Funkhaus, Studio 3.
Wien, Austria

I have with me today many historical images which I feel will be supportive and illustrative of those materials and statements presented at this Symposium. I have chosen not to simply present my own work, since I want to give you an expanded range of exemplary material which seems to exhibit the preconditions of Virtual Reality and Cyberspace.

The quickest introduction to my position can be revealed through selected pages from a book, which I produced in 1992. It is composed of poster images recycled from the events of *Mai '68*. The dedication of the book states: "To those people who originated these anonymous street posters" and the book is entitled *Every TV Needs A Revolution*. I think the next step to take is: "Every laptop, Every Notebook, and Every Think Pad" needs its own revolution and evolution. For from evolution, with consciousness, hopefully there would be Revolution: how one challenges dominant structures and methodologies of technology, its subsequent statements, ideologies, and forms of representation.

185

Every TV Needs A Revolution: The cover of the *Nouvel
Observateur* from May, 1968, inspired the creation of
one of the anonymous street posters *sois jeune et tais toi.*
This poster, as well as the poster *information libre,* serve
as critical commentaries on "Free Speech," as well as its
relationship to the Media: that, in fact, there is no sense
of *free information.* The feeling was that the media is not
seen as an act of liberation, but as an act of censorship.
In the poster *la beauté est dans la rue,* the statement is
"Beauty is in the Streets" – that a demonstration of
selfhood and individuality had to be accomplished
through a sense of corporeal identity. The idea was that
the individual had to take himself or herself into the
street, amongst others with similar points of view; to see
what could actively be done.

The idea of physical evidence, that "there are many
of us out there" (as with the Chinese Student protests
of 1986–1989, which culminated in the occupation of
Tiananmen Square), meant that by acknowledging each
other through *presence,* one could bring about political
identity and revolutionary movement. Now with the
computer, the Internet and related developments, it
becomes much more about a sense of the *invisible: to
be visible, you must become invisible.* With the Internet,
for example, there is a sense of *democracy:* that everyone
can eventually "surf the net;" but my feeling is that the
sense of freedom may, in fact, be false. That informa-
tion, supposedly free, is a generalization which only
arouses suspicion. So my tactic – since I am a "child of
the '60s" – was to throw a stone at the TV set, at the
Media.

186

In the original *Mai '68* street poster, *la beauté est dans la rue,* this stone, or rock, looked to me like a TV. In the book, *Every TV Needs A Revolution,* I also expanded this concept to breaking through the barbed wire of networking; of inter-communication.

So given these life experiences, as personal history, I began to work with my own form of sampling which in the '70s, was called "appropriation," as a critical strategy in the Arts. The first videowork from 1978, entitled *Technology/Transformation: Wonder Woman,* became quite well known. The work was installed in a storefront window, at H-Hair, Inc., NYC – a hair salon where people would go to transform *their* identity. In 1978, this was the only storefront window to have a monitor. Whereas in 1995, almost twenty years later, you can barely find a storefront in America without a monitor in the window. I asked the owner of the Salon if I could show *Wonder Woman.*

187

Dara Birnbaum

Even in this first work, a highly edited episode of the TV program *Wonder Woman, I* wanted to isolate and expose the representation of a woman who is trying to cut through her own (mirror image) identity. In the specific episode chosen, *Wonder Woman* is trying to uncover the method by which spies are taking secrets from Government Agents. The only way that she can find out this information is in a room surrounded with mirrors – this is the space she must break through.

When I started my work, in 1975–77, according to the Nielsen ratings the average American family was watching television approximately seven hours and twenty minutes a day. Many stereotypical images of women were represented during prime time, including that of *Wonder Woman*. Prime time was filled with such transformation series: *Bionic Women, Wonder Women, Six Million Dollar Man, The Hulk*. It was very interesting because half of these personages were going back in time in order to achieve their metamorphoses – like *The Hulk,* a primordial green guy: "Don't make me angry. You won't like me when I'm angry." Of course what he does is save mankind. *Wonder Woman* is Amazonian: her race is based back in time. She wears an American flag; a very scanty American flag. She already seems to represent the beginning of a Cyborg state. The parts of her that are similar to Cyborg are her wrist bracelets and helmet. However, they are not implants; I am only talking about a precondition. But she can spin around and transform her identity in one burst of light. Now if you take this further, that element of light can be any element which represents electro-magnetic fields of connection. I am not trying to say that there is anything preordained in this, I am simply stating that the type of networking which is now existent, those electromagnetic connections which occur as blindingly-fast bursts of light, already have been historically in place and structured by the mid-70s. The reason that I have continued with my work for the last 15 years, is that I did not know how to be *that woman*. I still don't know how to be her and I remain unsure that *implants* are what can assist me along the way.

188

I want to present to you some material which was widely programmed on MTV: the *Dire Straits* video "Money For Nothing." Precursor to Cyberspace: "Now look at them yo-yos that's the way you do it. You play the guitar on the MTV..." Then you get women, you get money, you get whomever you want and whatever you want. Whereas, we are in the labor-pool here – and you have to understand that the labor-pool is, in part, produced by the growing industry of Computer Graphics.

This *Dire Straits* video clip is from the mid-80s. Now, in the mid-90s, if we say instead of "We gotta move these refrigerators," "We gotta move these computers" or "We gotta move these laptops," it would not seem to be that different for me. In this mid-80s clip, they're saying:

"...Look at those guys... Wow. Rock'n'Roll is on other side..."

...Well, where did they go?

...They went into a micro-wave oven.

But the idea is: in Cyberspace where will one move into, and how will one express oneself? If you are an artist and you want to be heard, there seem to be very few industry-related choices. You always hope, in media, to go into *heavy rotation,* that' s where you want to be...

The point is – ten years ago this song made it to number one; the top song in America. Ten years later I can imagine young people – especially those who watch MTV – saying "I want my Cyber helmet," "I want my glove." I am not giving you answers; I am just expressing questions which were already evident a decade ago.

189

Dara Birnbaum

In one video clip, "Take on Me", which was done in 1985 for the group *a-ha* from Sweden (this song also reached number one in America) amazing things seemed to be happening: an awareness, perhaps even an ideological consciousness and a reflectiveness – which seems rarely to be exposed, or allowed, on MTV. It turns out that the clip had been produced by a woman who was previously an independent film-maker, but left her independent work to go into the industry; as many people did in the 80s. With a highly talented animator, who received his education at California Institute of the Arts, they produced a work based on cell animation. This was concurrent with the production of clips like "Sledge Hammer" by Peter Gabriel, which largely used claymation for its animated effects work. Everyone in the industry, at the time, seemed to be looking for the next new method of 3-D imaging to produce hit-imagery for hit songs.

These two cops (they just put cops on the Internet in the last few weeks) remain symbolic images which have been recycled throughout our cultural history: symbolic as with Cocteau – night riders of the underworld; and a kind of black power. What I find interesting is that in this clip line drawings are being used to talk about speed. And my question as an artist – or an independent producer, an independent voice – would be how to deal with, and represent, the increasing speed of technology – of information flow. How to cut through it; cut across it.

190

We are back in a 1950s cafe, *somewhere;* a comic book world of fantasy projection, where a hero is still to be found. Is it so different to look at a bulletin board on the Internet, in the 1990s, and say: "Where is *he?*" – He is *anywhere*. He is *everywhere*. But on the Internet *he* may end up being a *she;* being heterosexual, homosexual, probably a-sexual is more likely, in this era where identity seems increasingly fractured. As with the 'Doppelgänger', identity is on the other side; one looks for the other. It is a very easy *Other* in this case: it is the other of male to female.

He wants to take her into his world; to pull her in. He wants to get her inside *with* him. Perhaps this attempt is not that different from our newly accomplished entries into the world of Cyberspace. *She* comes into *his* world. The interesting thing is that his world is also *collapsing:* it is not a perfect world. It is not a world of blue sky and green grass. This *is* a world where lines can't keep still, planes are constantly shifting. She is in a 'reality,' but secondarily, entering into *another* reality. He, on the other hand, becomes *real* only by residing inside of the landscape, the world of the comic book. But who is more *real?* Is his identity more real when he is behind (enclosed within) the picture frame, or when he is trying to appear from outside of it: freed from it.

191

There is only one hole to jump through, or not, which punches a way through this reality. She is pushed through; their world has already crumpled. It's in the waste basket. The mirror is broken. The walls of the construct are already caving in on them, but why? Because something external to it, a woman serving coffee, has crumpled the pieces of paper... the fabric which, what is now their world, is made out of... and now it all must pass away. How does one get out of this space? How did *Wonder Woman* get out of her endless transformation? They jump through the hole that he has created – with the same tool that broke the mirror. It is a primitive tool, like a club; it has been around forever. She is in pain for this sense of *Other*. He is trying to come out of that flattened space that has been created for him by line drawings – cell animation. But what space will he end up in? Is it to have a cup of coffee in an American diner with her? But he can't break through it... And that is my fear actually for the onslaught of the Internet. Internetting... working only through networks on the computer. The trap may be in locating where and how reality really strikes you. For example, the conclusion of this *a-ha* cartoon-drama is that you don't know if he can ever break out of his space and cross the threshold to the other side, where she is waiting for him.

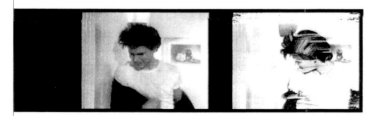

192

This is a silent black and white animation work of Max Fleischer from 1924. I believe Fleischer to be one of the greatest animators of this century. The *Out of the Ink-Well* series features his character, *Coco the Clown.* This specific cartoon, entitled "Cartoon Factory," already foretold the future of mechanical reproduction becoming 'electrified'. The ink bottle gets speedy through the addition of an electrical cord. Everything is getting faster; Fleischer jolts Coco into action. Now he is wired; it is 1924. Fleischer draws a mechanical machine; it was too fast, too speedy, for Coco to be electrified. Coco likes the idea of a mechanical machine better. His desire is better fulfilled through a mechanical animation machine. This machine has both an animation arm and an erase arm attached to it.

In 1987, when I was asked by MTV if I wanted to be one of the first six artists commissioned by them to do an *Artbreak* I got all of 30 seconds to say something within their *supermarket* of imagery. This dilemma can become only more profound within the newly developed contexts of Virtual Reality and Cyberspace – with its increasing profusion of imagery. For the *Artbreak* I found someone who worked for Fleischer's Studio in the 1940s. We were thus able to draw new cell animation, which was used to complement and provide a different ending to the storyline than that of the original cell animation which Fleischer created. To get the money from MTV, I had to show MTV's logo for at least one second out of the thirty second spot. Most artists put the logo at the beginning, or the end, of their work. I thought that you would have much more control if you include their logo within your 30-second clip, as part of the substantive content. When working with Buzzco Studios in NYC,

193

who drew the new animation, I said to them: here are
my sketches for what needs to be generated in this clip.
I need you to first do a "pencil test" for me. For example,
the MTV logo has to appear out of the kiss. Then they
would sketch this sequence, in pencil, from my prepared
drawings. Of course, when they first drew it, it seemed
to reflect what I feel to be the ideology of the industry.
They had their own, interpretative way of proceeding.
They drew the logo very big; almost occupying the whole
screen. I wanted it considerably smaller. Buzzco que-
stioned my decision: "...but aren't they paying your bills
here?" And, I responded: "They will pay the bill anyway.
Don't worry about it. I can direct *where* it goes and *how*

 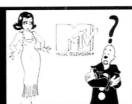

it will appear." A fortunate part of the contract was that
if I showed the logo for one second, I was allowed to do
whatever I wanted. In 1987, censorship in the arts had
become more prevalent in America, and all of a sudden
it seemed as if you were less censured in these "spots" in
the industry than in the arts. The brilliance of *Coco the
Clown* is that, in 1924, Fleischer was already saying: I am
drawing a character – but that character, that projection
of myself, is going to get angry at me. That was Coco's
job, all the time, to say: I am not going to let you animate
me any more. I am going to take the pen in my own
hand, and I will challenge you by animating myself. In
my work I wanted to emphasize this concern and
attempt to push it even further. In my *Artbreak,* here the
pen is animated to continuously attack each newly drawn
representation of Woman. The mechanical arm of the
animation machine draws a stereotyped image, derived
from representative fashion linedrawings from the

194

1930s, 40s, 50s, 60s, 70s. Each image is subsequently attacked by the machine – destroying the created image and replacing it with another 'stylized look'. Eventually, the woman grasps the attacking pen nib, she wrestles with it and the ink well spills. Ink rises from the overturned well. Captured within each bubble is a mass media, MTV-image, digitally created of women from 1987 when the spot was commissioned: a "dumb blond" in a golden gilded picture frame; a metal worker; Tina Turner flapping her wings; the image of a "headache" from the *a-ha* video; Whitney Houston; and ZZ Top – who chose to create a representation of a woman cut in half; only her legs are walking around, and pasted on top of her severed body is a "walk/don't walk" sign.

In contrast, this is an MTV break that I was commissioned to do in 1992, to celebrate the 500th year Anniversary of the, supposed, founding of America by Christopher Columbus. It was a work commissioned for public space – which for the video section of the *Transvoices* project was seen as MTV in America and Canal Plus in France.

195

Needless to say these spots, which were created by selected American and French Artists, did not go into *heavy rotation* on MTV. I wanted this work to speak from – and question – the position of "I". It is very hard to speak from the position of "I" in a highly engaged technological society, yet it is a position which we cannot afford to loose in coming generations. "I" pledge allegiance to what? In this specific case, when the work was commissioned, the organizer said to me: You're American. It is now 1992. In 1492 Columbus founded America. We're asking you to make a personal statement regarding your viewpoint on the celebration of this 500th Anniversary. Of course a lot of us thought: You don't find a country that is already "founded." Since the land was already occupied by indigenous American tribes, there was already something pre-existent. Then there was the establishment of French colonies, English colonies, and territorial expansion.

I am now creating and producing a work for Austria in which I will create four new *electronic* gates for St. Pölten. The video imagery that appears on each gate will show that in Austria – just as with *Transvoices* 500th year celebration of the "founding of America" – you don't just open, on May 1996 (the one-thousand year Anniversary of St. Pölten), a new Government Capital of Lower Austria. These electronic gates will be designed to interact with the presence of people passing through, or working within, the new Government Complex. As you approach, you activate each gate to reveal the historical changes of the physical – thereby, political – boundaries of Austria. Most specifically, these "mappings" will relate

196

St. Pölten to the larger State of Austria; in other words the location and area of St. Pölten since Roman times up until the present.

It seems important, during this frontier period of Cyberspace, to realize that not everything is immediately *visible* to us. Sometimes that which is *invisible* – or visible only through symbolic and graphic identification – remains that which is most important, such as: global warming; acid rain; hazardous industrial waste; air pollution; endangered species; and at this time we must, of course, include Aids and related deaths. We could say that we may, in fact, be facing an era of seemingly non-controllable viruses that threaten both our computer systems as well as our biological systems. In the late 1980s, computer viruses were seen to become increasingly threatening: a newly formed, nearly invisible, *terrorism.* All of a sudden instead of "taking to the streets" – a strategy of the 1960s – or utilizing public pathways in a visible fashion, what seemed to be happening was that one needed to look toward a different street: not the urban streets and infrastructures which were already familiar to us in America and Europe, but the pathways and networks of the computer. In the late 80s in America, *terrorism* now expanded its definition to attacks issued through the utilization of computer viruses. To become a *terrorist* can now mean to become *invisible.*

197

Art | *Theory* | *Criticism* | *Politics*

OCTOBER

90

David E. James	*Hollywood Extras: One Tradition of "Avant-Garde" Film in Los Angeles*
Nicolas Losson	*Notes on the Images of the Camps*
Jean-Louis Comolli	*Documentary Journey to the Land of the Head Shrinkers*
Kathryn Chiong	*Kawara On Kawara*
Birgit Pelzer	*Dissociated Objects: The Statements/ Sculptures of Lawrence Weiner*
Dara Birnbaum	*Elemental Forces, Elemental Dispositions: fire/water*

$10.00 / Fall 1999 *Published by the MIT Press*

**ELEMENTAL FORCES, ELEMENTAL DISPOSITIONS:
FIRE/WATER**

October, no. 90 (Fall 1999), pp. 109–35.

Elemental Forces
Elemental Dispositions:
fire/water

DARA BIRNBAUM

> *". . . under duress and beyond duress, in answer to the entreaty which strips and flays me and destroys my ability to answer, outside the world, where there is nothing save the attraction and the pressure of the other."*

—Maurice Blanchot, *The Writing of the Disaster*

Force can be seen as elemental destruction. It can be seen as that which overpowers, takes over. It can be that which produces a change in a body's state of rest or motion. In itself, force can be perceived as *body* (e.g., the armed forces; the police). Yet, counter to force, *reaction* also empowers, giving back to the body its elemental disposition: its capacity for expression.

The portrayal of force, action and reaction, can be seen to infiltrate various forms of mass media, pan-culturally. It seems a necessary component to the portrayal of the everyday. While the means of drawing oppositional elements varies through cultures, it also remains surprisingly the same. Perhaps a similarity of need yields the consistency within varying representations.

The need to portray reaction, to enforce one's position upon action, is a necessary part of the representation; a key component of the narrative flow. Reaction is, after all, not necessarily regression: it can be seen as the ability to grimace at the primary factors of life that are outside of one's control. The victim is no longer *victim*, in the sense that the strength of the reaction, as expressed through bodily gesture, can overpower even the worst of the disaster. The representation of reaction restores a sense of humility to the disaster; it re-establishes a body for its victim. Even in the most stereotypical of signs, the grimace can be seen as a form of emancipation.

Animation operates as a closed system of representation, of cells, each of which posits its ability for extension in a multitude of dimensions. This basic structure, of cell after cell, allows for endless expressions—it forges a

OCTOBER 90, Fall 1999, pp. 109–135. © 1999 Dara Birnbaum.

flow which leads up to and away from an event that is usually cataclysmic. The moment of the cataclysm acts as a pause within the linear flow. Each cell acts as a component vital to the corporeal body of the text. When a cell is isolated, taken out of its body and dislocated, narrative moments are forced to recombine into a succession of violent (violated) events. Each extracted cell can be seen as a moment which suspends *becoming*. Aligned cell by cell, these suspended moments perform a narrative of *intensities*.

> There is an entropy proper to sign systems that diminishes their capacity to signify. . . . As long as the forces are at work, no sign emerges. . . . We see that the meaning of the sign has to do with a differential gap resulting from the relation between forces.[1]

By dislocating and reconfiguring disaster within a strip composed only of similar elements (disaster upon disaster), the reader is provided with a consistent narrative. Piled upon each other, without abyss, cells upon cells command the reader to continue within the narrative flow. Yet, at the same time, the reader is also asked to pierce each frame in order to extract each artist's hand, to recognize individualized composition and stylized *look*. Within a newly engaged series, singular strokes of individuality are combined in order to take a larger look into the generalized issues of the subject matter.

1 Brian Massumi, *A User's Guide to Capitalism and Schizophrenia: Deviations from Deleuze and Guattari* (Cambridge: The MIT Press, 1992), p. 140.

NOTE:

The following animations have been extracted from comic book series that originated in the United States, Belgium, Holland, and Japan. The imagery has been cropped and dislocated from its original placement within the narrative. Further alterations were made to the aspect ratio of selected images in an attempt to provide a more consistent "frame" for the viewer; a more seamless reading of the new script. Almost all of the chosen animation cells have been reduced from color to black-and-white due to the limitations of publishing. In addition, the black-and-white renditions of these images have been altered by adjustments to gray-scale, as well as brightness and contrast ratios, again to provide a more fluid framework for reading.

SELECTED BIOGRAPHY AND BIBLIOGRAPHY

SELECTED BIOGRAPHY

BORN

New York, 1946.

EDUCATION

1976 Certificate in Video/Electronic Editing, Video Study Center of Global Village, New School for Social Research, New York, NY, US

1973 B.F.A., Painting, San Francisco Art Institute, San Francisco, CA, US

1969 B. Arch., Carnegie Mellon University, Pittsburgh, PA, US

SOLO EXHIBITIONS AND SOLO SCREENINGS

2010 "Dara Birnbaum: The Dark Matter of Media Light," Museu de Arte Contemporânea de Serralves, Porto, Portugal, March 26–July 4

2009 "Dara Birnbaum: The Dark Matter of Media Light," S.M.A.K.—Stedelijk Museum voor Actuele Kunst, Ghent, Belgium, April 4–September 6

"Dara Birnbaum: First Statements and Then Some . . .," Wilkinson Gallery, London, UK, October 14–November 22

"Dara Birnbaum: *Technology/Transformation: Wonder Woman*," Center for Contemporary Art Kitakyushu, Kitakyushu, Japan, May 25–June 27

2008 "It's Not Only Rock 'n' Roll Baby!," Bozar Expo, Center for Fine Arts, Brussels, Belgium, June 20–September 14

"To Illustrate and Multiply: An Open Book," MoCA Pacific Design Center, West Hollywood, CA, US, October 19, 2008–March 1, 2009

2007 "Art in Motion" (organized in association with EAI—Electronic Arts Intermix, New York, NY, US), Y-3, Miami, FL, US, December 5–8

"Dara Birnbaum: *Technology/Transformation: Wonder Woman*," MoMA—The Museum of Modern Art, New York, NY, US, January 27

2006 "Dara Birnbaum: *Technology/Transformation: Wonder Woman*," The Land of the Free and the Home of the Brave series, Kunsthalle Wien, Vienna, Austria, December 1, 2006–February 21, 2007

2005 "Dara Birnbaum" (screening, in association with the S.M.A.K.—Stedelijk Museum voor Actuele Kunst, Ghent, Belgium), Art Cinema Off Off, Ghent, Belgium, February 15

2003 "Erwartung/Expectancy," The Jewish Museum, New York, NY, US, September 5, 2003–January 4, 2004

2002 "Erwartung," Marian Goodman Gallery, New York, NY, US, January 8 –February 9

2001 "Erwartung," Galerie Marian Goodman, Paris, France, February 3–March 3

1999 "(A)Drift of Politics," Leo Koenig Inc., Brooklyn, NY, US

1997 "Dara Birnbaum: Videofilme aus den Jahren 1978 bis 1990," Künstlerhaus Bethanien, Berlin, Germany

"Hostage," Rena Bransten Gallery, San Francisco, CA, US

1996 Retrospective screening, Museum für Moderne Kunst, Frankfurt am Main, Germany

1995 "Dara Birnbaum" (retrospective exhibition), Kunsthalle Wien, Vienna, Austria

"Dara Birnbaum" (retrospective exhibition), Norrtälje Konsthall, Norrtälje, Sweden

1994 "Damnation of Faust, 1984/1993," Rena Bransten Gallery, San Francisco, CA, US

"Films at Portikus: Dara Birnbaum," Portikus, Frankfurt am Main, Germany

"Hostage," Paula Cooper Gallery, New York, NY, US

1992 "Damnation of Faust," Rhona Hoffman Gallery, Chicago, IL, US

Retrospective screening, Hamburger Kunstverein, Hamburg, Germany; Kölnischer Kunstverein, Cologne, Germany; Neues Museum Weserberg, Bremen, Germany

1991 "Dara Birnbaum. Canon: Taking to the Street (Part One)," Rena Bransten Gallery, San Francisco, CA, US

"Tiananmen Square: Break-In Transmission," Josh Baer Gallery, New York, NY, US; Rhona Hoffman Gallery, Chicago, IL, US

1990 "Dara Birnbaum," IVAM—Institut Valencià d'Art Modern, Centre del Carme, Valencia, Spain

"Dara Birnbaum: Retrospektiivi," Kuopio Videofestivaalit, Helsinki and Kuopio, Finland; Videowall, Main Rail Station, Helsinki, Finland

1989 "Dara Birnbaum . . . From Appropriation to the Sublime" (visiting artist screening series), The Art Institute of Chicago, Chicago, IL, US

"Rio Videowall," Rio Shopping and Entertainment Centre, Atlanta, GA, US

"Video Texte," 707 e.V., Frankfurt am Main, Germany

1988 "Liquid Perception," International Center of Photography, New York, NY, US

"Many Charming Landscapes: The Video Tapes of Dara Birnbaum," Pacific Film Archives, Berkeley, CA, US

1987 "Video Feature," International Center for Photography, New York, NY, US

1986 Retrospective screening, Kunsthaus Zürich, Zurich; Kunstmuseum Bern, Bern, Switzerland

1985 Retrospective, First International Video Biennale, Vienna, Austria

Retrospective screening, The American Center, Paris, France

"Talking Back to the Media," Time Based Arts, Amsterdam, Netherlands

"Dara Birnbaum", Museum für Moderne Kunst, Frankfurt am Main, Germany

1984 "Currents" and "PrimeTime," The Institute of Contemporary Art, Boston, MA, US

"Dara Birnbaum," Le Coin du Miroir, Dijon, France

Retrospective screening, Cinematheque/Videotheque, Institute of Contemporary Arts, London, UK

"The New American Filmmakers Series," Whitney Museum of American Art, New York, NY, US

"Rencontres Internationales Vidéo de Montréal—Vidéo 84," Galerie Graff, Montreal, QB, Canada

1983 "Dara Birnbaum" (retrospective screening), Musée d'art contemporain, Montreal, QB, Canada

1982 Retrospective screening, Museum van Hedendaagse Kunst, Ghent, Belgium

"Vidéo? Vous avez dit vidéo?," Musée d'art moderne de Liège, Liège, Belgium

1980 "Dara Birnbaum," AIR Gallery, London, UK

"Dara Birnbaum," Anna Leonowens Gallery, The Nova Scotia College of Art and Design, Halifax, NS, Canada

"Dara Birnbaum," The Kitchen Center for Video and Music, New York, NY, US

"Local TV News Analysis for Cable Television" (with Dan Graham), Television by Artists, A SPACE, Toronto, ON, Canada

1979 Multidisciplinary Program, P.S. 1, Long Island City, NY, US

1978 Artists' Reading Series (with Suzanne Kuffler), Franklin Furnace, New York, NY, US

"Dara Birnbaum," Centre for Art Tapes, Halifax, NS, Canada; Franklin Furnace, New York, NY, US

"Dara Birnbaum," The Kitchen Center for Video and Music, New York, NY, US

1977 "Dara Birnbaum," Artists Space, New York, NY, US

GROUP EXHIBITIONS

2010 "Changing Channels—Kunst und Fernsehen 1963–1987," MUMOK—Museum Moderner Kunst Stiftung Ludwig, Vienna, Austria, March 5–June 6

"CUE: Artist's Videos," Vancouver Art Gallery, Vancouver, BC, Canada, January 23–March 21

"Inaugural Group Show," BROADWAY 1602, New York, NY, US, February 21–April 10

"Mixed Use, Manhattan: Photography and Related Practices 1970s to the Present," Museo Nacional Centro de Arte Reina Sofía, Madrid, Spain, June 10 –September 27

"Street and Studio: Von Basquiat bis Séripop", Kunsthalle Wien, Vienna, Austria, June 25–October 10

2009 "Artworks that Ideas Can Buy: A Project by Cesare Pietoiusti," Wilkinson Gallery, London, UK, May 29–July 9

"Cargo / Cargo Manifest / Cargo Vision," Autocenter, Berlin, Germany, September 19–October 17

"Images & (re)presentations—The 1980s," Part 2, Magasin—Centre national d'art contemporain de Grenoble, Grenoble, France, May 31–September 6

"Moving Image Since 1965", The National Museum of Modern Art, Tokyo, Japan, March 31–June 7

"The Pictures Generation, 1974–1984," The Metropolitan Museum of Art, New York, NY, US, April 21–August 2

"Play—Film and Videos," Moderna Museet, Stockholm, Sweden, February 7–April 19

"Reflections on the Electric Mirror: New Feminist Video," Brooklyn Museum, Brooklyn, NY, US, May 1, 2009–January 10, 2010

"There Goes My Hero," The Center for Book Arts, New York, NY, US, September 23–December 5

"Waiting for Video: Works from the 1960s to Today," The National Museum of Modern Art, Tokyo, Japan, March 31–June 7

"Yebisu International Festival for Art & Alternative Visions," Tokyo Metropolitan Museum of Photography, Tokyo, Japan, February 20–March 1

2008 "Agency: Art and Advertising," McDonough Museum of Art, Youngstown State University, Youngstown, OH, US, September 19–November 8

"Alternating Beats," The RISD Museum, University of Rhode Island, Providence, RI, US, October 17, 2008–February 22, 2009

"Happy Together, an American Dream," Centre d'art Bastille, Grenoble, France, November 15, 2008–January 4, 2009

"In Collaboration: Early Works from the Media Arts Collection," SFMOMA—San Francisco Museum of Modern Art, San Francisco, CA, US, March 22–June 08

"La invención de lo cotidiano," MUNAL—Museo Nacional de Arte, Mexico City, Mexico, November 27, 2008–March 15, 2009

"Market Forces. Part II: Consumer Confidence," Carriage Trade, New York, NY, USA, May 23–June 29; Galerie Erna Hecey, Brussels, Belgium, May 28, 2009–August 8, 2009

"Rock My Religion: The Crossroads between the Visual Arts and Rock, 1956–2006," DA2, Domus Artium 02, Salamanca, Spain, October 10, 2008–January 7, 2009

"Sonic Youth etc.: Sensational Fix," LiFE, Saint Nazaire, France, June 17–September 7; Museion—Museum of Modern and Contemporary Art, Bolzano, Italy, October 10, 2008–January 4, 2009; Kunsthalle Düsseldorf, Düsseldorf, Germany, January 31, 2009–April 26, 2009; Museum of Malmö, Malmö, Sweden, May 29, 2009–September 21, 2009

"La Vidéo, un art, une histoire, 1965–2007," Musée Fabre, Montpellier, France, October 25, 2008–January 18, 2009

2007 "30/40: A Selection of Forty Artists from Thirty Years at Marian Goodman Gallery" (curated by Benjamin H. D. Buchloh), Marian Goodman Gallery, New York, NY, US, September 10–October 13

"Beauty and the Blonde: An Exploration of American Art and Popular Culture," Mildred Lane Kemper Art Museum, Washington University, St. Louis, MO, US, November 16, 2007–January 28, 2008

"Broadcast," The Contemporary Museum, Baltimore, MD, US, September 8–November 18; Museum of Contemporary Art Detroit, Detroit, MI, US, September 12, 2008–December 28, 2008; Pratt Manhattan Gallery, New York, NY, US, February 20, 2009–May 2, 2009; Picker Art Gallery, Dana Arts Center, Colgate University, Hamilton, NY, US, February 2, 2010–March 12, 2010

"Commemorating Thirty Years," Rhona Hoffman Gallery, Chicago, IL, US, May 18–June 16

"Extended Animation: Digital Effects, Corporate Logos and Style," Gallery F15, Moss, Norway, September 1–November 11

"First Generation: Art and the Moving Image, 1963–1986," Museo Nacional Centro de Arte Reina Sofía, Madrid, Spain, November 7–April 2

"The Future of Futurism," GAMeC—Galleria d'Arte Moderna e Contemporanea, Bergamo, Italy, September 21, 2007–February 24, 2008

"Mind Hacking (Overloaded)," exhibition evening, Akademie Schloss Solitude, Stuttgart, Germany, November 17

"Passages du temps," Fondation François Pinault, Lille, France, October 16, 2007–January 1, 2008

"Personae: Two Decades of Feminist Video," Colby College Museum of Art, Waterville, MA, US, April 12–July 1

"Playback, Art, Clip, Video," ARC/Musée d'art moderne de la Ville de Paris, France, October 20, 2007–January 18, 2008

"Sounding the Subject/Video Trajectories: Selections from the Pamela and Richard Kramlich Collection and the New Art Trust," MIT List Visual Arts Center, Cambridge, MA, US, October 12–December 30

"Television Delivers People," Whitney Museum of American Art, New York, NY, US, December 12, 2007–February 17, 2008

"Vertigo: Il secolo di arte off-media dal Futurismo al web / The Century of Off-Media Art from Futurism to the Web," MAMbo—Museo di Art Moderna di Bologna, Bologna, Italy, May 6–November 4

"WACK! Art and the Feminist Revolution," MoCA—The Museum of Contemporary Art, Los Angeles, CA, US, March 4–July 16; P.S. 1 Contemporary Art Center, New York, NY, US, February 17, 2008–May 12, 2008; Vancouver Art Gallery, Vancouver, BC, Canada, October 4, 2008–January 11, 2009

2006 "100% Centennial," The Regina Gouger Miller Gallery, Carnegie Mellon College of Fine Arts, Pittsburgh, PA, US, January 20–March 5

"Art Metropole: The Top 100," The National Gallery of Canada, Ottawa, ON, Canada, December 1, 2006–April 1, 2007

"Arteast Collection 2000+23," Moderna Galerija, Ljubljana, Slovenia, September 22–October 22

"Artists & Icons", Independent Cinema Office, Kenilworth House, London, UK, November

"The Early Show: Video from 1969–1979," The Bertha and Karl Leubsdorf Art Gallery at Hunter College, New York, NY, US, March 16–May 11

"PHILIP," Project Arts Centre, Dublin, Ireland, November 10, 2006–January 13, 2007

"Primera generación: Arte e imagen en movimiento, 1963–1986," Museo Nacional Centro de Arte Reina Sofía, Madrid, Spain, November 7, 2006–April 2, 2007

"Re-Vision: Sampling als kulturelle Strategie / Re-Vision: Sampling as a Cultural Strategy," Edith-Ruß-Haus für Medienkunst, Oldenburg, Germany, November 25, 2006–February 4, 2007

"Revisions and Queries," Catherine Clark Gallery, San Francisco, NY, US, November 2–December 22

"La scorpeta del corpo elettronico: Arte e video negli anni '70 / The Discovery of the Electronic Body: Art and Video of the '70s," Galleria Civica Filippo Scroppo, Torre Pellice, Turin, Italy, January 26–March 26

"Smile Machines," Akademie der Künste, Berlin, Germany, February 3–March 19

"Space, Time and the Viewer: Installations and New Media in the IVAM Collection," IVAM—Institut Valencià d'Art Modern, Valencia, Spain, September 25, 2006–January 27, 2007

"To Prevent Scratches on the Wooden Floor, the Couch Was Put on Four Different Towels to Drag It to the Other End of the Room," Galerie Micheline Szwajcer, Antwerp, Belgium, March 17–April 22

"Transmediale.06 International Media Arts Festival, Smile Machines," Akademie der Künste, Berlin, Germany, February 3–March 19

2005 "La Collezione Video," Castello di Rivoli—Museo d'Arte Contemporanea, Turin, Italy, September 21–October 16

"Centre Pompidou Video Art 1965–2005" (traveling exhibition of selected works from Centre Georges Pompidou's New Media Collection), CaixaForum, Barcelona, Spain (under the title "Tiempos de Video 1965¬–2005"), September 28, 2005–January 8, 2006; Taipei Fine Arts Museum, Taipei, Taiwan, Republic of China ("under the title "New Media: An Art of Time and Space"), April 29, 2006–July 23, 2006; MAC—Miami Art Central, Miami, FL, US, September 20, 2006–December 10, 2006; MCA—Museum of Contemporary Art, Sydney, Australia, December 14, 2006–February 25, 2007; ACMI—Australian Centre for the Moving Image, Melbourne, Australia, March 22, 2007–May 27, 2007; Museu do Chiado, Lisbon, Portugal, October 17, 2007–January 6, 2008; Musée national d'art moderne, Centre Georges Pompidou, Paris, France, October 25, 2008–January 18, 2009

Contour, 2nd Biennial for Video Art, Mechelen, Belgium, September 17–November 20

"Fair Play: Manifestazione di videoarte," 1ª Edizione, Complesso di Santa Sofia, Salerno, Italy, June 12–19

"For Presentation and Display: Some Art of the '80s," Princeton University Art Museum, Princeton, NJ, US, March 19–June 12

"Intuition Box," Curator's Office Micro-Gallery, Washington, DC, US, May 7–June 18

"Lisboa Photo 2005. Estados da imagem: Instantes e intervalos / States of the Image: Instants and Intervals," Centro Cultural de Belém, Lisbon, Portugal, May 25–August 21

"Markers V—Poles Apart / Poles Together," 51st International Venice Biennale, Venice, Italy, June 12–November 6

"Mira cómo se mueven / See How They Move," Fundación Telefónica, Madrid, Spain, April 14–May 22

"Mixed Doubles: Birnbaum, Arcangel / Paper Rad," Forum Gallery, Carnegie Museum of Art, Pittsburgh, PA, US, March 26–June 5

"Positionen Feministischer Videokunst von den 70er Jahren bis heute," Teil 4, Tiroler Landesmuseum Ferdinandeum, Innsbruck, Austria, May 12

"Il potere delle donne / The Power of Women," Galleria Civica di Arte Contemporanea di Trento, Trento, Italy, March 11–June 11

"Regarding Mobility. Mobility as a Walk: Robert Walser," Fundación Telefónica, Madrid, April 14–May 22

"Regarding Terror: The RAF Exhibition," Kunst-Werke Institute for Contemporary Art, Berlin, Germany, January 30–May 16; Neue Galerie am Landesmuseum Joanneum, Graz, Austria, June 24–August 28

"September 11, 1973," Orchard, New York, US, September 11–October 23

"Single Screen Selections of Rare Film and Audio from the Pamela and Richard Kramlich Collection," FWM—The Fabric Workshop and Museum, Philadelphia, PA, US; Part I: June 18–November 5; Part II: October 8 – November 5

"Upstarts and Matriarchs: Jewish Woman Artists and the Transformation of American Art: 1970–Now," Shwayder Theater of the Mizel Center for Arts and Culture, Denver, CO, US, January 13–March 27

"Utopia Station @ World Social Forum," Porto Alegre, Brazil, January 26–31

"Videographies—The Early Decades from the EMST Collection", National Museum of Contemporary Art, Exhibition Hall "The Factory" of the Athens School of Fine Art, Athens, Greece; I Cycle, July 13–September 4; II Cycle: October 3–December 31

"Wonder Woman," FRAC Lorraine —Fonds régional d'art contemporain de Lorraine, Metz, France, February 5–May 1

2004 "Arte del Video: Il viaggio dell'uomo immobile / The Art of Video: Journey of the Immobile Man," Fondazione Centro Studi sull'Arte Licia e Carlo Ludovico Ragghianti, Lucca, Italy, March 21–May 24

"Col.lecció MACBA (XVI) / MACBA Collection (XVI)," MACBA—Museu d'Art Contemporani de Barcelona, Barcelona, Spain, October 14, 2004 –January 23, 2005

"Constructive Engagement," Ocularis, Brooklyn, NY, US, February 22

"Da li ste videli? Stedelijk Museum Amsterdam at Usce," MoCAB—Museum of Contemporary Art Belgrade, Serbia, September 18–December 12

"Grasduinen 01," S.M.A.K.—Stedelijk Museum voor Actuele Kunst, Ghent, Belgium, April 3–June 13

"Hysterical," Dennis Kimmerich Gallery, Düsseldorf, Germany, November 13, 2004–January 8, 2005

"Momenta: Benefit 2004," Momenta Art, Brooklyn, NY, US, April 6–25; White Columns, New York, NY, US, April 28–May 1

"Music/Video," The Bronx Museum of the Arts, Bronx, NY, US, October 20–December 31

"Not Done! Het KUNSTenaarsboek," MuHKA—Museum van Hedendaagse Kunst Antwerpen, Antwerp, Belgium, June 19–August 29

"Prima e dopo l'immagine," Castello di Rivoli—Museo d'Arte Contemporanea, Turin, Italy, June 5–August 29; screening: August 21–22

"Transmit and Transform," Santa Fe Art Institute, Santa Fe, NM, US, July 2–August 13

"Utopia Station Revisited," TK Musei, Padiglione America Latina della Mostra d'Oltremare, Naples, Italy, July 26–October 9

"Utopia Station, Munich," Haus der Kunst, Munich, Germany, October 7, 2004–January 16, 2005

"Video—25 Jahre Videoästhetik—Kunst, Werbung, Musik," NRW-Forum Kultur und Wirtschaft, Düsseldorf, Germany, January 24–April 18

"VZW Square Feels the Old," Z33, Hasselt, Belgium, March 14–June 6

2003 "Acquisitions 2001–2002: Photography and Video," National Museum of Contemporary Art, Athens, Greece, March 4–April 30

"Because if it's not love, then it's the bomb that will bring us together," Institute of Visual Culture, Fitzwilliam Museum, Cambridge, UK, July 1–September 14

"The Disembodied Spirit," Bowdoin College, Bowdoin, ME, US, September 25–December 7

"Going Fast but Where," Alma Löv Museum of Experimental & Unexpected Art, Sunne, Sweden, June 7–August 22

"Die Medienkunstrolle" (traveling exhibition and screening; works from 11 years of the Internationaler Medien Kunstpreis, organized by ZKM—Zentrum für Kunst und Medientechnologie, Karlsruhe, Germany), Communal Movie Theatres and Art Spaces throughout Germany, October

"No Technical Difficulties," Pacific Film Archives, Berkeley, CA, US, November 5–December 10

"La Photographie: de fait à fiction," Galerie Marian Goodman, Paris, France, March 8–April 19

"Play: Action Figure," Bellevue Art Museum, Bellevue, WA, April 12–July 13

"Réalités: Collections sans frontières II," Galeria Zacheta, Warsaw, Poland, September 6–November 16

"Salute to Feminists in the Arts" (organized by Veteran Feminists of America), National Arts Club, New York, NY, US, November 5–16

"Splat Boom Pow!—The Influence of Cartoons in Contemporary Art" (traveling exhibition), Contemporary Arts Museum, Houston, TX, US, April 12–June 29; The Institute of Contemporary Art, Boston, MA, US, September 17, 2003–January 4, 2004; Wexner Center for the Arts, Columbus, OH, US, January 31, 2004–May 2, 2004

"Utopia Station," 50th International Venice Biennale, Venice, Italy, June 15–November 2; Haus der Kunst, Munich, Germany (poster project), September 21–November 30

"Video Acts: Single-Channel Works from the Collections of Pamela and Richard Kramlich and New Art Trust" (organized by P.S. 1, New York, NY, US), ICA—Institute of Contemporary Art, London, UK, July 30–November 19

"Video Zero / Communication Interferences: The Projected Image—The First Decade "(Chapter 1 of Videostoria Series), Haifa Museum of Art, Haifa, Israel, March 8–June 5

"Videos SONats," CaixaForum, Barcelona, Spain, December 22, 2003–January 11, 2004

"Wandering Library" (an artists' books event to mark the 50th International Venice Biennale), International Artists' Museum and the Museo Ebraico di Venezia, Venice, Italy, June 15–August 28

"X-Screen," MUMOK—Museum Moderner Kunst Stiftung Ludwig Wien, Vienna, Austria, December 13, 2003–February 29, 2004

2002 "Bioscope," Centre régional d'art contemporain, Sète, France, May 3–June 26

"Bon rotllo: Polítiques de resistència i cultures musicals. Programa 9: Imatges crítiques / Good Vibes: Politics of Resistance and Music Subcultures. Program 9: Critical Images," MACBA—Museu d'Art Contemporani de Barcelona, Barcelona, Spain, February 25–June 17

"Corps et territoires pour une vision sensible du monde" (with the participation of Frac Bretagne and Pays de la Loire, France), Passerelle, Brest, France, September 28–October 5

"En el lado de la televisión," EACC—Espai d'Art Contemporani de Castelló, Castelló, Spain, October 4– December 1

"The First Decade: Video from the EAI Archives," MoMA—The Museum of Modern Art, New York, NY, US, February 26–March 17

"Gloria: Another Look at Feminist Art of the 1970s," White Columns, New York, NY, US, September 13–October 20; The Galleries at the Moore College of Art and Design, Philadelphia, PA, US, January 21, 2003–February 26, 2003; Rhode Island School of Design, Providence, RI, US, November 21, 2003–February 1, 2004

"Konstfilm i Slottsträdgården," Slottsträdgårdens Café, Malmö, Sweden, June 25–August 13

"Outer & Inner Space: A Video Exhibition in Three Parts," Virginia Museum of Fine Arts, Richmond, VA, US, January 18–August 18

"Popcorn and Politics—Activists of Art: Works from Kiasma's Collections from the 1960s Onwards," Museum of Contemporary Art Kiasma, Helsinki, Finland, February 16, 2002–February 23, 2003

"Shoot the Singer: Music on Video," ICA—Institute of Contemporary Art, University of Pennsylvania, Philadelphia, PA, US, March 2–April 21

"Time Share," Sara Meltzer Gallery, New York, NY, US, June 19–August 2

"Video Acts: Single Channel Works from the Collections of Pamela and Richard Kramlich and New Art Trust," P.S. 1 Contemporary Art Center, New York, NY, US, November 10, 2002–April 1, 2003

"Video Cube" (curated exhibition), 29th FIAC, Paris, France, October 24–28

"Die Visionen des Arnold Schönberg, Jahre der Malerei / The Visions of Arnold Schönberg, The Painting Years," Schirn Kunsthalle, Frankfurt am Main, Germany, February 15–April 28

2001 "Into the Light: The Projected Image in American Art, 1964–1977," Whitney Museum of American Art, New York, NY, US, October 18, 2001–January 27, 2002

"Markers" (presented through the International Artists' Museum and the City of Venice), 49th International Venice Biennale, Venice, Italy, June 10–November 4

"New York ca. 1975," David Zwirner, New York, NY, US, June 22–August 10

"Pit Pony," Hoxton Distillery, London, UK, May 3–May 20

"Primera Biennal de València," Valencia, Spain, June 11–October 20

"Printemps de septembre," Toulouse, France, September 28–October 14

"Tele[visions]," Kunsthalle Wien, Vienna, Austria, October 18, 2001–January 6, 2002

"TV & Spielfilm," Gallerie Michael Zink, Munich, Germany, September 21, October 12, November 2; Hochschule für Gestaltung und Kunst Zürich, Zurich, Switzerland, November 6, 7, 8

2000 "Around 1984: A Look at Art in the Eighties," P.S. 1 Contemporary Art Center, Long Island City, NY, US, May 21–September 24

"Au-delà du spectacle," Musée national d'art moderne, Centre Georges Pompidou, Paris, France, November 22, 2000–January 8, 2001

"Das Gedächtnis der Kunst," Historisches Museum Frankfurt and Schirn Kunsthalle, Frankfurt am Main, Germany, December 16, 2000–March 18, 2001

"Let's Entertain: Life's Guilty Pleasures," Walker Art Center, Minneapolis, MN, US, February 12–April 30; Portland Art Museum, Portland, OR, US, July 7 –September 17; Musée national d'art moderne, Centre Georges Pompidou, Paris, France, November 15–December 18 (presented as "Sons et lumières"); Kunstmuseum Wolfsburg, Wolfsburg, Germany, March 16, 2001 –July 15, 2001 (presented as "Let's Entertain: Kunst Macht Spaß"); Miami Art Museum, Miami, FL, US, September 14, 2001–November 18, 2001

"Media_City Seoul 2000," 1st Seoul Biennial, The Metropolitan Museum of Art and 30 electronic billboards, Seoul, South Korea, September 2–November 15

"Never Never Land," Schmidt Center Gallery, Florida Atlantic University, Boca Raton, FL, US, November 11–December 22; USF Contemporary Art Museum, Tampa, FL, US, September 1, 2001–October 8, 2001; Stedman Gallery, Camden Center for the Arts, Rutgers University, Camden, NJ, US, March 4, 2002–April 27, 2002

"Video Time, Media Critique: Program II," MoMA—The Museum of Modern Art, New York, NY, US, November 20

"The Worlds of Nam June Paik," Solomon R. Guggenheim Museum, New York, NY, US, February 11–April 26

1999 "The American Century, Art & Culture 1900–2000. Part 2: 1950-2000," Whitney Museum of American Art, New York, NY, US

"Beauty Now," Haus der Kunst, Munich, Germany

"Bilder der Nacht," television broadcasts on Südwestrundfunk (SWF), Germany

"Kill All Lies," Luhring Augustine Gallery, New York, NY, US

"Multimedia Artist's Works," Handwerker Gallery, Ithaca College, Ithaca, NY, US

"The Museum as Muse: Artists Reflect," MoMA—The Museum of Modern Art, New York, NY, US

"Quiet," 359 Broadway, New York, NY, US

"Regarding Beauty in Performance and Media Art 1960–1998," Hirshhorn Museum and Sculpture Garden, Washington, DC, US

"Rewind to the Future," Bonner Kunstverein, Bonn, Germany

"Seeing Time: Selections from the Pamela and Richard Kramlich Collection of Media Art," SFMOMA—San Francisco Museum of Modern Art, San Francisco, CA, US; ZKM—Zentrum für Kunst und Medientechnologie, Karlsruhe, Germany

"Show and Tell: A Selected History of Photography and Video," Berkeley Art Museum, Berkeley, CA, US

"Video Impact," Contemporary Museum, Baltimore, MD, US

1998 "Animating the Static," The Yale Gallery, Yale University, New Haven, CT, US

"Couch Potatoes and Other Delicacies," Kunstlerhaus Bethanien, Berlin, Germany

"Social Space," Galerie Marian Goodman, Paris, France

"Surveying the First Decade: Video Art and Alternative Media in the United States. Program 7: Critiques of Art and Media as Commodity and Spectacle" (compilation of videotapes), Downtown Community Television, NY, US; American Museum of the Moving Image, Long Island City, NY, US (in partnership with DCTV)

"Transformation," Kim Yeong-gon Gallery, Shinbiro, Seoul, South Korea

"Video Lounge," Centre pour l'image contemporaine, Saint-Gervais, Geneva, Switzerland

"Vidéo: Repères historiques," La Saison Vidéo, Maubeuge, France

1997 "100 Photographs," American Fine Arts, Co., Colin de Land Fine Art, New York, NY, US

"Disrupture: Post-Modern Media," San Francisco Museum of Modern Art, San Francisco, CA, US

"Do It," organized by Independent Curators International Traveling Exhibitions, 1997–2001, Museo de Arte Carillo Gil, Mexico City, Mexico; home version: http://www.e-flux.com/projects/do_it/itinerary/itinerary.html

"KünstlerInnen," Kunsthaus Bregenz, Bregenz, Austria

"Medij v mediju/Media in Media," Soros Centre for Contemporary Arts, Ljubljana, Slovenia

"Rooms with a View: Environments for Video," Guggenheim Museum SoHo, New York, NY, US

"Surveying the First Decade: Video Art and Alternative Media in the United States. Program 7: Critiques of Art and Media as Commodity and Spectacle" (compilation of video tapes), San Francisco Museum of Modern Art, San Francisco, CA, US

"Der Traum vom Sehen" (Konzeption: Triad Berlin; joint project in association with the Deutsches Technikmuseum, Berlin, Germany), GasometerOberhausen, Oberhausen, Germany

1996 "The Great Collections IV: Moderna Museet, Stockholm," Kunst und Ausstellungshalle der Bundesrepublik Deutschland, Bonn, Germany

"More Than Minimal: Feminism and Abstraction in the '70s," Rose Art Museum, Waltham, MA, US

"Polyphonix 28," Musée d'art africain et océanien, Paris, France

"Surfing Systems" (organized by Kasseler Kunstverein, Kassel), Museum Fridericianum, Kassel, Germany

"Women's Work," Greene Naftali Gallery, New York, NY, US

1995 "3e Biennale d'art contemporain de Lyon: installation, cinéma, vidéo, informatique," Musée d'art contemporain, Lyon, France

"Club Berlin," Theatre Malibran, 46th International Venice Biennale, Venice, Italy

"L'Éffet cinéma," Musée d'art contemporain, Montreal, QC, Canada

"Féminin/Masculin (le sexe de l'art)," Musée national d'art moderne, Centre Georges Pompidou, Paris, France

"Glaube Hoffnung Liebe Tod," Kunsthalle Wien, Graphische Sammlung Albertina, Vienna, Austria

"L'Immagine e l'Oggetto," MACRO—Museo d'arte contemporanea di Roma, Rome, Italy

"InfoArt, Whole World Video," Kwangju Biennale (curated by Barbara London), Kwangju, South Korea

"Internationaler Videokunstpreis 1995," ZKM—Zentrum für Kunst und Medientechnologie, Karlsruhe, Germany

"Els Límits del Museu," Fundació Antoni Tàpies, Barcelona, Spain

"Video Spaces: Eight Installations," MoMA—Museum of Modern Art, New York, NY, US

1994 "Acting Out: The Body in Video, Then and Now," Henry Moore Gallery, Royal College of Art, London, UK

"Ars longa Video brevis," Kunst und Ausstellungshalle der Bundesrepublik Deutschland, Bonn, Germany

"The Art of Seduction," The Centre Gallery, Miami—Dade Community College, Miami, FL, US

"Beeld," Museum van Hedendaagse Kunst, Ghent, Belgium

"Corpus Loquendi / Body for Speaking: Body-Centered Video in Halifax 1972–1982," Dalhousie Art Gallery, Dalhousie University, Halifax, NS, Canada

"Heart of Darkness," Kröller-Müller Museum, Otterlo, Netherlands

"Medienkunsttage Mainz" (in association with Kulturzentrum Mainz), KOB 8 MediaArtNetwork, Mainz, Germany

"Radical Chic," Künstlerhaus, Stuttgart, Germany

"Suture: Phantasmen der Vollkommenheit," Salzburger Kunstverein, Salzburg, Austria

1993 "Contacts: Proofs," Jersey City Museum, Jersey City, NJ, US

"Die Eigenwelt der Apparatenwelt II," Institut für Neue Medien, Frankfurt am Main, Germany

"Das Fremde / Der Gast," Offenes Kulturhaus, Linz, Austria

"M.F.A. Program 1981–1993: Faculty Artists' Exhibition," Hunter College, M.F.A. Gallery, New York, NY, US

"MultiMediale 3," ZKM—Zentrum für Kunst und Medientechnologie, Karlsruhe, Germany

"Thresholds and Enclosures," San Francisco Museum of Modern Art, San Francisco, CA, US

"Trans-voices," A/C Project Room, New York, NY, US

"Works on Paper," Paula Cooper Gallery, New York, NY, US

"World Wide Video: The Tyne International Exhibition of Contemporary Art," Newcastle, UK

1992 15th Anniversary Exhibition, Rhona Hoffman Gallery, Chicago, IL, US

"Art at the Armory: Occupied Territory," Museum of Contemporary Art, Chicago, IL, US

"C'est pas la fin du monde—Un point de vue sur l'art des années 80,"
Le Musée d'application, Université Rennes 2, Rennes, France

"Choice Encounters," Long Beach Museum of Art, Long Beach, CA, US

"La Colleccion del IVAM: Adquisiciones 1985–1992," IVAM—Institut Valencià d'Art Modern, Valencia, Spain

"La Collection: Tableau Inaugural," Musée d'art contemporain de Montréal, Montreal, QB, Canada

"Dara Birnbaum: *The Damnation of Faust*, 1984/1992 and Richard DeVore: Stoneware and Drawings," Rhona Hoffman Gallery, Chicago, IL, US

"Dara Birnbaum," Video im Kölnischen Kunstverein, Cologne, Germany

Deutscher Videokunstpreis 1992, ZKM—Zentrum für Kunst und Medientechnologie, Karlsruhe, Germany

Documenta 9, Kassel, Germany

"DuKunst," Iserlohn, Germany

"Gegendarstellung," Kunstverein, Hamburg, Germany

"Künstler: Formen zeitgenössischer Praxis," Städelschule, Frankfurt am Main, Germany

"Die Künstlerpostkarte," Altonaer Museum, Hamburg, Germany

"Met open Vizier," Stichting Amazone, Amsterdam, Netherlands

"Performing Objects," The Institute of Contemporary Art, Boston, MA, US

"transForm: Reflection and Transparence," Kunsthalle Basel, Basel, Switzerland

"Trans-Voices," Whitney Museum of American Art, New York, NY, US; Musée national d'art moderne, Centre Georges Pompidou, Paris, France; WNET, New York, NY, US; WGBH, Boston, MA, US; MTV Network, US; Canal +, France

"Video: Two Decades," MoMA—The Museum of Modern Art, New York, NY, US

"Videowerkschauen der Documenta 9 Künstler/innen," Neues Museum Weserburg, Bremen, Germany

1991 "Arte & Arte," Castello di Rivoli—Museo d'Arte Contemporanea, Turin, Italy

"Assembled: Works of Art Using Photography as a Construction Element," The Wright State University Art Galleries, Dayton, OH, US

"Collision: Video Art and Popular Culture," The Savannah College of Art and Design, Savannah, GA, US

"An Exhibition of Works by Gallery Artists," Josh Baer Gallery, New York, NY, US

Group Exhibition, Ivan Dougherty Gallery, University of New South Wales, Sydney, Australia

"Inheritance and Transformation," The Irish Museum of Modern Art, Dublin, Ireland

"La Mondiale de films et vidéos réalisés par des femmes" (film festival), Quebec City, QB, Canada

"Moving Light: Seeing and Believing," John Michael Kohler Arts Center, Sheboygan, WI, US

"MultiMediale 2," ZKM—Zentrum fur Kunst und Medientechnologie, Karlsruhe, Germany

"The Pleasure Machine: Recent American Video," Milwaukee Art Museum, Milwaukee, WI, US

"Video in the Gallery: Realities," American Museum of the Moving Image, Astoria, NY, US

"Women and the Body," Bertha and Carl Leubsdorf Art Gallery, Hunter College, New York, NY, US

1990 "Assembled," The Wright State University Art Galleries, Dayton, OH, US

"The Decade Show: Frameworks of Identity in the 1980s," Museum of Contemporary Hispanic Art, New York, NY, US; New Museum of Contemporary Art, New York, NY, US; The Studio Museum in Harlem, New York, NY, US

"Life-Size: A Sense of the Real in Recent Art," The Israel Museum, Jerusalem, Israel

"Passages de l'image," Musée national d'art moderne, Centre Georges Pompidou, Paris, France

"Premières," 4th Videonale, Bonner Kunstverein, Bonn, Germany

"Tendances multiples: Vidéos des années 80," Musée national d'art moderne, Centre Georges Pompidou, Paris, France

"Video Poetics," Long Beach Museum of Art, Long Beach, CA, US

"What's on TV," The Brooklyn Museum, Brooklyn, NY, US

1989 2º Fórum de Arte Contemporânea, Lisbon, Portugal

"The Arts for Television," MoMA—The Museum of Modern Art, New York, NY, US

"Beyond Survival: Old Frontiers / New Visions," Ceres Gallery and NYFA/Woman´s Center for Learning, New York, NY, US

"Escultura Contemporânea Americana: Sinais de Vida," and "Video Drive-in," Encontros Luso-Americanos de Arte Contemporânea, Fundação Calouste Gulbenkian, Lisbon, Portugal

"A Forest of Signs: Art in the Crisis of Representation," MoCA—The Museum of Contemporary Art/The Temporary Contemporary, Los Angeles, CA, US

"Image World: Art and Media Culture," Whitney Museum of American Art, New York, NY, US

"Internationale Videokunst 1986–1988," Artothek und Video-Forum, Neuer Berliner Kunstverein, Berlin, Germany

"Making Their Mark: Women Artists Move into the Mainstream, 1970–1985," The Cincinnati Art Museum, Cincinnati, OH, US; New Orleans Museum of Art, New Orleans, LA, US; Denver Museum of Art, Denver, CO, US; Pennsylvania Academy of Fine Arts, Philadelphia, PA, US

"Sequence/(con)Sequence: (sub)versions of photography in the '80s," Video Section, Bard College, Annandale, NY, US

"Video Tape Gallery" (on the occasion of "Kunst-Video-Gesellschaft Symposium" and "Video-Skulptur Retrospective und Aktuell 1963–1989"), 235 Media and Pentagon, Cologne, Germany

"Video Scan: An Introduction to Video Art," Madison Art Center, Madison, WI, US

"Video-Skulptur: Retrospektiv und Aktuell 1963–1989," Kölnischer Kunstverein and DuMont Kunsthalle, Cologne, Germany

"What Does She Want?," Current Feminist Art from the First Bank Collection, Carlton Art Gallery, Carlton College, Northfield, MN, US; Woman's Art Registry of Minnesota, Minneapolis, MN, US

1988 "1988: The World of Art Today," The Milwaukee Art Museum, Milwaukee, WI, US

"American Landscape Video: The Electronic Grove," The Carnegie Museum of Art, Pittsburgh, PA, US; SFMOMA— San Francisco Museum of Modern Art, San Francisco, CA, US; Newport Harbor Art Museum, Newport Beach, CA, US

"Articulations: Picturing Women," Long Beach Museum of Art, Long Beach, CA, US

"Film/Video Arts: 21 Years of Independents," MoMA—The Museum of Modern Art, New York, NY, US

"New American Video Art: A Historical Survey, 1967–1988," Ars Electronica, Linz, Austria

"Special Effects," Video Feature, International Center of Photography, New York, NY, US

"TV: For Real," Halle Sud, Geneva, Switzerland; Center for Photography, Woodstock, NY, US; Bard College, Annandale, NY, US

1987 "The Arts for Television," MOCA—The Museum of Contemporary Art/ The Temporary Contemporary, Los Angeles, US; Stedelijk Museum, Amsterdam, Netherlands

Documenta 8, Kassel, Germany

"L'Époque, la mode, la morale, la passion (1977–1987)," Musée national d'art moderne, Centre Georges Pompidou, Paris, France

"The French Program/Revision: Art Programs of European Television Stations," Stedelijk Museum, Amsterdam, Netherlands

"Implosion: A Postmodern Perspective," Moderna Museet, Stockholm, Sweden

"Non in Codice," Galleria Pieroni, Rome, Italy

"Selections from the Video Study Collection: 1968–1987," MoMA —The Museum of Modern Art, New York, NY, US

"Video CD '87," 3rd International Biennial, Ljubljana, Yugoslavia

"Video des femmes," Maison des Jeunes et de la Culture, Saint Gervais, Geneva, Switzerland

1986 "A Different Climate: Women Artists Use New Media / Ein Anderes Klima: Künstlerinnen gebrauchen neue Medien," Kunsthalle Düsseldorf, Düsseldorf, Germany

"The Image of Fiction, cassette 1: The Hero / De Held," Infermental V Festival, Bonn, Germany

"Invitational," Curt Marcus Gallery, New York, NY, US

"Kunst und Technologie," Der Bundesministerium für Forschung und Technologie, Bonn, Germany

"Origins, Originality + Beyond," Sixth Biennale of Sydney, Art Gallery of New South Wales, Sydney, Australia

"Products and Promotion: Art, Advertising and the American Dream," San Francisco Camerawork, San Francisco, CA, US

"Remembrances of Things Past," Long Beach Museum of Art, Long Beach, CA, US

"Video Transformations" (Independent Curators International Traveling Exhibitions, 1986–1988), several locations in USA and Alberta College of Art Gallery, Calgary, AB, Canada

1985 1985 Carnegie International, Carnegie Institute, Museum of Art, Pittsburgh, PA, US

The 1985 Whitney Biennial Exhibition, Whitney Museum of American Art, New York, NY, US

"Difference: On Representation and Sexuality," New Museum of Contemporary Art, New York, NY, US; The Renaissance Society at the University of Chicago, Chicago, IL, US; ICA—The Institute of Contemporary Art, London, UK

Group exhibition, Kettle's Yard Gallery, University of Cambridge, Cambridge, UK

"Kunst mit Eigen-Sinn," Museum Moderner Kunst, Vienna, Austria

"The New Figure," The Birmingham Museum of Art, Birmingham, AL, US

"New Video Music USA" (org. Nouvelles Frontières), Musée d'art moderne de la Ville de Paris, Paris, France

"Performance Art and Video Installation," The Tate Gallery, London, UK

"Selections from the 1985 Whitney Biennial Exhibition" (traveling exhibition), The American Federation of the Arts, New York, NY, US

"TV Sculpture," Emily Lowe Gallery, Hofstra University, Hempstead, NY, US

"Video Visions," Institute of Contemporary Art, Boston, MA, US

1984 "Artists Videotapes: A Selection from Art Metropole," Art Metropole, Toronto, ON, Canada

"Contemporary Perspectives," Bucknell University, Lewisburg, PA, US

"Content: A Contemporary Focus 1974–1984," Hirshhorn Museum and Sculpture Garden, Washington, DC, US

"Currents 5," Milwaukee Art Museum, Milwaukee, WI, US

"A Decade of New Art," Artists Space, New York, NY, US

"Flyktpunkter: Vanishing Points," Moderna Museet, Stockholm, Sweden

"From TV to Video / Dal Video alla TV," 41st International Venice Biennale, Venice, Italy

"Grand Video," Grand Stereo Showroom, New York, NY, US

"The Luminous Image," Stedelijk Museum, Amsterdam, Netherlands

"Mediated Narratives," The Institute of Contemporary Art, Boston, MA, US

"New Voices 4: Women and the Media/New Video," Allen Memorial Art Museum, Oberlin, OH, US

"Rencontres vidéo internationales de Montreal—Video 84," Galerie Graff, Montreal, QB, Canada

"Selections from the Permanent Collection," Museum of Contemporary Art, Chicago, IL, US

"So There, Orwell 1984," Louisiana World Exhibition, New Orleans, LA, US

"Video: A Retrospective. Part 1, 1974–1984," Long Beach Museum of Art, Long Beach, CA, US

"Video Art: A History," MoMA—The Museum of Modern Art, New York, NY, US

"Women Artists/Filmmakers/Festival of Film as Art: The Woman's Perspective," University of North Carolina, Greensboro, NC, US

1983 "Art Video: Retrospectives and Perspectives," Palais des Beaux Arts, Charleroi, Belgium

"Comment," Long Beach Museum of Art, Long Beach, CA, US

"Film as Installation," The Clocktower, The Institute for Art and Urban Resources, New York, NY, US

Group Exhibition of Gallery Artists, Rhona Hoffman Gallery, Chicago, IL, US

"Language, Drama, Source and Vision," New Museum of Contemporary Art, New York, NY, US

"State of the Art: The New Social Commentary," Barbara Gladstone Gallery, New York, NY, US

Tenth Anniversary Exhibition, Artists Space, New York, NY, US

"Vidéos: Dara Birnbaum," Musée d'art contemporain, Montreal, QB, Canada

"Watching Television: A Video Event," University of Illinois at Urbana—Champaign School of Art and Design, Urbana, IL, US

"Word Works," Walker Art Center and The Minneapolis College of Art and Design, Minneapolis, MN, US

1982 "1ère Manifestation Internationale de Vidéo," Montbéliard, France

"'60 '80 Attitudes/Concepts/Images," Stedelijk Museum, Amsterdam, Netherlands

The 74th American Exhibition, The Art Institute of Chicago, Chicago, IL, US

Documenta 7, Kassel, Germany

"A Fatal Attraction: Art and the Media," The Renaissance Society at The University of Chicago, Chicago, IL, US

"From New York: Video Blitz 1982/83," Kunsthalle Düsseldorf, Düsseldorf, Germany

"Image Dissectors," University of California, Los Angeles, CA, US

"Reading Video," MoMA—The Museum of Modern Art, New York, NY, US

"Return/Jump," The Kitchen Center for Video and Music, New York, NY, US

1981 "Contemporary American Art from the Commodities Corporation Collection," Commodities Corporation, Princeton, NJ, US

Group exhibition, Collective for Living Cinema, New York, NY, US

Group exhibition, Real Art Ways, Hartford, CT, US

"The Kitchen Video Tapes on Tour," The American Center, Paris, France; Stedelijk van Abbemuseum, Eindhoven, Netherlands

"London Video Arts," AIR Gallery, London, UK

"Pictures and Promises," The Kitchen Center for Video and Music, New York, NY, US

"Scansss," La Mamelle Inc., San Francisco, CA, US

"Vanguard," Vancouver Art Gallery, Vancouver, BC, Canada

"Video Viewpoints," MoMA—The Museum of Modern Art, New York, NY, US

1980 "Deconstruction/Reconstruction," New Museum of Contemporary Art, New York, NY, US

"Exotic Events / Times Square Show," Times Square, New York, NY, US

"Film as Installation," The Clocktower, The Institute for Art and Urban Resources, New York, NY, US

"Installation: Video. An Exhibition of Diagrams, Documentation, and Video Installation," Hallwalls, Buffalo, NY, US

"New York Video," Kunsthaus Zürich, Zurich, Switzerland; Städtische Galerie im Lenbachhaus, Munich, Germany

"Remy Presents: Project Grand Central," Grand Central Station, New York, NY, US

"Tapes from the Museum of Modern Art," The American Center, Paris, France

"Television/Video," Princeton University Art Museum, Princeton, NJ, US

1979 "Filmworks 1978–1979," The Kitchen Center for Video and Music, New York, NY, US

"Re-Runs," The Kitchen Center for Video and Music, New York, NY, US

1978 Group exhibition, Mount Saint Vincent Art Gallery, Mount Saint Vincent University, Halifax, NS, Canada

1977 "Notebooks, Workbooks, Scripts, Scores," Franklin Furnace, New York, NY, US

OTHER SCREENINGS / PRESENTATIONS / BROADCASTS OF ARTWORK

2010 "An Evening with Dara Birnbaum," Conversations at the Edge, Gene Siskel Film Center, Chicago, IL, US, February 11

"Dara Birnbaum" (screening and discussion), Tate Modern, London, UK, November 2

2009 "Dara Birnbaum," Serpentine Cinema: CINACT 8, The Gate, London, UK, October 4

2008 "11 Session—Dara Birnbaum," Orchard, New York, NY, US, April 26

"Martha Rosler: Art & Social Life; The Case of Video Art", New Museum of Contemporary Art, New York, NY, US, February 27 and March 5

"Crossroads: A Tribute to Bruce Conner," Light Industry, Brooklyn, NY, US, October 14

"Videos (1970s–1980s) from EAI and the Kitchen selected by Rebecca Cleman," The Kitchen Center for Video and Music, New York, NY, US, October 2

"Women's Experimental Cinema, A Historical Survey" (screening organized by Rebecca Cleman, Electronic Arts Intermix), Issue Project Room, Brooklyn, NY, US, October 2

2007 "Artists and Icons," Hull International Short Film Festival, University of Lincoln, Lincoln, UK, October 5–7

"Dara Birnbaum" (part of "On the Collective for Living Cinema," organized in association with Anthology Film Archives), Orchard, New York, US, NY, April 26

"Feedback: The Video Data Bank, Video Art, and Artist Interviews" (organized to run alongside "The Feminist Future: Theory and Practice in the Visual Arts" symposium and the publication of *Feedback: The Video Data Bank Catalog of Video Art and Artist Interviews*), MoMA—The Museum of Modern Art, New York, NY, US, January 25–31, May 17–31; screening programs repeated over the course of the year

"Feminist Video Art of the '70s," The 24th Annual Olympia Film Festival, Olympia, WA, US, November 9

"Festival Côté Court," 16e Édition du Festival du film court en Seine-Saint-Denis, Pantin, France, March 27–April 6

"Film on Film," Berwick Film and Media Arts Festival, Berwick-upon-Tweed, UK, September 21–29

"Radical Desire," The 21st London Lesbian & Gay Film Festival, London, UK, March 31

"Teaching at the Tang" (screening program of videotapes), The Winter Gallery, The Frances Young Tang Teaching Museum and Schick Art Gallery, Skidmore College, Saratoga Springs, NY, US, November 12, 2007–February 14, 2008

"Throw Your TV out the Window," DeBoest Lecture Hall, Indianapolis Museum of Art, Indianapolis, IN, US, January 25

"Together at Last: A Contemporary Presentation of Historic Video Work," Abingdon Theater Arts Complex, New York, NY, US, July 22

"Vidéothèque JAP," Bozar Cinema, Paleis voor Schone Kunsten, Brussels, Belgium, March 3

2006 "Ambush: Ladies Who Launch," Chez Bushwick @ The Nut Roaster, Brooklyn, NY, US, November 18

"American Video Art, 1967–2006" (Courtesy of EAI—Electronic Arts Intermix and the American Embassy), Center for Contemporary Art, Warsaw, Poland, February 10–16; Centrum Sztuki Współczesnej Łaźnia, Gdansk, Poland, February 15–16

"Darklight: Video Variations," Irish Film Institute (IFI Cinemas), Dublin, Ireland, June 22

"Films of Benning, Birnbaum, Vasulka & Shadix," KLRU, Austin, TX, US, June 16

International Media Art Festival Berlin, Akademie der Künste, Berlin, Germany, February 3–7

"Music Video Art, on the River and Under the Stars" (Courtesy EAI—Electronic Arts Intermix, New York), Pier 63 Maritime, New York, NY, US, June 28; The Open Air Cinema at Art Positions, Art Basel Miami Beach, Miami Beach, FL, US, December 7–8

"The Territory" (produced by the Austin Museum of Art and the Southwest Alternate Media Project, Houston and KUHT-TV, Houston, TX, US), KLRU-TV (channel 18 and cable channel 9), April 28–July 21

"Women" (part of "Martha Rosler: Art & Social Life; The Case of Video Art"), Unitednationsplaza, Berlin, Germany, December 13

2005 "Electronic Arts Intermix Presents: Imagination Station," Monkeytown, Brooklyn, NY, US, October 6–27

"Flatscape Video Series: What Is Culture Jamming," Baton Rouge Gallery—Center for Contemporay Art, Baton Rouge, LA, US, March 26

"Geld/femme totale," 10th Internationales Filmfestival Dortmund 2005, Dortmund, Germany, April 12–17

"Gernsehabend: Highlights aus der Sammlung des Video-Forums," Neuer Berliner Kunstverein, Berlin, Germany, March 23

KO Video Festival, Durban, South Africa, October 1–31

"Montages/Démontages," Festival Côté Court, Cinéma Georges Méliès, Montreuil, France, April 14

"Otvoritev festivala" (lecture and short films), Kinodvor, Ljubljana, Slovenia, October

"EAI at Rooftop Films," Automotive High School, Williamsburg, Brooklyn, NY, US, July 29

2004 "Artists' Films on Music Culture," National Film Theater, London, UK, February 11

"City of Women" (10th International Festival of Contemporary Arts, "Past Transition—Welcome to the Future?"), Ljubljana, Slovenia, October 1–7

"Constructive Engagement," free103point9 Transmission Arts, Brooklyn, NY, US, February 22

"Die Medienkunstrolle," Internationaler Medien Kunstpreis, Brotfabrik, Frankfurt am Main, Germany, December 27–29; Bonn, Germany, December 14

"Screening of Work from Electronic Art Intermix," FACT—Foundation for Art and Creative Technology, Liverpool, UK, December 8

"Third Places—Music Clips" (curated by Archiv Music Clips), steirisc[:her:]bst festival (Steierischer Herbst 2004), Graz, Austria, October 9–November 11

"Videonale 10—Festival zur zeitgenössischen Videokunst," Kunstmuseum Bonn, Bonn, Germany, December 20, 2004–February 4, 2005

2003 "Une histoire de l'art vidéo," Espace Croisé—Centre d'art contemporain, Rubaix, France, May 17

"Standby: No Technical Difficulties," MoMA—The Museum of Modern Art, Gramercy Theatre, New York, NY, US, October 9–18

"Video Screening," Dia:Chelsea Bookshop, New York, NY, US, January 11

"Women Make Movies—Pop Unlimited," Scala Frauenfilminitiative, Werkstattkino, Munich, Germany, December 6

2002 "V Festival Internacional de Fotografía de Madrid, Photo España 2002," Art and TV section, presented by Fundación Telefónica, Madrid, Spain

"Dara Birnbaum and Dan Graham: A Program of Video at the Urban Rooftop Park Project," Dia Center for the Arts, New York, NY, US, June 7

"Frenetic Interferences" (a presentation of Memory/Cage Editions, Zurich), New Museum of Contemporary Art, New York, NY, US, May 15–28

"ILJU Art House Archive," Seoul, South Korea, March 30

"Moderna Museet c/o BAC," Program 4, Baltic Art Center, Visby, Sweden, February 1–23

"Surveying the First Decade: Video Art and Alternative Media in the United States: 1965–1980. Program 7: Critiques of Art and Media as Commodity and Spectacle" (compilation of videotapes), Cinema Texas, International Short Film Festival, Austin, TX, US, September 21–22

2001 "Media Forum," XXIII Moscow International Film Festival, Moscow, Russia, June 23–27

"Nuit de l'art vidéo," Facultés universitaires Notre-Dame de la Paix, Maison de la Poésie, Eglise Saint-Loup, Liège, Belgium, October 20

1999 "Andere Räume, andere Stimmen" (radio broadcast, curated by Daniel Kurjakovic and Franziska Baetcke), DRS 2 Aktuell, Swiss National Radio, Zurich, Switzerland,

"Bilder der Nacht," Television broadcasts on Südwestrundfunk (SWF), Germany

1997 "Mediated Presence: Three Decades of Artists' Video from Electronic Arts Intermix, NYC" (a joint presentation of Electronic Arts Intermix and Dia), Dia Center for the Arts, New York, NY, US

1996 13th Kasseler Dokumetarfilm und Videofest, Filmladen, Kassel, Germany

14th Worldwide Video Festival 1996, Stichting World Wide Video Centre, The Hague, Netherlands

1994 "Dekonstruktion + Video," 11th Dokumentarfilm und Videofestival, Filmladen, Kassel, Germany

"Conference—Vidéo: Dara Birnbaum," CAPC—Musée d'art contemporain, Bordeaux, France

"Soirée Exceptionelle: Dara Birnbaum," X Works at l'ESSEC, Paris, France

"Les Vidéos de Dara Birnbaum," École nationale supérieure des Beaux-Arts, Paris, France

1993 "Collective Dreams on the Edge of Night: A Decade of Video Art," The Kitchen Center for Video and Music, New York, NY, US

"Publicly Aired, Privately Discussed," DAAD, Berlin, Germany

1992 6ème Manifestation Internationale de Vidéo et Télévision de Montbéliard, Montbéliard, France

"Sound Basis," Visual Arts Festival, Wroclaw, Poland

"Videokunstfest," Filmladen, Kassel, Germany

1991 4ème Semaine Internationale de Vidéo, Geneva, Switzerland

The 6th Australian International Video Festival, Glebe, New South Wales, Australia

XII Festival international de la vidéo et des arts électroniques, Locarno, Switzerland

The 15th Annual Atlanta Film/Video Festival, Atlanta, GA, US

20th Montreal International Festival of New Cinema and Video, Montreal, QB, Canada

27th Chicago International Film Festival, Chicago, IL, US

38th Arts Festival of Atlanta, Atlanta, GA, US

European Media Art Festival, Osnabrück, Germany

Festival de Vídeo de Belo Horizonte, ForumBHZVideo, Belo Horizonte, Brazil

"Highlights of the 15th Annual Atlanta Film/Video Festival," The Tulla Foundation Gallery, Atlanta, GA, US

"Der mediale Raum" (Video+film program of the MultiMediale 2 festival), ZKM—Zentrum für Kunst und Medientechnologie, Karlsruhe, Germany

"Mixed Signals" (a cable series produced by the New England Foundation for the Arts, Boston, MA, US), broadcast by several cable televisions and screened at galleries and other venues around US

Retrospective screening, Australian International Video Festival, Sydney, Australia

"Time Festival," Museum van Hedendaagse Kunst, Ghent, Belgium

"Video Forum," Neuer Berliner Kunstverein, Berlin, Germany

1990 "Breaking the Codes: Women, Technology, and Art" (panel and screening of "Video Artists Showcase"), Women's Caucus for Art 1990 National Conference, New York, NY, US

"The Video Drive-In" (comissioned by The Public Art Fund and organized in association with Central Park Summer Stage and the Video Data Bank), Rumsey Playfield, New York, NY, US

"Videofest," 13th Annual Mill Valley Film Festival, Mill Valley, CA, US

"Videotaiteilija Dara Birnbaum Luennoi Taiteestaan," Kuvataideakatemia, Helsinki, Finland

"Works by Women," Dallas Video Festival, Dallas, TX, US

1989 39th Berliner Festwochen, Kongresshalle, Berlin, Germany; Kunsthaus Zürich, Zurich, Switzerland

Berlin Film Festival, Video Section, Berlin, Germany

"Femmes cathodiques," Festival Internationale de Vidéo, Palais de Tokyo, Centre Audiovisuel Simone de Beauvoir, Paris, France

"Sessão Especial com a Presença de Dara Birnbaum," 2º Fórum de Arte Contemporânea, Lisbon, Portugal

1988 3rd International Festival of Films by Women Directors, CineMatrix, Seattle, WA, US

3rd Videonale, Bonn, Germany

17th Montreal International Festival of New Cinema and Video, Montreal, QB, Canada

American Film Institute Video Festival, Los Angeles, CA, US

Dallas Video Festival, Dallas, TX, US

"Fall Lecture Series: Dara Birnbaum," San Francisco Art Institute, San Francisco, CA, US

"Landscapes of the Imagination: New American Makers," Opera Plaza Cinema, San Francisco, CA, US

"New Works," American Film Institute Video Festival, Los Angeles, CA, US

"Twilight," Festival Béluard-Bollwerk, Fribourg, Switzerland

1987 1987 American Film Institute Maya Deren Winners for Independent Film and Video (retrospective screenings), The American Film Institute Festival, Washington, DC, US; The American Film Institute, Los Angeles, CA, US

AFI FEST, American Film Institute, Los Angeles, CA, US

"Artbreak," MTV Networks, Inc., US

"New Television," WNET-TV, NY and WGBH-TV, Boston, MA, US

The Second Australian Video Festival, Sydney, Australia

"Two Moon July," The Kitchen Center for Video and Music, New York, NY, US

Video Television Festival, Spiral Gallery, Tokyo, Japan

World Wide Video Festival, Kijkhuis, The Hague, Netherlands

1986 "Ars Electronica" (TV broadcast), ORF Televison Broadcast, Austria

"New Television," WNET-TV, Channel 13, New York, NY, US

"New York City Video," First Australian Video Festival, Artspace Visual Arts Centre, Sydney, Australia

San Francisco International Video Festival and Road Show, San Francisco, CA, US

"The Territory," KUHT-TV, Channel 8 (PBS), Houston, TX, US

Videonale '86, Internationales Festival und Wettbewerb für Kunstvideos, Bonn, Germany

"Videowochen im Wenkenpark," Basel, Switzerland

World Wide Video Festival, Kijkhuis, The Hague, Netherlands

1985 1. Internationale Video-Biennale, "Der Beitrag von Frauen zum Thema Video," MUMOK—Museum Moderner Kunst Stiftung Ludwig, Vienna, Austria

"Communications for the Future," AFI's TV & Video Festival, New Delhi, Calcutta, Madras, and Bombay, India

"Made for TV Festival: Video Visions, New England Women in Film and Video", Institute of Contemporary Art, Boston, MA, US

"Meet the Makers: Video/Television/Media. Dara Birnbaum," Donnell Library, New York, NY, US

"Women's Video Art Showcase: Video Free America," Opera Plaza Theater, San Francisco, CA, US

1984 Berlin Film Festival, Berlin, Germany

"Dara Birnbaum," Anthology Film Archives, New York, NY, US

Festival Internacional de Cine de San Sebastian, San Sebastian, Spain

First European Music/Video Festival, Vienna, Austria

The New American Filmmakers Series, Whitney Museum of American Art, New York, NY, US

Primero Festival Nacional de Video, Madrid, Spain

Secondo Festivale Internazionale del Video, Rome, Italy

"Tape TV," VPRO-TV, Netherlands

Video Festival, A.I.R. Gallery, New York, NY, US

"Vidéos musicales," 5ème Festival international d'art vidéo, Locarno, Switzerland

1983 Festival Internacional de Cine de San Sebastian, San Sebastian, Spain

"Juste une image," Antenne 2, French National Television, France

International Festival of Video Art, The Saw Gallery, Ottawa, ON, Canada

Mill Valley Film Festival, Mill Valley, CA, US

National Video Festival, The American Film Institute, Los Angeles, CA, US; The American Film Institute, Washington, DC, US

"The Other Avant-Garde," Film and Video Festival, Linz, Austria

"Video Video," Toronto Film Festival, Toronto, ON, Canada

Worldwide Video Festival, Kijkhuis, The Hague, Netherlands

1982 11th Montreal International Festival of New Cinema and Video, Montreal, QB, Canada

Festival de Cine de Sevilla, Seville, Spain

Festival Internacional de Cine de San Sebastián, San Sebastián, Spain

Mill Valley Film Festival, Mill Valley, CA, US

National Video Festival, The American Film Institute, Washington, DC, US; The American Film Institute, Los Angeles, CA, US

"Nightflight," Cable Network, US

The Sixth Annual Chinsegut Film/Video Conference, Redington Beach, Tampa, FL, US

"Video in Person," Pittsburgh Film Makers Cooperative, Pittsburgh, PA, US

1981 "Dara Birnbaum," Pacific Film Archives, University Art Museum, Berkeley, CA, US

National Video Festival, The American Film Institute, Washington, DC, US

San Francisco International Video Festival, San Francisco, CA, US

"TV Tactics," Anthology Film Archives, New York, NY, US

"Video Viewpoints," MoMA—The Museum of Modern Art, New York, NY, US

1980 "Cold War Zeitgeist," The Mudd Club, New York, NY, US

The Collective for Living Cinema, New York, NY, US

SYMPOSIA / CONFERENCES

2007 Qui Enter Atlas, International Symposium of Young Curators, GAMeC—Galleria d'Arte Moderna e Contemporanea, Bergamo, Italy, June 3–5; S.M.A.K.—Stedelijk Museum voor Actuele Kunst, Ghent, Belgium, October 19–21

2005 "Video Art, from the Margins to the Mainstream: A Symposium Curated by Three Artists," Tate Britain, London, UK, December 3

1995 "Suture—Phantasmen der Vollkommenheit," Symposium, Salzburger Kunstverein, Salzburg, Austria

1986 "Video," Montreal International Video Conference, Montreal, QB, Canada

SELECTED BIBLIOGRAPHY

ESSAYS, ARTICLES, and INTERVIEWS

2010 Brown, Kathryn. "Disruption and Delight: Dara Birnbaum's Experiment with Sensory Pleasure." *N.Paradoxa International Feminist Art Journal*, no. 25 (January 2010): pp. 5–15.

Faria, Óscar. "A vida das imagens." *Público*, suppl. "Ipsilon," April 9, 2010, pp. 22–24.

Thorne, Sam. "Dara Birnbaum." *Frieze*, no. 128 (January–February 2010): pp. 119–20.

2009 Birnbaum, Dara. "Do It 2: Conversation with Cory Archangel." *Artforum* 47, no. 7 (March 2009): pp. 191–98.

"Dara Birnbaum: Talk, Art, Activism and TV's Need to Keep Its Belly Full." *Modern Painters* 21, no. 3 (April 2009): p. 15.

"The Dark Matter of Media Light: Interview with Dara Birnbaum." *Useless* 9 (June 2009): pp. 20–21.

Dorin, Lisa. "'Here to Stay': Collecting Film, Video, and New Media at the Art Institute of Chicago." *Museum Studies* 35, no. 1 (Spring 2009): p. 66.

Van Bogaert, Pieter. "Duisternis in het Licht." *<H>ART*, no. 51, May 15, 2009, p. 6.

2008 Guagnini, Nicolás. "Feedback in the Amazon." *October* 125 (Summer 2008): pp. 93–94.

Kelly, Karen, and Barbara Schröder. Interview with Dara Birnbaum. *Bomb*, no. 104 (Summer 2008): pp. 66–73.

2007 Ciuraru, Carmela. "Irregular Programming." *ARTnews* 106, no. 9 (October 2007): p. 58.

2006 "On the Proliferation and Collapse of the Moving Image." Roundtable discussion at Orchard, New York, March 17, 2006. *NDP*, no. 3 (2006): pp. 1–12.

"QUI.EnterAtlas: International Symposium of Young Curators." *Mousse Magazine* (2006): pp. 17–27.

2005 "Ach, die vielen, vielen Bilder." *Die Welt*, January 29, 2005.

Blumenstein, Ellen. "Beschaeftigung mit Gespenstern." *Die Tageszeitung*, January 27, 2005.

Cetinski, Ursula. "Rote Armee Fraktion." *Mladina*, April 18, 2005.

Lewine, Edward. "Art That Has to Sleep in the Garage." *New York Times*, June 26, 2005.

Lobo, Paula. "Fragmentos de um tempo reencontrado." *Diário de Notícias*, May 27, 2005.

2004 Baldinger, Jo Ann. "Sighting the Collective Shadow." *Pasatiempo*, June 18, 2004, pp. 54–56.

Burton, Johanna. "Dara Birnbaum: My Pop." *Artforum* 43, no. 2 (October 2004): p. 273.

Burton, Johanna. "Subject to Revision." *Artforum* 43, no. 2 (October 2004): p. 260.

Davis, Kathryn M. "Transmit + Transform." *THE Magazine*, August 2004, p. 63.

2003 Colpitt, Frances. "Report from Houston: Learning from Comics." *Art in America* 91, no. 10 (October 2003), pp. 65–67.

Preuss, Sebastian. "Der Effekt des Reinheitswahns." *Berliner Zeitung*, September 16, 2003.

Rimanelli, David. "Time Capsules: 1980–1985." *Artforum* 41, no. 7 (March 2003): p. 107.

Smith, Roberta. "Art Review: Video, in Its Infancy, Had to Crawl Before It Could Walk." *New York Times*, January 24, 2003.

2002 Guagnini, Nicolás. "Cable TV's Failed Utopian Vision: An Interview with Dara Birnbaum." *Cabinet*, no. 9 (Winter 2002–2003): pp. 35–38.

Marzo, Jorge Luis. "Mass Media y arte de hoy." *Cuadernos del Mediteraneo*, September 29, 2002.

Messier, Paul. "Dara Birnbaum's *Tiananmen Square: Break-in Transmission*: A Case Study in the Examination, Documentation, and Preservation of a Video-Based Installation." *Journal of the American Institute for Conservation* 40, no. 3 (Spring 2002): pp. 193–209.

2001 Breerette, Geneviève. "Bonjours de New York." *Le Monde*, December 2, 2001.

Chris, Cynthia. "Girls on the Re-Make." *Afterimage*, no. 28.5 (March–April 2001): pp. 11–12.

"Etonnante 'Attente.'" *Libération*, November 2, 2001.

Fouquet, Ludovic. "L'Attente, désir et transparence de l'image video; Dara Birnbaum: *Erwartung*." *Revue de l'Art Actuel*, June 1, 2001.

Goeller, Daniela. "Draussen ist es hell: Galerie Marian Goodman, Paris: Dara Birnbaum." *Frame Magazine* (May–June 2001).

Lebovici, Elisabeth. "L'Americaine Dara Birnbaum déconstruit en videos l'image télévisée: 'Manipuler la télé comme elle nous a manipulée.'" *Libération*, January 10, 2001.

Marger, Mary Ann. "It's a Play World, After All." *St. Petersburg Times*, September 6, 2001.

McCarthy, Anna. "From Screen to Site." *October* 98 (Fall 2001): pp. 93–111.

Moisdon Tremblay, Stéphanie. "Dara Birnbaum." *Art Press*, no. 267 (April 2001): pp. 82–83.

Rimanelli, David. "Around 1984: A Look at Art in the Eighties." *Artforum* 39, no. 6 (February 2001): p. 145.

2000 Anton, Saul. "Radio Activity." *Artforum* 38, no. 7 (March 2000): p. 37.

Colman, David. "Blockbuster Videos." *Harper's Bazaar*, April 2000.

Cummins, Pauline. "Seeing Time: Selections from the Pamela and Richard Kramlich Collection of Media Art." *Circa Magazine*, no. 91 (Spring 2000): p. 64.

Hamlin, Jesse. "For the Love of the Art." *San Francisco Chronicle Datebook*, April 16, 2000.

Widemann, Dominique. "Le spectacle est réel." *l'Humanité*, December 2, 2000.

Wilson, Martha. "Going Virtual." *CAA Art Journal* 59, no. 2 (Summer 2000): p. 104.

1999 von Schlege, Mark. "Art (A) Drift of Politics: Dara Birnbaum/Laura Emrick." *NY Arts*, no. 8 (September 1999): pp. 11–13.

Woodward, Richard B. "Fast Forward." *Wired*, October 1999, pp. 262–69.

1998 Hagen, Charles. "Video Art." *ARTnews* 88, no. 6 (Summer 1998): p. 123.

Saison Video, no. 23 (1998). Lille, France: Saison Video, 1998, p. 13.

Vincent, Steven. "Silicon Gallery." *Art & Auction* 20, no. 5 (January 1998): pp. 76–79, 114.

1997 Buchloh, Benjamin H. D. "Alegoric ni postopki: prila? Canje in monta? A v sodobni umetnosti." *CNN Interactive, World News*, January 9, 1997.

Deepwell, Katy. "Review Documenta X, Kassel 1997: A Brief Analysis of the Women Artists Shown in Documenta X." *N.Paradoxa International Feminist Art Journal*, no. 4 (August 1997).

Henze, Nikola. Letter to the Editor, "Unterwertung macht Spaß: Video Filme von Dara Birnbaum." *Berliner Morgenpost, Kultur*, August 17, 1997.

"On Fire: Page Six Girl: Dara Birnbaum." *Fat Magazine*, no. 3 (1997): p. 6.

Sustersic, Apolonija. Interview with Dara Birnbaum. *M'ARS—Magazine of the Museum of Modern Art Ljubljana 9*, no. 1 (1997).

Tuer, Dot. "Mining the Media Archive: When History Meets Simulation in the Recent Work of Dara Birnbaum and Stan Douglas." *Fuse 20*, no. 5 (November 1997): pp. 21–29.

Tuer, Dot. "Mirrors and Mimesis: An Examination of the Strategies of Image Appropriation and Repetition in the Work of Dara Birnbaum." *N.Paradoxa International Feminist Art Journal* no. 3 (May 1997).

Yagod, Mia Raini. "Dismantling TV's Politics of Desire: Dara Birnbaum's Televisual Videoworks." MA thesis, Department of Art History of the University of Chicago, 1997.

1996 Athineos, Doris. "O, Brave New World." *Forbes*, September 23, 1996.

MacDonald, Christine. "Experiments in Longevity." *The Independent*, July 1996, pp. 22–25.

van Winkel, Camiel. "Dara Birnbaum: A Thousand Points of Light." *Archis* 3, no. 123 (1996): pp. 32–37.

1995 Borchhardt-Birbaumer, Brigitte. "Medialisierung und Bild der Frau." *Wiener Zeitung*, October 17, 1995.

Christoph, Horst. "Wirklich wirklich?" *Profil*, October 9, 1995.

Dahlquist, Dennis. "Videokonstruktivt." *S.V.D.*, April 29, 1995.

"Dara Birnbaum. Bild der Frau." *Elle*, October 1995.

De Keyser, Erik. "Dara Birnbaum." *De Witte Raaf*, no. 57 (September –October 1995): p. 19.

"Erstmals Werkschau von Dara Birnbaum." *Neue Zeit*, October 7, 1995.

"Heldag Med Birnbaum." *Uppsala Nya Tidning*, April 3, 1995.

Hinnfors, Gunillagrahn. "Att Blinagon Pa Tio Sekunder." *Gotebongsposten*, April 11, 1995.

Hofleitner, Johanna. "Pionierin der Medienkunst." *Neue Zürcher Zeitung International*, November 4, 1995.

Jansson, Esse. "Ett Fantastikst aventgr." *Norrtälje Tidning*, April 11, 1995.

Krumpl, Doris. "Die Grauzonen der grauen Zellen—Dara Birnbaum: Medienkritische Installationen in der Kunsthalle Wien." *Der Standard*, October 7–8, 1995.

Larson, Kate. "Med Kojak Mot TV—Skvazet." *Affonbzadet*, April 18, 1995.

Lind, Maria. "Urval Med Udd." S.V.D., April 29, 1995.

Melchart, Erwin. "Kunst als Pausenfüller." *Kronen Zeitung*, October 7, 1995.

Najafi, Sina, and Sven-Olov Wallenstein. "Reversing Angles: Talking Back to the Media." *Material Magazine*, no. 25 (1995): pp. 8–9.

Olsson, Thomas. "Den Internationella Videokonsten Introduceras i Sverige." *Hallandsposten*, April 28, 1995.

Schöllhammer, Georg. "Birnbaum—Graham." *Springer (later Springerin)*, no. 5/95 (November 1995).

Sotriffer, Kristian. "Virtualität aus der Realität." *Die Presse*, October 9, 1995.

"Virtualität aus der Realität." *Die Presse*, November 9, 1995.

Wachtmeister, Marika. "Videokonsten: Svar, Kravande Och Dyr!" *Femina Magazine* (August 1995), pp. 70–73.

Wailand, Markus. "Wonderwoman-TV." *Falter*, no. 42 (1995).

1994 Clearwater, Bonnie. "The Art of Seduction." *South Florida Business Journal*, February 1994, p. 64.

Kayser, Lucien. "Suture." *D' Letzebugerland*, no. 18 (May 1994).

Kravagna, Christian. "Suture." *Artforum* 33, no. 3 (November 1994): p. 96.

1993 Gamble, Allison. "Strategic Occupation." *New Art Examiner* 20, no. 5 (January 1993): pp. 17–19, 47.

Kirshner, Judith Russi. "Dara Birnbaum." *Forum International* (March–April 1993): pp. 90–96.

Kravagna, Christian. "Dara Birnbaum: Talking Back to the Media."*Eikon*, no. 6 (1993): pp. 4–11.

Mathews, Stanley. "The Body Politic: The Chicago Armory Show." *Dialogue Magazine* (January–February 1993), pp. 12–13.

Smith, Roberta. "In Installation Art, a Bit of the Spoiled Brat." *New York Times*, January 3, 1993.

Wolff, Thomas A. "Zurück zum Inhalt." Frankfurter Rundschau, *Kulturspiegel*, January 27, 1993.

1992 Johns, Allison. "Shortcuts for Editing Video Walls." *Millimeter*, August 1992, p. 35.

Kline, Larry. "Dara Birnbaum: The Damnation of Faust 1984–1992." *Cover Magazine* (November– December 1992), p. 19.

Madoff, Steven Henry. "Documenta IX: More Is a Mess." *ARTnews* 91, no. 7 (September 1992): p. 131.

McWilliams, Martha. "The Way to Docu-drama." *New Art Examiner* 20, no. 2 (October 1992): pp. 12–16.

Mekkink, Mieke. "Documenta de Verborgen Geschiedenis." *Ruimte Magazine*, no. 2 (September 1992): p. 7.

Schjeldahl, Peter. "The Documenta of the Dog." *Art in America* 80, no. 9 (September 1992), p. 96.

Schwerdtle, Dieter. "Ein Foto-Rundgang durch die Documenta IX." *Kunstforum International*, no. 119 (Summer 1992): p. 283.

1991 Canning, Susan. "Interview with Dara Birnbaum." *Art Papers*, no. 6 (November–December 1991): pp. 54–58.

Cantor, Judy. "Interview: Dara Birnbaum." *Balcon*, no. 7 (1991): pp. 93–107.

Cilli, Cristina. "Fuochi Fatui Nel Castello." *Noi Donne*, no. 4 (April 1991): pp. 66–68.

Cornwell, Regina. "Art in the Agora." *Art in America* 79, no. 2 (February 1991): pp. 134–37.

"Dara Birnbaum." *Balcon*, no. 7 (1991): pp. 108–13.

di Francesca, Pasini. "La Marcia della Ida." *Il Secola* 19 (February 1991): p. 11.

Guido, Curto. "Rivoli Fills a Castle with Art." *Journal of Art* 4, no. 4 (April 1991): p. 25.

Hixson, Kathryn. "Dara Birnbaum." *Flash Art* 24, no. 158 (May–June 1991): pp. 142–43.

Meyers-Kingsley, Dara. "Beyond Toontown: What's on TV?" *The Independent*, July 1991, pp. 13–14.

1990 Beck, Robert. "An Interview with Dara Birnbaum." *Media Arts*, 1990.

Birringer, Johannes. "The Damnation of Culture in Postmodern Video Sculpture." *Tema Celeste*, no. 26 (1990): p. 31.

Gigliotti, Davidson. "The Allure of the Electronic: The Changing Vocabulary of Video and Sculpture." *Afterimage* 17, no. 8 (March 1990): pp. 13–15.

Grunberg, Andy. "Dara Birnbaum." *New York Times*, February 2, 1990.

Hapgood, Susan. "Dara Birnbaum." *Contemporanea* 3, no. 5 (May 1990): p. 104.

Nesbitt, Lois E. "Review." *Artscribe*, no. 81 (May 1990).

Shottenkirk, Dena. "Reviews." *Artforum* 27, no. 8 (April 1990): pp. 168–69.

1989 Barry, Robert. "Wonder." *Artforum* 28, no. 10 (Summer 1989): p. 127.

Daniels, Dieter. "Review of Rough Edits." *Kunstforum International*, no. 98 (January–February 1989): p. 177.

Foreman, Bill. "The Big Payback." *Isthmus*, October 27, 1989.

Hagen, Charles. "The Fabulous Chameleon." *ARTnews* 88, no. 6 (Summer 1989): pp. 118–23.

Mifflin, Margot. "New Media, New Art." *Elle*, May 1989, pp. 178–80.

Morse, Margaret. "Interiors: A Review of American Landscape Video." *Video Networks* 13, no. 1/2 (February–March 1989): pp. 15–19.

"Telewall at Rio Complex Taps Into Designer's Life." *Atlanta Constitution*, September 16, 1989.

"Video-Wand im öffentlichen Raum, Atlanta, USA." *Kunstforum International*, no. 98 (January–February 1989): p. 172.

1988 "Eight Days a Week." *San Francisco Bay Guardian*, December 7, 1988, p. 51.

Miller, Donald. "Video Artists Explore U.S. Landscapes in Show." Pittsburgh *Post Gazette*, May 6, 1988.

Morgan, Robert C. "Review of Rough Edits." *High Performance Magazine #44*, 11, no. 4 (Winter 1988): p. 84.

1987 Fallman, Christer. "Fadermord pa detantentiska?" *Correspondenten*, November 15, 1987.

Liebermann, Rhonda. "The Art of Television Reception in the Age of Endo-Colonization." *Copyright* (1987), pp. 146–61.

Lind, Ingela. "Egotianonym forkladnad." *Dagensnylieter*, November 11, 1987.

Liss, Andrea. "History Reconceptualized." *Artweek Magazine*, January 1987, pp. 5–6.

"Non In Codice." *Artmagazine Spazio Umano/Human Space*, December 1987, p. 113.

Tallmer, Jerry. "Wonder Woman of Avant-Garde." *New York Post*, January 22, 1987, p. 30.

Wallace, John. "Innovation Is a Primary Color on the Video Artist's Palette." *New York Times*, April 19, 1987.

1986 Kelly, Lorraine. "Reigning Cats." *Afterimage* 13, no. 8 (March 1986): pp. 21–22.

Trappschuh, Elke. "Künstlerinnen gebrauchen neue Medien in Düsseldorf: Von der Realität provoziert." *Handelsblatt*, April 11–12, 1986.

Velthoven, William. "To Talk Back or to Talk With: Gesprek met Dara Birnbaum." *Mediamatic* 1, no. 1 (May 1986): pp. 35–37.

1985 "The Biggest and the Best in Pittsburgh." *New York Times*, November 17, 1985, pp. 29–32.

Buchloh, Benjamin H. D. "From Gadget Video to Agit Video: Some Notes on Four Recent Video Works." *Art Journal: Video—The Reflexive Medium* (Fall 1985): pp. 219, 221–23.

Duguet, Anne-Marie. "The Luminous Image: Video Installation." *Camera Obscura*, no. 13/14 (1985): p. 41.

Groot, Paul. "The Luminous Image: Review." *Artforum* 23, no. 5 (January 1985): p. 97.

Hatton, Brian. "Between Here and Nowhere." *Flash Art*, no. 120 (January 1985): p. 48.

Mignot, Dorine. "The Luminous Image." *Kunstforum International*, no. 77/78 (January–February 1985): p. 64.

Reidy, Robin. "Pop-Pop Video: Dara Birnbaum Alters Familiar Images with Advanced Technology." *American Film* 10, no. 4 (January–February 1985): p. 61. (Reprinted in Performance *Art and Video Installation*. London: Tate Gallery, 1985, pp. 7–9.)

Russell, John. "Art: Whitney Presents its Annual Exhibition." *New York Times*, March 22, 1985.

Smith, Roberta. "Beyond Gender." *Village Voice*, January 22, 1985.

Sturken, Marita. "Feminist Video: Reiterating the Difference."*Afterimage* 12, no. 9 (April 1985).

Wentscher, Herbert. "Wir schalten um: Let's Go for the Real Public." *Kunstforum International*, no. 77/78 (January–February 1985): pp. 44–53.

White, Mimi. "Resimulation: Video Art and Narrativity." *Wide Angle* 6, no. 4 (1985): p. 64.

Wooster, Ann Sargent. "Manhattan Shortcuts." *Afterimage* 13 (Summer 1985): pp. 34–35.

Zauner, Ingrid. "Ohnmacht? Frauenmacht!" *Film Logbuch*, no. 2 (1985): pp. 38–41.

1984 Aldighieri, Merrill. "Video Active: Test Department—Dara Birnbaum and the Stations." *Rock Video*, no. 8 (December 1984).

Fargier, Jean-Paul. "Video: Dara Birnbaum à l'American Center: Raccord des Regards." *Cahiers du Cinema*, no. 368 (February 1984): p. 15.

Hagen, Charles. "Dara Birnbaum, Anthology Film Archives Video Program at Millenium Film Workshop." *Artforum* 22, no. 10 (June 1984): pp. 89–90.

Horne, Larry. "On Video and Its Viewers." *On Film*, no. 13 (Fall 1984): p. 43.

Reidy, Robin. "Video Effects Art/Art Effects Video: Dara Birnbaum's *Damnation of Faust: Evocation*." *Art Com*, no. 24 (1984): p. 57.

Rice, Shelley. "Dutch Treat: Amsterdam´s Luminous Image." *The Independent*, December 1984, pp. 7–8.

Stahr, Yvonne. "Dara Birnbaum: An Interview." *Art Papers* (March–April 1984): pp. 2–3.

Tee, Ernie. "Dara Birnbaum." *Openbaar Kunstbezit* 28, no. 4 (July–August 1984): p. 138.

Tee, Ernie. "Een Faustische Vraagstelling: Een Gesprek met Dara Birnbaum." *Andere Sinema*, no. 139 (Winter 1984–85): p. 38.

Zeichner, Arlene. "Clublike Video." *The Independent*, January–February 1984, p. 18.

1983 Ancona, Victor, and Michael Greenhouse. "Visual Music." *Videography* 8, no. 12 (December 1983): p. 82.

Beals, Kathie. "The Video Exhibition Merges Art and Technology." *The Herald Statesman*, February 26, 1983, p. 9.

Dercon, Chris. "Dara Birnbaum: Wonder Woman." *Schöne Vis à Vis*, no. 1 (1983): p. 2.

Jubela, Joan. "Video Art and the Marketplace." *Heresies*, no. 16 (1983): p. 34.

Loeffler, Carl. "TV: The Popular Front Form!" *Art Com* 6, no. 21 (1983): p. 20.

Wooster, Ann Sargeant. "Slow Scan, Video Video." *East Village Eye*, no. 38 (November 1983): p. 51.

1982 Buchloh, Benjamin H. D. "Allegorical Procedures: Appropriation and Montage in Contemporary Art." *Artforum* 21, no. 1 (September 1982): pp. 54–55.

Buchloh, Benjamin H. D. "Documenta 7: A Dictionary of Received Ideas." *October* (Fall 1982): pp. 102–26.

Coopman, Johan. "Dara Birnbaum." *Andere Sinema*, no. 44 (December 1982): p. 12.

Elwes, Katherine. "New York Video." *Performance Magazine*, no. 20/21 (December–January 1982): p. 20.

Fargier, Jean-Paul. "La Video Contre la Television. Un Exemple: Dara Birnbaum." *Nordeste*, no. 1 (December 1982): p. v.

Hartney, Mick. "Videotapes by American Artists: ICA New York." *Art Monthly*, no. 62 (October–November 1982): p. 34.

de Moffarts, Eric. "Video Art: Une mémoire pour la television. Une Interview de Dara Birnbaum." *Videodoc*, no. 54 (September 1982): p. 28.

Owens, Craig. "Phantasmagoria of the Media." *Art in America* 70, no. 5 (May 1982): pp. 98–100.

Schouten, Lydia. "Dara Birnbaum." *Modern Denken*, no. 4 (1982).

Tindemans, Klaas. "Verband Video—TV niet meer verbergen." *De Standaard*, October 29, 1982, p. 6.

1981 Brooks, Rosetta. "TV Transformations: An Examination of the Videotapes of New York Artist Dara Birnbaum." *ZG Magazine*, no. 1 (1981).

Ginsberg, Merle. "NY Video: State of the Art." *Soho Weekly News*, March 1981, p. 42.

Gintz, Claude. "Une saison à New York." *Artistes*, no. 9–10 (October–November 1981): pp. 26–35.

Monk, Philip. "Television by Artists." *Canadian Forum* 61, no. 709 (May 1981): pp. 37–40.

Sanborn, John. "Video Music Inc." *ZG Magazine*, no. 3 (1981).

1980 Grundberg, Andy. "Photography." *Soho Weekly News*, August 6, 1980, p. 46.

Hoberman, J. "Three Women." *Village Voice*, May 5, 1980, p. 42.

Larson, Kay. "Art." *Village Voice*, October 1, 1980, p. 109.

Lawson, Thomas. "Reviews." *Artforum* 19, no. 2 (October 1980): p. 84.

London, Barbara. "Independent Video: The First Fifteen Years." *Artforum* 19, no. 1 (September 1980): pp. 38–41.

London, Barbara, and Lorraine Zippay. "A Chronology of Video Activity in the United States." *Artforum* 19, no. 11 (September 1980): pp. 42–45.

Marton, Pierre. "Video Côte Ouest, USA." *Cahiers du Cinema*, no. 315 (September 1980).

McDarrah, Fred. "Voice Choices Photo." *Village Voice*, August 6, 1980, p. 49.

Morgan, Robert. "Transmission Aesthetics: Public Interaction and Private Awareness." *New York Arts Journal*, no. 18 (April 1980): p. 20.

Rice, Shelley. "Reviews." *Artforum* 19, no. 1 (September 1980), pp. 70–72.

"Video Côte Ouest, USA." *Le Journal du Cahier*, no. 7 (1980).

Wooster, Ann Sargeant. "Voice Choices Video." *Village Voice*, January 28, 1980, p. 55.

1979 Hoberman, Jim. "Voice Choices Film." *Village Voice*, May 7, 1979, p. 64.

1978 Dodge, William. "Perspectives: Within the Frame." *Dalhousie Gazette*, October 5, 1978, p. 13.

Hoberman, Jim. "Voice Choices Film." *Village Voice*, January 23, 1978, p. 49.

1977 Frank, Peter. "Dara Birnbaum—Artists Space." *ARTnews* 76, no. 8 (October 1977): p. 139.

Woodard, Stephanie. "Concepts in Performance: Views and Interviews: Dara Birnbaum." *Soho Weekly News*, January 6, 1977, pp. 23–25.

ONLINE PERIODICALS and BLOG REFERENCES

2010 Onli, Meg. "Tuesday's Video Pick: Dara Birnbaum." *Bad at Sports*. http://badatsports.com/2010/tuesdays-video-pick-dara-birnbaum/. February 10, 2010.

2009 "Dara Birnbaum." Video Art World: *The Imagery Planet*. http://www.videoartworld.com/beta/artist_163.html. 2009.

"Dara Birnbaum Podcast." Lux. http://www.lux.org.uk/media/dara-birnbaum-podcast. November 2009.

Lund, Karsten. "Art: Shorts—An Evening with Dara Birnbaum." *Flavorpill*. http://flavorpill.com/chicago/events/2010/2/11/an-evening-with-dara-birnbaum. 2009.

Tuck, Mike. Interview with Dara Birnbaum. *ArtSlant*. http://www.artslant.com/ny/articles/show/11621. November 2009.

2008 "Get Us Out from Under." *A Magnificent Bastard*. http://amagnificentbastard.blogspot.com/2008/02/get-out-from-under.html. 2008.

KaraGarga. "Dara Birnbaum—Technology/Transformation: Wonder Woman (1978)." *Art Torrents*. http:// arttorrents.blogspot.com/2008/01/dara-birnbaum-technologytransformation.html. January 29, 2008.

Woeller, Marcus. "Sonic Youth Show Bolzano/Dara Birnbaum." *Stylemag-online.net*. http://www.stylemag-online.net/2008/10/13/sonic-youth-show-bolzano-dara-birnbaum. October 3, 2008.

2007 Paul, Jonathan S. "TAG: Dara Birnbaum." *New York Times Magazine/The Moment*. http://themoment.blogs.nytimes.com/tag/dara-birnbaum/. December 7, 2007.

"TV Infiltrada: Exposição Centre Pompidou—Novos Media 1965–2003." *rreal TV*. http://irrealtv.blogspot.com/2007/10/tv-infiltrada.html. 2009.

2005 "Dara Birnbaum." *Manufactuur De Wit*. http://www.contour2005.be/UK/db.htm.

CATALOGUES AND EXHIBITION-RELATED PUBLICATIONS

2010 Cooke, Lynne, Douglas Crimp, with Kristin Poor, eds. *Mixed Use, Manhattan: Photography and Related Practices, 1970s to the Present*. Cambridge, MA: MIT Press, 2010.

2009 Eklund, Douglas, ed. *The Picture Generation 1974–1984*. New Haven, CT: Yale University Press, pp. 66, 118, 137, 144, 148, 156, 169–173, 283, 309.

Sickler, Erin Marie, ed. *There Goes My Hero*. New York: Center for Book Arts, pp. 7, 32.

2008 Concannon, Keven and John Noga. *Agency: Art and Advertising*. Youngstown, OH: McDonough Museum of Art, Youngstown State University, 2008, pp. 18, 19, 67.

Frankel, Stephen Robert. *2008 Traveling Exhibitions of Contemporary Art*. New York: Independent Curators International, 2008, pp. 14, 32.

2007 *Beauty and the Blonde: An Exploration of American Art and Popular Culture*. St. Louis, MO: Mildred Lane Kemper Art Museum, Washington University, 2007, p. 26.

Feedback: The Video Data Bank Catalog of Video Art and Artist Interviews. New York: Museum of Modern Art, 2007.

Passages du Temps. Collection François Pinault Foundation. Milan: Skira, 2007, pp. 44–45; also exhibition brochure, p. 10.

Playback, Art, Clip, Video. Paris: ARC/Musée d'art moderne de la Ville de Paris, 2007. "Bootleg/Covers & Alike" p. 95; "Seen On TV," p. 113.

Sounding the Subject/Video Trajectories: Selections from the Pamela and Richard Kramlich Collection and The New Art Trust. Cambridge, MA: MIT Press, 2007, pp. 61, 74.

WACK! Art and The Feminist Revolution. Cambridge, MA: MIT Press, 2007, pp. 219–20.

2006 Scott, Kitty, and Jonathan Shaughnessy, eds. *Art Metropole: The Top 100*. Ottawa: National Gallery of Canada, 2006, p. 12 (image), p. 56 (text).

2005 "States of the Images—Instants and Intervals." *Lisboa Photo 2005*. Lisbon: Câmara Municipal de Lisboa and Público, pp. 150–81.

Mira cómo se mueven / See How They Move, 4 Ideas on Mobility. Madrid: Fundación Telefónica, 2005, pp. 88–89, 126.

Zur Vorstellung des Terrors: Die RAF-Ausstellung. Göttingen, Germany: Steidl, 2005, pp. 207–9.

2004 "Chapter 4: Interview with Dara Birnbaum." In *Not Done (The Artist's Book)*. Ed. Kurt Vanbelleghem. Ghent, Belgium: Imschoot, 2004, pp. 41–45.

2003 de Bruyn, Eric, Brandon Joseph, and Matthias Michalka, et al. *X-Screen: Film Installations and Actions in the 1960s and 1970s*. Cologne: Walther König, 2003, pp. 150, 151, 186.

De houdbaarheid van videokunst (The Sustainability of Video Art) Preservation of Dutch Video Art Collections. 's-Hertogenbosch, Netherlands: Stichting Behoud Moderne Kunst/Foundation for the Conservation of Modern Art, 2003.

Réalités: Collections Sans Frontières II (Rzeczywistości Kolekcje bez granic II). Warsaw: Zacheta Panstwowa Galeria Sztuki et al., 2003, pp. 54–55.

Sogni e Conflitti, la Dittatura dello Spettatore, 50esima Asposizione internazionale d'arte. Venice: Venice Biennale, 2003, pp. 320, 326.

Splat Boom Pow! The Influence of Cartoons in Contemporary Art. Houston: Contemporary Art Museum Houston, 2003, pp. 54, 100.

*Video Acts: Single Channel Works from the Collection of Pamela and Richard Kramlich and the New Art Trust.*New York: P.S. 1 Contemporary Art Center, 2003.

2002 *En el lado de la televisión—In the Side of Television.* Castelló, Spain: Espai d'Art Contemporani de Castelló (EACC), 2002.

Exploding, Plastic and Inevitable: The Rise of Video Art. Oslo: Kunstnernes Hus, 2002.

Fri-Art 2000. Fribourg, Switzerland: Centre d'art contemporain, 2002.

Gloria: Another Look at Feminist Art of the 1970s. New York: White Columns, 2002.

Die Visionen des Arnold Schönberg, Jahre der Malerei (The Visions of Arnold Schönberg, The Painting Years). Ostfildern-Ruit, Germany: Hatje Cantz, 2002, pp. 37–39.

2001 *The 1st Valencia Biennial.* Milan: Charta, 2001.

Au–delà du spectacle. Paris: Centre Pompidou, 2001.

La Biennale di Venezia: 49. Esposizione Internazionale D'Arte: Platea dell'Umanità. Milan: Electa, 2001.

Iles, Chrissie, and Thomas Zummer. *Into the Light: The Projected Image in American Art, 1964–1977.* New York: Whitney Museum of American Art, 2001.

Markers, International Artists' Museum and the City of Venice. Venice: Venice Biennale, 2001.

Théâtres du fantastique: Printemps de septembre. Toulouse, France: Actes Sud, 2001.

Tele[visions]. Vienna: Kunsthalle Wien, 2001.

2000 *Around 1984: A Look at Art in the Eighties.* Long Island City, NY: P.S. 1. Contermporary Art Center, 2000.

Media_City Seoul 2000. Seoul, Korea: Media City Seoul 2000, 2000, pp. 196–97.

Vergne, Philippe, ed. *Let's Entertain: Life's Guilty Pleasures.* Minneapolis, MN: Walker Art Center, 2000, pp. 25, 248, 250.

Wettengl, Kurt, ed. *Das Gedächtnis der Kunst—Geschichte und Erinnerung in der Kunst der Gegenwart.* Ostfildern-Ruit, Germany: Hatje Cantz, 2000.

1999 McShine, Kynaston. *The Museum as Muse: Artists Reflect.* New York: Museum of Modern Art, 1999.

Rewind to the Future: Eija-liisa Ahtila, Dara Birnbaum, Klaus vom Bruch. Bonn: Bonner Kunstverein, 1999.

Seeing Time: Selections from the Pamela and Richard Kramlich Collection of Media Art. San Francisco: San Francisco Museum of Modern Art, 1999, pp. 42, 98–99, 177.

1997 Buchloh, Benjamin H. D. "Dara Birnbaum—Allegorical Procedures: Appropriation and Montage in Contemporary Art." In *Media in Media.* Ed. Open Society Institute, Slovenia, 1997, pp. 46–55.

Do It. New York: Independent Curators International, 1997, pp. 76–77; *Do It/Hazlo.* Mexico City: Museo de Arte Carrilo Gil, 2002, p. 88; *Do It.* Copenhagen: Nikolaj—Copenhagen Contemporary Art Center, 1997, pp. 40–41.

Kubity, Peter Paul. *Der Traum vom Sehen: Zeitalter der Televisionen.* Berlin: Triad-GmbH, in association with Verlag der Kunst, Dresden, 1997, p. 236.

KünstlerInnen, 50 Positionen zeitgenössischer internationaler Kunst, Videoportraits und Werke. Bregenz, Austria: Kunsthaus Bregenz, 1997, pp. 8, 9, 26, 27.

1996 *14th Worldwide Video Festival 1996 Catalogue.* The Hague, Netherlands: Stitching World Wide Video Centre, 1996.

L'Effet cinéma. Montreal: Musée d'art contemporain, 1996, p. 41.

Moderna Museet Stockholm Comes to Bonn. Ostfildern-Ruit, Germany: Hatje Cantz, in association with Kunst und Ausstellungshalle der Bundesrepublik Deutschland, 1996.

Surfing Systems. Die Gunst der 90er—Positionen zeitgenössischer Art. Kassel, Germany: Stroemfeld/Roter Stern, in association with Kasseler Kunstverein, 1996.

1995 *3e Biennale d'art contemporain de Lyon: installation, cinéma, vidéo, informatique.* Paris: Réunion des musées nationaux, 1995.

Dara Birnbaum. Vienna: Kunsthalle Wien; Klagenfurt, Austria: Ritter, 1995; also exhibition brochure.

Dara Birnbaum: Video Art. Stockholm: Norrtälje Konsthall, 1995.

Delany, Samuel R., and Barbara London. *Video Spaces: Eight Installations.* New York: Museum of Modern Art, 1995.

Els Límits del Museu. Barcelona: Fundació Antoni Tàpies, 1995.

InfoArt. Kwangju Biennale. Seoul, Korea: Sam Shin Gak, 1995.

Internationaler Videokunstpreis 1995. Karlsruhe, Germany: Zentrum für Kunst und Medientechnologie (ZKM), 1995.

*Suture—Phantasmen der Vollkommenheit. Symposium.*Salzburg, Austria: Salzburger Kunstverein, 1995.

1994 *Acting Out: The Body in Video, Then and Now.* London: Henry Moore Gallery, Royal College of Art, 1994.

La Collezione, Castello di Rivoli Museo d'Arte Contemporanea. Milan: Charta, 1994, pp. 62–63.

Corpus Loquendi/Body for Speaking/Body-Centered Video in Halifax, 1972–1982. Halifax, NS: Dalhousie Art Gallery, 1994.

Heart of Darkness. Otterlo, Netherlands: Kröller-Müller Museum, 1994, p. 193.

Hermans, Uwe, Gerhard Wissner, and Hoger Ventura. *Kube: Dekonstruktion x Video.* Kassel, Germany: Filmladen, 1994, p. 69.

1993 *At the Modern.* San Francisco: San Francisco Museum of Modern Art, 1993, p. 2.

Colleccion del IVAM, Dara Birnbaum, "Damnation of Faust." Valencia, Spain: Fundación Arte y Tecnología, 1993.

Multimediale 3: das Medienkunstfestival des ZKM Karlsruhe. Karlsruhe, Germany: Zentrum für Kunst und Medientechnologie (ZKM), 1993, pp. 72–75.

Pijnappel, Johan. *The Tyne International Exhibition of Contemporary Art.* London: Academy Editions, 1993.

Thresholds and Enclosures. San Francisco: San Francisco Museum of Modern Art, 1993.

1992 *Art at the Armory: Occupied Territories*, Chicago: Museum of Contemporary Art, 1992.

C'est pas la fin du monde—un point de vue sur l'art des années 80. Rennes, France: Centre d'histoire de l'art contemporain, 1992, p. 160.

La Collección del IVAM: Adquisiciones 1985–1992. Valencia, Spain: IVAM, 1992.

La Collection: Tableau Inaugural. Montreal: Musée d'art contemporain, 1992.

Deutscher Videokunstpreis 1992. Karlsruhe, Germany: Zentrum für Kunst und Medientechnologie (ZKM), 1992.

Documenta IX: Kassel. Ostfildern-Ruit, Germany: Hatje Cantz, 1992.

DuKunst. Iserlohn, Germany: Kulturamt Iserlohn, 1992, p. 83.

Performing Objects. Boston: Institute of Contemporary Art, 1992.

1991 4e Semaine International de Video. Geneva: International de Video, 1991.

The 6th Australian International Video Festival. Gleben, NS, Australia: Electronic Media Arts, 1991.

The 15th Annual Atlanta Film/Video Festival. Atlanta, GA: Atlanta Film/Video Festival, 1991.

20th Montreal International Festival of New Cinema and Video, Montreal: Festival International du Nouveau Cinema, 1991.

27th Chicago International Film Festival. Chicago: Chicago International Film Festival, 1991.

38th Arts Festival of Atlanta. Atlanta, GA: Arts Festival of Atlanta, 1991.

A Dialogue about Recent American and European Photography. Los Angeles: Museum of Contemporary Art, 1991.

Arte & Arte: Dara Birnbaum, Rebecca Horn, Sol Lewitt, Michelangelo Pistoletto, Alberto Savinio, Cindy Sherman, Ettore Spalletti. Turin: Castello di Rivoli—Museo d'Arte Contemporanea, 1991.

Assembled: Works of Art Using Photography as a Construction Element. Dayton, OH: University Art Galleries, Wright State University, 1991.

Der Mediale Raum, Videoprogramm, MultiMediale 2. Karlsruhe, Germany: Zentrum für Kunst und Medientechnologie (ZKM), 1991.

European Media Art Festival. Osnabrück, Germany: European Media Art Festival, 1991.

Festival de Vídeo de Belo Horizonte, Belo Horizonte, Brazil: ForumBHZVideo, 1991.

Inheritance and Transformation. Dublin: Irish Museum of Modern Art, 1991.

Time Festival. Ghent, Belgium: Museum van Hedendaagse Kunst, 1991.

Video Forum. Berlin: Neuer Berliner Kunstverein, 1991.

1990 Bellour, R., C. David, C. Van Assche, eds. Passages de l'image. Paris: Musée national d'art moderne, Centre Pompidou, 1990.

Dara Birnbaum. Valencia, Spain: Generalitat Valenciana, 1990.

Dara Birnbaum: Retrospektiivi, Kuopio Videofestivaalit 1990. Helsinki/Kuopio, Finland: Kuopio Videofestivaalit, 1990.

The Decade Show: Frameworks of Identity in the 1980s. New York: New Museum of Contemporary Art and the Museum of Contemporary Hispanic Art and the Studio Museum in Harlem, 1990.

Life-Size: A Sense of the Real in Recent Art. Jerusalem: Israel Museum, 1990.

Tendances multiples: Vidéos des années 80. Paris: Centre Georges Pompidou, 1990.

Video Poetics. Long Beach, CA: Long Beach Museum of Art, 1990.

1989 3. Videonale Bonn: Internationale Videokunst 1986–1988. Berlin: Neuer Berliner Kunstverein, 1989.

2º Fórum de Arte Contemporânea. Lisbon: Fórum de Arte Contemporânea, 1989.

American Landscape Video, Rita Myers, Dara Birnbaum, Doug Hall, Mary Lucier, Frank Gillette, Steina Vasulka, Bill Viola. San Francisco: San Francisco Museum of Modern Art, 1989.

Brawer, Coleman, Catherine Rosen, and Randy Rosen. Making Their Mark: Women Artists Move into the Mainstream, 1970–1985. New York: Abbeville Press, 1989.

Encontros Luso-Americanos de Arte Contemporânea: Contemporary American Sculpture. Lisbon: Fundação Calouste Gulbenkian, 1989.

Femmes cathodiques: Festival International de Vidéo/Palais de Tokyo. Paris: Centre audiovisuel Simone de Beauvoir, 1989.

Gudis, Catherine, ed. A Forest of Signs: Art in the Crisis of Representation. Cambridge, MA: MIT Press, in association with the Museum of Contemporary Art, Los Angeles, 1989.

Image World: Art and Media Culture. New York: Whitney Museum of American Art, 1989.

Mostra de Vídeo Norte-Americano. Porto: Fundação de Serralves, 1989.

Raven, Arlene. "Beyond Survival: Old Frontiers/New Visions—Artists Speak Out." In Positions. New York: Feminist Art Institute, 1989, pp. 16, 67.

Video Scan: An Introduction to Video Art. Madison, WI: Madison Art Center, 1989.

Video Transformations. New York: Independent Curators International, 1989.

Video-Skulptur: Retrospectiv und Aktuell 1963–1989. Cologne: Kölnischer Kunstverein and DuMont Kunsthalle, 1989.

What Does She Want? Current Feminist Art from the First Bank Collection. Carlton, MN: Carlton Art Gallery, Carlton College, 1989.

Zippay, Lori. "Collapse/Expansion: Parallel Realities of the Televisual." In Sequence/(con)Sequence: (sub)versions of Photography in the 80s. Ed. Julia Ballerini. Annandale-on-Hudson, NY: Bard College, in association with Aperture Foundation, New York, 1989, pp. 89–105.

1988 3. Videonale. Bonn: Videonale, 1988.

3rd International Festival of Films by Women Directors. Seattle, WA: CineMatrix, 1988.

1988: The World of Art Today. Milwaukee, WI: Milwaukee Art Museum, 1988.

American Film Institute Video Festival. Los Angeles: American Film Institute, 1988.

Festival International du Nouveau Cinema et de la Vidéo de Montréal. Montreal: Festival International du Nouveau Cinema et de la Vidéo, 1988.

Judson, William D. American Landscape Video: The Electronic Grove. Pittsburgh, PA: Carnegie Museum of Art, 1988.

Kirby, Kenneth. 1988 American Film Institute Video Festival. Los Angeles: American Film Institute, 1988, p. 78.

"TV: For Real." In Reprises de Vues. Geneva: Halle Sud, 1988.

1987 AFI FEST. Los Angeles: American Film Institute, 1987.

The Arts for Television. Los Angeles: Museum of Contemporary Art, and Stedelijk Museum, Amsterdam, 1987.

Documenta VIII. Kassel, Germany: Weber & Weidemeyer, 1987.

L'Époque, la mode, la morale, la passion: aspects de l'art d'aujourd'hui 1977–1987. Paris: Centre Georges Pompidou, 1987.

Implosion: A Postmodern Perspective. Stockholm: Moderna Museet, 1987.

Non in Codice. Rome, Italy: Galleria Pieroni, 1987.

Revision: Art Programmes of European Televising Stations. Amsterdam: Stedelijk Museum, 1987.

Vidéo des femmes. Saint Gervais, Geneva: Maison des Jeunes et de la Culture, 1987.

World Wide Video Festival. The Hague, Netherlands: Kijkhuis, 1987.

1986 *A Different Climate: Women Artists Use New Media*. Düsseldorf, Germany: Kunsthalle Düsseldorf, 1986.

Gautherot, Franck, and David Ross. *Dara Birnbaum*. Vol. 10 of *Succès du bedac* (1986).

The Image of Fiction, cassette 1: *The Hero / De Held*. Vol. 5 of *Infermental* (Rotterdam, 1986).

Kunst und Technologie, Der Bundesministerium für Forschung und Technologie. Bonn, Germany: Bundesministerium für Forschung und Technologie, 1986.

New York City Video. Sydney: Artspace Visual Arts Centre, 1986.

Origins Originality + Beyond. Sydney: Art Gallery of New South Wales, 1986.

Products and Promotion: Art, Advertising and the American Dream. San Francisco: San Francisco Camerawork, 1986.

Remembrances of Things Past. Long Beach, CA: Long Beach Museum of Art, 1986.

Video. International Video Conference. Montreal: Artextes, 1986.

Videonale '86, Internationales Festival und Wettbewerb fur Kunstvideos. Bonn: Videonale '86, 1986.

World Wide Video Festival. The Hague, Netherlands: Kijkhuis, 1986.

1985 *1. Internationale Video-Biennale, Der Beitrag von Frauen zum Thema Video, Dara Birnbaum Retrospektive*. Vienna: Internationale Video-Biennale, 1985.

Caldwell, John, and John R. Lane. *1985 Carnegie International*. Pittsburgh PA: Carnegie Museum of Art, 1985.

Communications for the Future: Television and Video Festival in India. Los Angeles: American Film Institute, 1985.

Huffman, Kathy Rae. *Video: A Retrospective 1974–1984*. Long Beach, CA: Long Beach Museum of Art, 1985.

Kunst Mit Eigen-Sinn. Vienna: Museum fur Moderner Kunst, 1985.

Made for TV Festival: Video Visions. New England Women in Film and Video (WIFV). Boston: Institute of Contemporary Art, 1985.

Performance Art and Video Installation. London: Tate Gallery, 1985.

Selections from the 1985 Whitney Biennial. New York: Whitney Museum of American Art, 1985.

Talking Back to the Media: Time Based Art, Amsterdam: de Appel, 1985.

Video Visions. Boston: Institute of Contemporary Art, 1985.

1984 *Artists' Videotapes: A Selection from Art Metropole*. Toronto: Art Metropole, 1984.

La Biennale di Venezia: XLI esposizione internazionale d'arte: arte e arti, attualita e storia. Milan: Electa, 1984.

Contemporary Perspectives. Lewisburg, PA: Bucknell University, 1984.

Content: A Contemporary Focus 1974–1984. Washington, DC: Hirshhorn Museum and Sculpture Garden. Smithsonian Institution, 1984.

Dara Birnbaum. Dijon, France: Le Coin du Miroir, 1984.

A Decade of New Art. New York: Artists Space, 1984.

Difference: On Representation and Sexuality. New York: New Museum of Contemporary Art, 1984.

Festival Internacional de Cine de San Sebastián. San Sebastián, Spain: Festival Internacional de Cine de Donostia-San Sebastián, 1984.

First National Video Festival. Madrid: Circulo de Bellas Artes, 1984.

Flyktpunkter: Vanishing Points. Stockholm: Moderna Museet, 1984.

From TV to Video, Bologna: Cineteca Comunale: Venice Biennale, 1984.

The Luminous Image. Amsterdam: Stedelijk Museum, 1984.

Mediated Narratives. Boston: Institute of Contemporary Art, 1984.

New American Video Art, A Historical Survey 1967–1980. New York: Whitney Museum of American Art, 1984.

New Voices 4: Women and the Media/New Video. Oberlin, OH: Allen Memorial Art Museum, 1984.

Poloni, Philippe. *Installation vidéo*. Montreal: Galerie Graff, 1984.

Rencontres Vidéo Internationales de Montreal-Video 84. Montreal: Galerie Graff, 1984.

Selections from the Permanent Collection. Chicago: Museum of Contemporary Art, 1984.

So There, Orwell 1984. New Orleans, LA: Louisiana World Exhibition, 1984.

Vidéos Musicales, 5ème Festival international d'art video. Locarno, Switzerland: Festival international d´art vidéo, 1984.

Women Artists/Filmmakers: Festival of Film as Art: The Women's Perspective. Greensboro, NC: University of North Carolina, 1984.

1983 Abish, Cecile, and Constance Fitzsimons. *Comment*. Long Beach, CA: Long Beach Museum of Art, 1983.

Film as Installation II. New York: Clocktower, Institute for Art and Urban Resources, 1983.

International Festival of Video Art. Ottawa, ON: Saw Gallery, 1983.

Mill Valley Film Festival. Mill Valley, CA: Mill Valley Film Festival, 1983.

National Video Festival. Los Angeles: American Film Institute, 1983.

Tenth Anniversary Exhibition. New York: Artists Space, 1983.

Video Video. Toronto: Toronto Film Festival, 1983.

Watching Television: A Video Event. Champaign, IL: University of Illinois, 1983.

Worldwide Video Festival. The Hague, Netherlands: Kijkhuis, 1983.

1982 1ère *Manifestation Internationale de Vidéo*. Montbeliard, France: Manifestation Internationale de Video, 1982.

11ème *Festival International du Nouveau Cinema*. Montreal: International du Nouveau Cinema, 1982.

'60/'80: Attitudes/Concepts/Images. Amsterdam: Stedelijk Museum, 1982.

The 74th American Exhibition. Chicago: Art Institute of Chicago, 1982.

Documenta VII. Kassel, Germany: D. V. P. Dierichs, 1982.

A Fatal Attraction: Art and the Media. Chicago: Renaissance Society at the University of Chicago, 1982.

From New York: Video Blitz 82/83. Düsseldorf, Germany: Kunsthalle Düsseldorf, 1982.

National Video Festival. Los Angeles: American Film Institute, 1982.

Rassegna Internazionale Donne Autrici di Cine e Video. Rome: Coop. Il Bagatto, 1982.

Seville Film Festival. Seville, Spain: Seville Film Festival, 1982.

Video Video. Toronto: Toronto Film Festival, 1982.

1981 *Contemporary American Art from the Commodities Corporation Collection*. Princeton, NJ: Commodities Corporation, 1981.

National Video Festival. Los Angeles: American Film Institute, 1981.

San Francisco International Video Festival. San Francisco: San Francisco International Video Festival, 1981.

1980 *Deconstruction/Reconstruction, The Transformation of Photographic Information into Metaphor*. New York: New Museum of Contemporary Art, 1980.

Film as Installation. New York: Clocktower, Institute for Urban Resources, 1980.

Video Installations Show, An Exhibition of Diagrams, Documentation and Video Installation. Buffalo, NY: Hallwalls, 1980.

BOOKS

2010 Demos, T. J. *Dara Birnbaum: Technology/Transformation: Wonder Woman*. London: Afterall, 2010.

Schreuder, Catrien. *Pixels and Spaces: Video Art in Public Space*. Rotterdam: NAi, 2010, pp. 17–19, 22, 26, 31, 58, 148.

2009 Comer, Stuart, ed. *Film and Video Art*. London: Tate, 2009, pp. 83, 85, 104, 125.

2008 Casagrande, Gaia, ed. *Castello di Rivoli Museum of Contemporary Art. The Castle—The Collection*. Milan: Skira, 2008, pp. 114–15.

Celant, Germano. *The American Tornado: Art in Power 1949–2008*. Milan: Skira, 2008, pp. 297, 317–22, 352.

Mulvey, Laura, and Jamie Sexton. *Experimental British Television*. Manchester, UK: Manchester University Press, 2008.

Obrist, Hans Ulrich, ed. *Formulas for Now*. London: Thames & Hudson, 2008, p. 27.

Oster, Martina, Waltraud Ernst, and Marion Gerards, eds. *Performativität und Performance: Geschlecht in Musik, Theater und Medienkunst*. Berlin: LIT, 2008.

Spielmann, Yvonne. *Video: The Reflexive Medium*. Cambridge, MA: MIT Press, 2008, pp. 117, 153–59, 168, 232–35, 312–17.

First published in German under the title *Video: Das reflexive Medium*. Frankfurt: Suhrkamp, 2005, pp. 85–87, 117, 153–54, 156–59.

2007 Buchloh, Benjamin H. D., ed. *30/40: A Selection of Forty Artists from Thirty Years at Marian Goodman Gallery*. New York: Marian Goodman Gallery, 2007, pp. 56–59.

Ceuleers, Jan, ed., with Ronny Van De Velde. *Artists' Handbook*. Ghent, Belgium: Ludion, 2007, pp. 42–43.

Costello, Diarmuid, and Jonathan Vickery. *Art: Key Contemporary Thinkers*. Oxford, UK: Berg, 2007.

Daneri, Anna, Andrea Lissoni, and Adelina Von Furstenberg. *Collateral: Quando l'arte guarda il cinema = When Art Looks at Cinema*. Milan: Charta, 2007.

De Paz, Alfredo. *L'Arte contemporanea. Tendenze, poetiche e ideologie dall'Espressionismo tedesco alla Postmodernità*. Naples: Liguori, 2007.

Henninger, Simone. *Das Fernsehen hat uns ein Leben lang attackiert— Jetzt schlagen wir zurück!—Das Videobild als Material künstlerischer Arbeit*. Munich: GRIN, 2007.

Lord, Susan, and Janine Marchessault. *Fluid Screens, Expanded Cinema*. Toronto: University of Toronto Press, 2007.

2006 Alberro, Alexander, and Sabeth Buchmann. *Art After Conceptual Art*. Cambridge, MA: MIT Press, 2006, pp. 16, 38, 39, 45–50, 139.

Hui Kyong Chun, Wendy, and Thomas Keenan. *New Media, Old Media: A History and Theory Reader*. New York: Routledge, 2006.

Katzeff, Miriam, and Thomas Lawson, eds. *Real Life Magazine: Selected Writings and Projects 1979–1994*. New York: Primary Information, 2006, pp. 152–55, 276–77.

Martin, Sylvia, and Uta Grosenick, eds. *Video Art*. Cologne: Taschen, 2006, p. 15.

Ross, Christine. *The Aesthetics of Disengagement: Contemporary Art and Depression*. Minneapolis: University of Minnesota Press, 2006.

Tuer, Dot. *Mining the Media Archive: Essays on Art, Technology and Cultural Resistance*. Toronto: YYZ Books, 2006.

2005 Buurman, Gerhard M. *Total Interaction: Theory and Practice of a New Paradigm for the Design Disciplines*. Basel: Birkhäuser, 2005.

Elwes, Catherine. *Video Art: A Guided Tour*. London: I. B. Tauris, 2005.

Kocur, Zoya, and Simon Leung. *Theory in Contemporary Art since 1985: From 1985 to the Present*. Blackwood, NJ: Blackwell Publishing, 2005.

McEvilley, Thomas. *The Triumph of Anti-art: Conceptual and Performance Art in the Formation of Post-modernism*. Kingston, NY: McPherson, 2005.

Spielmann, Yvonne. *Video—Das reflexive Medium*. Berlin: Suhrkamp, 2005.

de Valck, Marijke, and Malte Hagener. *Cinephilia: Movies, Love and Memory*. Amsterdam: Amsterdam University Press, 2005.

Video Art: The Castello di Rivoli Collection. London: I. B. Tauris, 2005.

2004 Bordini, Silvia. *Arte Elettronica*. Florence: Giunti, 2004.

Cahiers 89—Design Graphique. Paris: Éditions du Centre Georges Pompidou, 2004.

Daniels, Dieter, and Rudolph Freiling, eds. *Medien Kunst Netz: Medienkunst im Ueberblick*. Vienna: Springer, 2004.

"Dara Birnbaum, Instruction, 1996." In *Do It*. Ed. Hans Ulrich Obrist. Frankfurt am Main: e-flux / Revolver Archiv für aktuelle Kunst, 2004, pp. 38–39.

Fleming, William, and Mary Warner Marien. *Arts & Ideas*. Stamford, CT: Cengage Learning, 2004.

Gale, Peggy. *Artists Talk: 1969–1977*. Halifax, NS: Press of the Nova Scotia College of Art and Design, 2004.

Kacunko, Slavko. *Closed Circuit Videoinstallationen*. Berlin: Logos Verlag, 2004. (Book and DVD)

Kuni, Verena, and Claudia Reiche. *Cyberfeminism. Next Protocols*. Brooklyn, NY: Autonomedia, 2004.

Lovejoy, Margot. *Digital Currents: Art in the Electronic Age*. New York: Routledge, 2004, pp. 108, 122, 129–30.

Mayo, Marti, Lynn McLanahan Herbert, and Theresa Papanikolas. *Perspectives@25: A Quarter Century of New Art in Houston*. Houston: Contemporary Arts Museum, 2004.

2003 Auslander, Philip. *Performance: Critical Concepts in Literary and Cultural Studies*. London: Routledge, 2003.

Beccaria, Marcella, and Ida Gianelli, eds. *Castello di Rivoli—Museum of Contemporary Art, The Castle of the Savoy Dynasty—The Collection*. Turin, Italy: Humberto Allemandi & Co., 2003, pp. 104–5.

Cahoone, Lawrence E. *From Modernism to Postmodernism: An Anthology*. Blackwood, NJ: Blackwell Publishing, 2003.

Cubitt, Sean. *Videography: Video Media as Art and Culture*. New York: Macmillan, 2003.

Danino, Nina, and Michael Mazière. *The Undercut Reader: Critical Writings on Artists' Film and Video*. London: Wallflower Press, 2003.

Gaiger, Jason, and Paul Wood. *Art of the Twentieth Century: A Reader*. New Haven, CT: Yale University Press, 2003.

"The Individual Voice as a Political Voice: Critiquing and Challenging the Authority of Media, Dara Birnbaum." In *Women, Art and Technology*. Ed. Judy Malloy. Cambridge, MA: MIT Press, 2003, pp. 135–47.

Mullen, Megan Gwynne. *The Rise of Cable Programming in the United States: Revolution or Evolution?* Austin: University of Texas Press, 2003.

Obrist, Hans Ulrich. *Interviews, Volume I*. Milan: Charta, 2003, pp. 78–88.

Stich, Sidra. *Art-SITES San Francisco: The Indispensable Guide to Contemporary Art—Architecture—Design*. San Francisco: Art-SITES Press, 2003.

2002 Ault, Julie. *Alternative Art, New York, 1965–1985: A Cultural Politics Book for the Social Text Collective*. Minneapolis: University of Minnesota Press, 2002.

Marwick, Arthur. *The Arts in the West since 1945*. Oxford, UK: Oxford University Press, 2002.

Patrick, Frank, Duane Preble, and Sarah Preble. *Artforms*. Englewood Cliffs, NJ: Prentice Hall, 2002, p. 177.

Pendergast, Sara. *Contemporary Artists*. London: St. James Press, 2002.

Vidal, Jordi. *Résistance au chaos: pour une critique du nouvel ordre feudal*. Paris: Éditions Allia, 2002.

2001 Bell, Cory. *Modern Art: A Crash Course*. New York: Watson-Guptill, 2001.

A Creative Legacy, A History of the National Endowment for the Arts Visual

Artist's Fellowship Program 1966–1995. New York: Harry N. Abrams, 2001, pp. 23, 38.

McCarthy, Anna. *Ambient Television: Visual Culture and Public Space*. Durham, NC: Duke University Press, 2001.

Neidhöfer, Herbert, Bernd Ternes, and Hans Peter Weber. *Mediaanariten: Maske und Modell*. Marburg, Germany: Tectum, 2002.

Pearson, Roberta E., and Philip Simpson. *Critical Dictionary of Film and Television Theory*. London: Routledge, 2001.

Saper, Craig J. *Networked Art*. Minneapolis: University of Minnesota Press, 2001.

Stemmrich, Gregor. *Kunst/kino*. Cologne: Oktagon, 2001.

Welchman, John C. "Technology/Transformation: Wonder Woman." *Art After Appropriation, Essays on Art in the 1990s*. Amsterdam: G+B Arts International, 2001, pp. 33, 190, 210.

2000 Bee, Susan, and Mira Schor. *M/E/A/N/I/N/G: An Anthology of Artists' Writings, Theory and Criticism*. Durham, NC: Duke University Press, 2000.

Elwes, Catherine, Lisa Steele, and Jeremy Welsh. *Video Loupe: A Collection of Essays by and about the Video Maker and Critic*. London: KT Press, 2000.

Harding, James Martin. *Contours of the Theatrical Avant-Garde: Performance and Textuality*. Ann Arbor: University of Michigan Press, 2000.

Herkenhoff, Paulo, Milena Kalinovsky, and Michael Newman. *Beyond Preconceptions: The Sixties Experiment*. New York: Independent Curators International, 2000.

Obrist, Hans Ulrich. "Urban Rumors." In *Mutations: Rem Koolhaus, Harvard Project on the City*. Barcelona: Actar, 2000, p. 721.

Sayre, Henry M. *A World of Art*. Englewood Cliffs, NJ: Prentice Hall, 2000.

1999 Gould, Claudia, and Valerie Smith, eds. *5000 Artists Return to Artists Space: 25 Years*. New York: Artists Space, 1999.

Heudin, Jean-Claude. *Virtual Worlds: Synthetic Universes, Digital Life, and Complexity*. Cambridge, MA: Perseus Books, 1999.

Höller, Christian, ed. *Widerstände, Kunst—Cultural Studies—Neue Medien*. Interviews und Aufsätze aus der Zeitschrift springerin 1995–1999. Vienna: Folio Verlag Wien, 1999, pp. 19–26, 274.

Kurjakovic, Daniel, and Sebastian Lohse, eds. *Other Room, Other Voices, Audio Works by Artists*. Zurich: Memory/Cage Editions, 1999, pp. 77–82.

Philips, Lisa. *The American Century: Art and Culture 1900–2000*. Vol. 2. New York: Norton, in association with Whitney Museum of American Art, 1999.

Reiss, Julie H. *From Margins to Center: The Spaces of Installation Art*. Cambridge, MA: MIT Press, 1999, pp. 132, 134.

Rush, Michael. *New Media in Late 20th-Century Art*. London: Thames and Hudson, 1999, pp. 106, 126, 127.

Traveler's Guide to Art Museum Exhibitions: 2000 Edition. New York: Harry N. Abrams, 1999.

Women in Photography International Archive. Los Angeles: Women in Photography International Archive, 1999.

1998 Baqué, Dominique. *La Photographie plasticienne: un art paradoxal*. Paris: Éditions du Regard, 1998, pp. 182, 198.

Birringer, Johannes H. *Media & Performance: Along the Border*. Baltimore, MD: Johns Hopkins University Press, 1998.

"Dara Birnbaum, Four Gates." In *Public Art Lower Austria, volume 4 (Veröffentlichte Kunst, Kunst im öffentlichen Raum Niederösterreich, Band 4).* Vienna: Österreichischer Kunst- und Kulturverlag, 1998, pp. 172, 173.

Kincheloe, Joe L., and Shirley R. Steinberg. *Unauthorized Methods: Strategies for Critical Teaching.* New York: Routledge, 1998.

Maza, Monique. *Les Installations vidéo: "œuvres d'art."* Paris: L'Harmattan, 1998.

Perree, Rob. *Into Video Art: The Characteristics of the Medium.* Amsterdam: Con Rumore, 1988, pp. 59, 68.

Roberts, John Maddox. *The Art of Interruption: Realism, Photography, and the Everyday.* Manchester, UK: Manchester University Press, 1998.

1997 Atkins, Robert. *Artspeak: A Guide to Contemporary Ideas, Movements, and Buzzwords, 1945 to the Present.* New York: Abbeville Press Publishers, 1997.

Baigorri Ballarín, Laura. *El vídeo y las vanguardias históricas.* Barcelona: Edicions de la Universitat de Barcelona, 1997.

Bertens, Hans, Johannes Willem Bertens, and Douwe Wessel Fokkema. *International Postmodernism: Theory and Literary Practice.* Amsterdam: John Benjamins, 1997.

Eyewitness Travel Guides: California. London: Duncan Baird, 1997.

Hugetz, Ed. "Experimental Video." In *Encyclopedia of Television.* Chicago: Museum of Broadcast Communications, 1997.

Obrist, Hans Ulrich. "Dara Birnbaum: An Interview by Hans Ulrich Obrist." *Art Recollection, Artists' Interviews and Statements in the Nineties.* Ed. Gabriele Detterer. Florence, Italy: Danilo Montanari & Exit & Zona Archives Editori, 1997, pp. 34–46.

"Project 08: Dara Birnbaum, Proposal for a Permanent Video Installation for the NYC Headquarters of Sony Corporation." In *Unbuilt Roads: 107 Unrealized Projects.* Ed. Hans Ulrich Obrist and Guy Tortosa. Ostfildern-Ruit, Germany: Hatje Cantz, 1997.

Steyn, Juliet. *Other than Identity: The Subject, Politics and Art.* Manchester, UK: Manchester University Press, 1997.

1996 Campbell, Patrick. *Analysing Performance: A Critical Reader.* Manchester, UK: Manchester University Press, 1996.

Klein, Norman M. *Seven Minutes: The Life and Death of the American Animated Cartoon.* London: Verso, 1996.

Mayer, Marc. *Being & Time: The Emergence of Video Projection.* Buffalo, NY: Buffalo Fine Arts Academy, 1996.

Müller-Funk, Wolfgang, and Hans Ulrich Reck, eds. *Inszenierte Imagination: Beiträge zu einer historischen Anthropologie der Medien, Ästhetik und Naturwissenschaften, Medienkultur.* Vienna: Springer, 1996.

Welsh, J. "One Nation Under a Will (of Iron), The Shiny Toys of Thatcher's Children." In *Diverse Practices: A Critical Reader on British Video Art.* Ed. Julia Knight. Bedfordshire, UK: Luton Press, 1996.

1995 Brown, Marshall. *The Uses of Literary History.* Durham, NC: Duke University Press, 1995.

Burnett, Ron. *Cultures of Vision: Media and the Imaging.* Bloomington, IN: Indiana University Press, 1995.

Davidson, Cynthia C. *Anyplace.* New York: Anyone Corp., 1995.

Graham, Dan, and Hans Dieter Huber. *Dan Graham Interviews.* Ostfildern-Ruit, Germany: Hatje Cantz, 1995.

Huhtamo, Erkki. *Taidetta koneesta: media, taide, teknologia.* Täydennyskoulutuskeskus, Finland: Kulttuurihistoria, 1995.

Kahn, Robin. *Time Capsule: A Concise Encyclopedia by Women Artists.* New York: Creative Time, in association with SOS Int'l, 1995.

Malsch, Friedemann, and Dagmar Streckel. *Künstler-Videos: Entwicklung und Bedeutung.* Zurich: Kunsthaus, 1995, pp. 75–76.

1994 De Oliveira, Nicolas, Nicola Oxley, and Michael Petry. *Installation Art.* Washington, DC, and London: Smithsonian Institution Press and Thames and Hudson, 1994.

Hodges, Nicola. *Performance Art: Into the 90s.* London: Academy Editions, 1994.

Owens, Craig. *Beyond Recognition: Representation, Power, and Culture.* Berkeley, CA: University of California Press, 1994.

Williams, Linda. *Eyewitness Guide to San Francisco.* London: Dorling Kindersley, 1994.

Witzling, Mara Rose. *Voicing Today's Visions: Writings by Contemporary Women Artists.* New York: Universe, 1994.

1993 Andriese, Antionette, and Nio Hermes, eds. *Met Open Vizer: Moment uit de beeldvorming rond Amazonen.* Amsterdam: Amazone, 1993, p. 82.

The Hydrogen Jukebox: Selected Writings of Peter Schjeldahl, 1978–1990. Berkeley, CA: University of California Press, 1993.

Popper, Frank. *Art of the Electronic Age.* New York: Harry N. Abrams, 1993.

Walker, John Albert. *Arts TV: A History of Arts Television in Britain.* New Barnet, Herts, UK: John Libbey, 1993.

1992 Bruegmann, Robert, Anne Rorimer, and Beryl J. Wright. *Art at the Armory: Occupied Territory.* Chicago: Museum of Contemporary Art, 1992.

Garrard, Mary D., and Norma Broude. *The Expanding Discourse: Feminism and Art History.* Boulder, CO: Westview Press, 1992.

Jencks, Charles. *The Post-modern Reader.* London: Academy Editions, 1992.

Kostelanetz, Richard. *On Innovative Art(ist)s: Recollections of an Expanding Field.* Jefferson, NC: McFarland, 1992.

Raven, Arlene. "Beyond Survival: Old Frontiers/New Visions—Artists Speak Out." In *Positions.* New York: NY Feminist Art Institute, 1992, pp. 16, 67.

Seigel, Judy. *Mutiny and the Mainstream: Talk That Changed Art, 1975–1990.* New York: Midmarch Arts Press, 1992.

Sten, Ulrika. *Video = Jag Ser.* Stockholm: Stockholm University, 1992.

Vidéo et après, La Collection vidéo du Musée national d'art moderne, Centre Pompidou. Paris: Éditions Carré, 1992, p. 82.

Walker, John Albert. *Glossary of Art, Architecture and Design since 1945.* Boston: G. K. Hall, 1992.

1991 Anderson, Janet A. *Women in the Fine Arts: A Bibliography and Illustration Guide.* Jefferson, NC: McFarland, 1991.

Bibliography of the History of Art: BHA = Bibliographie d'histoire de l'art, Institut de l'information scientifique et technique (France), Getty Art History Information Program, Comité international d'histoire de l'art, College Art Association of America, Art Libraries Society of North America. Vandoeuvre-lès-Nancy, France: Centre national de la recherche scientifique Institut de l'information scientifique et technique, in association with J. Paul Getty Trust, Getty Art History Information Program, Los Angeles, 1991.

Birringer, Johannes H. *Theatre, Theory, Postmodernism*. Bloomington, IN: Indiana University Press, 1991.

Breakthroughs: Avant-Garde Artists in Europe and America, 1950–1990. New York: Rizzoli, 1991, p. 169.

Dunlop, Beth, and Massimo Vignelli. *Arquitectonica*. Washington, DC: American Institute of Architects Press, 1991.

Hoffman, Katherine. *Explorations: The Visual Arts since 1945*. New York: HarperCollins, 1991.

Perchuck, Andrew, and Geno Rodriguez. *Artists of Conscience: 16 Years of Social and Political Commentary*. New York: Alternative Museum, 1991.

1990 Acconci, Vito, and Barry A. Rosenberg. *Assembled: Works of Art Using Photography as a Construction Element*. Dayton, OH: Wright State University Art Galleries, 1990.

Fifer, Sally Jo, and Doug Hall, eds. Illuminating Video—An Essential Guide to Video Art. New York: Aperture, in association with the Bay Area Video Coalition, 1990.

Finn-Kelcey, Rose, and Chrissie Iles. *Signs of the Times: A Decade of Video, Films and Slide-tape Installation in Britain, 1980–1990*. Oxford, UK: Museum of Modern Art, 1990.

Grundberg, Andy. *Crisis of the Real: Writings on Photography, 1974–1989*. New York: Aperture, 1990.

London, Mel. *Getting into Video. A Career Guide*. New York: Random House, 1990.

"Out of the Blue, Dara Birnbaum." In *Discourses: Conversations in Postmodern Art and Culture*. Ed. Russell Ferguson, Karen Fiss, William Olander, and Marcia Tucker. New York: New Museum of Contemporary Art, 1990, pp. 192–95.

Risatti, Howard Anthon. *Postmodern Perspectives: Issues in Contemporary Art*. Englewood Cliffs, NJ: Prentice Hall, 1990.

1989 Langer, Cassandra L. *Positions: Reflections on Multi-racial Issues in the Visual Arts*. New York: Feminist Art Institute/Women's Center for Learning, 1989.

Lovejoy, Margot. *Postmodern Currents: Art and Artists in the Age of Electronic Media*. Ann Arbor: University of Michigan Research Press, 1989, pp. 230, 238–42.

Sayre, Henry M. *The Object of Performance: The American Avant-Garde since 1970*. Chicago: University of Chicago Press, 1989, pp. 79–80.

Straayer, Arny Christine. "Sexual Subjects: Signification, Viewership, and Pleasure in Film and Video." PH. D. diss., Northwestern University, 1989.

1988 Beckett, Wendy. *Contemporary Women Artists*. New York: Universe, 1988.

Fisher, Mary Pat, and Paul Zelanski. *The Art of Seeing*. Englewood Cliffs, NJ: Prentice Hall, 1988.

1987 Branca, Glenn, and Barbara Ess, eds. *Thought Objects*. New York: CEPA and JAA Press, 1987.

Discussions in Contemporary Culture. Seattle, WA: Bay Press in association with Dia Center for the Arts, 1987.

Frye Burnham, Linda. *High Performance, Art in the Public Interest*. Los Angeles: Astro Artz, 1987.

Jameson, Fredric. *Utopia Post Utopia: Configurations of Nature and Culture in Recent Sculpture and Photography*. Boston: Institute of Contemporary, 1987.

Walker, John A. *Cross-Overs: Art into Pop/Pop into Art*. London: Methuen, 1987, p. 154.

1986 Bois, Yve Alain. *Endgame: Reference and Simulation in Recent Painting and Sculpture*. Boston: Institute of Contemporary Art, 1986.

Boyle, Deirdre. *Video Classics: A Guide to Video Art and Documentary Tapes*. Phoenix, AZ: Oryx Press, 1986.

Crary, Jonathan, Michael Feher, Hal Foster, and Sanford Kwinters, eds. *Zone 1/2*. New York: Urzone, 1986.

Hanhardt, John, ed. *Video Culture: A Critical Investigation*. Rochester, NY: Peregrine Smith Books, 1986, pp. 22, 169, 174–78.

MacCabe, Colin. *High Theory/Low Culture: Analysing Popular Television and Film*. Manchester, UK: Manchester University Press, 1986.

Olander, William. "Women and the Media: A Decade of New Video." In *Resolution: A Critique of Video Art*. Ed. Patti Podesta. Los Angeles: LACE, 1986, pp. 76–81.

Ross, David. "Truth or Consequences: American Television and Video Art." In *Video Culture: A Critical Investigation*. Ed. John G. Hanhardt. Rochester, NY: Visual Studies Workshop Press, 1986, pp. 169–70, 174–78.

Saltz, Jerry. *Beyond Boundaries: New York's New Art*. New York: Alfred Van Der Marck Editions, 1986, pp. 114, 115, 123.

Tanaka, Seiichi. *The Avant-Garde in New York*. Tokyo: Tanaka Studio, 1986.

1985 *American Film*. Los Angeles: American Film Institute, Arthur M. Sackler Foundation, 1985.

D'Agostino, Peter. T*ransmission: Theory and Practice for a New Television Aesthetics*. New York: Tanam Press, 1985.

Foster, Hal, ed. *Postmodern Culture*. London: Pluto Press, 1985.

Hertz, Richard, ed. *Theories of Contemporary Art*. Englewood Cliffs, NJ: Prentice Hall, 1985, p. 153.

1984 Fox, Howard N., Miranda McClintic, and Phyllis D. Rosenzweig. *Content: A Contemporary Focus, 1974–1984*. Washington, DC: Smithsonian Institution Press, 1984.

Frank, Peter. *Re-dact: An Anthology of Art Criticism*. New York: Willis, Locker & Owens, 1984.

Hoberman, J. "After Avant-Garde Film." In *Art After Modernism: Rethinking Representation*. Ed. Brian Wallis. Boston: David R. Godine, in association with New Museum of Contemporary Art, New York, 1984, pp. 70–72.

1983 Celant, Germano. "I Gergo Inquiero." In *Inespressionismo Americano*. Ed. Germano Celant. Milan: Bonino Editore, 1983

Owens, Craig. "The Discourse of Others: Feminists and Postmodernism." In *The Anti-Aesthetic: Essays on Postmodern Culture*. Ed. Hal Foster. Seattle, Wash.: Bay Press, 1983, p. 57.

1978 Battcock, Gregory. *New Artists Video*. New York: E. P. Dutton, 1978.

1977 Davis, Douglas, and Allison Simmons. *The New Television, A Public-Private Art*. Cambridge, MA: MIT Press, 1977.

1976 Korot, Beryl, and Ira Schneider. *Video Art, An Anthology*. New York: Harcourt Brace Jovanovich, 1976.

WRITINGS/PROJECTS BY THE ARTIST

2010 A project by Dara Birnbaum. *Esopus 15: TELEVISION*, November 2010.

2009 "Poussin and Nature: Arcadian Visions." *Artforum* 47, no. 4 (December 2008): p. 110.

2008 "Downtown Body: A Tear-Out Poster by Ward Shelley." *Bomb*, no. 105 (Fall 2008): pp. 32–33.

2005 Cover for *The Drama Review* 49, no. 1–T185 (Spring 2005).

2004 "Answering a Proposition with a Question—Or, What Is Wrong with This Picture?" In *The Next Documenta Should Be Curated by an Artist*. Ed. Jens Hoffman. Frankfurt am Main: Revolver Archiv für aktuelle Kunst, 2004, pp. 18–21.

2003 "The Individual Voice as a Political Voice: Critiquing and Challenging the Authority of Media." In *Women, Art and Technology*.Ed. Judy Malloy. Cambridge, MA: MIT Press, 2003, pp. 135–47.

1999 "Elemental Forces, Elemental Dispositions: fire/water." *October*, no. 90 (Fall 1999): pp. 109–35.

1996 "Dara Birnbaum/Dan Graham Collaboration." *Springer*, no. 7/8 (February 1996).

"Electronic Incision: Four Gates for St. Pölten." *BauArt*, no. 4 (1996): pp. 10–19.

Étant donné, no. 6. Cover design. Brussels, Belgium, 1996.

"Media's Affectation of Public Space: The Video Installation Works of Dara Birnbaum." *ArisMEDIArchitecture, Journal of the Carnegie Mellon Department of Architecture*, 1996.

"Media's Continuous and Discontinuous Forms." *Inszenierte Imagination*. Ed. Wolfgang Müller-Funk and Hans Ulrich Reck. Cologne: Kunsthochschule für Medien Köln. 1996, pp. 185–97.

"Raum denken"/"Thinking space," *BauArt 4*. Vienna: Verein für die Förderung von Architektur, 1996.

1995 "Finding Any Place in Cyberspace" (with Scott Lyall). In *Anyplace*. Ed. Cynthia C. Davidson. Cambridge, MA: MIT Press, 1995, pp. 160–70.

"Media's Affection: Public Space." *Aris 2*, Department of Architecture. Pittsburgh: Carnegie Mellon University, 1995.

1993 "A Statement of Manifestation for the Conference: Radical Chic." In *Radical Chic Reader*. Stuttgart: Künstlerhaus, 1993, pp. 57–61.

1992 *Every TV Needs a Revolution*. Ghent, Belgium: Imschoot, 1992.

"Overlapping Signs." In *War After War*. Ed. Amy Scholder. San Francisco: City Lights Publishers, 1992, pp. 27–36.

"Trans-Voices." *Whitney Museum of American Art 66, New American Film and Video Series*. New York: Whitney Museum of American Art, 1992.

1991 "The Rio Experience: Video's New Architecture Meets Corporate Sponsorship." In *Illuminating Video: An Essential Guide to Video Art*. Ed. Sally Jo Fifer and Doug Hall. New York: Aperture, in association with the Bay Area Video Coalition, 1991, pp. 189–204.

"Yearbook." In *Jahresring #38*. Ed. Kasper König and Hans Ulrich Obrist. Munich: Silke Schreiber, 1991.

1990 "Out of the Blue." In *Discourses: Conversations in Postmodern Art and Culture*. Ed. Russell Ferguson, Karen Fiss, William Olander, and Marcia Tucker. Cambridge, MA: MIT Press, 1990, pp. 192–95.

1989 Deleuze, Gilles. *Masochism*. (Art and graphic design for cover.) New York: Zone Books, 1989.

"The Wondering of Context." *Real Life Magazine*, no. 20 (1989): pp. 16–17.

1988 "Out of the Blue." *Artforum* 26, no. 7 (March 1988): pp. 117–19.

"Photo Essay." *City Lights Review*, no. 2 (1988): pp. 16–20.

1987 *Rough Edits: Popular Image Video Works, 1977–1980*. Ed. Benjamin H. D. Buchloh. Halifax, NS: Press of the Nova Scotia College of Art and Design, 1987.

"Wonder, Wonder Woman." *Telos*, no. 9 (March–May 1987): pp. 159–61.

1986 "Talking Back to the Media." In *Resolution: A Critique of Video Art*. Ed. Patti Podesta. Los Angeles: LACE, 1986, pp. 51–56.

1985 "Every Color TV Needs a Revolution." In *TV Guides*. Ed. Barbara Kruger. New York: Kuklapolitan Press, 1985, pp. 24–25.

"Playground (The Damnation of Faust)." *Zone*, no. 1/2 (1985): pp. 70–79.

"Talking Back to the Media." In *Talking Back to the Media* (November 1985), pp. 46–49.

1984 "Special Artist Portfolio." *Send*, no. 9 (Spring 1984): pp. 46–47.

1983 "If It's Tuesday This Must Be Belgium." *The Independent*, May 1983, pp. 19–20.

"Up Against the Wall!" *Art Com Magazine*, no. 20 (1983): p. 26.

1979 "Use of Corner Insert: Comparative Realities, 1978." In *Dan Graham: Video—Architecture—Television*. Ed. Benjamin H. D. Buchloh. Halifax, NS: Press of the Nova Scotia College of Art & Design, 1979, pp. 77–85.

RADIO AND TELEVISION BROADCASTS ABOUT BIRNBAUM AND OF WORKS BY BIRNBAUM

2006 "The Territory." Produced by the Austin Museum of Art and the Southwest Alternate Media Project, Houston and KUHT-TV, Houston; KLRU-TV (channel 18 and cable channel 9).

2004 90.7 FM KSFR—Santa Fe Public Radio, Program: Santa Fe Radio Cafe, Santa Fe, NM, June 6.

2001 Televisions, FM4, Austria.

1995 Ö1 Kulturjournal, 15 h 40, October 4.

Ö1 Transparent, 22 h 20, October 4.

1986 "Ars Electronica." ORF Televison Broadcast, Austria.

DOCUMENTARIES

2007 Blumberg, Skip. *Nam June Paik: Lessons from the Video Master*. 92 min. Chicago: Facets Multimedia 2007.

2003 Tapia-Urzua, Andres, and Ralph Vituccio. *When Video Came*. 42 min. Pittsburgh: Plan Z Media, 2003.

2000 Birnbaum, Dara, and T. Vitale. *Interview with the Artist*. MiniDV. 60 min. 2000.

Sigrid Adorf is deputy director of and teaches at the Institute for Cultural Studies, Academy of Fine Arts Zürich. She has published a digital catalogue raisonné of work by Valie Export (1998–99) and curated, with Monika Schieren, the exhibition "Metanomie" for the Städtische Galerie Bremen in 2006. Adorf is a copublisher of *Frauen Kunst Wissenschaft,* a magazine for gender studies and visual culture. As an art critic, she has contributed to such magazines as *Camera Austria, Noema,* and *Texte zur Kunst.* Her book on video art by women in the 1970s, *Operation Video. Eine Technik des Nahsehens und ihr spezifisches Subjekt: Die Videokünstlerin der 1970er Jahre,* was published by Transcript in 2008.

Marianne Brouwer is an independent curator and writer. She was born in the Netherlands and has lived in Japan and in France, where she obtained her master's degree in art history at the Sorbonne. In the 1970s, she worked as an art critic and journalist. During the 1980s and 1990s, she was the curator of sculpture at the Kröller-Müller Museum in Otterlo, the Netherlands. In addition to teaching at various art institutions, she has curated many major shows, has widely published and lectured, and has participated in international juries. In 1994 she curated the exhibition "Heart of Darkness," dedicated to issues of exile and the "Other." She was the guest curator of the exhibition "Another Long March: Chinese Conceptual and Installation Art in the Nineties," held in 1997 in Breda, the Netherlands. In 2003 she received the Netherlands' International Association of Art Critics (AICA) Award for the exhibition and catalogue *Dan Graham: Works 1996–2000* (with Corinne Diserens). In 2005 she obtained a grant from the Dutch Government to research the history of non-Western women artists.

Johanna Burton is a New York–based art historian and critic and director of the Graduate Program at Bard College's Center for Curatorial Studies. She has written extensively on postwar and contemporary art for numerous publications, including *Artforum, Parkett,* and *Texte zur Kunst;* she is the editor of *Cindy Sherman* (2006), a collection of critical essays on the artist for MIT Press's October Files series. Burton's other recent writings include texts on the women-only art magazine *Eau de Cologne* (published in *Witness to Her Art,* edited by Rhea Anastas and Michael Brenson, 2006), and Lee Lozano (2008); and she has written catalogue essays for recent career survey exhibitions of Mel Bochner and Mary Heilmann. Burton was associate director and senior faculty member at the Whitney Independent Study Program in New York until 2010 and is currently completing her dissertation at Princeton University on appropriation in American art of the 1980s.

Rebecca Cleman is the director of distribution at Electronic Arts Intermix (EAI). Since joining EAI in 2000, she has programmed numerous screenings devoted to the history of video art for such venues as the New York Underground Film Festival; Light Industry, Brooklyn; Anthology Film Archives, New York; and ISSUE Project Room, among others. She has presented and discussed the emergence of video art in New York as a frequent participant in panel discussions about media and the art world, including "On the Collapse and Proliferation of the Moving Image" (Orchard, New York, 2006); "Moving/Images: Preserving Downtown Time-Based Works" (The Fales Library, New York University, 2008); and "Neither Here Nor There: Preservation and Access in the Art World" (Association of Moving Image Archivists Conference, 2009). In May 2009, Cleman organized and moderated "Copyright and the Moving-Image, Online" for the Oberhausen International Film Festival in Germany.

Diedrich Diederichsen was editor of several music magazines in the 1980s (including *Sounds,* Hamburg; *Spex,* Cologne) and taught at several academies in the 1990s in Germany, Austria, and the United States in the fields of art history, musicology, theater studies, and cultural studies. He is currently professor for theory, practice, and communication of contemporary art at the Academy of Fine Art in Vienna. His most recent publications include *Eigenblutdoping* (2008), *Kritik des Auges* (2008), *Argument Son* (2007), *Peronas en loop* (2006), *Musikzimmer* (2005).

Marina Gržinić is a philosopher, artist, and theoretician, who is based in Ljubljana and Vienna. She is a professor of post-conceptual art practices at the Academy of Fine Arts in Vienna, Institute of Fine Arts and is a researcher at the Institute of Philosophy at the ZRC SAZU (Scientific and Research Center of the Slovenian Academy of Science and Art) in Ljubljana. Gržinić also works as freelance media theorist, art critic, and curator. Her nost recent book is *Re-Politicizing Art, Theory, Representation and New Media Technology* (2008). Marina Gržinić has been involved with video art since 1982. In collaboration with Aina Smid, Gržinić has realized more than forty video-art projects (see http://www.grzinic-smid.si/).

Steven Jacobs is an art historian specialized in the photographic and cinematic representations of architecture, cities, and landscapes. He has published essays and articles in such journals as *Andere Sinema, Exposure, History of Photography, The Journal of Architecture, De Witte Raaf,* and in numerous books and catalogues. As a member of the Ghent Urban Studies Team (GUST), he coedited and coauthored *The Urban Condition: Space, Community, and Self in the Contemporary Metropolis* (1999) and *Post Ex Sub Dis: Urban Fragmentations and Constructions* (2002). In 2007, he published *The Wrong House: The Architecture of Alfred Hitchcock.* Jacobs has taught at several universities and art schools in Belgium and the Netherlands and is currently a professor of film history at the Hogeschool Sint-Lukas Brussels, the Academy of Fine Arts in Ghent, and the University of Antwerp,

Michael Newman teaches at the School of the Art Institute of Chicago and is professor of art writing at Goldsmiths College at the University of London. He holds degrees in literature and art history and a doctorate in philosophy from the Katholieke Universiteit Leuven, Belgium. He has written extensively on contemporary art, including the books *Richard Prince: Untitled (couple)* (2006) and *Jeff Wall* (2007), as well as essays on Seth Price, Alfred Jensen, Hanne Darboven, and Joëlle Tuerlinckx. Newman's curatorial projects include "Tacita Dean" at the Art Gallery of York University, Toronto (2000), on whom his essays have been published by Tate Britain (2001) and Musée d'art moderne de la Ville de Paris (2003). He coedited *Re-Writing Conceptual Art* (1999). In philosophy, he has published essays on Kant, Nietzsche, Derrida, Levinas, and Blanchot.

Hans Ulrich Obrist was born in Zurich in May 1968. He joined the Serpentine Gallery as codirector of exhibitions and programs and director of international projects in April 2006. Prior to this, he was curator of the Musée d'art moderne de la Ville de Paris, as well as curator of Museum in Progress, Vienna, from 1993 to 2000. He has curated over two hundred exhibitions internationally since 1991, including "Do It," "Take Me, I'm Yours," "Cities on the Move," "Live/Life," "Nuit Blanche," st Berlin Biennale, Manifesta 1, and more recently "Uncertain States of America," st Moscow Triennale, 2nd Guangzhou Triennale, and Lyon Biennale. In 2007, Obrist co-curated *Il Tempo del Postino,* with Philippe Parreno, for the Manchester International Festival. In the same year, the Van Alen Institute awarded him the New York Prize Senior Fellowship for 2007–2008.

Lori Zippay is executive director of Electronic Arts Intermix (EAI), a nonprofit arts organization and video art resource in New York. She has developed EAI's collection and initiated its pioneering preservation program and extensive digital resources. For over twenty-five years, she has been active in video art exhibition, distribution, education, and preservation and has curated numerous video programs and exhibitions at international venues including *That Obscure Object at the Museum* of Fine Arts, Lausanne (2006); *First Decade: Video from the EAI Archives* at the Museum of Modern Art, New York (co-curator, 2002), *Downtown New York, circa 1970* (2002) at EAI; *Joan Jonas: Early Films and Videos* (2001) and *Silent Screen* (1998) for the Lux Centre, London. Zippay has lectured, taught, and written widely on media art and is editor and co-author of the EAI Online Catalogue (1997–2010), a digital publication on the EAI media art collection, and *A Kinetic History,* an archival project on the emergent video art movement. Her articles and essays on media and art have appeared in publications such as *Artforum* and *Art Journal.* She is editor and co-author of *Artists' Video: An International Guide* (Cross River Press: New York, London, Paris, 1992).

This book is published in conjunction with the exhibition

DARA BIRNBAUM
THE DARK MATTER OF MEDIA LIGHT

S.M.A.K.–Stedelijk Museum voor Actuele Kunst
April 4–September 6, 2009

Curators Philippe Van Cauteren, Giel Vandecaveye
Coordination of production Giel Vandecaveye
Registrar Catherine Ruyffelaere
Restauration and conservation Ann Brusselmans, Marieke Verboven
Installation staff K. Fine Art Services, Giel Vandecaveye, Tony © Video

Sponsor of the Exhibition

Museu de Arte Contemporânea de Serralves
March 25–July 4, 2010

Curators João Fernandes, Paula Fernandes
Coordinator of production Paula Fernandes
Registrar Ana Sofia Andrade
Restoration and conservation Filipe Duarte
Installation staff João Brites, Vítor Costa, João Covita, Nelson Faria, Rúben Freitas, Carlos Lopes, Adelino Pontes, Lázaro Silva, Giel Vandecaveye, Tony © Video
Video Amarante Abramovici; Pedro Catarino; Carla Pinto, Paulo Silva
Sound Nuno Aragão, Filipe Ratão

Support

Exclusive Sponsor of the Exhibition

fundação
edp

CATALOGUE
Editors Karen Kelly, Barbara Schroeder, Giel Vandecaveye
Graphic design Koen Bruyñeel
Coordination Maria Ramos, Giel Vandecaveye
Research Aniko Erdosi, Rachel Wolf
Translation James Gussen; Steven Lindberg;
Rosemarie Vermeulen (with Karen Kelly and Barbara Schroeder)
Copyediting Domenick Ammirati, Jeremy Sigler (Grižinić)
Proofreading Richard Gallin, Sam Frank, Maria Ramos
Prepress Digital Evolution, New York, USA; Cassochrome, Waregem, Belgium
Printing and binding Cassochrome, Waregem, Belgium

Cover illustration
Dara Birnbaum, adaptation of her *Erwartung/Expectancy* (1995/2001), including
reproduction of Arnold Schönberg's *Erwartung* op. 17, c. 1911 (watercolor, pen, and
Chinese ink on paper, 10.9 x 17.1 cm)

Photographic credits
All images courtesy of Dara Birnbaum Archive, except
All single-channel video stills: Courtesy Electronic Arts Intermix (EAI), New York
pp. 154–55, 228–29, 246–47, 271, 278, 285: Dirk Pauwels, Courtesy S.M.A.K., Ghent
pp. 245 top, 284–85: Filipe Braga, Courtesy Fundação de Serralves, Porto
Acconci, pp. 55 and 108; Rosler, p. 102; Benglis, p. 110: Courtesy Electronic Arts
Intermix (EAI), New York
Acconci, p. 105: Courtesy Acconci Studio, New York
Capa, p. 53: Robert Capa © 2001 By Cornell Capa/Magnum Photos
Cover: © Belmont Music Publishers, Pacific Palisades / SABAM Belgium 2011
Dujourie, p. 107: Collection FRAC © D.R.
Goldstein, p. 60: Courtesy Galerie Daniel Buchholz, Cologne/Berlin and the Estate
of Jack Goldstein
Graham, p. 53: Courtesy Fundação de Serralves, Porto
Manet, p. 107: © RMN (Musée d'Orsay) / Hervé Lewandowski
Ms. Magazine, p. 60: Courtesy *Ms.* Magazine, © 1972
Nauman, p. 107: © Bruce Nauman / SABAM Belgium 2011
Wilke, p. 107: Courtesy Electronic Arts Intermix (EAI), New York. © SABAM Belgium 2011
p. 75: © Archives de l'AP-HP

ISBN 978-972-739-240-7 (Serralves)
ISBN 978-90-75679-36-6 (S.M.A.K.)
ISBN 978-3-7913-5124-7 (Prestel)

© of the publication 2010, SMAK, Ghent & Fundação de Serralves, Porto
© of artwork by Dara Birnbaum: Dara Birnbaum
© of texts, translations, and photographs: the authors

Published in 2011 by the S.M.A.K.—Stedelijk Museum voor Actuele Kunst,
and the Fundação de Serralves, in association with DelMonico Books,
an imprint of Prestel Publishing.

S.M.A.K.

S.M.A.K.
Museum for Contemporary Art
Cidadelpark
9000 Ghent – Belgium
tel +32 (0)9 240 76 01
fax + 32 (0)9 221 71 09
e-mail: info@smak.be
website: www.smak.be

SERRALVES

Museu de Arte Contemporânea de Serralves
Rua D. João de Castro, 219
4150-410 Porto – Portugal
tel + 351 22 615 65 00
fax + 351 22 615 65 33
e-mail: edicoes@serralves.pt
website: www.serrralves.pt

**Prestel, a member of Verlagsgruppe
Random House GmbH**

Prestel Verlag
Königinstrasse 9
80539 Munich
Germany
tel: 49 89 242908 300
fax: 49 89 242908 335
website: www.prestel.de

Prestel Publishing Ltd.
4 Bloomsbury Place
London WC1A 2QA
United Kingdom
tel: 44 20 7323 5004
fax: 44 20 7636 8004

Prestel Publishing
900 Broadway, Suite 603
New York, NY 10003
tel: 212 995 2720
fax: 212 995 2733
e-mail: sales@prestel-usa.com
website: www.prestel.com